THE BRILLIANT
BATHROOM READER

5,000 FACTS FROM THE
SMARTEST BRAND IN THE WORLD

THE BRILLIANT BATHROOM READER

5,000 FACTS FROM THE SMARTEST BRAND IN THE WORLD

AMERICAN MENSA®

Skyhorse Publishing
New York, NY

Dedicated to all the thinkers, the seekers, the curious,
and all the brilliant minds that too often go unnoticed.

CONTENTS

Introduction 1
Facts about Mensa® 1
Facts about Trivia 2

Chapter 1—Geniuses 4
Chapter 2—Fauna 36
Chapter 3—Insects & Arachnids 74
Chapter 4—Flora & Fungi 88
Chapter 5—Around the World 110
Chapter 6—Geography 135
Chapter 7—US National Parks 167
Chapter 8—Food 179
Chapter 9—History 207
Chapter 10—All the Presidents 250
Chapter 11—Music 296
Chapter 12—Famous People 327
Chapter 13—TV & Movies 342
Chapter 14—Art, Fashion, & Architecture 371
Chapter 15—Literature 405
Chapter 16—Comics 442
Chapter 17—Games & Leisure 461
Chapter 18—Sports 475
Chapter 19—The Olympics 519
Chapter 20—Science & Math 531
Chapter 21—Technology & Inventions 561
Chapter 22—Health, Wellness, & the Body 578
Chapter 23—Bizarre but True 605
Chapter 24—In the News 635
Chapter 25—Weird Words & Numbers 675

Exercise Your Mind at American Mensa® 702

THE BRILLIANT BATHROOM READER

5,000 FACTS FROM THE SMARTEST BRAND IN THE WORLD

INTRODUCTION

Did you know that:

1. 5,000 is an even composite number composed of 2 prime numbers multiplied together?

Or that

2. 5,000 has a total of 20 divisors?

Or that

3. The sum of its divisors is 11,715?

4. If you counted from 1 to 5,000, it would take you around 23 minutes, according to numbermatics.com!

5. Also, 5,000 seconds is equal to 1 hour, 23 minutes, and 20 seconds.

Facts about Mensa®

6. Mensa® is a club for the most intelligent people on the planet.

7. You can be a member as long as you score in the top 2 percent of the general population in an approved intelligence test.

8. Mensa® comes from the Latin word for table, which is supposed to reflect the organization's round table philosophy of equality.

9. Two animated characters are honorary Mensa® members—Lisa Simpson from *The Simpsons* and Mr Peabody from *Mr. Peabody & Sherman*.

10. Mensa® is the oldest high-IQ society in the world, and was founded 1946.

11. Famous Mensa® members include actors Nolan Gould and Geena Davis. Geena Davis is also an Olympic archer.

Facts about Trivia

12. Dr. John Kounios, director of the doctoral program in applied cognitive and brain sciences at Drexel University in Pennsylvania, says that playing trivia games can provide a dopamine rush much like gambling does. "You get a rush or a neuroreward signal or a dopamine burst from winning."

13. Dr. Deborah Stokes, a psychologist, says learning large bodies of knowledge can start with trivia and that people who like trivia can be brainy, have a high IQ, and be smart on a lot of levels.

14. People who have more education aren't necessarily better at trivia.

15. Trivia is like exercise for the frontal cortex of the brain, according to Stokes.

16. Neuroscientists at the Ruhr-University Bochum and Humboldt University of Berlin, found that people who have more general knowledge or are good at retaining trivia-type facts, have more efficient brain connections, while also noting that this doesn't mean these people are necessarily smarter.

17. A person's level of general knowledge (trivia) is also known as semantic memory. It refers to part of our long-term memory that processes ideas that don't come from personal experience. For example, the capital of Rhode Island most likely comes from your semantic memory.

18. Finally, 5,000 is the number of facts in this book.

Whether gearing up for a big trivia night or simply wanting to give your brain something interesting to think about, this big book of 5,000 facts fits the bill. We cover as many topics as possible, including facts that got our attention while weeding out the stuff that made us yawn or go, "Yeah, yeah, I've heard that one a million times." These facts will make you think. They'll make you wonder. You may even want to research more about some of these topics. Most of all, you'll have fun learning about everything from Thomas Edison's attempts at mind reading to Dr. Lucy King's beehive fences that scare elephants from destroying farms.

CHAPTER 1
GENIUSES

19. German composer Ludwig van Beethoven (1770–1827) composed 722 musical pieces during his 45-year career.

20. Born into a musical family, Beethoven's father forced him to practice in order for him to be a prodigy like Mozart. Neighbors recalled the small boy crying as his father loomed over him at the piano.

21. Beethoven left school at age 11 to help earn money for his family.

22. On his first visit to Vienna, the 17-year-old Beethoven played for Mozart. Mozart, who was generally disdainful of other musicians, allegedly said of Beethoven that he will give the world something to talk about.

23. Beethoven was completely deaf by the time he was 45 or 46. He continued to compose music, however.

24. Beethoven often had to give piano lessons to make ends meet.

25. Beethoven composed *Moonlight Sonata* for Countess Julie "Giulietta" Guicciardi, a student of his that he was in love with.

26. The actual name for this score is *Piano Sonata No. 14*. It was renamed 5 years after Beethoven's death after German poet Ludwig Rellstab described the piece as "Lake Lucerne shining in the moonlight."

27. Beethoven proposed marriage at least 3 times and was turned down.

28. He only wrote one opera, *Fidelio*, which took him years to write.

29. The Royal Philharmonic Society in London commissioned a symphony from Beethoven in 1817. This became the Ninth Symphony, Beethoven's final symphony, and perhaps his most famous.

30. Sir Isaac Newton (1642–1727), is considered one of the greatest mathematicians and scientists of all time, whose findings on gravity, light, mathematics, motion, and more resonate to this day.

31. As a child, Newton built a tiny mill that actually ground flour. It was powered by a mouse running in a wheel.

32. Newton came out of the Scientific Revolution of the 16th and 17th centuries in which a new view of nature replaced the Greek view of the previous 2,000 years.

33.

Newton discovered that white light is the combination of all the colors of the rainbow.

34. Using what he learned about light, he designed a reflecting telescope that used mirrors rather than just glass lenses. This allowed the telescope to focus all the colors on a single point.

35. Newton's 3 laws of motion (Law of Inertia, Law of Acceleration, Law of Action and Reaction) are the basic principles of modern physics.

36. Newton discovered calculus while on hiatus from his studies due to the bubonic plague of 1665–1666.

37. The story of Newton discovering gravity while watching an apple fall to the ground (or on his head, depending on the source) in his garden is a myth.

38. One of the reasons the myth gained traction was that toward the end of his life, Newton, himself, repeated it a few times to friends.

39. You can visit the apple tree the story is based on at Woolsthorpe Manor, the farmhouse where he was born and spent the plague years.

40. In 1687, Newton published his book, *Philosophiæ Naturalis Principia Mathematica*, which included his explanations of some of the most fundamental laws of science, including his laws of motion and his universal law of gravitation. Today, it is still considered one of the most important single works in the history of modern science.

41. Despite all of his scientific brilliance, Newton also pursued alchemy, which was the pseudo-science of turning base metals into gold.

42. After his death, large amounts of mercury were found in his system, likely due to his alchemy work.

43. In 1979, members of the Royal Society, to which Newton belonged, attributed his insomnia, poor digestion, and "irrational letters to friends" on mercury poisoning.

44. Newton also set up the basic steps for scientific research: the scientific method, in which hypotheses must be tested.

45. On more than one occasion, Newton inserted a hairpin into his eye socket and moved it around "betwixt my eye and the bone as near to the backside of my eye as I could." He saw dots—the same kind we see when you press on your eyes.

46. These dots of light are called phosphenes.

47. He also once stared at the sun through a mirror for as long as he could bear in order to determine what effect it would have on his vision. The image of the sun stayed when he closed his eyes . . . for months . . . until he spent days in a dark room.

48. Newton was most likely bipolar. He was a loner as a child, egotistical and high-strung, and he often had rageful bouts where he attacked his family and friends.

49. He also suffered bouts of depression and self-criticism. In 1662, Newton compiled a catalog of his sins, which included "robbing my mother's box of plums and sugar, punching my sister, threatening my father and mother Smith to burn them and the house over them, and making pies on Sunday night."

50. Newton believed fervently that the end of times was near. First would come war and plagues, and then the second coming of Christ, followed by a 1,000-year reign of saints living on Earth.

51. Newton believed he would be one of those saints.

52. Born Marguerite Annie Johnson in St. Louis, Missouri, Maya Angelou (1928–2014) was a poet, activist, actor, screenwriter, dancer, and more.

53. As a 7-year-old, Angelou stopped talking for 5 years after being sexually assaulted. She later explained, "In those 5 years, I read every book in the Black school library. When I decided to speak, I had a lot to say."

54.

As a young, teenaged mother, Angelou held several odd jobs to support her son, including being a fry cook in hamburger joints and working in a mechanic's shop removing paint off cars.

55. While studying dance and acting at the California Labor School, Angelou became the first Black cable car conductor in San Francisco.

56. In 1952, she married a Greek sailor named Anastasios Angelopulos. When she began her career as a nightclub singer, she took the professional name Maya Angelou, which combined her childhood nickname with a shortened form of her husband's name. The marriage didn't last.

57.
Angelou landed a role in a touring production of *Porgy and Bess*.

58. Angelou was also a successful calypso singer and dancer and released her first album *Miss Calypso* in 1957.

59. She acted alongside James Earl Jones, Lou Gossett Jr., and Cicely Tyson in the 1961 off-Broadway production of Jean Genet's *The Blacks*.

60. In 1959, Angelou was appointed the Northern coordinator for the Southern Christian Leadership Conference at the request of Dr. Martin Luther King.

61. Her close friend, Martin Luther King Jr. was assassinated on her birthday in 1968. For years afterwards, Angelou stopped celebrating her birthday. She also sent flowers to Coretta Scott King, King's widow, for more than 30 years.

62. Angelou was nominated for a Tony Award for her role in the 1973 play *Look Away*.

63. Angelou never went to college, but during her lifetime received more than 50 honorary degrees.

64. Her 1969 autobiography of her childhood and young adult years, *I Know Why the Caged Bird Sings*, stayed on the *New York Times* bestseller list for 2 years, and she became the first Black woman to make the nonfiction bestseller list.

65. Angelou revealed that she wrote *I Know Why the Caged Bird Sings* because her future longtime Random House editor said writing autobiography as literature was "almost impossible."

66. She was also urged to write her story by friend and fellow writer James Baldwin.

67. The book's title comes from the Paul Laurence Dunbar poem "Sympathy."

68. Angelou was nominated for the National Book Award for *I Know Why the Caged Bird Sings* in 1970.

69. In 1972, Angelou became the first Black woman to have her screenplay produced, with her play *Georgia, Georgia*.

70. Angelou's 1974 follow-up to *A Caged Bird*, *'Gather Together in My Name*, covers her life as an unemployed teenage mother who turned to drugs and prostitution.

71. Angelou's 1971 poetry collection *Just Give Me a Cool Drink of Water 'Fore I Die* was nominated for the Pulitzer Prize.

72. In 1977, Angelou was nominated for an Emmy for her role as Kunta Kinte's grandmother in the miniseries *Roots*.

73. She was the first Black woman to have a production company film her screenplay.

74. Angelou's published cookbooks include *Hallelujah! The Welcome Table: A Lifetime of Memories with Recipes* (2005) and *Great Food, All Day Long* (2010).

75. Angelou was fluent in 6 languages: English, French, Spanish, Italian, Arabic, and West African Fanti.

76. She taught modern dance at the Rome Opera House and the Hambina Theatre in Tel Aviv.

77. Angelou was only the second poet and the first Black person and woman to recite a poem at a presidential inauguration. She read "On the Pulse of Morning" at President Bill Clinton's 1993 inauguration.

78. "On the Pulse of Morning" won a Grammy Award for best spoken word album.

79. In 1998, Angelou became a movie director, debuting with *Down in the Delta*, which won the Chicago International Film Festival's 1998 Audience Choice Award.

80. In doing this, she became the first Black woman to direct a major feature film in the US.

81. Angelou and her poem "Phenomenal Woman" were featured in John Singleton's film *Poetic Justice.*

82. In the year 2002, Angelou agreed to do a line of products for Hallmark. The line included cards, bookmarks, bookplates, picture frames, and treasure boxes.

83. The line of products was called the Life Mosaic collection, and it generated $45 million in its first 5 years for Hallmark.

84. Billy Collins, the then US Poet Laureate said of the Angelou/Hallmark collaboration, "It lowers the understanding of what poetry actually can do."

85. Meanwhile, knowing she'd face criticism for this, she said, "If I'm America's poet, or one of them, then I want to be in people's hands. All people's hands. People who would never buy a book."

86.
Angelou appeared in "Tree of Life," an episode of the TV show *Touched by an Angel* in 1995.

87. She received the Presidential Medal of Freedom in 2010 from President Barack Obama.

88. In 2022, Angelou became the first Black woman to be included on the back of a US quarter when the US Mint released the first coins in its American Women Quarters Program. The quarter shows her with outstretched arms, with a bird and a rising sun behind her.

89. Shortly before her death in 2014, Angelou worked with Shawn Rivera and RoccStarr on an album that blended Angelou's words with modern hip-hop.

90.

Early in his career, Bob Dylan (1941–), whose real name is Robert Allen Zimmerman, briefly tried out the name Elston Gunnn—yes, with 3 "Ns."

91. Bob Dylan's other pseudonyms include Dedham Porterhouse, Blind Boy Grunt, Robert Milkwood Thomas, Boo Wilbury, and Jack Frost.

92. The first time Dylan ever hit #1 on a Billboard chart was in 2020, with his 17-minute ballad, "Murder Most Foul."

93. Dylan's iconic hit "Like a Rolling Stone," hit #2 on the Billboard Hot 100 back in 1965, as did his 1966 song, "Rainy Day Women #12 and 35."

94. A tenth-grade Dylan had his talent show act pulled at Hibbing High in Hibbing, Minnesota, due to the "unsuitable" nature of the music.

95. Dylan's first professional recording was as a backup harmonica player for Harry Belafonte in 1962.

96. While opening for the Smothers Brothers in Denver in 1960, the headliners tried to get him removed, claiming he looked and sounded homeless.

97. Dylan recounted during an interview that he once traded an Andy Warhol *Elvis* painting for a couch. He said, "I always wanted to tell Andy what a stupid thing I done, and if he had another painting he would give me, I'd never do it again."

98. In 2009, Dylan was detained by police in Long Branch, New Jersey, when he was found wandering onto someone's property in the pouring rain. The police responded to a report of an "eccentric-looking old man."

99. In 2016, Dylan won a Nobel Prize for Literature, becoming the first songwriter to do so.

100. Thomas Edison (1847–1931) acquired 1,093 patents in this lifetime.

101. Edison was born in Milan, Ohio, on February 11, 1847, and was the youngest of 7 children.

102. Edison was a poor student. One teacher of his went so far as to call him "addled." His mother took him out of school and homeschooled him.

103. Edison said of his mother, "(She) was the making of me. She was so true, so sure of me, and I felt I had someone to live for, someone I must not disappoint."

104. At the age of 12, Edison got a job selling candy and newspapers on the Grand Trunk Railroad. He set up a chemistry lab and a printing press in the baggage car of the train.

105. He published the *Grand Trunk Herald*, which became the first newspaper published on a train.

106. Around this time, Edison lost almost all of his hearing. He blamed this on an incident in which he was picked up by his ears and lifted onto a train. Edison thought this condition actually helped him concentrate on his work because he had fewer distractions.

107. At the age of 15, Edison saved a 3-year-old boy from being hit by a boxcar. The boy's father rewarded Edison by teaching him telegraphy.

108. Edison was 22 when he patented his first invention in 1869. It was for an electrographic vote recording device to help US Congress vote. A switch on the machine was flipped one way or the other to indicate a yes or no vote.

109. Congressmen didn't like the invention, which convinced Edison to only focus on inventions people wanted.

110. Edison nicknamed his 2 children Dot and Dash, referring to the Morse Code used to transmit messages via telegraph.

111. Edison's work improving Alexander Graham Bell's telephone and the telegraph led to his phonograph invention.

112. He realized that sound could be recorded as indentations on a moving piece of paper.

113. The first words ever recorded by Edison were, "Mary had a little lamb."

114.

In 1880, Edison was granted a patent for an incandescent light bulb.

115. However, Edison did not invent the light bulb as electric lamps had been around since 1802. The electric lights available before Edison were expensive and didn't last long.

116. Edison's improvements on the light bulb included replacing the oxygen used in existing lightbulbs with gases that worked better. He also experimented with thousands of different filaments until he found one that glowed the best and lasted the longest: carbonized thread.

117. The first commercial electric light system was installed in 1882 by Edison on Pearl Street in Manhattan, New York. The system included 400 lamps.

118. Just a year later, 500 customers were using more than 10,000 lamps.

119. Thomas Edison believed direct current (DC) was the way to distribute electricity. Nikola Tesla, who was working for Edison's rival George Westinghouse, believed in alternating current (AC).

120. The Battle of the Currents that emerged in the late 1880s had little to do with which was best, but everything to do with winning.

121. DC current couldn't travel over as long a system as AC, but AC generators weren't as efficient.

122. Nikola Tesla had worked for Edison at one time, and by many accounts, Edison owed him money.

123. To prove to the nation that AC was dangerous, Edison sponsored demonstrations showing AC electricity killing cats, dogs, and even Topsy, a circus elephant (who was going to be terminated anyway for killing a man).

124.

Edison liked to call the act of electrocution as being Westinghoused.

125. Edison's obsession over AC's danger led to one invention he wasn't proud of: the electric chair.

126. One of Edison's failures included single-piece cement homes. He believed that one way to make homes affordable was to create homes from a single mold into which cement was poured.

127. The homes came with cement furniture and a piano, but also weighed close to 500,000 pounds.

128. By 1917, less than a dozen homes were built using this technique in Union Township, New Jersey.

129. One problem with this house-building method was that the mold included up to 2,300 different parts that needed to be assembled. Also, the cost of creating these houses was too high. A few houses remain.

130. Edison's cement company, however, did provide 68,000 bags of concrete to build Yankee Stadium.

131. In a magazine article from 1920, Edison said, "I have been at work for some time building an apparatus to see if it is possible for personalities which have left this earth to communicate with us." There is no evidence the device was ever built.

132. Patented in 1878, the Vocal Engine, or phonomotor, was another of Edison's failures.

133. The Vocal Engine attempted to use the energy of voices to power a small engine. For instance, say your electric wall clock had stopped. All you would have to do to get it going again would be to speak into the mouthpiece. Your voice vibrations would turn a wheel, which, when connected to a belt, would drive a machine.

134. According to author William M. Hartmann in his book *Signals, Sound, and Sensation*, it would take "one million people, all talking at once" to light a 60-watt lightbulb.

135. Edison was the first to create a talking doll. Patented in 1888, he placed a miniature version of his phonograph invention into a toy doll. Kids could then turn a crank in the doll's back to hear a nursery rhyme. The doll cost $10 when it went on sale in 1890. Unfortunately, the nursery rhymes were too difficult to hear, and the recordings screeched and scared children. Edison later said that "the voices of the little monsters were exceedingly unpleasant to hear." Of the 2,500 dolls produced, only 500 were sold.

136. Fooled by a self-proclaimed mind reader named Bert Reese (who was later exposed as a fraud by Harry Houdini), Edison once wrapped electric coils around his head and the heads of 3 other colleagues who were stationed at various locations within the same house. The 4 men then tried to communicate telepathically. Later Edison commented, "We achieved no result in mind reading."

137. Not long before he died in 1931, he said to his friends Henry Ford and Harvey Firestone, "I'd put my money on the sun and solar energy. What a source of power! I hope we don't have to wait until oil and coal run out before we tackle that."

138. Nellie Bly (1864–1922) was an American journalist who wrote an exposé on Blackwell's Island (now Roosevelt Island), an asylum in New York, which brought about reforms in mental health care.

139. When she was 16, Bly read a column in the *Pittsburgh Dispatch* called "What Are Girls Good For?" The male author basically said they were good for making babies and doing housework.

140.

Bly wrote a scathing response that impressed the editor enough to give her a job.

141. As a 23-year-old undercover reporter for Joseph Pulitzer's *New York World*, Bly got herself admitted to the asylum by pretending to be a deranged woman.

142. Bly practiced looking insane in front of a mirror before moving into a boardinghouse, hoping to scare the other boarders.

143. It worked, and a judge ordered her admitted to the asylum. During the first few days, she was forced to take a bath in dirty water and share 2 towels among 45 patients.

144. She later wrote of that incident: "My teeth chattered and my limbs were goose-fleshed and blue with cold. Suddenly I got, one after the other, 3 buckets of water over my head — ice cold water, too — into my eyes, my ears, my nose and my mouth. I think I experienced the sensation of a drowning person as they dragged me, gasping, shivering and quaking, from the tub. For once I did look insane."

145. Bly wrote of the horrible conditions, rotten food, and freezing temperatures inside the building.

146. Ten days after being admitted, she was released, but only after help from her newspaper.

147. Her reporting and the subsequent book, *Ten Days in a Mad House*, prompted the asylum to implement reforms.

148.

Bly posed as an unwed mother and caught a trafficker in infants.

149. In 1889, she traveled around the world in a time of 72 days, 6 hours, 11 minutes, and 14 seconds, beating the 80 days in the Jules Verne novel *Around the World in 80 Days*.

150. One of her stops was in France, where she met Jules Verne.

151. A competing newspaper sent their own reporter to beat the 80-mark, and they sent her in the opposite direction. She arrived 4 days after Bly.

152. Bly is known as one of the stunt girl reporters who were popular during the late 19th and 20th centuries.

153. Newspapers employed women to go undercover into factories, mills, institutions, and more to report on conditions or uncover scandals.

154. The term was used derogatorily; however, according to academic Kim Todd, "Stunt reporters changed laws, launched labor movements, and redefined what it meant to be a journalist."

155. Stephen Hawking was born in Oxford, England on January 8, 1942. He passed away on March 14, 2018.

156. Hawking was a theoretical physicist best known for his work in the field of general relativity and the physics of black holes.

157. When Stephen was a teenager, he and his friends built a computer out of old clock parts, telephones, switchboards, and more.

158. At the age of 21, Hawking was told he only had 2 years to live. He had been diagnosed with amyotrophic lateral sclerosis (ALS). He lived for 55 years after his diagnosis.

159. ALS is a degenerative neurological disorder that causes muscles to atrophy, leading to paralysis. ALS affects the nerve cells involved in voluntary muscle movement, decreasing a person's ability to move and speak over time.

160. Hawking communicated by tensing his cheek. A.I. detected the movements and an algorithm translated these into sound. The technology learned from speech patterns.

161. He was once quoted saying, "The human race is so puny compared to the universe that being disabled is not of much cosmic significance."

162. Hawking enjoyed running over people's toes with his wheelchair.

163.

In 1976, Hawking ran over the former Prince of Wales's (King Charles III) toes.

164. In 1975, Hawking bet Kip Thorne, a physicist, a subscription to a magazine (some reports say it was *Penthouse* while others say it was *Private Eye*) that Cygnus X-1 wasn't a black hole. He lost this bet.

165. He bet $100 that no one would ever discover the Higgs boson—the missing piece of the standard model of particle physics. He lost this bet too.

166. In 2009, Stephen Hawking threw a party to prove a point. He said, "I gave a party for time travelers, but I didn't send out the invitations until after the party." He continued, "I sat there a long time, but no one came."

167. The Discovery Channel recorded the party—showing Hawking dressed up and waiting. He even gave precise GPS coordinates in the invitation so no one would get lost.

168. The invitation read, "You are cordially invited to a reception for Time Travelers. I am hoping copies of it, in one form or another, will survive for many thousands of years. Maybe one day someone living in the future will find the information and use a wormhole time machine to come back to my party, proving that time travel will one day be possible."

169. Along with scientists Roger Penrose, Hawking showed that Einstein's theory of relativity suggested space and time had a definitive beginning and end.

170. This led to the theory that black holes aren't completely black.

171. He also predicted that by the middle of the 21st century we'll have images of another planet, which may be life-bearing.

172. And that finding another planet to live on is essential because it's the only way humankind will escape mass extinction in about 100 years.

173. If aliens came calling, Hawking explained why we should be wary of answering back: "Meeting an advanced civilization could be like Native Americans encountering Columbus. That didn't turn out so well."

174. In 2017, Hawking predicted that Earth's rising population will use enough energy to turn the world into a "ball of fire" within 600 years.

175. It's not known whether or not Hawking ever took an IQ test, but it's estimated his was 160, which is what Einstein's was estimated to be. (The average IQ score in the US is 98.)

176. Hawking had thoughts about A.I. in 2014: "Alongside the benefits, A.I. will also bring dangers, like powerful autonomous weapons, or new ways for the few to oppress the many."

177.

Hawking's first wife described Hawking as "a child possessed of a massive and fractious ego."

178. In her memoir she wrote, "I call Hawking a misogynist. He may be a talented, or even extraordinary, physicist, but he was a very ordinary husband of his own space and time."

179. He was a fan of strip clubs, and lap dances. A member of a swinger's club once said, "Last time I saw him, he was in the back play area lying on a bed fully choked with 2 naked women gyrating all over him."

180. His final words in his last book, *Brief Answers to the Big Questions*, were: "There is no God. No one directs the universe."

181. Stephen Hawking never won a Nobel Prize.

182. Hawking could have won one when data confirming his prediction that black holes could only grow larger was obtained, but he died before it could be presented. And Nobel Prizes are not awarded posthumously.

183. German naturalist and illustrator Maria Sibylla Merian (1647–1717) was one of the world's first ecologists and one of the most significant contributors to entomology.

184. In 1679, Merian published the first volume of a 2-volume series on caterpillars; the second volume followed in 1683. Each volume contained 50 plates that she engraved and etched.

185. Merian documented evidence on the process of metamorphosis and the plant hosts of 186 European insect species. Along with the illustrations Merian included descriptions of their life cycles.

186. Up until 1700s, scientists believed insects spontaneously spawned from dust, dirt, or rotten meat. Merian was the first to describe the metamorphosis of insects in detail and that moths and butterflies hatched from eggs after reproduction.

187. Merian sold 255 paintings to finance a mission to Suriname in South America.

188. She published *The Metamorphosis of the Insects of Suriname* in 1705—a work that is valued by scientists to this day!

189. She also wrote of the mistreatment of enslaved indigenous and African people in Suriname.

190. Of the Peacock flower, she wrote, "The Indians, who are not treated well by their Dutch masters, use the seeds to abort their children, so that they will not become slaves like themselves."

191. Six plants, 9 butterflies, 2 bugs, a spider, and a lizard have been named after her.

192. Cecilia Payne-Gaposchkin (1900–1979) was a British-born American astronomer and astrophysicist who proposed in her 1925 doctoral thesis that stars were made primarily of hydrogen and helium.

193. Payne-Gaposchkin became the first person to earn a PhD in astronomy from Radcliffe College of Harvard University. (Harvard did not grant doctoral degrees to women at this time.)

194. Her assertion was rejected initially because it was believed at the time that there were no major elemental differences between the Sun and Earth.

195. Years later, one of the men who rejected her conclusions, Henry Norris Russell, realized she was in fact right.

196. Russell briefly acknowledged Payne-Gaposchkin's earlier contribution, but credit for this discovery was given to him for several years.

197. Albert Einstein was born March 14, 1879, in Ulm, Württemberg, Germany. He died on April 18, 1955, in Princeton, New Jersey.

198. Albert Einstein is best known for his equation E = mc2.

199. The "E" stands for energy, and the "m" and "c" stand for mass and the speed of light.

200. This equation states that energy and mass (matter) are the same thing, just in different forms.

201. In 1921, Einstein won the Nobel Prize for Physics for his discovery of the photoelectric effect.

202. Einstein's understanding of light as something which can function both as a wave and as a stream of particles became the basis for what is known today as quantum mechanics.

203. Einstein was a professor at the University of Berlin from 1914 to 1933. Later, he taught at the Institute for Advanced Study at Princeton, New Jersey.

204. When he was 16, Einstein renounced his German citizenship and was officially state-less until he became a Swiss citizen in 1901.

205. In 1903, Einstein married Mileva Maric, a Serbian physics student whom he had met at school in Zürich.

206. Mileva was the only female student at Zurich Polytechnic, where Einstein was studying.

207. She was the second woman to finish a full program of study in the Department of Mathematics and Physics.

208. Historians disagree over whether or not Mileva helped Einstein with his early work.

209. Einstein divorced Mileva in 1919, which is the same year he married his first cousin Elsa.

210. Elsa was the daughter of Albert's mother's sister.

211. They were also second cousins as Elsa's father and Albert's father were cousins. Her maiden name was Einstein.

212.

Shortly before his third trip to the US in 1933, the FBI started keeping a dossier on Einstein.

213. The file grew to 1,427 pages and focused on Einstein's association with pacifist and socialist organizations.

214. J. Edgar Hoover even recommended that Einstein be kept out of America by the Alien Exclusion Act, but he was overruled by the US State Department.

215. After Einstein fled Germany in 1932, 100 Nazi professors published a book condemning his theory of relativity.

216. The book was creatively titled *One Hundred Authors against Einstein*.

217. When told of this book, Einstein supposedly either said, "If I were wrong, one professor would have been enough" or "To defeat relativity one did not need the word of 100 scientists, just one fact."

218. During World War II, Einstein played a role in the development of the atomic bomb by writing a letter to President Franklin D. Roosevelt in 1939 warning him of the potential for Germany to develop nuclear weapons.

219. He later became an advocate for nuclear disarmament and used his fame and influence to promote peace and international cooperation.

220. In 1935, Einstein's stepdaughter, Margot, introduced him to Margarita Konenkova, and they became lovers.

221. In 1998, Sotheby's auctioned 9 love letters written between 1945 and 1946 from Einstein to Konenkova.

222. According to a book written by a Russian spy master, Konenkova was a Russian agent, though historians have not confirmed this claim.

223. Albert's second son, Eduard, whom they affectionately called "Tete," was diagnosed with schizophrenia and institutionalized for most of his adult life.

224. Eduard was fascinated with psychoanalysis and was a big fan of Freud.

225. Once when speaking at the Sorbonne in the 1930s, Einstein said, "If my relativity theory is verified, Germany will proclaim me a German and France will call me a citizen of the world. But if my theory is proved false, France will emphasize that I am a German and Germany will say that I am a Jew."

226.

Thomas Harvey, the pathologist who performed the autopsy on Einstein's body after his death in 1955, removed his brain and had it dissected into tiny blocks. All without anyone's consent.

227. He also removed Einstein's eyes and gave them to Einstein's eye doctor. They remain in a safe-deposit box in New York.

228. Harvey was fired a few months later for refusing to give up the brain.

229. Harvey put the brain cubes into 2 formalin-filled mason jars, and then stored them in his basement.

230. Over the next 40 years, Harvey fielded questions about the brain, and he always said that he was about a year away from publishing the results of his studies. He also gave several pieces to different researchers.

231. It wasn't until 1978 that journalist Steven Levy tracked down Harvey and the brain in Wichita, Kansas. (The brain was still in the jars, safe inside a cardboard box.)

232. In the early '90s, Harvey, along with a freelance writer, drove from New Jersey (where Harvey had relocated) to California to meet Einstein's granddaughter. Harvey took the brain with him and stored it in the trunk of his Buick Skylark.

233. He offered the brain to the granddaughter, but she didn't want it.

234. Finally, Harvey brought the brain back to Princeton in 1996, saying, "Eventually, you get tired of the responsibility of having it."

235. There have been several tests done on the brain cubes, and scientists have studied the photographs. Though the results are inconclusive, scientists report that Einstein's brain weighed less than the average adult male brain, but his cerebral cortex was thinner, and the density of neurons was greater.

236. Einstein also had an unusual pattern of grooves on both parietal lobes, which could have helped his mathematical abilities. Finally, his brain was shown to be 15 percent wider than average brains.

237. Nikola Tesla (1856–1943) was a mechanical and electrical engineer who is known as one of the main contributors to the birth of commercial electricity.

238. He formed the basis of modern alternating current, made great contributions to research into electricity and electromagnetism, invented the radio and remote control, and contributed to early robotics and nuclear physics.

239. He was friends with Mark Twain and lifelong enemy to Thomas Edison.

240. Twain often visited him in his lab, where in 1894, Tesla photographed the great American writer in one of the first pictures ever lit by phosphorescent light.

241.

Tesla was scared of germs, and he refused to touch anything that might have dirt on it.

242. He disliked anything round, was repulsed by jewelry (especially pearls), and obsessed with pigeons.

243. He would be seen walking around New York City covered in pigeons, sometimes taking some back to his hotel with him.

244. He had an idea to create a teleforce particle beam weapon, which was called a peace ray and could shoot down "10,000 enemy planes."

245. He also wanted to create an antigravity airship, time machines, and a camera that would take pictures of images from your imagination.

246. Tesla created a miniature boat that could be controlled by radio signals.

247. The US Patent Office didn't believe it worked, so he put on a demonstration.

248. Tesla told reporters that this invention would allow battles to be fought without people.

249. He predicted, "Battle ships will cease to be built, and the most tremendous artillery afloat will be of no more use than so much scrap iron."

250. During the summer of 1899, Tesla was tracking lightning storms at his Colorado Springs, Colorado, lab when his equipment picked up a series of beeps.

251. After ruling out terrestrial and solar causes, he concluded that the beeps came from another planet.

252. The following year, in response to a request for a prediction of the "Greatest Scientific Achievement of the Coming Century," Tesla wrote, "Brethren! We have a message from another world, unknown and remote. It reads: one . . . two . . . three . . ."

253. In 1996, scientists published a study duplicating Tesla's experiment and showing that the signal was caused by the moon Io passing through Jupiter's magnetic field.

CHAPTER 2
FAUNA

254. Many believe scientists only had 2 classifications for living organisms (Plant or Animal) up till the 1970s, but the first 3-kingdom model that included microscopic organisms was developed in 1866, when Ernst Haeckel proposed a third kingdom of life called Protista, which included unicellular organisms.

255. Since then, there have been kingdoms added and distinctions made so that any internet search will yield anywhere from 5 current kingdoms to 7 or more.

256. Carl Linnaeus introduced this rank-based system of nomenclature in 1735 in his book *System Naturae*.

257. Linnaeus divided nature into plants, animals, and minerals.

258. The highest rank he gave organisms was kingdom, which was followed by class, order, genus, and species.

259. Since then, 2 further main ranks were introduced: phylum or division and family. So, the order goes: kingdom, phylum or division, class, order, family, genus, and species.

260. In 1990, the rank of domain was introduced above kingdom.

261. Today, there are 6 families generally agreed upon. These are Amoebozoa, Archaeoplastida, Chromalveolata, Rhizaria, Opisthokonta, and Excavata.

262. Amoebozoa is a kingdom of amoeba-like cells that move and gather food.

263. Archaeoplastida is the kingdom of plants, glaucophytes, and red and green algae.

264. Glaucophytes are unicellular freshwater algae that resemble an ancient ancestor of plants.

265. Chromalveolates include photosynthetic organisms such as diatoms, brown algae, and more, but they aren't plants.

266. Rhizaria are unicellular eukaryotes that are mostly non-photosynthetic.

267. Various amoebas and marine plankton are in the Rhizaria kingdom.

268.

Opisthokonta are animals, fungi, and choanoflagellates.

269. Excavata are flagellated single-celled organisms with a feeding groove and lacking mitochondria.

270. Choanoflagellates are free-living unicellular and colonial flagellate eukaryotes that are considered to be the closest living relatives of animals.

271. Eukaryota is a domain or superkingdom that includes organisms that have cells with a nucleus.

272. Animals cannot produce their own energy and must eat other animals or plants to get energy to survive.

273. Sea lilies are animals, even though they look like plants.

274. The sea lily has a stalk that is attached to the sea bottom, but it also has a mouth and stomach and eats microscopic plants and animals.

275. Corals are animals.

276. Protists are single-cell organisms that are neither animals, plants, nor fungus but instead are classified as protozoans.

277. Orcas, also known as killer whales, are marine animals and are also the largest member of the dolphin family.

278. Orcas are the most widely distributed of all whales and can be found in all the world's oceans.

279. Males can be nearly 33 feet long and weigh up to 22,000 pounds.

280. Females can live up to 80 years or longer.

281. Orcas have been recorded traveling up to 33.5 miles per hour.

282. Orcas eat fish, seals, sea lions, dolphins, sharks, seabirds, and larger whales.

283. Orcas got their "killer whale" reputation from ancient sailors who witnessed orcas hunting much larger whales.

284. Different populations of orcas—called pods—have unique characteristics. They hunt for prey based on their specific needs and even have their own languages or accents. Knowledge is passed down to younger individuals from older whales.

285. These pods or cultural groups have evolved to become genetically distinct from one another. Orcas will only breed within their "ecotypes."

286. Orcas are the first non-humans whose evolution is driven by culture.

287. There's a population of orcas off the coast of Vancouver Island whose diet consists mostly of Chinook salmon.

288. With the scarcity of Chinook salmon due to human activity, the whales have not yet adapted to a new diet.

289. Offshore killer whales in the Pacific Ocean are thought to eat mostly sharks.

290. There are no documented cases of an orca harming a human in the wild.

291. Sperm whales have the largest brains of any animal. Orcas have the second largest.

292. Lobsters can regrow limbs. It could take up to 5 years for a claw to regenerate.

293. Lobsters smell and taste with hair identifiers on their legs and feet.

294. They chew with a set of teeth that is in their stomachs, which are right behind the eyes.

295. In 2015, a 2-toned brown-and-orange lobster was found in Maine. The chances of finding this genetically mutated coloring is 1 in 50 million.

296. Lobsters are cannibalistic and will eat each other.

297. The noise you hear when cooking a lobster is not screams of pain. It's air that has been trapped in the stomach. Lobsters don't have vocal cords and they cannot process pain.

298. Elephants are the largest existing land mammals on earth, with males reaching 11 feet tall at the shoulder and weighing up to 7 tons.

299. Elephants can run up to 25 miles an hour.

300.

Elephants can eat up to 19 hours a day, consuming 600 pounds of food during that time.

301. A single elephant calf is born to a female once every 4 to 5 years, with a 22-month gestation period.

302. There are 3 living species of elephants: the African bush elephant, the African forest elephant, and the Asian elephant.

303. There are subtle differences between elephant species. For example, African elephants are larger, have bigger ears, and both the male and female grow tusks, while only some Asian elephant males grow tusks.

304. Elephant females and calves live in groups of families that consist of 10 or more members.

305.
Male elephants live alone or in groups with other bachelor males.

306. Elephants can live up to 70 years and don't reach their full size until they are 35 to 40 years old.

307. The eldest female elephant is the leader of the family and is called the matriarch.

308. Elephants can be right- or left-tusked, and the one they use more is smaller because of wear and tear.

309. Elephant tusks are extended teeth that are used to protect the trunk, defend themselves, move objects, gather food, and strip bark from trees.

310. Elephants have been known to mourn the death of family members, pausing in silence where their loved one died, even years later.

311. Elephants have been known to show compassion, and their intelligence is about the same as primates.

312. An elephant can lift a horse with its trunk. It is also sensitive enough to pick up a grape on the ground. Trunks also breathe, smell, reach, trumpet noises of warning or greeting, suck up to 2 gallons of water at a time, and more.

313. Elephants' trunks have up to 150,000 muscles, and they are considered one of the most sensitive organs found on any mammal.

314. Elephants are afraid of bees. Dr. Lucy King has used this information to create safe bee fences around farms that keep elephants away from the tasty crops, while also helping farmers produce honey.

315. Why do elephants have such wrinkly skin? The wrinkles and folds can hold up to 10 times more water than flat skin. This helps them stay cool.

316. Elephants can communicate through vibrations in the ground. They can detect these seismic signals through their bones.

317. There were 1.2 million elephants in the 1970s. Today, there are 400,000. Meanwhile, during that time, the human population has quadrupled.

318. For years, dogs and wolves were considered different species, *Canis familiaris* (dogs) and *Canis lupus* (wolves).

319. Today, however, most scientists agree they are both a subspecies of *Canis lupus*.

320. One indicator that dogs and wolves are the same species is that, unlike dogs and foxes, wolves and dogs can reproduce fertile offspring.

321. All dogs descended from a now extinct species of wolf.

322. Bloodhounds have been used to track criminals since the Middle Ages.

323. Bloodhounds' sense of smell is so accurate that their tracking results can be used as evidence in court.

324. Most archeological evidence points to humans domesticating dogs anywhere from 15,000 to 40,000 years ago, during the last Ice Age, before we became farmers and were still hunter-gatherers.

325. Humans domesticated dogs long before any cattle, chickens, or other animals often associated with farming.

326. Even though dogs and wolves are the same species, they are not the same. A wolf's eyes, for instance, are always yellow or amber, while a dog's eye color can range from blue to brown.

327. A wolf's chest and hips are narrower as well—to help with hunting and running through woodlands. Dogs have wider hips and chests and shorter legs.

328. Wolves has straight tails, and their giant paws have 2 extra-large front toes, which are webbed.

329. A wolf's head is larger in comparison to its body size than a dog's.

330. A human yawn can trigger a dog yawn. And it's 4 times more likely to happen if the human yawn comes from someone the dog knows.

331.

A dog's nose print is as unique as a human fingerprint.

332. Dalmatians are born completely white. Their spots don't develop until they get older.

333. According to the American Kennel Club, 70 percent of people sign their dog's name on their holiday cards.

334. Animal psychologists believe dogs are as intelligent as the average 2-year-old child.

335. Dogs can understand up to 250 words and gestures, can count to 5, and can perform simple math.

336. Dogs have 18 muscles to move their ears. These muscles allow dogs to pick up sounds as well as to clue you in to how they're feeling.

337. Ears laid back against their head can mean a dog is scared.

338. Ears pointing up can mean a dog is alert and paying attention.

339. Dogs can hear sounds that are 2 times beyond a human's range of hearing.

340. In 2021, the most popular dog breed according to the American Kennel Club was the Labrador Retriever, which tops the list for the thirtieth year in a row—longer than any other breed has even been in the top 10.

341. The least popular breed was the Norwegian Lundehunds.

342.

Norwegian Lundehunds were bred specifically to hunt puffin, which is now illegal.

343. A study by researchers at the University of California, San Diego found that dogs showed "jealous behaviors" when their owners turned their affection toward a stuffed dog that barked and wagged its tail. Dogs snapped at and pushed the fake dog, trying to get between it and its owner.

344. Dogs can give birth any time throughout the year, while wolves only do so in the springtime.

345. A 2016 study found that dogs can understand and respond to emotions on human faces—even in photographs.

346. Wolves and dogs both have 42 teeth.

347. Thirteenth-century hunters used a small breed of Beagle called a Pocket Beagle to hunt. They were only 8 inches tall, and they were tucked into pockets of saddlebags.

348. British nobility, including Queen Elizabeth used Pocket Beagles to hunt.

349. According to WorldAtlas.com, there are approximately 900 million dogs in the world as of 2022. More than 73 million of them live in the US.

350. According to a 2017 study, dogs purposely make their eyes bigger (puppy eyes) when they know a person is looking at them. It's the first evidence in a non-primate that facial expressions can be used to communicate.

351. In a study called "Paedomorphic Facial Expressions Give Dogs a Selective Advantage," researchers state that dogs in a shelter who use puppy eyes are more likely to get adopted.

352. Many dogs' feet smell like popcorn. The condition is known as Frito Feet, and it is caused by bacteria and yeast growing in the folds of their paws.

353. Dogs have sweat glands on their paws but not on the rest of their body. These glands aren't enough to cool a dog down, however, which is why dogs pant.

354. Dogs use these glands to mark their territory.

355. Small dogs can hear sounds in higher ranges than big dogs.

356. This is because the smaller a mammal's head is, the higher frequencies it can pick up and compare in each ear.

357. Dog urine contains markers that inform other dogs of its presence, social standing, and sexual availability.

358. Dogs lift their legs as high as they can so they can distribute their message better and allow its scent to travel farther.

359. A 2018 study found that smaller dogs try to lift their legs as high as possible so that they may seem bigger to other dogs.

360. Dogs being walked by men are 4 times more likely to bite and attack another dog.

361. The American Heart Association states that interacting with dogs can boost your production of oxytocin, serotonin, and dopamine—the happy hormones.

362. This can lead to a greater sense of well-being and help lower levels of cortisol, the stress hormone.

363. Having a dog can also help lower blood pressure and cholesterol, ease depression, and improve fitness.

364. Petting a dog lowers the dog's blood pressure, too.

365. Dogs cannot see the same colors that we do, but they are not colorblind.

366. They have 2 color receptors, while humans have 3. Dogs see everything in shades and combinations of blue and yellow.

367. Most dogs do not like hugs. It stresses them out.

368. Dogs see having a limb thrown over them as a sign of dominance. They'll show their stress by licking their lips, folding their ears, or looking away.

369. Dogs use their sense of smell to sense our feelings. Studies show that dogs can detect feelings of fear and stress as well as happiness.

370. Dogs play "sneeze" when they are feeling playful. It's an indication that the dog is actually having fun.

371.

Grown cats only purr around people and not with other cats.

372. Purring can mean the cat is content, but it can also mean it is sick or hurt or even giving birth.

373. In 2015, David Teie, a soloist with the National Symphony Orchestra, partnered with animal scientists to make an album called *Music for Cats*.

374. According to Teie's website, the songs are "based on feline vocal communication and environmental sounds that pique the interest of cats."

375. Cats were domesticated in Egypt around 2,000 BCE.

376. But cats were first domesticated between 9,500 to 12,000 years ago.

377. The ancient Egyptian gods and goddesses were associated with cats, including Bastet, the goddess of cats.

378. Killing a cat in ancient Egypt was often punishable by death.

379. Cats spend 30 to 50 percent of their time grooming. This helps circulation, keeps them clean, and provides comfort.

380. Cats can drink seawater.

381. Their kidneys can filter out the salt from water; however, this can lead to health problems after a while.

382. Cats cannot taste sweetness.

383. Male cats tend to be left-pawed, while females tend to be right-pawed.

384. A group of tortoises is called a creep.

385. In 1854, the British Navy retrieved a tortoise from a Portuguese pirate ship. They kept the tortoise on their ship and named it Timothy.

386. When it died in 2004, it was believed to be 165 years old. Also, at some point, they realized Timothy was a she.

387. Jonathan the tortoise is 190 years old (as of 2022) and was born around 1832, making it the oldest tortoise ever.

388. Jonathan lives on St. Helena, an island in the South Atlantic Ocean.

389. A photograph of Jonathan from between 1882 and 1886 shows him grown, which means he was at least 50 years old at that time.

390. Greenland sharks have an estimated lifespan of at least 270 years.

391. Hydra, small jellyfish-like invertebrates, continually regenerate their cells and don't seem to age at all.

392. Called the immortal jellyfish, hydra are only an inch long and live in freshwater environments.

393. In some situations, an entirely new hydra can grow from a detached piece of hydra tissue.

394. On average, hydra replace all their cells every 20 days.

395. There are 2 types of camels. Dromedary camels have only one hump and live in North Africa, the Middle East, Australia, and eastern Asia.

396. Bactrian camels have 2 humps and are found in central and eastern Asia.

397.

Camels have 3 eyelids and 2 rows of eyelashes.

398. The third eyelid opens and closes from side to side and is used to clean the eyes. This thin eyelid is thin enough to see through. This helps camels protect themselves from sand.

399. Camel humps are stored fat, which they can live off when there is no food or water available.

400. Octopuses and squids have beaks made of keratin— the same material as birds' beaks and fingernails.

401. The coconut crab is a species of terrestrial hermit crab and is the largest terrestrial arthropod in the world.

402. Coconut crabs live on islands throughout the Indian and Pacific Oceans.

403. The coconut crab can grow up to 3 feet long and weigh up to 9 pounds.

404. Also known as the robber crab or palm thief, the coconut crab will grab anything on the ground it thinks is food. Hence the name.

405. The pinch force of a coconut crab is almost equal to the bite force of a lion—roughly 742 pounds of force, which is about 90-times their body weight.

406. The pinch force is greater than any other crustacean.

407. Marine iguanas found on the Galapagos Islands are the only sea-swimming lizards in the world. They can dive nearly 100 feet and stay underwater for up to an hour.

408. Coconut crabs have been filmed climbing coconut and pandanus trees, and although they are rumored to grab coconuts from trees, there is only evidence that they use the trees to escape predators.

409. Coconut crabs use their pincers to crack open felled coconuts, but they eat everything from cats to chickens and fellow coconut crabs.

410. Some researchers believe that Amelia Earhart didn't drown in the Pacific when her plane went down but was instead stranded on a remote atoll named Nikumaroro, where she was eaten by coconut crabs.

411. Researchers in 2007 used a pig carcass to test their theory. The bones were scattered quickly.

412. The bite force of a saltwater crocodile rivals that of a T. *rex*.

413. The American alligator has between 74 and 80 teeth in their mouth at a time.

414. Alligator teeth are replaced as they get worn down, and an alligator can go through 3,000 teeth in its lifetime.

415.

There are an estimated 1.25 million alligators in Florida alone, with 200,000 in the Everglades.

416. American alligators and several species of crocodiles can climb trees.

417. Indian and American alligators have been observed luring waterbirds by placing sticks and twigs across their snouts while submerged. A bird goes to pick up the twig, and the gator chomps.

418. Alligators don't have vocal cords, but they make sounds by sucking in and expelling air from their lungs.

419. Alligators can regenerate up to 9 inches of their tail.

420. In 2019, an alligator in Clearwater, Florida, crashed through a woman's condo window. He went after the woman's red wine. "The good stuff," she told reporters.

421.

Juvenile alligators will stay with their mother for up to 2 years after hatching.

422. The oldest alligator is currently Muja, an 85-year-old living in Serbia's Belgrade Zoo. The reptile survived World War II and the NATO bombing of Yugoslavia.

423. The word "koala" derives from an Aboriginal word meaning "no drink." It was thought that since koalas rarely venture down to the ground that they didn't need to drink water.

424. It was also thought that koalas got almost all their water from the eucalyptus leaves that make up their diet. A recent study shows that koalas actually lick water that's running down the smooth surface of tree trunks during rainstorms.

425. Koalas aren't bears; they're marsupials.

426. Hippopotamuses can hold their breath underwater for 5 minutes.

427. Being able to hold their breath is good, because hippos can't actually swim . . . or float.

428. Hippos have very sensitive skin, but their skin can produce a red or pink oily liquid that acts as a natural sunblock.

429. A group of hippos is called a bloat.

430. Hippo breast milk is not actually pink, no matter what it says on the internet.

431. There are 3 species of zebra living today: the Grévy's zebra, the mountain zebra, and the plains zebra.

432. The Grévy's zebra is found only in Kenya and Ethiopia and is the largest of the 3. Plains zebras are smaller, and their range extends from South Sudan and southern Ethiopia to northern South Africa. The smallest, the mountain zebra, is in South Africa, Namibia, and Angola.

433. Each species has a different width and pattern of stripes.

434. There are only 2,000 Grévy's zebras left in the wild.

435. Zebroids are the result of breeding zebras with other equines such as horses or donkeys. There are zedonks, zorses, and zonies.

436. There are many theories as to why zebras have stripes, including it acts as camouflage, it is a way of communicating with other zebras, or it helps regulate temperature.

437. The most likely reason, however, is that the stripes act as a form of pest control.

438. A group of scientists put striped coats on horses in 2019. They found that these horses attracted fewer flies than horses without the covering and with a covering without stripes.

439. Then, the scientists painted 6 pregnant Japanese Black cows, and found that the numbers of biting flies on black-and-white painted cows were significantly fewer than those on the all-black and black-striped cows.

440. Ligers are the cross of a male lion and a female tiger. They don't occur naturally but only with human intervention.

441. Ligers are the largest of all living cats and felines, reaching 10 feet in length and weighing more than 700 pounds.

442. Their large size may be the result of imprinted genes that are not fully expressed in their parents but left unchecked when the different species mate.

443. Tigons come from a female lion and male tiger.

444. The first grolar bear was sighted in Canada in 2006.

445. A grolar bear is the offspring of a grizzly bear and a polar bear.

446. Grolar bears may be occurring in the wild because of climate change, which has caused polar bears to move into grizzly bear territory.

447. Grizzly bears sometimes cover their tracks for protection against hunters.

448. Polar bears have black skin under their white fur. This helps them absorb heat to keep warm.

449. Infrared cameras don't work on polar bears because their fur insulates them so well.

450. A camas is hybrid of a llama and a camel.

451. Geep are a cross between a sheep and a goat. Since sheep and goat belong to a different genus, the offspring is most often stillborn, but live births have happened.

452.

Mules are actually a hybrid of a male donkey and a female horse.

453. All male mules and most female mules are infertile.

454. Mules often show higher intelligence than either of their parents.

455. Narwhals and beluga whales belong to the Monodontidae family, and a narluga is the offspring of a female narwhal and a male beluga.

456. Speciation is when hybrid animals wind up becoming a whole new species that combines the best traits from each parent.

457. Armadillo means "little armored one" in Spanish.

458. The armadillo is native to South America. Of the 21 species, 2 are present in Mexico.

459. The 9-banded armadillo is the only armadillo species found in the US. They have been found as far north as Nebraska and Illinois.

460. When startled, an armadillo can jump 3 to 4 feet in the air.

461. Armadillos are the only nonhuman animal that can spread leprosy (Hensen's Disease).

462. Scientists believe armadillos first acquired the bacteria that causes leprosy from 15th-century European explorers.

463. Only 2 species of armadillos can actually roll up into a ball. The others have too many plates to be flexible.

464. The pink fairy armadillo is named for its small size and its pink armor. It's only around 5 inches in length and weighs 3.5 ounces.

465.

The screaming hairy armadillo screams when alarmed.

466. Nine-banded armadillos always give birth to identical quadruplets.

467. Capybaras are native to Central and South America.

468. Capybaras are semiaquatic and have partially webbed feet.

469. Weighing up to 150 pounds and 2 feet tall at the shoulder, capybaras are the world's largest rodents.

470. Roadrunners are birds in the cuckoo bird family.

471. Roadrunners can fly, but they tend not to because they can run up to 15 miles per hour.

472. The first-known animal recruited to spy on an enemy was nicknamed Acoustic Kitty. The CIA launched a top-secret project in the 1960s that involved using house cats on spy missions. First a microphone and battery were implanted into a cat—along with an antenna in its tail. Then the cat was trained not to run after birds and mice. The procedure, along with the training, is said to have cost more than $60 million.

473. The first cat mission was to listen in on some Soviets in Washington, DC. The cat was released near the men and almost immediately run over by a taxi and killed.

474. Unlike what you may hear elsewhere, Komodo dragons do not kill with spit so full of bacteria that one drop of it is enough to give you a deadly infection.

475. Scientists have confirmed that they actually ooze a venom that decreases blood pressure, expedites blood loss, and sends a victim into shock.

476. Known as the "world's smallest monkey" at 3 to 6 inches tall, the Philippine tarsier is actually a suborder of Prosimii, so not really a monkey at all.

477. They *can* lay claim to being the world's second-smallest primate.

478. The actual smallest monkey is the pygmy marmoset, which is 6 inches from head to toe.

479. Tarsiers have lived in the Philippines for 55 million years, although today there are only 5,000 to 10,000 left in the wild.

480. Tarsiers have the largest eye-to-body size ratio of all mammals, which is helpful since they are nocturnal hunters.

481. Tarsiers are also the only species of primate that is completely carnivorous.

482. The cute, little slow loris is the only venomous primate. They secrete a toxin from a gland in their elbow that can cause a severe allergic reaction in predators.

483. Slow lorises will coat their young in the venom to make them poisonous to potential predators.

484. Dolphins have been trained to detect explosives hidden in oceans. The US Navy Marine Mammal Program has been in existence since 1959, and it uses bottlenose dolphins and California sea lions to detect underwater mines.

485. Around the same time, the Soviet Union had a program that purported to create dolphins that could attack with mounted harpoons and others that were called "kamikaze dolphins" because they were strapped with explosives.

486. In 2012, the US tried to replace their bomb-detecting dolphins with robots, but even after spending $90 million, the dolphins still do a better job.

487. African grey parrots can learn up to 200 words, as opposed to other types that can learn around 50.

488.

Some ravens in captivity can mimic human speech better than parrots.

489. In the wild, ravens imitate other animals like wolves or foxes in order to lead them to carcasses the ravens can't open on their own.

490. Ostrich eyes are bigger than their brains.

491. In fact, the ostrich has the largest eyes of any bird. An ostrich eye is the size of a pool ball and 5 times the size of a human eyeball.

492. A kick from an ostrich can kill a lion.

493. Reaching heights up to 9 feet tall, the ostrich is the world's tallest bird.

494. More than 200 bird species do something called anting. It's when they place or rub crushed or live ants on their feathers. Scientists aren't sure why they do this, but it could be a grooming method, or it might just feel good.

495. Kiwi birds of New Zealand only have hidden vestigial wings.

496. Kiwi feathers feel like hair.

497. Kiwi eggs can weigh up to 1 pound.

498.

Kiwis have nostrils at the end of their long beaks.

499. The kakapo of New Zealand is known as an "owl parrot." It has an owl's face, a penguin's stance, and a duck's gait. As the world's heaviest parrot, it also cannot fly.

500. Crows and ravens are members of the same genus, *Corvus*. We call the big ones ravens and the smaller ones crows, but there is no real genetic basis for these categories.

501. The *Corvus* family of birds includes ravens, crows, jackdaws, rooks, and more.

502. Ravens are about the size of a red-tailed hawk and have thicker beaks. Ravens also have long, shaggy throat feathers and their call is a deep croak.

503. Crows are about 18 inches with a thinner beak. Their feathers are rounded with a fan-shaped tail. Their call is a *caw-caw*, and they are generally more social than ravens.

504. Crows have big brains that enable them to adapt to many situations and environments.

505. Researchers at the University of Washington captured crows in nets while wearing cavemen masks, and then released them back into the wild. When the researchers later walked around campus with the masks on, the crows scolded and dive-bombed them.

506. More than 10 years after capturing 7 crows, more than half of the crows on campus still raised an alarm at the sight of the masks.

507. Research has shown that crows hold funerals and wakes for dead crows. A crow will call out to others in the area who show up and make a bunch of noise.

508. Researchers think this helps crow communities learn about threats and know where to avoid predators.

509. Crows form close family units that include up to 5 generations.

510. Yearling crows will help their parents raise chicks.

511. The body-to-brain ratio of a crow equals that of a chimpanzee.

512. Parrots are the only birds that have bigger brains than a crow.

513. Crows in Japan have been observed using cars on the road to crack open walnuts.

514. Crows engage in mobbing behavior when predators are nearby. They work together to chase off hawks and owls.

515. Scientists have documented crows pulling on the tails of predators to distract them, allowing other crows to steal their food.

516. Crow calls vary across regions—meaning they have dialects.

517. In 2011, a 4-year-old girl in Seattle formed a friendship with neighborhood crows by dropping food for them.

518. The crows then started leaving gifts for her such as a broken light bulb, pieces of glass, a small silver ball, a black button, a blue paper clip, a LEGO piece, and even a pearl-colored heart.

519. This relationship began by accident when one day while getting out of the car, she dropped a chicken nugget. Then she did it again another day. Soon the crows were watching her and waiting for her to drop food.

520. The wandering albatross has the largest wingspan of any living bird—up to 12 feet across.

521. It can fly 500 miles a day with speeds up to 80 miles per hour simply by gliding on air currents—meaning it doesn't have to flap its wings.

522. It has locking elbow joints, which enable the bird to keep its wings extended for long periods of time with no energy expended.

523. Albatrosses can spend a year or longer at sea without setting foot on land. This has led scientists to speculate that they can sleep while flying.

524.

In 2021, Wisdom, the 68-year-old Laysan albatross, laid an egg, making it one of the oldest breeding birds.

525. On the Hawaiian island of Oahu, up to 30 percent of the mated pairs of Laysan albatrosses are 2 females.

526. Satellite tag data suggests that a 5-month-old bar-tailed godwit flew from Alaska to Tasmania without stopping. That's 8,435 miles. The flight took 11 days and 1 hour and set a world record.

527. The Demilitarized Zone (DMZ) between North and South Korea is home to hundreds of rare animal species.

528. The 1-mile wide and 155-mile-long strip of land is off-limits to people, making it a haven for animals, including the endangered red-crowned crane.

529. According to the Republic of Korea Ministry of Environment, 5,097 animal and plant species have been identified in the DMZ so far, 106 of them labeled as endangered or protected.

530. The Amur leopard and the Siberian tiger (2 of the most endangered cats in the world), have been reported by observers.

531.

Syrian brown bears are a subspecies of brown bears and are native to the Middle East and Caucasia.

532. In 1986, a 5-year-old boy fell into the gorilla enclosure at the Durrell Wildlife Park in Jersey, Channel Islands (an island country off the coast of France).

533. Jambo the silverback gorilla stood guard over the boy, who had lost consciousness, and protected him from the other gorillas in what ethologists analyzed as a protective gesture.

534. When the boy regained consciousness and started crying, Jambo led the other gorillas away from the boy, who was then rescued.

535. Born in 1961, Jambo was the first gorilla born in captivity.

536. In 1996, a 3-year-old boy fell 24 feet into the gorilla enclosure at Brookfield Zoo in Illinois.

537. Binti Jua, an 8-year-old western lowland gorilla, walked toward the unconscious boy, picked him up, and cradled him. She laid him down when she heard the door to the enclosure open. Her own 17-month-old baby, Koala, was on her back the whole time.

538. Primatologist Frans de Waal uses this event as an example of empathy in animals. Others believe that because Binti had been hand-raised humans and had to be trained to care for her infant the behavior was the result of this training.

539. Harambe, a western lowland gorilla at the Cincinnati Zoo didn't fare as well in 2016, when yet another little boy fell into the gorilla enclosure. Harambe, "agitated and disoriented" by the screams of onlookers grabbed and dragged the boy and exhibited "strutting" behaviors.

540. When Harambe carried the boy up a ladder, zoo officials made the decision to kill the gorilla, and did so with a single rifle shot.

541. The boy's mother didn't face any charges over the incident, but she became the target of online harassment.

542. In the wild, gorillas live in social groups that are comprised of one adult male, several females, and their children.

543. Gorillas are mainly herbivores and eat leaves, stems, and fruit. They also eat larvae, snails, and ants.

544. There are 2 species of gorillas: the eastern gorilla and the western gorilla. The mountain gorilla is a subspecies of the eastern gorilla.

545. There are only an estimated 1,000 mountain gorillas left in the wild.

546. We share 98.3 percent of our DNA with gorillas.

547. Male gorillas between the ages of 8 and 12 are called blackbacks. After that they are called silverbacks because of the silver section of hair that develops over their back and hips.

548.
Male gorillas are up to 10 times stronger than humans.

549. In 2012, in Rwanda, researchers witnessed 2 four-year-old gorillas destroying poachers' traps.

550. Researchers speculate that the gorillas may have learned how to destroy the traps by watching humans taking them apart.

551. Is your room a pigsty? Pigs roll around in mud to stay cool since they don't have fur, and they are actually very clean animals.

552. Pigs have sparse coarse and bristly hair. Wild boars have more hair than domesticated pigs.

553. Are you sweating like a pig? Pigs can't sweat since they don't have sweat glands. That's another reason they roll in mud.

554. Do you eat like a pig? Wild pigs don't overeat, although they are considered foragers who will eat a wide variety of foods—they're not picky.

555. Pigs are the fifth-most intelligent animal in the world and are more trainable than dogs.

556. Lions sleep for 20 hours a day.

557. Lions live in groups called prides, which consist of around 15 lions.

558. The females do all the hunting, while the males defend their territory. When food is caught, the males eat first.

559. In 2005, an Ethiopian girl was kidnapped. She screamed for help, and perhaps mistaking her screams for a lion cub's call, 3 lions circled the girl and chased the kidnappers away. They stayed with her for hours until the police found her.

560. Kangaroos hop because they can't move their legs independently from each other on land. They can when swimming in the water though.

561. Kangaroos cannot move backwards.

562. A newborn kangaroo is only an inch long.

563. In 2009, a parrot named Willie shouted, "Mama, Baby!" when it saw the baby its owner was babysitting choking. The babysitter performed the Heimlich maneuver and saved the little girl's life.

564. One way to tell whether or not a snake is poisonous is to look at its eyes. If it has diamond-shaped pupils, it's poisonous.

565.

Snakes can't close their eyes.

566. Snakes' scales are made of keratin, the same material as our fingernails.

567. Opossums have a serum protein in their blood that neutralizes snake venom.

568. Sea cucumbers hide from predators by liquefying and solidifying their bodies as needed.

569. Clownfish are the only animals that can change sex following social cues. If a breeding female dies, her male mate changes sex and takes her place while another male rapidly gets bigger and becomes the breeding male.

570. The shoebill is a large, stalk-like bird that looks like a remnant from the age of dinosaurs. They can be up to 5 feet tall and have up to an 8-foot wingspan. They have long, sharp beaks with a hook at the tip.

571. Their beaks can decapitate baby crocodiles and other prey. Because of their strange beaks, they are also known as whalebills, whale-headed storks, or shoe-billed storks.

572. Cuckoo birds hide their eggs in the nests of other species of birds. These birds then raise the chick as its own.

573. They are endemic to the east-central part of Africa with the main population in southern Sudan, northern Uganda, and western Tanzania.

574. The wood frog of Alaska hibernates by freezing for up to 7 months. Its heart stops beating and breathing stops.

575. These frogs have a blood glucose level that's around 10 times higher than normal, which helps the cells retain water.

576. Hummingbirds are the only birds that can fly backwards, sideways, and can hover.

577. A hummingbird can flip over and fly upside down.

578. The tiniest bird is the Cuban bee hummingbird. From the tip of its bill to the end of its tail, it's only up to 2 inches long. It weighs about the same as a penny.

579. A hummingbird's wings flap 55 times in 1 second, and up to 200 times per second when flying quickly.

580. A hummingbird's heart is the largest (compared to body size) of all warm-blooded animals. It beats from 500 to 1,200 times a minute.

581. Otters hold hands when they're sleeping so they don't float away from each other.

582. Documentarians witnessed dolphins "passing around" a pufferfish, which release toxins that are a powerful hallucinogenic. The dolphins then floated just underneath the water's surface, "apparently mesmerized by their own reflections."

583. Bats are the only animals with fur that fly.

584. The giant flying fox is the biggest bat in the world and can weigh up to 3 pounds. Its wingspan can reach up to 6 feet wide.

585. Flying squirrels don't really fly—they glide from a higher place to a lower place.

586. The echidna is related to the duck-billed platypus. It has a beak, spikes, a pouch, and even though it is a mammal, it lays eggs.

587.

The duck-billed platypus has poison-tipped spurs behind each leg.

588. Giraffes have 7 bones in their necks—the same number as humans.

589. Europeans introduced rabbits to Australia in the 1800s so they would have something to hunt. As an invasive species, their numbers swelled to half a billion.

590. At birth a foal's hooves are covered in finger-y projections called eponychium.

591. All animals with hooves are born with eponychium.

592. These rubbery hoof coverings help the foal move through the birth cancel and ensure the mare's uterus isn't damaged by the sharp hooves during pregnancy.

593. These protective soft capsules are commonly called "golden slippers" or "fairy fingers."

594. The eponychium starts to get hard immediately after birth. Within 24 to 48 hours, they have worn down and the hard horse hooves are exposed.

595. When threatened by predators, reindeer run in a cyclone-like circling pattern that not only confuses predators but also can run them over. The calves are kept in the middle.

596. Dutch scientists left a hamster wheel outside in 2014, and saw that wild mice used it just for fun as well as frogs and slugs.

597. An African buffalo's horns can help it float in water.

598. The Arctic fox has fur on both the top and bottom of its paws.

599. A beaver's tale can store fat.

600. Leopards have hair on their tongues.

601. The tongue of an adult giant anteater is about 24 inches long.

602. Kodiak bear can reach over 12 feet tall on its hind legs.

603. A wren can sing 36 different notes in 1 second.

CHAPTER 3
INSECTS &
ARACHNIDS

604. Cockroaches have 2 brains—one in their skulls and another more primitive one near their abdomen. They can learn things in both brains independently.

605. Cockroaches don't have lungs. Instead, they have tubes all over their bodies that send oxygen to their cells. Since their blood doesn't carry oxygen, it's not red but clear.

606. The oldest cockroach fossil is 350 million years old. That's 150 million years before dinosaurs.

607. These cockroach ancestors had external ovipositors (egg-laying apparatuses), and today's roaches have internal ovipositors.

608. Modern cockroaches evolved 145 to 66 million years ago.

609. The *Megaloblatta longipennis* cockroach can grow to nearly 4 inches in length with a wingspan of nearly 8 inches.

610. They can go up to 45 days without food.

611. Cockroaches have a single hair connected to nerves all over their body. This hair can detect the movement of air as something approaches them.

612. Since this hair goes right to their leg muscles, a decapitated cockroach will still run away from you.

613. Cockroaches have 14 breaking points on their body where they can instantly release the body part caught by a predator or trap.

614. They can go hours without oxygen.

615. They can survive 10 times the amount of radiation humans can . . . and survive 10 times longer.

616. A cockroach can squeeze into a crack as small as a quarter of their body height. For some, that's as thin as a dime. This is due to their extremely flexible exoskeletons and the fact they can splay their legs to the side.

617. Cockroaches can live without their heads for about a week before they die of dehydration. This is because they use openings in their bodies to breathe, so they don't need a nose.

618. Cockroaches are among the fastest insects, reaching speeds up to 3 miles per hour or to put it in cockroach terms, 50 body lengths per second. If they were human, they'd be running at 210 miles per hour.

619.

One species of cockroach, *Diploptera punctata*, actually produces milk to feed its young.

620. This crystal-like substance contains high concentrations of protein, carbs, fat, and all 9 essential amino acids, making it a sought-after "superfood" for humans.

621. However, one researcher estimates you would have to kill over 1,000 cockroaches for 3.5 ounces of the milk.

622. The fear of cockroaches is called katsaridaphobia.

623. When a cockroach touches a human, it runs to safety to clean itself.

624. House flies are native to the steppes of Central Asia, but now occur on all inhabited continents, in all climates.

625. According to Erica McAlister, the author of *The Secret Life of Flies*, there are an estimated 17 million flies for each person on earth.

626. House flies (*Musca domestica*) are synanthropic organisms, meaning that they benefit from their association with humans and their animals. Houseflies are rarely found in the wilderness or where there are no humans.

627. Adult house flies have straw-like mouths and can only drink their meals. So, if a fly wants to chow down on something solid, it first has to vomit chemicals on the food to break it down into a liquid.

628. Female house flies can be told apart from males by their eyes. Females have a wide space between the eyes, while in males, the eyes nearly touch.

629. Scientists have calculated that a pair of flies, under optimal conditions, without any of their offspring dying, would produce 191,010,000,000,000,000,000 flies within 5 months.

630. Botflies, native to the tropics, will lay an egg on you so the larva can burrow under your skin and develop into a painful, itchy worm before emerging.

631. Knowing which type of maggots are on a dead body can help determine how long ago that person died.

632. Scientists at the Salk Institute reported that their work on how fly brains work can help improve internet search engines.

633. Houseflies use their feet, which are 10 million times more sensitive than our tongues, to find sugar.

634. Scientists at a US weapons lab in New Mexico reported in 2009 that they have trained honeybees to sniff out explosives.

635. By exposing the insects to the odors of several types of explosives followed by a sugar-water "reward," the researchers believe the bees will be able to detect dynamite, C-4, and other explosives, and alert their handlers by sticking out their proboscis.

636. A honeybee colony has up to 50,000 bees.

637. More than 99 percent of bees are infertile female worker bees.

638. The queen bee will only mate once, usually within 10 days of being born.

639. The queen flies to mate with up to 20 males (drones), and then it will store 100 million sperm in its spermatheca (sperm storing receptacle) for the rest of its life.

640. A bee flaps its wings up to 200 times a second. This produces a small positive charge that attracts pollen to its furry body.

641.

In its lifetime, a single honeybee will produce 1/12 of a teaspoon of honey.

642. The male drone bees only have a mother and a grandfather. They are created from an unfertilized egg and inherit all its genetics from its mother and grandfather. This is called parthenogenesis.

643. Nearly 90 percent of wild plants and 75 percent of crops depend on animal pollination from pollinators such as bees.

644. Honeybees have a move called the waggle dance that is actually a way of communicating where to go to find food.

645. Bumblebees and honeybees can count, navigate complex environments, learn concepts, and display emotions.

646. Even though bee brains are as small as a sesame seed, researchers taught bumblebees how to play a simple form of football in exchange for sugary treats.

647. The bees learned how to play the game by observing other bees, which is pretty sophisticated for such tiny brains.

648. Researchers at the University of São Paulo found that molecules in bee venom can help ease the pain caused by rheumatoid arthritis.

649. Bee stings are acidic, while wasp stings are alkaline.

650. Scientists at Washington University in St. Louis have shown that a toxin found in bee venom can destroy HIV cells while leaving surrounding cells unharmed.

651. When older bees perform tasks usually reserved for younger bees, their brains stop aging. In fact, their brains age in reverse.

652. Scientists at Arizona State University believe this discovery can help slow the onset of dementia.

653.

Bees remember faces the same way we do. Using a technique called configural processing, they piece together the components of a face to form a recognizable pattern.

654. The scientists doing this study think that by studying this we can improve factual recognition software.

655. Mathematician Thomas Hales proved that of all possible structures, honeycombs use the least amount of wax, and the walls meet at a precise 120-degree angle—a perfect hexagon.

656. Studying how bees collect pollen has helped authorities catch serial killers. Bees collect pollen close to home, but far enough away that predators cannot find their hive. Scientists used this "buffer zone" to write algorithms to improve computer models to catch felons.

657. Bees travel up to 60 miles a day in search of food.

658. Darwin's bark spider, which lives in the jungles of Madagascar, spins the biggest webs in the world.

659. These webs can reach 80 feet in length, with some spanning rivers and lakes.

660. Darwin's bark spider's silk is also the strongest ever encountered.

661. Ingi Agnarsson, the director of the Museum of Zoology at the University of Puerto Rico, says the web is twice as resilient as the next strongest and 10 times tougher than the material used in bulletproof vests.

662. The ancient Greeks put spider webs on wounds to help stop the bleeding.

663. Scientists now know that the silk has vitamin K, which indeed, helps reduce bleeding.

664. New-world tarantulas can fling annoying little hairs at predators, much like a porcupine with its quills.

665. Even though most spiders are solitary as adults, some form large communal webs. In these cases, thousands of spiders can come together to make a giant web that can cover whole trees, and then they share the rewards.

666. The ogre-faced spider weaves a small net between its front legs to throw at prey.

667. The tarantella is a dance created in Italy during the 16th and 17th centuries to ward off the supposed fatal bite of the wolf spider.

668. The world's biggest spider is the Goliath spider. It can grow to nearly a foot wide, with one-inch fangs.

669. The Goliath spider is big enough to hunt mice, lizards, frogs, and even small birds.

670. The smallest spider is the *Patu marplesi*. They are so small that 10 of them could fit on a pencil eraser.

671. The web of the gold orb can last years and can catch birds.

672. While most spiders can live up to a year, tarantulas can live up to 20 years.

673. In an article in the *New Yorker*, Nicola Twila states that a spider web that's long enough to go around the world would only weigh about a pound.

674. Spider webs are only 3-thousandths of a millimeter in diameter.

675. A web scaled up to one millimeter would be strong enough to ensnare a helicopter.

676. It is a myth that people swallow up to 8 spiders a year in their sleep. It is actually highly unlikely for a spider to end up in anyone's mouth.

677. Researchers in Brazil found that a bite from a Brazilian wandering spider can cause "long and painful" erections in male humans.

678. Other researchers are testing the toxin responsible for possible relief of erectile dysfunction.

679. In 2014, British pop star Katie Melua had been complaining of a weird scratching or rustling noise for about a week before she went to a doctor to check it out. Yeah, there was a spider living in her ear.

680. After getting the spider suctioned out, Melua released a single called "Spider's Web."

681. A study from the University of Oxford reports that spider webs "actively spring towards prey," due to "electrically conductive glue."

682.
Some species of spiders can see spectrums of light humans cannot detect, including UVA and UVB light.

683. Spider silk is a liquid that hardens once it is exposed to the air.

684. It takes 2,000 silkworm cocoons to produce one pound of silk.

685. One monarch butterfly weighs 1/100 of an ounce.

686. Monarch butterflies are poisonous to many predators because of their diet of milkweed sap, which is filled with toxic steroids.

687. Some insects replace their body water with glycerol during the winter. This acts as a sort of antifreeze against cold temperatures.

688. The white birdwing of the Solomon Islands has a 12-inch wingspan.

689. So far, there have been 1.5 million different species of insects named around the world.

690. It is estimated that there are more than 30 million insect species worldwide.

691.
Insects have the largest biomass of any land animal. It is estimated there are some 10 quintillion (19 zeroes after the 1) insects alive at any given moment.

692. Dragonflies can travel up to 35 miles an hour, making them the fastest flying insect.

693. The longest insect in the world is a stick insect in China that is 25 inches long.

694. The loudest insect is a cicada, which can be heard up to a quarter mile away.

695. A South American termite nest was found to have 3 million individuals.

696. Locust swarms can include up to 1 billion insects.

697. In 1929, California was the first state to select a state insect: the dogface butterfly (*Zerene eurydice*).

698. Today, 48 states have state insects, including Washington (Green Darner Dragonfly), Rhode Island (American Burying Beetle), New Mexico (Tarantula Hawk Wasp), and Nevada (Vivid Dancer Damselfly).

699. A ladybug can eat up to 5,000 insects in its lifetime.

700. Throughout history, species of biting ants have been used as sutures to close wounds.

701. There are more than 12,000 species of ants worldwide.

702. The driver ant in Africa is over one inch long.

703. Ants do not have lungs, ears or blood.

704. Ants have 2 stomachs.

705. Ants can lift 20 times their body weight.

706. Ants can swim and can live for up to 2 hours without oxygen.

707. Some queen ants can live for several years and have millions of offspring.

708. When ants fight, they usually fight to the death.

709. An ant colony can only survive for a few months once its queen dies.

710. Mosquitoes are the deadliest insects on the planet. According to the World Health Organization, this is because they carry and transmit diseases and viruses like yellow fever, dengue, malaria, and more. They result in more than 1 million deaths a year—mostly due to malaria.

711. Caterpillars can eat up to 25,000 times their weight.

712. Scientists believe that millipedes were one of the first animals to move from water to land and to breathe air over 425 million years ago.

713. Pill bugs (a.k.a. roly-poly bugs) are not insects, but crustaceans like lobsters or shrimp.

714.

Pill bugs are the only crustacean to live completely on land.

715. As ancient sea critters, pill bugs have adapted to life on land, yet they still use gills to breathe. The gills need to stay moist to work.

716. Pill bugs have 7 pairs of legs.

717. Some people eat pill bugs, and if cooked right they taste a little like shrimp, or as they are sometimes called, wood shrimp.

718. Even though we use bug to mean just about any type of creepy crawly, and "insect" and "bug" are both used interchangeably, bugs and insects are not technically the same thing.

719. Insects have 6 segmented legs, 2 antennae, a body segmented into 3 sections, and hard exoskeletons.

720. All bugs are insects, but not all insects are bugs. True bugs belong to an order called *Hemiptera*, and bugs have a straw-shaped mouth for sapping juice from plants or blood from animals. These include stink bugs, bed bugs, cicadas, and more.

721. Ladybugs are beetles, and so are June bugs. But they are not technically bugs.

722. The flannel moth caterpillar is very furry and bright orange. This "fur" is actually a collection of venomous hairs. In 2016, researchers and newspapers decided this caterpillar looked an awful lot like presidential candidate Donald Trump's hair.

723. It has since been nicknamed the "Trumpapillar."

724. *Men's Journal* wrote, "Donald Trump's Hair Discovered Crawling in Amazon."

725. *Wired* wrote, "Never Touch Anything that Looks Like Donald Trump's Hair." The caterpillar is poisonous to the touch.

726. The *New York Post* wrote, "Trump's hair-raising campaign has made it all the way to the Amazon."

CHAPTER 4
FLORA & FUNGI

727. Plants use photosynthesis to get energy from the sun for their survival. Chlorophyll is the green pigment in plant cells that enables this process to happen.

728. Fungi are spore-producing organisms that feed on organic matter.

729. Seaweeds are not plants but a kind of alga.

730. Algae are usually photosynthetic and can be single-celled or as big as 150 feet (giant kelp).

731. Nori seaweed, red dulse, and kelp are all unrelated to plants.

732. Organisms are considered plankton if they are carried by tides and currents and cannot swim well enough to move against them. They can be plantlike (or plants) or animal organisms.

733. Plankton are named for the Greek word "planktos," which means to drift or float.

734. Plankton size ranges from microscopic to less than one inch, although jellyfish and some crustaceans, which are considered plankton, can be larger.

735. Plankton that are plants are called phytoplankton. Animal plankton are zooplankton. There are also bacterial and fungal plankton.

736. Aeroplankton are plankton that float through the atmosphere.

737. Phytoplankton are microscopic plants (a type of alga) that perform photosynthesis and are found near the water's surface.

738. Dinoflagellates are types of phytoplankton that are bioluminescent.

739. Around 100,000 different phytoplankton species have been identified, but scientists believe there are more than 1 million species.

740. Nearly half of the world's oxygen is produced by freshwater and saltwater phytoplankton that also help absorb carbon emissions.

741. One species, *Prochlorococcus*, is the smallest photosynthetic organism on Earth and yet produces up to 20 percent of the oxygen for our planet. This is more than all the rainforests combined.

742. A chemical emitted by phytoplankton, called isoprene, is responsible for cloud formation.

743. Most zooplankton eat phytoplankton, and then, larger animals eat zooplankton.

744.

Krill, a zooplankton, are a major component of the diet of humpback, right, and blue whales.

745. An ocean dead zone is an area where oxygen levels are too low to support marine life.

746. Dead zones are caused when algal blooms die and the decomposition process uses oxygen faster than it can be replenished, creating areas of low oxygen concentrations known as hypoxia.

747. *Mesodinium chamaeleon*, a creature found at the bottom of the sea in Denmark, has characteristics of both animals and plants.

748. It has thousands of hair strands that help it move through water to find plants to eat. Sounds like an animal.

749. After it eats the plant, it becomes a "plant" as it keeps the plant's chlorophyll active in its stomach, using the plant's ability to convert sunlight into energy. Sounds like a plant—kind of.

750. After the plant is digested, this critter turns back into an animal.

751. Tropical trees don't have rings because they grow year-round.

752. Scientists use tree-ring patterns to reconstruct regional patterns of drought.

753. The thickness of tree rings can indicate when growing seasons were longer and shorter, and we determine the age of a tree by counting its rings.

754. The study of the growth of tree rings is called dendrochronology.

755. A single tree ring represents one year and has 2 layers. The light-colored layer forms in the spring and early summer, and it is usually thicker since this is the tree's growing season. The second layer is the dark layer, which forms in the late summer and fall. It's thinner since the tree's growth slows at this point.

756. Trees have been around for 380 million years.

757. The tallest living plant is a coastal redwood that is native to California. Named Hyperion, this tree is 379.3 feet tall and resides in a secret location in the Redwood National and State Parks.

758. Some of these giant trees have lived for over 2,000 years.

759. Trees have the longest lifespan of any organism on Earth.

760. Pando is a massive clonal colony of quaking aspens in the Fishlake National Forest in Utah. The colony of trees is said to be over 80,000 years old, making it the oldest plant in the world as well as the largest known living organism in the world, taking up 106 acres.

761. Pando consists of 40,000 individual trees.

762. Pando originated from a single seed and spreads by sending up new shoots from an expanding root system.

763. A clonal colony is a group of genetically identical individuals.

764. Pando is thought to be dying due to overgrazing, development, drought, and fire suppression techniques.

765. California has the oldest trees, with some of their bristlecone pines and giant sequoias reaching 4,000 to 5,000 years old.

766. Methuselah, a bristlecone pine, is over 4,800 years old, making it the oldest known tree on the planet.

767. There are 60,000 tree species in the world. Brazil, Colombia, and Indonesia have the highest number of native tree species.

768. A US Forest Service study in 2013 reported that cities with community forests save an average of one life each year. In New York City, it's 8 lives per year.

769.

More than 20 percent of the world's oxygen supply is produced in the Amazon Rainforest.

770. In one year, an acre of mature trees can absorb the amount of carbon dioxide produced by a car driven 26,000 miles.

771. In one year, a single mature tree will absorb more than 22 to 48 pounds of carbon dioxide per year.

772. A 2012 study by the University of Vermont and the US Forest Service found that in Baltimore, a 10 percent increase in tree canopy led to a 12 percent decrease in crime.

773. Another study revealed that there is less graffiti, vandalism, and littering in outdoor spaces that have trees.

774. Trees use the wind to pollinate.

775. The smallest tree is the dwarf willow (*Salix herbacea*), reaching only 2 inches in height.

776. Most of the world's plant life is aquatic, with 85 percent in the ocean.

777. There are more than 80,000 species of edible plants on Earth.

778. However, 90 percent of the food we eat comes from 30 plants.

779. Bamboo is the fastest growing woody plant on the planet. It can grow up to 3 feet a day.

780.

Bamboo is the largest member of the grass family.

781. There are more than 1,500 species of bamboo native to Asia and Australia.

782. Strawberries are the only fruit that has seeds on the outside. Each contains 200 seeds or more.

783. Blueberries have the highest antioxidant level of all commonly eaten fruits and vegetables.

784. A Venus flytrap is triggered when an insect brushes against its exposed hairs. But the trap isn't triggered until this happens twice. Why? The first one may be a false alarm. A wave of calcium is generated when a hair is triggered, but one wave isn't enough to close it.

785. A Venus flytrap may have up to 12 or more traps, each able to shut on its prey in 1/10th of a second.

786. It takes a Venus flytrap 3 to 5 days to digest its catch.

787. The only place you can find Venus flytraps in the wild is on a 100-mile long and 10-mile-wide strip of land along the coasts of North and South Carolina, where it's illegal to pick or otherwise bother them.

788. The Venus flytrap was first described botanically in 1768 by John Ellis in England. "Venus" can refer to its beautiful flower (Venus, the goddess of love and beauty) or its alien-like feeding habit.

789. In colonial days, it was known as "tipitiwitchet."

790. There are more than 100 species of sundew plants. They have what is called a flypaper trap.

791. Sundews attract insects with sweet-smelling and sticky nectar balls that look like glistening dew. An insect goes for a drink and gets stuck.

792. The Borneo pitcher plant can grow to 60 feet long—large enough to trap a frog, small rat, or bird.

793. The California pitcher plant is also called the cobra plant or cobra lily. It has hooded leaves that look like striking cobras and purple-red appendages that look like a snake's forked tongue or a set of fangs.

794. Pitcher plants bait insects into their pitcher-shaped leaves with sweet-smelling nectar. When insects enter, they get stuck because the walls of the leaves are too slippery to climb back up.

795. Active traps can also be found in bladderworts (*Utricularia*). These plants are either aquatic or terrestrial.

796. The first carnivorous plants appeared around 65 million years ago—toward the end of the age of the dinosaurs.

797.

Meat-eating plants evolved because of nitrogen-starved soil. The plants evolved to catch insects to provide the missing nitrogen.

798. The corpse flower (*Amorphophallus titanum*), native to Indonesia, has only 1,000 plants growing in the wild.

799. The plant produces a putrid stench of rotting flesh during its nightly peak bloom, attracting insects from miles away.

800. The corpse flower can grow up to 8 feet tall and weigh 170 pounds.

801. The largest flower in the world is a type of corpse flower called *Rafflesia arnoldii*—the stinking corpse lily.

802. The flower is more than 3 feet across. It has no roots, stems, or leaves, but instead grows on existing vines. The corpse lily is pollinated by carrion flies.

803. The corpse lily is not named after Arnold Schwarzenegger, but instead Joseph Arnold, who in 1818, became the first British person to see one.

804. *Wolffia arrhiza*, or spotless water meal, are found in Asia, Europe, Australia, Africa, and parts of South America. They are the smallest vascular (having tubes that connect all parts of the plant) plants in the world, only reaching a size of 100 millimeters.

805. Spotless water meal are a good source of protein and minerals for frogs, fish, and humans.

806. *Euphorbia obesa*, or the baseball plant, is a South African succulent that's in the shape of a ball.

807. It's considered endangered and nearly extinct in its natural habitat due to harvesting. It is however cultivated around the world for gardens and nurseries.

808. There are 1,750 cactus species, with all but 1 native to the Americas.

809. The mistletoe cactus is the only cactus naturally found outside the Americas, and scientists think bird migration or human trade led to this cactus being native to Africa and Asia (as well as in the Americas).

810. Giant water lilies (*Victoria amazonica*) are the largest member of the water lily family, with pads reaching 8 feet across.

811. Giant water lilies have flowers that open and close—trapping beetles overnight before releasing them to complete the pollination process.

812. *Welwitschia mirabilis* are bizarre plants with a stem base, roots, and just 2 leaves. Found in the Namibia Desert in Namibia and Angola, these can live for 500 to 600 years. The largest are thought to be 2,000 years old.

813.

Dodders are plants that attach themselves to other plants and suck on their sap.

814. Lithops are called living stones because they look just like small, flowering rocks. Found in Southern Africa, these plants can store large amounts of water.

815. Some plants can send out chemical signals to warn other plants that insects are approaching.

816. Researchers discovered that undamaged trees near infested trees pump out bug-repelling chemicals called phenolics to ward off attack.

817. Willow trees emit certain chemicals when attacked by webworms. Other willows in the area then produce more tannin, making their leaves less digestible.

818. Scientists are exploring another way plants communicate: through electric pulses.

819. Native to the Americas, pumpkins have been around since at least 7,000 BCE, and today, they are grown on all of Earth's continents except Antarctica.

820. As one of the most popular crops in the US, 1.5 billion pounds of pumpkins are grown every year. There are more than 50 varieties.

821. Pumpkins are known for their orange color; however, they can also be green, yellow, white, red, and even gray.

822. Commercial oranges are injected with Citrus Red Number 2, an artificial dye, in order to look bright orange.

823. The giant saguaro cactus can store 200 gallons of water. After a downpour, the plant swells up like a balloon, nearly doubling in width.

824. Saguaro cacti can grow up to 50 feet tall.

825. Dandelions are edible and were introduced by European settlers in the US as a salad green—not a weed.

826. A sunflower is actually an inflorescence, which means its head has many tiny flowers (florets). These ripen and become sunflower seeds.

827. Vanilla pods are called vanilla beans, but they're more closely related to corn than beans.

828. Pineapples are the only edible members of the bromeliad family.

829. A chemical irritant known as syn-Propanethial-S-oxide is to blame for onion cutting bringing tears to your eyes. The National Onion Association says if you chill the onion and cut the root end last, you'll be nearly tear-free.

830. Kudzu is an invasive plant species brought from Asia to the US in the late 19th century as a garden vine.

831. In the South, kudzu is known as the vine that ate the South and mile-a-minute.

832. Kudzu was then used to help with soil erosion after the Dust Bowl.

833. Kudzu can grow up to 60 feet per season, and up to 1 foot per day.

834. Kudzu spreads over landscapes and smothers plants and trees and actually doubles emissions of nitric oxide and increases ozone pollution.

835. Kudzu flowers, leaves, and roots are edible.

836. Since kudzu thrives in places with mild winters and hot summers, climate change may make it even easier for kudzu to spread.

837. Experts estimate that invasive species infest more than 100 million acres of land in the US.

838. Of the 235 woody plants known to invade natural areas in the US, 85 percent were introduced for ornamental and landscape reasons.

839. English ivy was brought to America by colonists who wanted to recreate their native landscaping. It is considered an invasive species in the US.

840. Other invasive species include wisteria, barberry, butterfly bushes, purple loosestrife, and Japanese honeysuckle.

841. *Welwitschia mirabilis* is considered a living fossil.

842.

A living fossil is an animal or plant that resembles a related species known only from the fossil record.

843. Welwitschias are endemic to the Namibia Desert, and most likely rely on fog for moisture.

844. During its lifetime, a Welwitschia will only produce 2 leaves during its lifespan, which split into segments.

845. Carbon-14 datings of the largest Welwitschias show that some are over 1,500 years old, making its leaves the longest-lived leaves in the world.

846. The Namibian national rugby team is nicknamed the Welwitschias.

847. Water hemlock is known as "the most violently toxic plant in North America."

848. Water hemlock looks like Queen Anne's lace and can be confused with celery or parsnips.

849.

Eating water hemlock will result in painful convulsions, nausea, cramps, and death.

850. Nightshade contains atropine and scopolamine in its stems, leaves, berries, and roots, and causes paralysis in the involuntary muscles of the body, including the heart.

851. Just touching nightshade leaves will cause skin irritation.

852. White snakeroot is an herb with white flowers that contain a toxic alcohol called tremetol.

853. Nancy Hanks, Abraham Lincoln's mother, died from drinking milk from a cow that grazed on white snakeroot.

854. One to 2 caster beans is enough to kill a child. They contain ricin.

855. Tobacco is the most widely grown commercial non-food plant in the world.

856. Eating tobacco plants can be fatal, as all parts of the plant contain toxic nicotine and anabasine.

857. Linen, one of the oldest human fabrics, is woven from flax plant fibers located in its stalk.

858. Despite the popularity of aloe vera, it only grows wild in Madagascar and Africa. Its sap is used for healing and cosmetics.

859. Carrageenan and alginate are compounds extracted from red algae (seaweed) that are used to stabilize and gel foods.

860. Carrageenan is used in nut and soy milks, deli meats, protein shakes and powders, chocolate milk, yogurt, ice pops, frozen foods, ice cream, and infant formula.

861. Poligeenan is made synthetically by subjecting seaweed to very high temperatures and boiling it in acid.

862. Brown algae have alginates that make foods thicker and creamier.

863. Brown algae alginates are used to keep ice crystals from forming on ice cream.

864. Kelp is used in lipstick, toothpaste, and dye.

865. Toothpaste contains cellulose and cellulose gum, which are both derived from wood pulp.

866. Willow bark has acetylsalicylic acid, which led to the creation of aspirin.

867. Foxglove leaves have chemicals called cardiac glycosides, which have been used to treat heart failure since the 1780s.

868. Large doses of foxglove leaves are fatal.

869. According to biologist Zhen Want, "The reason why plants make so many natural products with medicinal properties is because they are also fighting diseases."

870. Oak trees get struck by lightning the most among all the trees. It is because they are taller than most of the trees.

871.

The oldest olive tree in the world is 4,000 to 5,000 years old. It is called al-Badawi, and it is located in Palestine.

872. This ancient olive tree was famously named in memory of Ahmad Al-Badawi, a wise villager who lived in Al-Walaja over 200 years ago. He had often been found sitting underneath this tree for countless hours reflecting on life.

873. Olive trees are able to self-pollinate and live off of little to no water.

874. Colombia has 1,500 species of orchids, which is more than anywhere else on Earth.

875. Most of the Colombian orchid species are epiphytes, which are plants that live on the bark of other trees and depend on the moist air and debris accumulated at the branches of trees.

876. The cloud forests of the Nariño department in western Colombia hold the record for the place with the highest epiphyte diversity in the world.

877. Fungi is the kingdom of fungi, which includes mushrooms, yeasts, rusts, molds, and mildew.

878. Fungi are composed of long filaments called hyphae, which are either long tubes enveloping living matter or tubes divided into segments. Hyphae grouped together is called mycelium.

879. The hyphae of some fungi are so thin that it would take 50,000 of them, side by side, to equal one inch.

880. The study of fungi is called mycology.

881. Mushrooms are fungi, not plants.

882. Over 90 percent of the estimated 3.8 million fungi in the world are unknown to scientists.

883. We've classified 120,000 types of fungi.

884. Some mushrooms are bioluminescent. They use this to attract insects.

885. Scientists are working on genetically engineering bioluminescent trees as an alternative to streetlights.

886. Fungi belong to their own kingdom and are closer to animals than plants.

887. Fungi breathe in oxygen and release carbon dioxide.

888. Fungi don't need sunlight to reproduce.

889. Fungi don't have chlorophyll and need to make their own food by taking in food from living or dead plants or animals.

890. Fungi do not have roots, stems, leaves, flowers, or seeds. They also do not need light to live.

891. Chemicals (chitin) in their cell walls are the same as cells in lobsters and crabs. Chitin gives the fungus cell walls strength, since they do not contain cellulose.

892. Fungi that live on decaying materials are called saprophytes.

893. Those that live on eating animals and plants are called parasites.

894. A parasitic fungus wiped out most of the chestnut trees in the US.

895. A lichen is formed when a fungus and an alga live symbiotically. Alga provides food, and the fungus prevents the lichen from drying out and attaches it to a surface.

896. Fungi reproduce by creating a fruiting body—like the umbrella-shaped part of a mushroom. The fruiting body produces spores, which are like seeds, but simpler and smaller.

897. Spores are only 5 to 10 microns big. (5,000 spores in a single line would equal about one inch.)

898. *Trichoderma reesi* is a type of fungus used to make jeans feel softer.

899. Itaconic acid is an enzyme produced by fungi and used to make plastic toys such as Legos, as well as UV coatings and printing ink.

900. The roots of trees can be connected together into a vast system called a mycorrhizal network that uses fungi to communicate and share resources.

901. Called the Wood Wide Web by Dr. Suzanne Simard, the fungi form a symbiotic relationship with tree roots. The network allows trees to warn each other about pests, drought, and disease as well as share nitrogen, water, and more.

902. Simard identified what she calls mother trees, which are the largest trees in forests that act as hubs for these mycorrhizal networks.

903. Simard discovered that Douglas firs provide carbon to baby firs and that they change their root structures to make room for baby trees.

904. Simard also found fir trees trading nutrients with birch trees through this fungal web. Birch trees receive extra carbon from Douglas firs when the birch trees lose their leaves, and birch trees supply carbon to Douglas fir trees that are in the shade.

905. Dr. Simard's work was referenced in Season 2, Episode 11 of the Apple TV+ series *Ted Lasso*. Coach Beard says, "You know, we used to believe that trees competed with each other for light. Suzanne Simard's field work challenged that perception, and now we realize that the forest is a socialist community. Trees work in harmony to share the sunlight."

906. A biotechnology company in Sweden is creating vegan leather, animal feed, and meat substitutes out of fungi.

907. The potato-blight fungus, *Phytophthora infestans*, wiped out the entire Irish potato crop in 1845–1846. More than 1 million people died of starvation, and several million Irish people emigrated to the US.

908. Witches' butter (*Dacrymyces palmatus*) is a yellow fungus that turns into a melting blob when imbibing water.

909.

The company Mycorena uses mycoprotein, microscopic filaments from which mushrooms grow. It's fibrous like animal muscles, neutral in taste, and produces fewer carbon emissions than conventional meat production.

910. Fungi have been found growing around the hot springs of volcanoes.

911. Yeasts are single-celled organisms.

912. White-rot fungus produces a powerful enzyme that can break down tough wood fibers. Scientists are exploring using this to get rid of toxic waste.

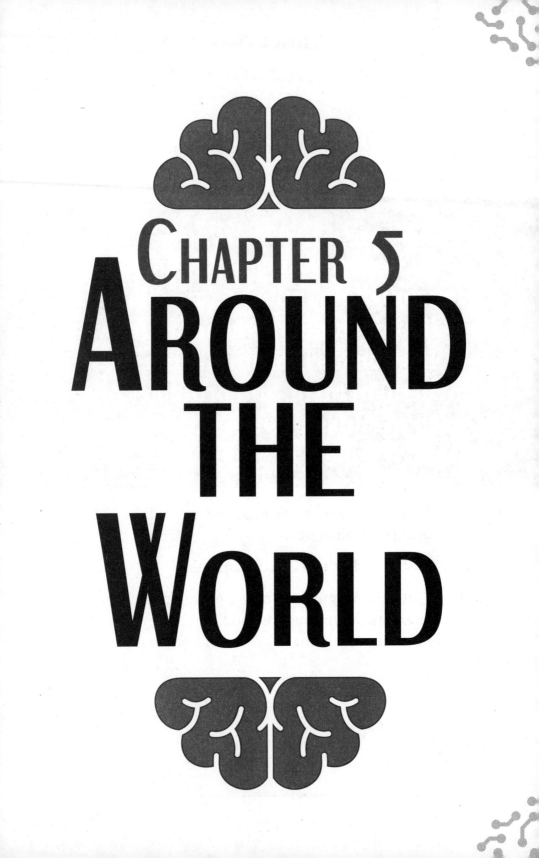

CHAPTER 5
AROUND THE WORLD

913. The metric system was adopted in France in 1795 and designed during the French Revolution.

914. In 1875, an International Bureau of Weights and Measures met in Paris to sign the Treaty of the Metre. Forty countries, including the US, signed the treaty.

915. May 20th is World Metrology Day.

916. The US Constitution states in Section 8 of Article I that Congress shall have the power to "fix the standard of weights and measures."

917. It's called a decimal-based system because it's based on multiples of 10.

918. The metric system is also known as the International System of Units (SI).

919. In 1790, the US Secretary of State, Thomas Jefferson, proposed using the metric system, but it didn't catch on.

920. Despite a general resistance to changing the metric system, the US uses it in many instances, including with products such as wine, spirits, and colas.

921. Metric units are used on food packages to provide quantity, nutrition, and health information.

922. An inch was traditionally the width of a thumb.

923. A foot (12 inches) was the length of a foot.

924. A yard was about the distance from the tip of the nose to the end of the middle finger of an outstretched hand.

925. An adult arm span—the measurement of their arms stretched as far as possible—is a fathom, which is 6 feet or 1.83 meters.

926. A league was the distance you could walk in one hour, which ranges from 2.4 to 4.6 miles. In English-speaking countries, a land league is generally accepted as 3 miles.

927. A hectare (ha) equals 10,000 square meters. It's used only for measuring land. There are 100 hectares in 1 square kilometer.

928. One acre equals 43,560 square feet.

929. The word "acre" is derived from the Latin word *ager*, meaning "field."

930. The basis for choosing the acre's measurements came from the Anglo-Saxons, who defined an acre as a strip of land 1 1/10 furlong.

931. A furlong is the length of a plowed furrow.

932. Ancient Egyptians used a cubit, which was based on a forearm from the elbow to the tip of the middle finger. The word *cubit* comes from the Latin word for "elbow."

933. A stone is 14 pounds in England. In the US, it's 16 pounds.

934. James Watt, the inventor of the steam engine, came up with the term horsepower to represent the power of his invention.

935. One horsepower equals approximately 746 watts, which Watt came up with after determining that a horse can lift 550 pounds at the rate of 1 foot per second.

936. Today, the standard unit of power is named after James Watt.

937.

A nautical mile measures 6,076 feet, while a mile on land measures 5,280 feet.

938. One troy ounce equals 31.1 grams. Troy weight is used to measure gold and silver.

939. A carat equals 200 milligrams and is the standard unit of measurement for gems.

940. The weight of one carat is based on the weight of a carob seed, which was once used by African and Middle Eastern jewelers.

941. A cord is used to measure stacked firewood. The name derives from the method of using a cord or string to measure firewood piles.

942. One cord equals 4 feet wide by 8 feet long, and 4 feet high.

943. Each calendar year is exactly 365 days, 5 hours, 48 minutes, and 46 seconds or 365.242199 days.

944. This is the amount of time between 2 successive crossings of the celestial equator by the sun at the vernal equinox.

945. In 2008, scientists added a second (called a leap second) to 2008 to make up for the slowing of Earth's rotation.

946. The IERS atomic clock keeps time by measuring the vibrations of atoms.

947. The cesium atom vibrates 9,192,631,770 times per second, and this number doesn't change over time either on Earth or in space.

948.

The original Roman calendar was 304 days long and had 10 months that began with March and ended with December.

949. The Roman ruler Julius Caesar (100–44 BCE) reorganized the calendar year to start with the month of January.

950. Janus was the god of beginnings and transitions and also of gates, doors, doorways, endings, and time.

951. He is usually a 2-faced god since he looks to the future and the past.

952. Early Romans believed that the beginning of each day, month, and year were sacred to Janus, and they believed Janus opened the gates of heaven at dawn to let out the morning, and then he closed them at dusk.

953. February was named for Februalia, the Roman festival of purification.

954. March was named for Mars, the Roman god of war.

955. April comes from the Roman word *aperire*, meaning "to open," which represents spring.

956. May is named for Maiesta (Maia), the Roman goddess of honor and reverence.

957. June is named for Juno, the Roman queen of the gods.

958. July is named after Caesar, who was born in this month. Before that, July was Quintillis, which means fifth month.

959. August is named for Augustus, the Roman emperor. Before that, August was Sextilis, or the sixth month.

960. September comes from the word *septem*, meaning "seven."

961. October comes from the word octo, meaning "eight."

962. November comes from the word *novem*, meaning "nine."

963. December from the word *decem*, meaning "ten."

964. Caesar's Julian calendar reformed the Roman republican calendar by increasing the length of the solar year from 355 days to 365.25 days, and then dividing the year into 12 months.

965. To align calendars, Caesar added days to 46 BCE so that it had 445 days.

966. There are a few different theories as to why September is not the seventh month, etc.

967. Peter Heslin, a professor at Durham University in the UK, believes New Year's Day used to be celebrated on March 1, which would account for why September is the "seventh" month. He believes there was "a series of slow incremental changes where the March new year was pushed back." And since the change happened gradually, no one took much notice that the names of the last 4 months no longer made sense.

968. January 1st was not universally accepted as the start of the New Year and many countries continued to observe New Year at various times. For example, the Byzantine Empire or the old Eastern Roman Empire celebrated New Year on September 1st.

969. After the fall of the Roman Empire, the start of the New Year became March 25. This date remains the start of the financial new year in many territories including the UK but is now April 5th because 10 days were annulled as part of the Gregorian calendar reforms.

970. In 1582, Pope Gregory XIII proclaimed the Gregorian calendar as the official one to use.

971. January and February are the newest months added to the calendar. They were originally inserted as the 11th and 12th month.

972. The average calendrical month, which is one twelfth of a year, is about 30.44 days, while the Moon's phase (synodic) cycle repeats on average every 29.53 days. Therefore, the timing of the Moon's phases shifts by an average of almost one day for each successive month.

973. The 7-day week comes from the lunar cycle due to the 4 principal lunar phases: first quarter, full, last quarter, and new.

974. Each lunar phase is approximately 7 days.

975. According to OXFAM International, the 22 richest men in the world have more wealth than all the women in Africa.

976.

The 10 richest men in the world owned more than the combined wealth of the bottom 3.1 million people.

977. The combined wealth of the 10 richest men doubled during the COVID-19 pandemic.

978. Getting the richest 1 percent to pay 0.5 percent extra in taxes on their wealth over the next 10 years would equal the investment needed to create 117 million jobs in elderly and childcare and education and health.

979. The bottom half of the world adult population owns 1 percent of global wealth.

980. According to the Global Wealth Report 2021 published by Credit Suisse, there are 56 million millionaires in the world in 2020, increasing by 5.2 million from a year earlier.

981. The US has 22 million millionaires—the most in the world at 39 percent of the world total.

982. Kwanzaa, the annual holiday affirming African family and social values is celebrated mostly in the US from December 26 to January 1.

983. The celebration was created in 1966 by Maulana Karenga, a professor of Africana studies at California State University in Long Beach.

984. Karenga took the name from the Swahili word *kwanza* (first). He added an extra "a" to accommodate one letter for each of the 7 children present at an early celebration.

985. Kwanzaa is also celebrated in Caribbean and other countries.

986. Each of the days of the celebration is dedicated to one of the 7 principles of Kwanzaa: unity (*umoja*), self-determination (*kujichagulia*), collective responsibility (*ujima*), cooperative economics (*ujamaa*), purpose (*nia*), creativity (*kuumba*), and faith (*imani*).

987. There also are 7 symbols of the holiday: fruits, vegetables, and nuts; a straw mat; a candleholder; ears of corn (maize); gifts; a communal cup signifying unity; and 7 candles in the African colors of red, green, and black, symbolizing the 7 principles.

988. Every Halloween, people in the US spend more than 2 billion dollars on candy.

989. In the US, the day after Thanksgiving is called "Brown Friday" by plumbers because it is their busiest day of the year.

990.

In 1995, John Baur and Mark Summers of Albany, Oregon, decided that each year, September 19 would be Talk Like a Pirate Day.

991. On that day, everyone should talk like a pirate. "Arrrr," "shiver me timbers," and "ya scallywag," are just a few of the popular noises and phrases uttered by people pretending to be pirates with their pirate accents.

992. Pirates, however, never talked that way. Nor did they dress like the pirates in *Pirates of the Caribbean* or *Peter Pan* or make their enemies walk the plank.

993. Many of the stereotypes about pirates come from Disney's 1950 movie *Treasure Island*, and its star actor, Robert Newton. Newton's exaggerated English accent has become synonymous with pirate talk, even though pirates came from all over the world.

994. Australian conservation groups, in an effort to save the endangered bilby, have promoted the Easter bilby as an alternative to the Easter bunny.

995.

On the Polynesian island of Vanuatu in Pentecost, Naghol tribe members create towers made of bamboo that are up to 100 feet in the air. And then, with vines attached to their feet, they jump, hoping to just graze their head on the ground.

996. Land-diving is a way of asking for a good yam harvest as well as a test of young men's virility.

997. Naghol land-diving led to the birth of bungee jumping.

998. In 1979, the Naghol land-diving inspired Oxford University's Dangerous Sports Club, which recreated the dive over the Clifton Suspension Bridge. A New Zealand entrepreneur then founded the first bungee jumping operation in 1988.

999. In Germany, Austria, and Hungary, they have a counterpart to Santa. While Santa brings toys to good boys and girls, Krampus, a hairy, devil-like creature, punishes children on the naughty list.

1000. He throws the worst of these bad kids in a sack or chains them up in a basket and carts them off to hell.

1001. The year 1994 marked the first SantaCon in San Francisco. It started as a pub crawl, but it has since grown into a worldwide phenomenon where people show up in full Santa gear.

1002. The official SantaCon website tells Santas that want to get drunk to stay home, but that doesn't stop Santas from having a good time.

1003. In 2018, SantaCon in Hoboken, New Jersey, led to 14 arrests and 4 cops in the hospital. Police officers also handed out 33 summonses for public drinking and urination.

1004. The origins of SantaCon have been traced back to 1974 in Copenhagen. A group protesting a holiday based on "religious hypocrisy" dressed as Santas and held a 4-day demonstration.

1005. In Oaxaca, Mexico, December 23 is La Noche de Rabanos or the Night of the Radishes. During this festival, merchants and artists sell carved radishes that are used as Christmas centerpieces.

1006. The radishes usually depict the Nativity scene or Mexican folklore events.

1007. Millions of Japanese families eat Kentucky Fried Chicken on Christmas Eve. This is due to a marketing stunt in 1974 by the fast-food company called "Kentucky for Christmas."

1008. Many of KFC's ads featured a family eating from a "party barrel" with "My Old Kentucky Home" playing.

1009. Christmas is a secular holiday in Japan, as less than 1 percent of the population identifies as Christian.

1010. The Christmas Log is a hollow log with legs, face, and little red hat that hails from Catalan mythology. It is introduced in homes at the Feast of the Immaculate Conception on December 8.

1011. Children feed the log every night, and the log rewards them with presents on Christmas Eve.

1012. The log is placed in an unlit fireplace, and family members take turns hitting the log with a stick to make it poop out the presents inside.

1013. In the Ukraine, spider webs on Christmas trees are good luck.

1014. In the Venezuelan city of Caracas, residents roller-skate to church on Christmas morning.

1015. Mari Lwyd is a ritual in Wales where a person dressing up as a horse (with a real horse skull) goes caroling with a bunch of people who are not dressed up as horses.

1016. The running of the bulls during the San Fermin festival in Spain features a dozen bulls set loose to run the streets of the town. Up to 300 people are injured every year.

1017. India's Holi festival features singing, dancing, and best of all, color fights. Colored powders and water are thrown at participants, creating a colorful mess on clothing, hair, and everywhere else.

1018.

Up Helly Aa in Shetland, Scotland, is a mid-winter celebration where participants dress like Vikings and ultimately burn a replica Viking ship. This is to mark the end of the Yule season.

1019. Up Helly Aa grew out of an older tradition called tar barreling, where young men drag barrels of burning tar through town. It was outlawed in the 1870s over safety concerns.

1020. The Korean Alphabet Day, known as Hangeul Day in South Korea and Choson'gul Day in North Korea, is a celebration of the creation of the Korean alphabet.

1021. Día Del Mar (Day of the Sea) is an annual celebration in Bolivia that observes the loss of their coastline (Port of Calama) during the 1879–1883 War of the Pacific with Chile. The day is recognized by listening to recordings of sea birds and ship horns.

1022.

The Cooper's Hill Cheese-Rolling and Wake is an annual event held near Gloucester in England. Participants race down a 200-yard-long hill, running after a 7- to 9-pound round of Double Gloucester cheese. The first person to the bottom wins the cheese.

1023. There are traditionally 5 races, including a women's race.

1024. One participant in the cheese race called it "20 young men chasing a cheese off a cliff and tumbling 200 yards to the bottom, where they are scraped up by paramedics and packed off to hospital."

1025. The 1997 cheese-rolling races reported 33 injuries.

1026. The Anastenaria is a barefoot fire-walking ritual performed in Greece and Bulgaria.

1027. The Hadaka Matsuri (Naked Festival) is a Japanese festival in which up to 10,000 mostly naked men battle to grab a pair of sacred sticks known as shingi that are thought to bring good luck.

1028. Go Topless Day is an annual event in the US that supports the right of women to go topless on gender-equality grounds.

1029. Go Topless Day was started in 2007 by a Nevada group formed by a leader of a UFO religion.

1030. La Tomatina is an annual food fight festival held on the last Wednesday of August in the town of Buñol near Valencia in Spain.

1031. The food item used in the fight, which can field up to 20,000 participants, is 100 tons of overripe tomatoes.

1032. Traditionally, the fight can only start after someone has climbed a 2-story-high greased pole and retrieved the coveted Spanish ham at the top. However, the fight usually starts if the ham retrieval takes too long.

1033. One of the rules of La Tomatina is that you must squash the tomatoes before throwing them at people, so no one gets hurt.

1034. Frozen Dead Guy Days, held in Nederland, Colorado, is an annual festival that celebrates the preserved, frozen corpse of Bredo Morstol.

1035. When Morstol passed away in Norway in 1989, his grandson brought the body, which was preserved in dry ice, to the US in the hopes of creating a cryonics facility.

1036. When the family fell on hard times, locals volunteered to keep the body frozen. Brad Wickham, a resident of Nederland, is the current caretaker.

1037. The festival features coffin obstacle course races, a hearse parade, and a Frozen Dead Guy lookalike contest. A viewing of the film *Grandpa's Still in the Tuff Shed* is also held.

1038. The 2019 event hosted over 25,000 visitors.

1039. Every year on St. Sebastian Day in Piornal, Spain, locals attack a person dressed up as Jarramplas with turnips. The Jarramplas turnip is reinforced so that the person in the costume doesn't get hurt, because turnips hurt.

1040. Kumbh Mela is a multi-day pilgrimage that's celebrated every 12 years or so that is marked by a ritual dip in one of India's sacred rivers. It is one of the largest peaceful gatherings in the world and has been inscribed on the UNESCO's Representative List of Intangible Cultural Heritage of Humanity.

1041. More than 200 million Hindus gathered for Kumbh Mela in 2019.

1042. The 2019 Kumbh Mela pilgrimage could be seen from space.

1043. The inhabitants of Chumbivilcas Province, near Cuzco in Peru, meet on December 25 each year to beat the crap out of each other.

1044. The purpose of the ceremonial fighting, called Takanakuy (which means "to hit each other") is to settle conflicts, and it involves kicking and punching, and the fights take place one conflict at a time in a ring.

1045. The Bolivian tradition of Tinku takes Takanakuy to a new level. It starts with women and men from different communities meeting and dancing. The women then form a circle and chant while the men fight each other. Then, the women join in.

1046. The most famous Tinku happens in Macha, a small village on the Altiplano, where 3,000 villagers meet. By the third day, police need teargas to break it up.

1047.
During the annual Monkey Buffet Festival in Lopburi, Thailand, thousands of macaques are treated to towers of fruits and vegetables. The treats are a way of expressing appreciation for a monkey king and its army rescuing a princess from a demon lord 2,000 years ago.

1048. In early April, the city of Kawasaki, Japan, holds a penis festival called Kanamara Matsuri. The festival features 3 phallus-shaped shrines that are carried in processions.

1049. The Kanamara Boat Mikoshi contains a phallus made of black iron. The Elizabeth is pink and was donated by a drag club. The Kanamara Omikoshi is made of wood.

1050. Baby jumping is a traditional Spanish festival that dates back to 1621. Men dressed in red and yellow suits, called devils, jump over babies born during the previous year. The babies are laid on mattresses in the middle of a closed-off street. This is said to cleanse the babies of original sin.

1051.

Norwegians use the word "Texas" as slang for "crazy."

1052. According to the Language Council of Norway, this began as Norwegians started watching cowboy movies in the 1950s.

1053. Norwegians also use the term "Hawaii football" to describe an out-of-control football match.

1054. The only country named after a woman is Saint Lucia in the Caribbean, after St. Lucy of Syracuse.

1055. In Japan, letting a sumo wrestler bring your baby to tears is good luck.

1056. In Romania, placing money under a rock before the clock ticks midnight on New Year's Eve guarantees a prosperous year ahead.

1057. In Denmark, people throw broken plates at friends' homes to wish them a Happy New Year.

1058. In Denmark, they also stand on chairs on New Year's Eve and "leap" into January by jumping.

1059. In the United Kingdom, if you wake up on the first day of the month and say "rabbit, rabbit," you will have good luck for the rest of the month.

1060. If you forget to say "rabbit, rabbit," you can instead say "tibbar, tibbar" right before you go to sleep.

1061. In some Asian countries, when a child loses a lower tooth, they throw it on the roof. If it's an upper tooth, goes on or under the floor.

1062. In Spain, Mexico, Peru, and more, instead of a Tooth Fairy, they have Ratoncito Perez or Raton Perez. This mouse collects teeth and replaces them with a gift.

1063. In South Africa, children place their teeth in slippers.

1064. Slurping your soup in Japan and Korea is considered proper.

1065. In Nepal, don't sit with the bottoms of your feet pointing towards others. The soles of your feet are dirty, so this is rude.

1066. In Russia, it's bad luck to return to your home after you already left.

1067. Papua-New Guinea has a population of 7 million people and is about the size of Sweden.

1068. The residents, however, speak an estimated 850 languages (of all 7,000 known worldwide), belonging to dozens of distinct language families. This makes the country the most linguistically diverse place on Earth.

1069. There is no official language in the US.

1070. Cambodia's Khmer alphabet has 74 letters.

1071. Around 3.3 billion people in the world are bilingual. That's about 43 percent of the population.

1072. Only 20 percent of Americans are bilingual.

1073. Mexico has the highest number of Spanish speakers in the world.

1074. Spain is fourth on the list after Colombia and Argentina.

1075. There is no word for "fun" in Russian. They have words for joy or merriment, though.

1076. Beer wasn't considered an alcoholic drink until 2011 in Russia.

1077. According to an article in the Daily Beast, due to the horrible traffic in Moscow, wealthy commuters are retrofitting ambulances with plush interiors to dodge the traffic.

1078. In the Philippines, it is tradition to scatter coins across the living room of a new home in order to bring prosperity.

1079. In Puerto Rico, they celebrate New Year's by dumping a bucket of water out the window, which drives away evil spirits.

1080.

Getting hit by bird poop is good luck in Russia.

1081. In Australia, it's back luck to wish a performer "good luck." Instead, they say "chookas!" In Australia, "chook" is slang for "chicken."

1082. In Brazil, you can increase your luck on New Year's Eve by going in the ocean and jumping over 7 waves. You get one wish per jump.

1083. Historians believe that the tradition of making resolutions on New Year's Eve goes back 4,000 years. The ancient Babylonians made promises during this time to pay debts and return borrowed items.

1084. In Ireland, those looking for love can place a sprig of mistletoe under their pillow on New Year's Eve. If you do, you'll dream of your future partner.

1085. On New Year's Eve in Greece, it is a symbol of good luck and fertility to place bundles of onions above your door. The next day, parents hit their children (gently) on the head with these onions.

1086. In Colombia, people run around the block as fast as they can with empty suitcases at midnight on New Year's. This will guarantee a year of travel.

1087. In some Latin American countries, the color of your underwear can bring certain types of luck on New Year's. Yellow will bring luck, red will bring love, and white brings peace.

1088. Since the early 20th century, the Coney Island Polar Bear Club celebrates New Year's Day by jumping in the ocean.

1089.

The world's tallest statue is in Gujarat, India. Called the Statue of Unity, it depicts Indian freedom fighter and politician Sardar Vallabhbhai Patei.

1090. It took 4 years to complete and it's 597 feet tall.

1091. To put that in perspective, the Statue of Liberty is only 152 feet tall.

1092. It took 2,500,000 cubic feet of concrete, 5,700 tons of steel structure, and 18,500 tons of reinforced steel rods to build the statue, and 12,000 bronze panels cover the structure.

1093. Visitors can go up to the viewing gallery, in the chest of the statue, which is 500 feet up.

1094. The Danyang-Kushan Grand Bridge in China is 100 miles long, making it the longest bridge in the world. It is part of the Beijing-Shanghai High-Speed Railway.

1095. It was built in 4 years at a cost of $8.5 million.

1096. The world's longest road bridge is the 34-mile (55-km) long Bang Na expressway in Thailand, which was constructed in 2000.

1097. The world's longest continuous bridge over water is the Lake Pontchartrain Causeway in southern Louisiana. The causeway is 2 parallel bridges, with the longer of the 2 measuring close to 24 miles.

1098. The International Hair Freezing Contest is a sculpted hair competition held at a resort in Yukon, Canada.

1099. It involves participants sitting in a hot spring and sculpting their wet hair in freezing temperatures. It takes about one minute for the hair to start freezing. First prize is $2,000.

1100. In Chongqing, China, an apartment building has been built with a train running through it.

1101. The light rail passenger train passes through the 19-story residential building, but also has a stop in it. Just go to the sixth through eighth floors to catch the train.

1102.

Called China's Mountain City, Chongqing is a sprawling city with more than 49 million residents.

1103. There are approximately 350 million native English-speaking people in the world. There are 2 billion who are learning / have learned it as a second language.

CHAPTER 6
GEOGRAPHY

1104. There are 195 countries in the world today.

1105. There are 193 member states of the United Nations, and 2 non-member "observer states:" the Holy See and the State of Palestine.

1106. The UN considers Taiwan part of China.

1107. The newest internationally recognized country is South Sudan in Africa. It declared independence in 2011.

1108. Kosovo is a self-declared independent country in the Balkans region of Europe. The US and most of Europe have recognized its independence from Serbia in 2008, but Russia, China, and other countries have not.

1109. Kosovo has thus far been denied full recognition, as well as membership in the United Nations and the European Union, because Serbia continues to claim Kosovo. This is despite the International Court of Justice ruling that Kosovo was a sovereign nation in 2010.

1110. The Montevideo Convention of 1933 defined a state as a sovereign unit that could meet four benchmarks: having a permanent population, having defined territorial boundaries, having a government, and having an ability to enter into agreements with other states.

1111. Russia and the US (Alaska) are only 2 miles apart.

1112. More people speak Mandarin than Spanish and English combined.

1113. The Earth's circumference is 24,901 miles, and its diameter is 7,917.5 miles.

1114. The highest point on Earth is Mount Everest, which stands at 29,032 feet above sea level.

1115. Earth is 196.9 million square miles.

1116.
Earth's total land surface area is 57,308,738 square miles.

1117. Mount Everest is located in the Mahalangur Hilal sub-range of the Himalayas.

1118. The China–Nepal border runs across Mount Everest's summit point.

1119. The mountain was named after Sir George Everest, the Surveyor General of India in the mid-19th century. He was responsible for the first survey of the mountain, but he never actually set foot on it.

1120. The mountain was first climbed by Sir Edmund Hillary of New Zealand and Tenzing Norgay, a Sherpa of Nepal, on May 29, 1953.

1121. The summit of Mount Everest is made up of sedimentary rock, which was once at the bottom of an ancient sea.

1122. The mountain has 2 main climbing routes: the Southeast Ridge route, which was the route taken by Sir Edmund Hillary and Tenzing Norgay, and the Northeast Ridge route, which was first climbed in 1960 by a Chinese team.

1123. The Southeast Ridge, which is in Nepal, is easier to climb than the Northeast Ridge (in China).

1124.

The temperature on Mount Everest can drop as low as -76°F and winds reach up to 200 mph.

1125. The air at the summit of Mount Everest contains only about one-third of the oxygen found at sea level, which can lead to altitude sickness and other health issues for climbers.

1126. The mountain is home to several species of wildlife, including the Himalayan tahr, a type of wild goat, and the snow leopard, a critically endangered species.

1127. The mountain is a major source of tourism for Nepal, and hundreds of people attempt to climb it each year.

1128. The people of Nepal call Mount Everest "Chomolungma."

1129. In 2005, French pilot Didier Delsalle landed a helicopter on Mt. Everest.

1130. In 1978, Reinhold Messner and Peter Habeler were the first to make it to the top of Everest without supplemental oxygen.

1131. The second-highest point on Earth is K2 at 28,251 feet.

1132. K2 lies in the Karakoram range in Kashmir.

1133. Mauna Kea in Hawaii is actually a bigger mountain than Mount Everest . . . if you measure it from its base, which is below sea level.

1134. The lowest point on Earth is the Challenger Deep, the deepest part of the Mariana Trench, which is located in the Pacific Ocean and reaches a depth of approximately 36,000 feet.

1135. The Mariana Trench is a crescent-shaped trench in the floor of the western Pacific Ocean.

1136. The Challenger Deep was named after the HMS *Challenger*, which conducted the first scientific survey of the area in the 1870s.

1137. The HMS *Challenger* was part of the British Royal Navy, and on March 23, 1875, scientists recorded a sounding of 4,475 fathoms, which equals 26,850 feet at the trench.

1138. The expedition also provided the first map of the ocean floor.

1139. The pressure at the bottom of the Challenger Deep is between 15,000 and 16,000 pounds per square inch.

1140. That's over 1,000 times greater than at sea level.

1141. The temperature is just above freezing.

1142. Its bottom is approximately 7 miles long and 1 mile wide.

1143. The Mariana Trench is the result of the Pacific tectonic plate subducting, or sliding under, the Mariana Plate. This process has created the deep trench and the surrounding underwater mountain range.

1144.

The first recorded dive to the Challenger Deep was made by Swiss oceanographer Jacques Piccard and US Navy Lieutenant Don Walsh in 1960.

1145. They descended to the bottom of the trench in a submersible called the *Trieste*.

1146. During the descent one of the outer windows of the *Trieste* cracked.

1147. They reached a depth of 37,797 feet and found a flatfish.

1148. The Mariana trench is home to several species of deep-sea animals, including giant tube worms, blind crabs, and various species of fish.

1149. The Mariana Trench is also home to several species of bacteria that are capable of surviving in extreme conditions, including high pressures and low temperatures.

1150. Scientists believe that the Challenger Deep is simply the lowest point on Earth so far discovered.

1151. In 2012, James Cameron, the Hollywood director and producer responsible for the movie Titanic, descended to 35,754 feet below the ocean surface in a small submarine.

1152. In 2019, an American undersea explorer Victor Vescovo set the record by descending 35,853 feet.

1153. On the bottom of the ocean, James Cameron found candy wrappers and plastic bags.

1154. The longest river in the world has traditionally been the Nile, which stretches 4,258 miles from the mountains of Burundi to where Egypt meets the Mediterranean Sea.

1155. Many researchers now contend that the actual longest river from mouth to most-distant year-round source, is the Amazon, which flows 4,345 miles from the Peruvian Andes to the Atlantic Ocean.

1156. The geographers who first crowned the Amazon the longest river, were funded in part by the Brazilian government.

1157. The largest inland body of water in the world is the Caspian Sea.

1158. It covers an area of 143,244 square miles and is located between Europe and Asia.

1159. Its maximum depth is 3,363 feet.

1160. There are approximately 50 small islands in the Caspian Sea.

1161. There is some confusion over whether the Caspian Sea is a lake or a sea. It is considered a sea because of its saline water and size. It is considered a lake because it is enclosed by land, and the water is diluted by fresh water from the north. This means it's not as salty as seawater.

1162. The only sea in the world without any coasts, the Sargasso Sea is found in the Atlantic Ocean. It is surrounded by 4 ocean currents and named for sargassum, the floating seaweed that covers it.

1163. It borders the North Atlantic Current on the north, the Gulf Stream on the west, the North Atlantic Equatorial Current on the south, and the Canary Current on the east.

1164. These currents form a clockwise-circulating gyre that surrounds the Sargasso Sea much like a terrestrial coastline would.

1165. In addition to giving the Sargasso Sea this unique geographical claim to fame, the gyre that surrounds the sea also makes for excellent visibility, with warm, dark blue water transparent for up to 200 feet.

1166. The Sargasso Sea was mentioned in Jules Verne's *Twenty Thousand Leagues Under the Sea*.

1167. The stillness of the Sargasso's calm waters allows the sea to trap up to 200,000 pieces of trash per square mile in some areas, forming what's called the North Atlantic Garbage Patch.

1168. Earth's water is 4.6 billion years old.

1169. Water is the only natural substance that occurs in 3 states of matter (solid, liquid, and gas) at normal temperatures on Earth.

1170. There is about the same amount of water on Earth now as there was millions of years ago.

1171.

Around 70 percent of Earth is covered in ocean, and 98 percent of the water on the planet is in oceans.

1172. Only 0.036 percent of our total water supply is found in lakes and rivers.

1173. There are 1,681 lakes in the US, and 117 million worldwide.

1174. There are 326 million trillion gallons of water on Earth.

1175. The largest desert in the world is the Antarctic Polar Desert, which covers an area of about 5.5 million square miles (about the same area as the US and Mexico combined). In fact, the desert spans the whole of Antarctica.

1176. This makes it about twice the size of the Sahara Desert (3.5 million square miles).

1177. A desert is defined by the amount of precipitation in the area. There can be subtropical, coastal, and polar deserts.

1178.

The average yearly rainfall at the South Pole is 0.4 inches.

1179. Scientists believe that in parts of the McMurdo Dry Valleys in East Antarctica it hasn't rained in 14 million years.

1180. Approximately 98 percent of the Antarctic continent is covered by a permanent ice sheet.

1181. At its deepest, Antarctica's ice is 2.7 miles thick.

1182. If the ice sheet melted, global sea levels would rise up to 200 feet.

1183. Antarctica is the highest, driest, coldest, and windiest continent on Earth.

1184. The coldest ever land temperature was recorded in Antarctica, where it reached -128.6°F.

1185. However, after analyzing 32 years of data collected by satellites, scientists measured pockets of air close to the surface of the East Antarctic ice sheet at -135.9°F.

1186. The Antarctic Peninsula is warming more quickly than most other places on Earth. Over the past 50 years, average temperatures have risen by 5.4°F, 5 times the average increase on Earth.

1187. Most of Antarctica experiences 6 months of constant daylight in summer and 6 months of darkness in winter.

1188. Since longitude lines, which give us our time zones, meet at the South Pole, Antarctica has no time zones.

1189. On December 1, 1959, 12 countries signed the Antarctic Treaty, which is an international agreement to govern the continent together as a reserve for peace and science. Today, 48 nations have now signed the treaty.

1190. There are 46 species of birds, 10 cetaceans (including killer whales and humpback whales), 6 species of seals, and 7 penguin species in Antarctica.

1191. There are no trees or shrubs in Antarctica.

1192. The Antarctic hair grass and Antarctic pearlwort are the only 2 flowering plants on the continent.

1193. There are over 1,000 species of fungi, 700 species of algae, and 20 or more species of macro-fungi in Antarctica.

1194. There are also over 100 species of mosses, 25 species of liverworts, and approximately 350 species of lichens in Antarctica.

1195. There are 67 species of insects in Antarctica.

1196. Lake Vostok is a freshwater lake buried under 2.5 miles of ice. It is around the size of Lake Ontario.

1197. Norwegian explorer Roald Amundsen was the first human to reach the South Pole.

1198. There are more than 80 research stations in Antarctica from nearly 30 countries.

1199. In 1977, Argentina airlifted a pregnant woman to Antarctica in order to give birth to a child on the continent. This was part of Argentina's attempt solve a sovereignty dispute over territory.

1200. The Denmark Strait cataract, an underwater waterfall, is 11,499 feet.

1201. The highest waterfall in the world is Angel Falls in Venezuela, which stands at a height of 3,212 feet.

1202. Angel Falls is considered the highest since it has the tallest uninterrupted waterfall.

1203. Tugela Falls in South Africa is considered the world's tallest in terms of height, but it is divided into 5 smaller tiers, and its tallest individual tier is 1,348 feet.

1204. Of course, there is controversy over the actual measurement of both falls, so you'll see either as the tallest depending on where you look.

1205. The longest mountain range in the world is the Andes, which stretches 4,300 miles through South America.

1206. The range stretches from north to south along the west coast of South America, and runs through Venezuela, Colombia, Ecuador, Peru, Bolivia, Chile, and Argentina.

1207. Aconcagua is the highest peak at 22,841 feet.

1208. Of course, when it comes to length, that's not including the 40,390-mile mid-ocean ridge. Most of it is under the ocean, which is why it's not included as longest.

1209. Most of the world's volcanoes form along the boundaries of this mountain system, which consists of thousands of volcanoes that periodically erupt.

1210.

The longest coastline in the world belongs to Canada, which has 125,567 miles of coastline.

1211. The largest island in the world is Greenland, which covers an area of 836,330 square miles.

1212. Greenland is 3 times the size of Texas.

1213. Greenland is part of Denmark, but it has its own home-rule government for domestic affairs. Its population is primarily Inuit.

1214. The largest country in the world by land area is Russia, which covers an area of 6,323,142 square miles.

1215. The smallest country in the world by land area is Vatican City, which is an independent city-state enclaved within Rome and covers an area of about 0.17 square miles.

1216. Also known as The Vatican, the state became independent from Italy in 1929 with the Lateran Treaty.

1217. With an area of 49 hectares and a population of about 453, it is the smallest state in the world both by area and population.

1218. Lesotho, San Marino, and Vatican City are the only countries landlocked by another country. Lesotho is located within South Africa, while San Marino and Vatican City are both situated within Italy.

1219. Lesotho, officially the Kingdom of Lesotho, is situated in the Maloti Mountains and contains the highest mountains in Southern Africa.

1220. San Marino, officially the Republic of San Marino, also known as the Most Serene Republic of San Marino, is the fifth-smallest country in the world and has a population of 33,562.

1221. Its northeastern end is within 6 miles of the Italian city of Rimini on the Adriatic coast.

1222.

The highest capital city in the world is La Paz, Bolivia, which is located at an altitude of 11,893 feet above sea level.

1223. The northernmost capital city in the world is Reykjavik, Iceland.

1224. The southernmost capital city in the world is Wellington, New Zealand.

1225. The westernmost capital city in the world is Honolulu, Hawaii.

1226. The easternmost capital city in the world is Suva, Fiji.

1227. Damascus, the capital of Syria, is the oldest continuously inhabited city in the world.

1228. Damascus has been inhabited for at least 11,000 years.

1229. Damascus was named the Arab Capital of Culture in 2008.

1230. Founded in the 3rd millennium B.C., Damascus was an important cultural and commercial center, mostly because it was the crossroads between Africa and Asia.

1231. As of September 2019, 8 years into the Syrian Civil War, Damascus was named the least livable city out of 140 global cities in the Global Livability Ranking.

1232. The only continent without a desert is Europe.

1233. Australia has no active volcanoes.

1234. The only continent with a majority of its land area in the Southern Hemisphere is Australia.

1235.
The only continent with a single country is Australia.

1236. The largest country in Africa is Algeria.

1237. The smallest country in Africa is Seychelles.

1238. Africa has more countries or sovereign states (54) than any other continent. There are also 8 territories and 2 de facto indented states with limited or no recognition.

1239. The smallest and least populous African country is the island country of Seychelles.

1240. The world's deepest lake is Lake Baikal in Siberia, reaching a depth of 5,315 feet.

1241. Lake Baikal is also the world's largest freshwater lake, holding more than 20 percent of the unfrozen freshwater on Earth's surface.

1242. The Baikal seal, which calls Lake Baikal home, is the only seal species in the world to live exclusively in a freshwater habitat. No one knows how the seals got there, as the lake is hundreds of miles inland.

1243. The world's driest place (non-polar) is the Atacama Desert in Chile. It receives less than 1 millimeter of precipitation a year. Some areas haven't seen a drop of rain in 500 years.

1244. The world's longest cave system is the Mammoth Cave in Kentucky, extending over 400 miles.

1245. The word "map" comes from the Latin "mappa," which means "napkin" or "cloth." In ancient Rome, maps were drawn on cloth or parchment and used as tools for navigation and military planning.

1246. The term "cartography" refers to the study and practice of making maps. It comes from the Greek words "khartes," meaning "map," and "graphein," meaning "to write."

1247. Some of the people and animals he claimed to have met included a race of dog-headed people ruled by a dog king, people with 4 eyes, ants as big as dogs, a mule-like creature with an upper lip so long that it must walk backwards in order to eat, tribes who had 8-toed feet that were turned backwards, people with only 1 leg and a foot so large that it protected them from the hot sun by working as an umbrella, and people whose eyes and mouth were on their chest.

1248. Many of these notions were considered fact for 1,000 years. Dark ages, indeed.

1249. The Mercator projection, created by Flemish cartographer Gerardus Mercator in 1569, is a widely used conformal map projection, meaning that it preserves angles and shapes, but it distorts the size of land masses near the poles.

1250. The Peters projection, created by historian and cartographer Dr. Arno Peters in 1974, is an area-accurate map projection that shows the size of countries and continents more accurately than the Mercator projection.

1251.

The first world map to show the continents in their correct relative sizes was the Peters projection.

1252. The Robinson projection was created in 1963 by cartographer Arthur H. Robinson. It's a compromise between other maps that isn't good for navigating and even though it minimizes size and shape distortions, some distortions still exist, especially in the polar regions. Distances are also distorted.

1253. The Winkel Triple projection improves on the Robinson projection by distorting the polar areas less to give an even more accurate perspective of the world.

1254. The London Underground map, designed by Harry Beck in 1933, is an example of a topological map, which shows the relationships between points rather than the actual distances between them. It is still in use today.

1255. Latitude determines one's distance either north or south of the equator.

1256. Latitude is measured in degrees 70 miles apart.

1257. Longitude lines determine one's distance east or west of the prime meridian.

1258. The 360 degrees of a circle are essential for pinpointing location. Each 15 degrees represents 1 hour of rotation of the Earth.

1259. The concept of latitude and longitude was developed by the ancient Greeks, but it was not until the invention of the marine chronometer in the 18th century that it became possible to determine longitude accurately at sea.

1260. Historically, the prime meridian runs from the North Pole through Greenwich, England, to the South Pole and separates the eastern hemisphere from the western hemisphere.

1261. In 1984, new coordinate systems were adopted based on satellite data. The 0° meridian is now 336 feet east of the historical meridian.

1262. This same line on the other side of the world is the International Date Line, which is at 180°.

1263. This is also called the antemeridian.

1264. If you're standing on one side of the IDL and your friend is on the other side, you would each be enjoying different days of the week.

1265. The survivors of Magellan's voyage around the world kept good records of the number of days they'd been away, and when they returned home, they lost a day. They lost it when they crossed the International Date Line.

1266. In the 17th and 18th centuries each country had its own prime meridian, typically running through its capital city.

1267. England's passed through a point at the Royal Observatory in Greenwich.

1268. In 1884, 22 of 25 countries present at an international conference in Washington D.C., voted to make the Greenwich meridian the initial meridian for longitude.

1269. France abstained from voting and continued using their Paris meridian until 1911.

1270. Latitude at the equator is 0°.

1271. Latitude at the North Pole: 90° N. At the South Pole it's 90° S.

1272. The International Date line is 180° longitude.

1273. Null Island is an imaginary island located at 0°N 0°E. It's located in the South Atlantic Ocean, and it's where the equator meets the prime meridian.

1274. Instead of an island, at that location is a NOAA weather observation buoy.

1275. There the equator and international dateline meet is 0°, 180°.

1276.

Each degree of latitude or longitude can be broken down into 60 minutes, which looks like this: 44'. These minutes help pinpoint location even more accurately when a location doesn't appear exactly on the latitude or longitude line.

1277. To find the exact opposite side of the world of where you are, take your latitude, and change its direction. For longitude, take your longitude and subtract it from 180°. Then switch directions. So, if your location is 35° 53' N, 82° 33' W, the other side of the world is 35° 53' S, 98° 67' E.

1278. A cross staff, also called a Jacob's staff, is one of the oldest navigational instruments and it was used as early as the 1300s to measure the altitude of stars, which allowed sailors to find their latitude, tell time, and find their direction at night.

1279. In the 1850s, an officer on a British ship off the coast of Alaska noted on a map that a place nearby had no name. He wrote "? Name" next to the point on the map. When the map was recopied, another mapmaker thought that the "?" was a "C" and the "A" in name was an "o," and thus the mapmaker named the city Cape Nome, which eventually became Nome, Alaska.

1280.

The world's population stands at 8 billion.

1281. We hit 6 billion in 1998; 7 billion in 2010, and 8 billion in 2022.

1282. According to UN projections, there will be 9 billion people by 2037 and 10 billion by 2058.

1283. Over 36 percent of people live in either China or India.

1284. It is estimated that 106 billion people have been born since the dawn of the human species.

1285. Around 50 percent of people live within 30 miles of an ocean. Sixty percent live within 100 miles of an ocean, sea, or lake.

1286. Forty-five percent of people live in cities.

1287. Thirty percent of people living in developing countries live in poverty.

1288. Seventy percent of the world's poor are female.

1289. Twenty-three percent of the population lives on less than $1 a day.

1290. Two billion people have no electricity.

1291. One billion people lack adequate housing.

1292. According to the US Environmental Protection Agency, American families use 300 to 400 gallons of water a day.

1293. Roughly 70 percent of this use is indoors.

1294. Toilets can use 27 percent of household water.

1295. Our domestic use of water is only 1 percent of US freshwater use.

1296. Thermoelectric power accounts for 45 percent, and irrigation accounts for 32 percent.

1297. Americans flush 7 billion gallons of water every day. One quart of oil is enough to contaminate 250,000 gallons of water.

1298. It takes more than 6,500 gallons of water to grow a day's food for a family of 4.

1299. According to UNICEF, girls and women around the world spend 200 million hours a day gathering water.

1300. In 8 out of 10 homes without running water, it is the girls who collect water.

1301. UNICEF's head of water, sanitation, and hygiene, Sanjay Wijesekera, said "It would be as if a woman started with her empty bucket in the Stone Age and didn't arrive home with water until 2016."

1302. In 2022, it was reported that Kenya is enduring its worst drought in 40 years.

1303. More than 4 million people are food insecure, and 3.3 million don't have enough water to drink.

1304. Today, 1 in 4 people around the world lack safe drinking water. That's 2 billion people.

1305. Half of the global population lacks safely managed sanitation, according to UNICEF.

1306. Around the world, 40 percent of the population or as many as 700 million people are at risk of being displaced because of droughts by the year 2030.

1307. The human right to safe drinking water was first recognized by the UN General Assembly and the Human Rights Council as part of binding international law in 2010.

1308. A water-efficient dishwasher uses as little as 4 gallons per cycle but hand washing dishes uses 20 gallons of water.

1309. The world creates 2 billion tons of municipal solid waste a year.

1310. One third of this waste is not managed in an environmentally safe manner.

1311. High-income countries generate 34 percent of the waste, while accounting for 16 percent of the world's population.

1312. The US Environmental Agency defines containers and packaging as "products that are assumed to be discarded the same year the products they contain are purchased."

1313.

Packaging makes up to 28 percent of the total municipal solid waste per year in the US.

1314. Of the 34.5 million tons of plastic waste generated each year, only 9 percent is recycled, with most of the recyclable waste shipped to other countries for processing.

1315. China used to be the primary recipient of US recycling waste, but they banned waste imports in 2018.

1316. The amount of plastic "recycled" and used for new things is around 5 percent. About 85 percent went to landfills, and 10 percent was incinerated.

1317. Greenpeace found that no plastic meets the threshold to be called "recyclable" according to standards set by the Ellen MacArthur Foundation New Plastic Economy Initiative.

1318. According to the initiative, plastic must have a recycling rate of 30 percent, and to date, no plastic has been recycled and reused close to that rate.

1319. Waste management experts say that there are thousands of different kinds of plastics, and they can't be melted down together. Also, the more plastic is used, the more toxic it becomes as it degrades after one or 2 uses.

1320.
Five trillion plastic bags are produced worldwide per year.

1321. Up to 14 million tons of plastic end up in the world's oceans per year.

1322. There are 24.4 trillion pieces of microplastics in the world's oceans.

1323. Up to 80 percent of all marine debris found on ocean surfaces is plastic.

1324. Fish is one of the most important sources of animal protein. It accounts for about 17 percent of protein at the global level and exceeds 50 percent in many least-developed countries.

1325. Approximately 50 percent of all international tourists travel to coastal areas. In some developing countries, tourism accounts for over 25 percent of GDP.

1326. By 2050, oceans will carry more plastic mass than fish, and an estimated 99 percent of seabirds will have ingested plastic.

1327. Plastic waste kills up to 1 million sea birds, 100,000 sea mammals, marine turtles, and countless fish each year.

1328. Fishing gear in the oceans makes up around 10 percent of all marine litter.

1329. This gear continues to catch fish through what is called ghost fishing.

1330. Land-based activities account for 80% of all pollution in seas and oceans.

1331. Nitrogen loads in oceans tripled from pre-industrial times due to fertilizer, manure, and wastewater.

1332. Pollution and eutrophication (excessive nutrients in water) are also caused by runoff from the land, which cause dense plant growth and the death of animal life.

1333. The 5 large marine ecosystems most at risk from coastal eutrophication are the Bay of Bengal, East China Sea, Gulf of Mexico, North Brazil Shelf, and South China Sea.

1334. An investigative report by National Public Radio in 2020 found that industry officials knew as early as the 1970s that plastic cannot be economically recycled.

1335. There are approximately 2,000 active satellites orbiting Earth, as well as 3,000 dead ones.

1336. Coral reefs are very sensitive to ocean acidification, with 60 percent of reefs currently threatened by ocean warming, acidification, and more.

1337. By 2050, that number will be 100 percent.

1338. About 20 percent of the world's coral reefs have been destroyed and show no signs of recovery.

1339. The first major coral bleaching event was in 1998.

1340. The second was triggered by the El Niño of 2010.

1341. The third was declared in 2015, and it has become the longest, most widespread, and most damaging event recorded, impacting some reefs in consecutive years.

1342. The leading causes of coral bleaching are the above-average sea water temperatures caused by climate change.

1343. An estimated 20 percent of global mangroves have been lost since 1980.

1344. Projected increasing temperatures in oceans will likely result in changes in distribution of marine species and can significantly influence the reproductive cycles of fish.

1345. Between 1901 and 2010, global sea level rise increased at an accelerating rate and recent sea level rise appears to have been the fastest in at least 2800 years.

1346. During the last 4 decades, 75 percent of the sea level rise can be attributed to glacier mass loss and ocean thermal expansion.

1347. Nearly 2/3 of the world's cities with populations of over 5 million are located in areas at risk of sea level rise.

1348. Ocean warming has been linked to extreme weather events as increasing seawater temperatures provide more energy for storms that develop at sea, leading to fewer but more intense tropical cyclones globally.

1349. There are around 34,000 pieces of space junk bigger than 4 inches orbiting Earth, and more than 128 million pieces larger than 1 millimeter.

1350. The chances of a collision between a rocket and space litter are 1 in 10,000.

1351. It takes paper 2 to 5 months to biodegrade.

1352. An orange peel takes 5 to 6 months to biodegrade.

1353. Tree leaves take 1 year to biodegrade.

1354.
Plastic-coated paper milk cartons take 5 years to biodegrade.

1355. Nylon fabric takes 30 to 40 years to biodegrade.

1356. Tin cans take 50 to 100 years to biodegrade.

1357. Aluminum cans can take 80 to 100 years to biodegrade.

1358. Polystyrene foam may never biodegrade.

1359. Plastic bags may biodegrade in 500 to 1,000 years.

1360. Plastic bags don't biodegrade because microorganisms responsible for biodegrading items don't recognize polyethylene (the most common type of bag) as food.

1361. Plastic bags do photodegrade, meaning ultraviolet radiation from sunlight breaks polyethylene's polymer chains. However, that just means the pieces get smaller and smaller, but never disappear.

1362. Scientists use respirometry tests to estimate degradation.

1363. Solid waste is placed in a container with microorganisms, soil, and air. Scientists measure the resulting carbon dioxide created by microorganisms and use that as an indicator of degradation.

1364. In 1962, Brendon Grimshaw, an unemployed newspaper editor, bought the island of Moyenne from its previous owner for approximately $10,000.

1365. Moyenne Island is only about a half mile wide and is off the north coast of Mahé, Seychelles, in the middle of the Indian Ocean.

1366. With the help of a 19-year-old local, René Antoine Lafortune, Grimshaw planted 16,000 trees, built 3 miles of nature paths, and reintroduced the Aldabra giant tortoises on the island.

1367. He had been offered up to $50 million for his island paradise, but instead Grimshaw signed a perpetual trust with the Seychelles' Ministry of Environment in 2009, and it became a national park.

1368. Iceland is the only country in the world that has no mosquitos.

1369. Saudi Arabia is 95 percent desert and has nearly 1,700 miles of coastline.

1370. Saudi Arabia has plenty of sand, but it's not good for building. Hence, they have to import sand from Australia and Scotland.

1371. Desert sand is different from beach sand. Desert sand has been eroded by thousands of years of wind and as a result, it is very smooth and fine. Beach sand is coarser because of water erosion.

1372. China uses more sand in 1 year than the US has used in the entire 20th century.

1373.

China dredges nearly 1 million tons of sand a day from Lake Poyang.

1374. The world's longest nonstop commercial flight is from New York to Singapore. The flight lasts 19 hours over 9,527 miles.

1375. The Mississippi River was once the border between the Spanish Empire and the British Empire.

1376.

Modern skyscrapers should be able to withstand an 8.5 earthquake as recorded on the Richter scale.

1377. Meteorologist Alfred Wegener proposed in 1911 that the continents all were once one large land mass.

1378. Pangaea is the name given to the supercontinent that existed in the late Paleozoic and early Mesozoic era.

1379. Panthalassa is the name given to the global ocean that surrounded Pangaea.

1380. An earthquake that measures 6.0 on the Richter scale is 10-times more powerful than a 5.0.

CHAPTER 7
US
NATIONAL
PARKS

1381. The US has 2.8 million square miles of land. The US National Park System spans across more than 84 million acres or 3.4 percent of the US.

1382. The US National Park System comprises 424 areas of national significance. Only 63 are designated as national parks.

1383. The National Park Service is a federal agency that manages all of the national parks in the US.

1384. Delaware is the only state in the US without either a national park or a national monument.

1385. The largest national park is Wrangell-St. Elias National Park in south central Alaska, taking up 13.2 million acres.

1386. Wrangell-St. Elias National Park is bigger than Yellowstone, Yosemite, and Switzerland combined.

1387. More than 25 percent of Wrangell-St. Elias is covered by glaciers.

1388. The smallest national park is Gateway Arch National Park in Missouri. It's 91 acres.

1389. Gateway Arch National Park is the site of the 630-foot Gateway Arch.

1390. In 1864, Yosemite became the first land preserved for public use and preservation by the US government. President Abraham Lincoln signed the bill.

1391. In 1872, Yellowstone became the first official national park in the US.

1392. Yellowstone is the largest and most diverse virgin landscape in the lower 48 states of the US.

1393. There's a 37-mile-long magma chamber Under Yellowstone National Park in Wyoming, Montana, and Idaho.

1394. The hot springs of Yellowstone are so acidic, they can dissolve a human body overnight.

1395. The fractured crust of Yellowstone National Park lets groundwater seep down until it touches magma. The superheated water then returns to the surface as a geyser.

1396.

There are more than 300 geysers at Yellowstone—more than half of the world's total.

1397. There are up to 5,500 bison at Yellowstone. In the early 1900s, there were only 23.

1398. From 1890 till World War II, Yellowstone's main attraction was watching bears eat the trash at open garbage heaps. Wooden bleachers were built so guests could watch from a comfortable place.

1399. Horace M. Albright, Yellowstone's superintendent in the 1920s, would tell visitors who got bit by bears that "the bear's bite was actually a unique souvenir to take home."

1400. Albright also recounted a time a women wanted a bear executed for ripping her dress off.

1401. If you want to see bears eat, head to Katmai National Park in Alaska. Viewing platforms are set up to watch brown bears catch salmon along the Brooks River.

1402. The North Cascades National Park in Washington state has more plant species than any other national park (more than 1,600!).

1403. The author Jack Kerouac worked for 2 months as a fire-tower watchman on Desolation Peak at North Cascades National Park.

1404. The National Park of American Samoa in the South Pacific is the least visited US national park. It reported 1,887 visits in 2022.

1405. The National Park of American Samoa is the only National Park Service site south of the equator.

1406. Nearly 13 million people visited the Great Smoky Mountains National Park (in North Carolina and Tennessee) in 2022, making it the most visited national park in the US.

1407. You can sign up for a lottery to watch the synchronous fireflies at the Great Smoky Mountains National Park each spring. These beetles flash in unison, creating a pulsating light show.

1408. Alaska was home to 5 of the 15 least-visited national parks in 2022.

1409. In December 2020, the US designated the New River Gorge in West Virginia its newest national park.

1410. Mount Rainier National Park in Washington state rises 14,410 above sea level and is an active volcano.

1411. Crater Lake in Crater Lake National Park in Oregon is the deepest lake in the US and the ninth deepest in the world. It's 1,943-feet deep at its deepest.

1412.

The water in Crater Lake is considered the cleanest and clearest large body of water on the planet.

1413. Glacier National Park in Montana featured more than 80 glaciers in 1850. Today, there are approximately 25 left.

1414. The Glaciers are at least 7,000 years old and peaked in size in the mid-1800s.

1415. Glacier National Park was inscribed as a UNESCO World Heritage site in 1995.

1416. Mammoth Cave National Park in Kentucky has 400 miles of mapped caves (with up to 600 additional miles yet to be mapped)—the longest cave system in the world.

1417. The deepest cave in the US is 1,593 feet deep and can be found at Mammoth Cave.

1418. In 2009, Sequoia National Park had to shut down a popular cave exhibit because of a $36 million drug bust. Authorities had found a large marijuana growing operation just a half mile from the caves.

1419.

By 2017, rangers at Sequoia were calling marijuana cultivation "one of the greatest human-caused threats to [the park]."

1420. The Star Dune and Hidden Dune—both in Great Sand Dunes National Park in Colorado—are tied for the tallest dune in the US at 741 feet from base to summit.

1421. You can sled down the dunes in Great Sand Dunes National Park, but you have to bring your own sled.

1422. When there's an avalanche at Great Sand Dunes, the sand in the dunes starts to hum. This sound was the inspiration behind "The Singing Sands of Alamosa," a hit for Bing Crosby in 1942.

1423. Dry Tortugas National Park in Florida is a remote island 70 miles west of Key West. You can only get there by boat or seaplane.

1424. One of the highest waterfalls are found in Yosemite National Park in California. Yosemite Falls at 2,425 feet is 9 times taller than Niagara Falls.

1425. The highest point at any national park is Denali (Mount McKinley) in Denali National Park at 20,302 feet.

1426. Denali is the tallest peak in North America.

1427. Denali has a working sled dog kennel. Rangers use sled dogs to patrol the park.

1428. "Denali" is an Athabaskan Indian name that means "The Great One."

1429. Arches National Park in Utah has the largest concentration of stone arches in the world.

1430. There are more than 2,000 documented arches at Arches National Park—each illustrating 300 million years of erosion.

1431. The 2002 Winter Olympics torch passed beneath the Delicate Arch in Arches before visiting Bryce Canyon and Zion National Parks. The Olympics were held in Salt Lake City that year.

1432. South Dakota's Badlands National Park is known for its colored layers of its landscape. Each color represents a different material. For example, white is volcanic ash and purple is oxidized manganese.

1433. White Sands National Park in New Mexico boasts the largest gypsum dune field in the world.

1434. All of the sand at White Sands is actually gypsum. No matter how hot it gets, gypsum stays cool to the touch because it doesn't absorb the sun's heat.

1435. Gypsum is a soft mineral and is found where ocean water has evaporated. It's used in building plaster or drywall.

1436. In 1906, Mesa Verde National Park in Colorado became the first national park established to protect manmade structures. The park has 5,000 archeological sites, including 600 cliff-dwelling of the Ancestral Pueblo people.

1437. The biggest salmon in the world was captured in 1985 in the Kenai River in Kenai Fjords National Park in Alaska. It weighed 97 pounds and 4 ounces and was caught using a hook and line.

1438. The 28-mile-long Mount Evans Scenic Byway in Rocky Mountain National Park in Colorado is the highest paved road in the US at 14,130 feet.

1439. Acadia National Park in Maine has one of the highest coastal mountain ranges in the world with Mount Fairweather topping 15,300 feet.

1440. Acadia is the oldest national park east of the Mississippi River.

1441. Between October and March, Acadia is the first place in the US to see the sunrise each morning—about 50 minutes before dawn on the East Coast.

1442. Death Valley National Park in California is the hottest place on Earth. On July 10, 1913, a temperature of 134°F was recorded at Furnace Creek in Death Valley.

1443. The lowest point in the western hemisphere is Badwater Basin in Death Valley. It is 282 feet below sea level.

1444. Death Valley was a 600-foot lake 50,000 years ago.

1445.
Great Basin National Park in Nevada features the remains of the Prometheus tree, a Great Basin Bristlecone pine that was once recorded as the oldest tree in the world at 4,700 to 5,000 years old.

1446. Biscayne National Park in Florida is 95 percent underwater.

1447. Biscayne shelters the world's third-largest coral reef.

1448. There are hundreds of shipwrecks dating back to the 1500s at Biscayne. Only a few have been mapped for divers to explore.

1449. Illustrator Amber Share makes a living turning really bad reviews of national parks, monuments, and other public lands from Google, Yelp, and TripAdvisor into art. Some of the reviews that inspired her include: This review of North Cascades National Park in Washington state: "Too many mountains, trees, snow, etc." Voyageurs National Park: "There was no one except us." Yellowstone National Park: "Save yourself some money and boil some water at home."

1450. Black Canyon National Park in Colorado isn't named for the color of its rocks. Because the canyon walls are 2,722 feet tall, the sun only reaches the bottom for 33 minutes a day.

1451.

The Hoh Rain Forest at Olympic National Park in Washington gets more rainfall per year than the Amazon.

1452. Bryce Canyon National Park in Utah is a 55-square-mile valley featuring rock spires called "hoodoos" that have been carved by seasonal rain and melting snow.

1453. Bryce Canyon was "discovered" by Ebenezer Bryce in 1875 while looking for lost livestock. He said it was "one hell of a place to lose a cow."

1454. The canyon in Grand Canyon National Park in Arizona is 277 miles long, 4,000 feet deep, and 1.2 million acres.

1455. The Grand Canyon's layered rock exhibits five eras of geologic time: the Cambrian, Devonian, Mississippian, Pennsylvanian, and Permian.

1456. Erosion has removed most Mesozoic Era evidence, although small remnants can be found in the western Grand Canyon.

1457. The oldest rocks in the Grand Canyon are 1.8 billion years old.

1458. No dinosaur bones have been found at Grand Canyon National Park. The canyon walls are older than dinosaurs by millions of years. There are fossils of ancient marine animals, though.

1459. A town with 200 residents is located at the base of the Grand Canyon. Supai Village is part of the Havasupai Indian Reservation.

1460. Gates of the Arctic National Park in Alaska is the northernmost national park in the US and sits entirely above the Arctic circle.

1461. Gates of the Arctic has no roads, trails, or facilities.

1462. Grand Teton National Park in Wyoming is only 10 miles south of Yellowstone.

1463. Grand Teton is the only national park with its own commercial airport.

1464. Congaree National Park in South Carolina served as an ideal hiding place for escaping slaves before the Civil War because of its jungle-like wilderness.

1465. Congaree National Park in South Carolina has the largest old-growth bottomland hardwood forest in the US.

1466.

Everglades National Park in Florida covers 2,357 square miles and is the largest subtropical wilderness left in the US.

1467. Petrified Forest National Park in Arizona was once an ancient grove of tropical trees. The logs from these trees are now solid quartz.

CHAPTER 8
FOOD

1468. Ketchup, the ubiquitous condiment, dates back to 300 BCE; however, this ketchup didn't have any tomatoes.

1469. The precursor to our ketchup was a fermented fish sauce from southern China called *ge-thcup* or *koi-cheup*.

1470. By the early 1700s, British traders brought the recipe back and made their own versions, featuring oysters, mushrooms, walnuts, lemons, and more.

1471. A 1758 version of the condiment included white wine vinegar, eschalot cloves, "the best lagoon white wine," anchovies, mace, ginger, cloves, pepper, nutmeg, lemon peel, horseradish, and the "clear liquid that comes from mushrooms."

1472. A Philadelphia scientist named James Mease is credited with creating the first tomato-based ketchup in 1812.

1473. Heinz introduced its ketchup in 1876. It had tomatoes, distilled vinegar, brown sugar, salt, and spices.

1474. One of the first references to tomatoes comes from one of Cortés's companions who reported that the Aztecs used tomatoes as a side dish along with squash blossoms and peppers. What was the main course? Human flesh.

1475. The Aztecs called this fruit *tomatl*.

1476. The tomato found its way to Europe by the 1500s, where the Italians enthusiastically embraced it. The English, on the other hand, feared it was a deadly aphrodisiac and shunned it. Tomatoes were called love apples for their supposedly aphrodisiac qualities.

1477. Coriander and cilantro are the same thing.

1478. Bananas are technically berries because they come from a single seed. So are cucumbers and melons.

1479.

Bananas are the most popular fresh fruit in the US.

1480. Cauliflower is technically a flower.

1481. The head of a cauliflower is the beginning of the flower (the immature buds) and known as the curd.

1482. Broccoli is also a flower in which the head is picked for eating before it can bloom into flowers.

1483. Nectarine and peaches are nearly genetically identical. If one gene is dominant, the fruit becomes a fuzzy peach. If the gene is recessive, the fruit becomes a smooth nectarine.

1484. Fruit Salad Trees are multi-grafted trees created in Australia that have up to 6 different types of fruit all growing from one tree.

1485. Peanuts are not actually nuts. They are actually legumes, as the "nuts" inside the shell are seeds, and they grow underground. Nuts grow on trees.

1486. A legume is an edible seed that is enclosed in a pod, such as beans and peas.

1487. A fruit with a hard, stony layer covering the seed is called a drupe.

1488. Cherries and peaches are drupes.

1489. Tree nuts such as almonds, pistachios, and coconuts fall into the drupe category.

1490. Hawaiian pizza is a classic American-style cheese pizza topped with pineapple and ham. Despite its name, Hawaiian pizza was invented in Canada.

1491. Three billion pizzas are sold in the US every year . . . not including the one billion frozen pizzas sold per year.

1492. Pepperoni is the most popular pizza topping in the US.

1493. In India, pizzas are topped with pickled ginger, minced mutton, and paneer. In Japan, the most popular topping is eel. In Brazil, it's green peas.

1494. Häagen-Dazs is an ice-cream brand created in 1959–1960 by Reuben Mattus, a Polish immigrant living in the Bronx, New York. He and his wife, Rose, started with 3 flavors: chocolate, vanilla, and coffee.

1495. The Mattus's opened their first store on November 15, 1976, in Brooklyn, New York.

1496. They named their ice cream "Häagen-Dazs" because it sounded Danish. They wanted the company's name to have a foreign-sounding name. Reuben and Rose, both Jewish, did this as a tribute to Denmark's good treatment of Jews during World War II. The name is not Danish.

1497. "Häagen-Dazs" means . . . absolutely nothing. Mattus said, "it would attract attention, especially with the umlaut." The Danish language doesn't use umlauts.

1498.

Pepsi was invented in 1893 in New Bern, North Carolina, by drugstore owner Caleb Bradham. At first, it was called Brad's Drink.

1499. The ingredients included sugar, water, caramel, lemon oil, kola nuts, nutmeg, and other additives.

1500. Since Bradham saw his drink as something to aid in digestion, he renamed it Pepsi, because it aided in dyspepsia (indigestion).

1501. According to the American Heart Association, Americans consume an average of 77 grams of sugar a day, which is more than 3 times the recommended amount for women. This adds up to around 60 pounds of sugar. For American children, it's even worse as their annual consumption averages 81 grams of sugar per day or 65 pounds.

1502. The AHA recommends no more than 36 grams of sugar a day for men and 25 grams for women.

1503.
Children ingest over 30 gallons of added sugars from beverages alone.

1504. After the success of Pop-Tarts in the 1960s, inventors came up with toaster eggs, toaster French fries, toaster chicken patties, and, in 1964, Reddi-Wip developed Reddi-Bacon, which was precooked bacon in a foil pouch you simply dropped into a toaster.

1505. The fat that sometimes leaked from the pouch made Reddi-Bacon a fire hazard.

1506. When the iPhone 5 was released in 2013, the Senbei Rice Cracker iPhone Case soon followed. Made of brown rice and salt, the case was fully edible, but it didn't do much for the phone if you dropped it.

1507. In 1974, Gerber released Gerber Singles, which were larger servings of their baby foods meant for college students. Turns out young adults (or any adults for that matter) did not like the idea of eating baby food for dinner.

1508. In the 1960s, the makers of Jell-O created a gelatin for salads. It came in 4 flavors: seasoned tomato, mixed vegetable, Italian, and celery.

1509. In 2020, *Italy Magazine* estimated that there are 350 unique shapes of pasta in existence.

1510. The island of Sardinia in Italy has a pasta shape known as *su filindeu*, which translates to "the threads of god."

1511. Only 3 people on the island know how to make su filindeu, making it the rarest pasta in the world.

1512. The recipe is more than 300 years old and credited to the Abraini family, who are still keepers of the family recipe today.

1513. Su filindeu is made by pulling and folding semolina dough into 256 perfectly even strands using the tips of your fingers. Su filindeu is about half as wide as angel-hair pasta.

1514. Celebrity chef Jamie Oliver visited one of the women who makes the pasta and tried to learn how. After 2 hours, he gave up, saying, "I've been making pasta for 20 years and I've never seen anything like this."

1515. In Hong Kong in 2016, the food chain KFC took its motto, "finger lickin' good" literally when they debuted edible nail polish. The nail polish came in Hot & Spicy and Original Recipe.

1516. A reporter at the BBC tried both and found that while the polish tasted okay, besides the fact they didn't taste like chicken, they were pretty horrible as nail polish.

1517. In 1934, A.W. Leo, Tom Yates, and Ralph Harrison developed the first Hawaiian Punch recipe in a garage in California. It was meant to be an ice-cream topping. Consumers, however, discovered that the concentrate tasted good when mixed with water.

1518. Before refrigeration, Russians dropped live frogs in their milk buckets to keep the milk from going bad.

1519. Modern researchers have discovered that some frogs secrete a "goo" that has antibacterial and antifungal properties.

1520. The first plate of Buffalo wings was served in 1964 at a restaurant called the Anchor Bar in Buffalo, New York. Teressa Bellissimo invented these wings and served them with a side of blue cheese and celery because that's what she had available.

1521. Buffalo wing sauce is a combination of hot sauce, red pepper, and melted butter.

1522. Until the 1880s, lobsters were so cheap and plentiful they were considered the cockroaches of the sea in the Northeast and only fit for prison food.

1523. In 2022, TGI Friday's was sued in a class action lawsuit against them for selling frozen mozzarella sticks in grocery stores that had no mozzarella cheese in them. The fine print on the back of the package states it's cheddar cheese.

1524. The word "chocolate" comes from the ancient Aztec word "xocoatl," which was a bitter drink made from cacao beans. Xocoatl means "bitter water."

1525. The authors of *The True History of Chocolate* state that chocolate has been around for 4,000 years.

1526.
Chocolate is made from the fruit of a cacao tree, which only grows in tropical climates.

1527. The cacao tree is native to Central and South America, but by the 1700s, Europeans established plantations in other parts of the world, which were farmed by enslaved Africans.

1528. The fruit of a cacao tree is about the same size and shape as a football. The fruit is lumpy and contains up to 50 seeds (beans) covered in a white pulp.

1529. The beans are fermented and then dried before being roasted. From there, chocolate liquor is created, which is a thick paste that doesn't have any alcohol in it.

1530. Chocolate liquor is processed into cocoa solids (the non-fatty parts) and cocoa butter.

1531. Chocolate liquor is blended with the separated cocoa butter in different proportions to make different types of chocolate.

1532. More than half of the chocolate consumed comes from West African countries, mostly Ghana and Cote d-Ivoire.

1533. Other chocolate-producing countries are in Nigeria, Indonesia, and Brazil.

1534. The Fine Chocolate Industry Association (FCIA) designates fine chocolate as containing only cacao liquor, cacao butter (optional), sugar, lecithin, vanilla (optional), and milk fats and solids (for milk chocolate).

1535. White chocolate has the same ingredients as milk chocolate, minus the chocolate liquor.

1536. Some experts state that white chocolate isn't chocolate at all, and until 2002, the US Food and Drug Administration had it classified as a confectionary rather than a chocolate since it didn't have chocolate liquor.

1537. In 2017, Barry Callebaut, the world's largest cocoa processing company, developed a pink-colored chocolate called ruby chocolate.

1538. The coloring comes from a powder that's naturally extracted during processing. This chocolate has a lighter flavor than milk chocolate and doesn't taste as sweet.

1539. Chocolate was enjoyed by Europeans during the 1700s, but as a drink.

1540. In 1815, a Dutch scientist, Conrad Van Houten, experimented with removing different amounts of cocoa butter from chocolate liquor, leading to the invention of cocoa powder and solid chocolate.

1541.

Fry's, an English chocolate company, created the first mass-produced chocolate bar in 1847.

1542. Henri Nestlé invented milk chocolate.

1543. Hershey's Kisses were introduced in 1900.

1544. M&Ms were created in 1941 for US service members overseas during World War II. The candy shells kept the chocolate inside from melting into a mess.

1545. M&Ms didn't become available to the public until 1947.

1546. The melting point of chocolate is just below a human's body temperature. That's why it melts in your mouth.

1547. In 1996, Neil Martin, a British psychologist, tested food smells and found that the smell of chocolate depressed theta brain waves, which are associated with attention. At the same time, smelling chocolate was found to increase alpha waves, seen in relaxed people, and beta waves, which are seen when people are doing mental work such as math.

1548. According to a 2016 report by the National Oceanic and Atmospheric Administration (NOAA), viable land for cacao production will shrink due to rising temperatures and lower humidity levels.

1549. The report states that 89.5 percent of the nearly 300 chocolate-production locations that were studied would become less suitable by 2050.

1550. Scientists are working on using DNA-editing technology to develop a cacao seed that can withstand climate change.

1551. Slave Free Chocolate, a coalition that seeks to bring an end to child slavery and child labor in the cocoa industry, states that an estimated 1.8 million children are at risk for falling under the worst forms of child labor conditions set by the United Nations.

1552. From 40 to 50 million people depend on cocoa for their livelihoods.

1553. The Philippines' most popular condiment is banana ketchup.

1554. Its main ingredients include mashed bananas, vinegar, sugar, and spices.

1555. Banana ketchup was invented by Maria Orosa, a food technologist and actual war hero.

1556. Born in the Philippines in 1893, Orosa studied pharmaceutical chemistry and food chemistry in the US She then returned to the Philippines to fight malnutrition in her home country.

1557. During World War II, she created provisions that Filipino soldiers lived on. One such food was a nutrient-rich soya bean drink called Soyalac.

1558. Another was Darak, rice cookies rich in B vitamins, thiamine, and more.

1559. During the war, with tomatoes in short supply, Orosa experimented with different ingredients until she came up with banana ketchup.

1560. Today, banana ketchup's red color comes from food coloring.

1561. Also, during the war, Orosa fought alongside the US against the Japanese, as a captain in Marking's Guerrillas, a Filipino group organized by Marcos "Marking" V. Augustin. Orosa helped devise a system for smuggling food into Japanese-run concentration camps.

1562. Orosa and her guerrillas hired carpenters to put powdered Soyalac and Darak into hollow bamboo sticks, which were then smuggled into the camps.

1563. She was killed by shrapnel from friendly fire in 1945.

1564. Orosa's niece, Helen Orosa del Rosario, published a book that contained 700 of Orosa's recipes.

1565. *Balut* is a delicacy in the Philippines, Cambodia, and Vietnam, and is half-hatched duck eggs (the eggs with legs!) that are boiled or steamed and eaten from the shell.

1566. The eggs are fertilized and incubated for up to 21 days before steaming.

1567. *Kopi luwak* is a coffee made from partially digested coffee cherries collected from the poop of the civet, a small mammal. The coffee beans inside remain intact as they are not digestible.

1568. The cherries are fermented as they pass through the animal's intestines.

1569. One of the reasons these beans make such a great cup of coffee is that wild civets only pick the ripest, reddest, and sweetest coffee cherries.

1570. Kopi luwak originated in Indonesia and is one of the most expensive coffees in the world, fetching up to $45 per pound for farmed and $600 per pound for wild-collected beans.

1571. Dormice stew is a native dish of Slovenia in Europe, and the name pretty much says it all. The mice are bred and fattened for cooking.

1572. Edible dormice were a favorite of the ancient Romans, who grilled the dormice with honey.

1573. *Sanguinaccio dolce* is an Italian pudding made from pig's blood, chocolate, milk, pine nuts, raisins, and sugar.

1574. Sanguinaccio dolce makes an appearance in the TV series *Hannibal* as a favorite dish of Hannibal Lecter.

1575.
P'tcha is a traditional Ashkenazi Jewish jelly made out of calves' feet.

1576. Originating in Scotland, haggis features minced sheep liver, heart, and lung, mixed with spices, oatmeal, and more. The ingredients are then boiled in the sheep's stomach for hours.

1577. Haggis is traditionally served with neeps and tatties, which are turnips and potatoes.

1578. *Casu marzu* is a sheep milk cheese made on the island of Sardinia, which is off the coast of Italy. Its name means "rotten cheese," mostly because it has maggots crawling inside it.

1579. Cheesemakers leave a pecorino wheel outside for the flies to lay their eggs on.

1580. The maggot excretions break down the cheese, creating a soft texture and *lagrima* or tears that ooze from the rind.

1581. Cheese skipper flies (*Piophila casei*) are the type of fly that lays eggs in the cheese.

1582. A single wheel can host thousands of maggots.

1583. The cheese is ready to eat after 3 months. It should only be eaten while the maggots are still alive. If not, the cheese is toxic.

1584. You are cautioned to protect your eyes before taking a bite of casu marzu since the maggots can jump. Also, eating live maggots is bad for your stomach.

1585. Casu marzu has a strong smell and an acidic, pungent . . . rotten . . . taste.

1586. Casu marzu has been illegal to sell in Italy since 1962. It's also illegal in the US and Europe.

1587. *Beondegi* is one of South Korea's most popular snack-food items. You can buy them from street vendors nearly everywhere you go. Beondegi is boiled, steamed, or deep-fried silkworm pupae.

1588. Beondegi is served in paper cups with toothpick skewers.

1589. Beondegi has a nutty taste or a flavor similar to crab meat. The texture is firm and chewy, and according to an article in matadornetwork.com, they "release a squirt of warm, briny juice when you bite into them."

1590. *Gomutra* is cow urine from India, where it has been a medicinal drink for thousands of years.

1591. To make *kiviak*, a dish from south-western Greenland, you stuff 500 small Arctic birds into a freely disemboweled seal. The seal carcass is then sewn shut, buried, and left to ferment for months.

1592. To eat kiviak, you bite off the bird's head and then suck out the juices. You can also eat the whole bird with the bones.

1593. The only bird you can use for kiviak is the Little Auk, a small Arctic bird.

1594.

In many countries in Asia, you can consume snake wine. It's produced by infusing whole snakes, preferably venomous ones, in rice wine or grain alcohol.

1595. If you happen to visit the Mexican cities of Oaxaca or Puebla, you're sure to run into *chapulines*, which are eaten like nuts, popcorn, or potato chips and are a big snack-food item at sport events.

1596. Chapulines are cooked and seasoned grasshoppers, and they have been part of the indigenous diet for 3,000 years.

1597. *Fugu* is a Japanese dish made from the meat of a pufferfish, which contains lethal amounts of poison.

1598. Only licensed and trained chefs are allowed to prepare it, but people still die from eating this sometimes.

1599. When eating it, you may feel a small prickling sensation, which is caused by the small amounts of poison in the meat.

1600. Hákarl is fermented, dried Greenland shark.

1601. Since the meat of a Greenland shark is toxic, Icelanders used to bury the shark under the ground to ferment it. Then it is hung to dry for 5 months.

1602. Hákarl has an ammonia-type smell, and chef and author Anthony Bourdain called it "the single worst, most disgusting and terrible thing" he had ever eaten.

1603.

Bird nest soup is a Chinese dish made from the nests of swiftlets, which are tiny birds that live in caves.

1604. Swiftlets don't use twigs and leaves to build their nests; they use their own saliva, which hardens into a gummy-like substance when exposed to air.

1605. These nests are not easily obtained, which is why this dish is known as the Caviar of the East.

1606. Cuy is a Peruvian dish consisting of roasted guinea pigs.

1607. Stargazy pie is a Cornish pie featuring eggs and potatoes with fish heads sticking out of it.

1608. Head cheese is a Scottish meat jelly made with the head of a calf or pig.

1609. Jellied moose nose is an Alaskan dish of sliced moose snout.

1610. Fried spiders in Cambodia are palm-sized tarantulas tossed with sugar, salt, and crushed garlic, and fried until the legs are stiff and the stomach contents no longer runny.

1611. *Smalahove* is a Norwegian dish made from smoked sheep's head.

1612. Escamole are ant larvae from the roots of agave or mescal plants, from Mexico.

1613. *Blodplatter* is a Swedish blood pancake made of pork blood, milk, rye flour, dark molasses, onion, and butter.

1614. *Sannakji* is a raw Korean dish consisting of sliced octopuses killed just before serving. The octopuses' arms are still moving while eaten.

1615. If you ever find yourself in Malmö, Sweden, make sure to visit the Disgusting Food Museum, which features 80 of the world's most disgusting foods. Visitors are encouraged to smell and taste some of the food at the tasting bar.

1616. Their website states, "Disgusting Food Museum invites visitors to explore the world of food and challenge their notions of what is and what isn't edible. Could changing our ideas of disgust help us embrace the environmentally sustainable foods of the future?"

1617. Open since 2018, the Disgusting Food Museum attracts up to 20,000 visitors a year.

1618. According to their website, 108 vomits have occurred in the museum, with *surstömming* the cause of roughly 50 percent of them.

1619. The museum states that surstömming might be "the ultimate disgusting food."

1620. This fermented fish from Sweden, "smells very bad, tastes very salty, and . . . has a gooey texture."

1621. A 2002 Japanese study found that its smell is one of the most putrid in the world.

1622. One of the ways to get around the smell is to open a can of surstömming in a bucket of cold water.

1623. This foul-smelling delicacy is served with flatbread, onions, and potatoes.

1624. Mongolian Mary, also known as sheep eyeball juice, is pickled sheep eyeballs in tomato juice. It's a hangover cure that goes back to the times of Genghis Khan.

1625. According to the Disgusting Food Museum, the eyeball doesn't have much taste, but when you chew one, it burst in your mouth, and the "gel-like vitreous humor of the eye fills your mouth."

1626. *Shirako* is a Japanese delicacy that is the sperm sacs of cod. Served cook or raw, "shirako" translates to "white children."

1627. Its taste is described as salty and fishy with a cream-like texture, like custard.

1628. Molokai is herring sperm that is eaten in Russia.

1629. Rocky Mountain oysters are bull testicles eaten in ranching communities in the US and Canada, where they are known as prairie oysters.

1630. The testicles are usually deep-fried and served as an appetizer.

1631. Rocky Mountain oysters are also known as cowboy caviar, Montana tendergroins, dusted nuts, swinging beef, calf fries, and huevos de toro (bull's eggs).

1632. You can order Rocky Mountain Oyster Po'Boys at Coors Field, home of the Major League Baseball team, the Colorado Rockies, which are served with garlic coleslaw, guacamole, green chili ranch dressing, pico de gallo, and cotija cheese.

1633. *Súrir Hrútspungar*, also known as sour ram's testicles, is an Icelandic delicacy. The testicles are removed, boiled, cured with lactic acid, and then sliced like a loaf of bread.

1634. In 1940, when Richard and Maurice "Mac" McDonald opened their first McDonald's location in San Bernardino, California, barbecued meat was their specialty.

1635. They also served peanut butter and jelly sandwiches, chili with baked beans, and pie.

1636. The McDonalds didn't allow women to work at their restaurant. They didn't want teenage boys loitering outside.

1637. Ray Kroc kept the no-women allowed policy until the mid to late 1960s. Even then, he stated that the female employees be flat-chested. They also couldn't work the grill since they didn't have the "stamina."

1638.

The McDonald's chain's first mascot was Speedee, a chef with a burger for a face.

1639. In the 1960s, a few McDonald's restaurants would wash your windshield while you waited for your drive-thru order.

1640. The world's first floating McDonald's opened on the banks of the Mississippi River in 1980. It closed 20 years later in 2000.

1641. The McBarge, which is officially named the *Friendship 500*, was a McDonald's built on a 187-foot-long barge for Expo '86 in Vancouver, British Columbia.

1642. The nation's oldest McDonald's is in Downey, California, and it has been open since 1953. Employees wear 1950s-style uniforms.

1643. In 1962, McDonald's experimented (and failed) with a "burger" that consisted of a grilled piece of pineapple with cheese. It was meant as a meatless alternative for Catholics during Lent. It was called the Hula burger.

1644. Ray Kroc, the man who took McDonald's global, didn't want McDonald's to sell hot dogs.

1645. In his 1977 memoir, Kroc stated, "There's damned good reason we should never have hot dogs. There's no telling what's inside a hot dog's skin, and our standard of quality just wouldn't permit that kind of item."

1646. McDonald's waited until a few years after Kroc's death to introduce the McHotDog. It didn't succeed.

1647. In Sweden, there's a McDonald's with a drive-thru window meant only for skiers. It's called McSki.

1648. In Italy, McDonald's sells the Sweet con Nutella, which has the shape and buns of a regular burger. Instead of a burger, though, the middle is filled with Nutella hazelnut and cocoa spread.

1649. In 2009, Hjötur Smárason purchased the last McDonald's burger and fries sold in Iceland before the franchise closed its doors for good.

1650. Instead of eating the burger and fries, Smárason gave them to the National Museum of Iceland. "I had heard something about McDonald's never decaying so I just wanted to find out for myself whether this was true or not," he said.

1651. Thirteen years later, burgers and fries are now on display in the lounge of a guesthouse, with neither showing much sign of decay.

1652. In Hong Kong, you can have McDonald's cater your wedding.

1653. In Germany, McDonald's sells a nurnburger, which is 3 bratwursts on a bun.

1654. In the Philippines, you can order McSpaghetti (pasta) with Chicken McNuggets on the side.

1655. In Singapore, you can order a McRice burger, which is a burger with rice-patty buns.

1656. Burger King was first known as Insta-Burger King.

1657. A copycat restaurant called MaDonalds opened in Kurdistan and sold Big Macks.

1658. When A&W tried to compete against McDonald's Quarter Pounder with their third-pound burger, they found that customers thought ¼ was bigger than ⅓.

1659. A chili pepper's spicy heat comes from the pith and ribs of the pepper and not from the seeds.

1660. If you look at the pith through a magnifying glass, you can see tiny blisters that are glands that make a stinging chemical called capsaicin.

1661. Capsaicin is odorless and tasteless, but one drop in 100,000 drops of water will make your tongue burn.

1662. In other words, "spicy" isn't a basic taste (sweet, salty, bitter, sour, and umami), but more of a pain response.

1663.

The top half of a chili pepper is hotter than the bottom half.

1664. Peppers grown in very warm climates tend to be spicier than the same peppers grown in colder climates.

1665. In 1912, a pharmacist named Wilbur L. Scoville came up with a chili pepper heat scale called the Scoville Heat Unit scale.

1666. According to Scoville's scale, if jalapeños rate a 10,000 on the Scoville scale, that meant a jalapeño solution would have to be diluted 10,000 times before the heat was neutralized.

1667. Today, scientists use high-performance liquid chromatography (HPLC) to determine the exact concentration of capsaicin in a pepper. We still call the heat units Scoville Heat Units (SHU).

1668. Pure capsaicin is 16,000,000 SHU.

1669. The Carolina reaper takes the prize at 2,200,000 SHU.

1670. A ghost pepper rates up to 1,041,427 SHU.

1671. A chipotle pepper is 8,000 SHU.

1672. A sweet green bell pepper rates a 0.

1673. Hot, spicy foods don't destroy your taste buds; they just numb them.

1674. Water doesn't help put out the spicy fire in your mouth. In fact, capsaicin is insoluble in water, which means the water simply spreads the spicy further around your mouth.

1675. Milk, sour cream, ice cream, and sugary drinks like juice or wine work better because sugar blocks capsaicin from attaching to your pain receptors.

1676. Scientists have found that spicy food can boost metabolism and perhaps lead to a longer life.

1677. Margherita pizza is named for Queen Margherita of Savoy.

1678. The edible ice-cream cone was introduced at the 1904 World's Fair in St. Louis, Missouri.

1679. Honey can last for thousands of years if sealed properly.

1680.

Honey has a low water content and high acidity, which helps with keeping honey from spoiling, as bacteria cannot thrive in these conditions.

1681. Grape-Nuts contains neither grapes nor nuts.

1682. The original breakfast cereal— called granola—was sold in blocks and needed to be chipped away by consumers and soaked in milk.

1683. Snoop Dogg holds the record for the largest paradise cocktail. It contained 180 1.75-liter bottles of gin, 156 1-liter bottles of apricot brandy, and 28 3.78-liter containers of orange juice.

1684. Which came first: hot dogs or hamburgers? There are lots of claims as to who invented what and when and where, but to the best of our knowledge, hamburgers were first invented around the 1880s to 1890s while hot dogs didn't come around until 10 to 20 years later.

1685. The term hot dog may have come from a cartoonist who was making fun of the cheap sausage-type food being sold at Coney Island, New York—saying they were made of dog meat.

1686. According to one legend, the hamburger originated in Hamburg, New York, when 2 vendors at a county fair ran out of sausages and cooked up some ground beef patties instead.

CHAPTER 9

HISTORY

1687. Genghis Khan grew up in the early 13th century in northern Mongolia. As a child, he was called Temujin.

1688. When his father was poisoned by an enemy tribe, Temujin built up his own tribe and conquered the one that killed his father.

1689. Then, he kept going, conquering one Mongol tribe after the other until he had united them.

1690. "Genghis Khan" means "ruler of all."

1691. From 1210 to 1215, Genghis Khan conquered the Xia and Jin dynasties in China.

1692. He also suppressed the Persian Empire of Khwarezmia from 1219 to 1221.

1693. Genghis Khan was the first to take advantage of a horse's strength during combat.

1694. He preferred to use female horses since his soldiers could also drink the horses' milk.

1695. Genghis Khan died in 1227. Some historians believe he died falling off his horse.

1696. In William Dean Howells's book, *My Mark Twain*, he recounts a conversation with Twain about history. Howells said, "I wonder why we hate the past so." Twain responded, "It's so damned humiliating."

1697. Charles III, king of France from 883 to 922, was known as Charles the Simple. His father was known as Louis the Stammerer. His cousin was Charles the Fat.

1698. Ethelred the Unready was the king of the English from 978 to 1016. He failed to prevent the Danes from overrunning England, even though he had years to prepare. Here, "unready" comes from the word "unraed," which meant "bad counsel."

1699.

Louis XV ruled France from 1715 to 1774. At first, he was known as the Well-Beloved after nearly dying in 1744.

1700. However, his ineffective rule, which was a contributing factor that led to the French Revolution, and penchant for young women (he had affairs with several women, including 5 sisters) led to his new nickname by the time of his death: Louis the Well-Hated.

1701. Charles D. B. King was president of the west African nation of Liberia, from 1920 until 1930. He was challenged in 1927 during one of his re-election bids by Thomas J. R. Faulkner.

1702. King beat him by 600,000 votes, which is curious since there were only 15,000 registered voters at the time.

1703. King made the *Guinness Book of Records* for the most fraudulent election reported in history.

1704. Varius Avitus Bassianus, also known as Heliogabalus, was Roman Emperor from 218 to 222 CE. He was only around 15 when he became Emperor, which can perhaps explain some of his indiscretions, including supposedly entering Rome as Emperor upon a chariot drawn by 50 naked slaves.

1705.

Bassianus is credited with inventing an early type of whoopee cushion. He would place inflated animal bladders under his guests' chair cushions at parties.

1706. Bassianus liked to get party guests so drunk that they'd pass out. He'd then move them to a room filled with toothless leopards, lions, and bears so his friends would have a surprise waiting for them when they awoke.

1707. He married and divorced 4 women during his short reign, yet he also had time for his chariot driver Hierocles, whom he called his husband.

1708. Heliogabalus was assassinated at the age of 18 and was erased from all public records. He is remembered today for his "unspeakably disgusting life."

1709. Nero Claudius Caesar Augustus Germanicus (37–68 CE) was a Roman Emperor from 54 to 68 who was known for his many tyrannical acts; however, he is probably best remembered for something he didn't do: sing and play his lyre while Rome burned.

1710. Nero was out of town at the time, but returned upon hearing the news and personally took part in search-and-rescue operations.

1711. Nero fancied himself an actor and singer. He gave public performances in which no one was allowed to leave until he was finished. The ancient historian Suetonius wrote that pregnant women who went into labor had to give birth during his recitals and men pretended to die so they could be carried out.

1712. Tokugawa Tsunayoshi (1646–1709) was the fifth shogun of the Tokugawa dynasty of Japan. He was known as a religious man and a very strict ruler. And he liked dogs.

1713. Born in the Year of the Dog, he felt canines should be treated well. In a series of edicts on "Compassion for Living Things," Tsunayoshi commanded his people to protect dogs at all costs. Under these edicts, if you injured, killed, or even ignored a dog, you could be put to death or be forced to commit suicide.

1714. At one point, 300 people were put to death in one month for failing to live up to the edicts, and anywhere from 60,000 to 200,000 people were killed or exiled during Tsunayoshi's reign for violations.

1715. Soon the city became so overrun with dogs that Tsunayoshi had 50,000 dogs sent out from the city to live in special kennels where they were fed rice and fish each day—all at taxpayers' expense.

1716. Roland was a medieval flautist who lived in 12th century England. A flautist is someone who makes a living farting.

1717. Each Christmas, Roland performed for King Henry II the song "Unum salute et siffleturn et unum bumbulum," which meant "one jump, one whistle, and one fart."

1718. For his efforts, Roland was awarded 30 acres and a house, which were then confiscated when the next King, Henry III, was ordained. He was not a fan.

1719. Soon after Peter I (the Great) of Russia married off his niece Anna to Friedrich Wilhelm, Duke of Couland, on October 31, 1710, and threw a 2-day banquet, he held another lavish wedding, this time for the royal dwarf Iakim Volkov and his dwarf bride.

1720. Peter rounded up all the dwarfs in Moscow to attend (up to 70). During the ceremony, the full-sized guests remained on the sidelines and laughed—especially since Peter made sure that elements of the wedding resembled his niece's recent nuptials.

1721. Anna Ivanovna, Peter the Great's niece, ruled Russia from 1730 until her death in 1740. Her court included a nobleman who was not only forced to be her fool, but also had to pretend to be a chicken . . . all the time.

1722. Anna Ivanovna ordered an ice palace built for a marriage that she arranged between a court jester and one of her elderly maids. The bride and groom had to dress as clowns, and then they had to sleep naked in the ice palace during a freezing cold Russian night.

1723.

Frederick II of Hehenstaufen was one of the most powerful Holy Roman Emperors of the Middle Ages. He was known as the "Wonder of the World" for his knowledge and curiosity.

1724. Frederick wanted to know whether people were born with a natural language. In other words, what language did Adam and Eve speak?

1725. Frederick supposedly ordered a number of infants raised without any adults talking to them at all. According to the 13th-century Italian monk Salimbene's *Chronicles*, he ordered, "foster-mothers and nurses to suckle and bathe and wash the children, but in no ways to prattle or speak with them."

1726. The experiment failed because, "The children could not live without clappings of the hands, and gestures, and gladness of countenance, and blandishments."

1727. As a religious skeptic, Frederick wanted to know if humans had a soul. So, he shut a prisoner up in a cask to see if the soul could be observed escaping a hole in the cask as the prisoner died.

1728. The insane king-in-name-only Otto of Bavaria supposedly started each day by shooting a peasant. His attendants, not wanting to upset him, made sure the pistol was loaded with blanks, and then they'd dress someone up like a peasant and have them drop dramatically to the ground after the shot.

1729. King Charles II, ruler of England in the 1600s, collected mummies of dead Egyptian pharaohs. He liked to cover himself in mummy dust, hoping it would make him as great as they were.

1730. Construction of the White House began on October 13, 1792. It was completed in 1800.

1731. Its architect was James Hoban who was from Ireland.

1732. White House records show that African American slaves built the White House.

1733. The original White House was burned in 1814 after US forces set fire to government buildings in Canada during the War of 1812. Only some exterior stone walls survived from the original building.

1734. James Hoban, the original architect, was hired to rebuild the White House.

1735. The White House is 55,000 square feet and on 18 acres of property.

1736. The White House has 147 windows, 412 doors, 132 rooms, 32 bathrooms, 28 fireplaces, 8 staircases, 6 levels, 3 elevators, and 3 kitchens.

1737. The "White House" has been the official name of the president's residence since Teddy Roosevelt's administration, in 1901.

1738. Names that were used included the Palace, The President's House, and the Executive House or Mansion. It was informally called the White House because it was painted white in 1798.

1739. Up until the late 1800s, the White House was open to the public. It was a way to prove that the White House belonged to the people.

1740. The White House didn't have indoor plumbing until 1833.

1741. On Christmas Eve in 1929, a fire gutted parts of the West Wing and Oval Office. President Hoover tried to help put the fire out, but the Secret Service removed him from the scene. The fire was caused by a blocked fireplace.

1742. President Harry Truman and his family were forced to vacate the White House in 1948 because the White House was close to collapsing. Engineers discovered that the home was structurally unsound.

1743. The Chief Usher of the White House is the head of the household and operations. He or she organizes all the social events, maintains the mansion, and supervises the staff.

1744. Irwin "Ike" Hood Hoover worked at the White House for more than 40 years (1891–1933). He began as an electrician and was Chief Usher for nearly 25 years.

1745. Hoover saw 10 First Families come and go during his years of service.

1746.

The US Marine Band is the oldest continuously active professional musical organization in the US.

1747. Founded in 1798 by an act of Congress, it first played in the White House at Thomas Jefferson's inauguration. It has played at every inauguration since.

1748. The White House's first bowling alley was a birthday gift for Harry Truman.

1749. President Franklin Roosevelt commissioned a 42-seat movie theater.

1750. The White House's first pool was installed inside the White House in 1935 for Franklin Roosevelt. The *New York Daily News* raised money to build the pool to help FDR with his polio.

1751. President Richard Nixon built a press room over the pool but left it intact so it could one day be restored. It's currently filled with computer servers.

1752. President Gerald Ford had an outdoor pool built.

1753. The term "First Lady" wasn't commonly used until around the mid-1800s.

1754. When a woman is voted president, her husband (if she has one) will be First Gentleman.

1755. Although he was known as the Butcher of Uganda for his brutal rule of the country during the 1970s, Idi Amin preferred to be known as His Excellency President for Life, Field Marshal Al Hadji Doctor Idi Amin, VC, DS. MC, Lord of all the Beasts of the Earth and Fishes of the Sea, and Conqueror of the British Empire in Africa in General and Uganda in Particular.

1756. During his reign, he had around 300,000 people tortured and/or killed.

1757. Amin was Uganda's light heavyweight boxing champion from 1951 until 1960.

1758. After receiving a message from God in a dream, Amin decided to make Uganda a "Black man's country." He expelled the up to 80,000 Indians and Pakistanis in the country.

1759. Amin once wrote to Britain's Queen Elizabeth, "Dear Liz, if you want to know a real man, come to Kampala."

1760. The US didn't end diplomatic relations with Amin until 1978—7 years into Amin's reign of terror.

1761. Lina Basquette was an American actress known for her 75-year career, which began in the silent film era, and her 9 marriages. She received a fan letter from Adolf Hitler in 1929 that proclaimed her his favorite movie star after seeing her performance in *The Godless Girl.*

1762. In 1937, Basquette met with Hitler and reported that he made a pass at her. Basquette recounted, "The man repelled me so much. He had terrible body odor; he was flatulent. But he had a sweet smile, and above all, he had these strange penetrating eyes."

1763. When Hitler got too close for her comfort, Basquette declared that she kicked him in the groin and then told him she was part Jewish.

1764. "Maybe if I hadn't been so fastidious, I could have changed history," Lina Basquette once remarked.

1765. During the 1500s, if you were accused of gossiping, the British used a scold's bridle or *branks*, which was a cage that locked around a woman's head. The cage also had a spiked plate that was inserted in the mouth to curb the tongue, literally.

1766. If that wasn't enough, the convicted gossiper was then sometimes led through the streets on a leash.

1767. During the Middle Ages, the Judas Cradle was a torture device that was simply a stool with a wooden pyramid on the top.

1768. In 17th-century France, the remains of executed murderers were considered good luck charms. After a hanging or burning at the stake, crowds swarmed over the remains.

1769. In 1911, the Suffragettes in the UK published a list of advice for women. The first item was, "Do not marry at all." The second was, "But if you must, avoid the Beauty Men, First, and the Bounders, Tailor's Dummies, and the Football Enthusiasts." Also, "Don't except too much, most men are lazy, selfish, thoughtless, lying, drunken, clumsy, heavy-footed, rough, unmanly brutes, and need taming."

1770. Three days before the Wall Street crash of 1929, Irving Fisher, a noted economist, stated that "stocks have reached what looks like a permanently high plateau."

1771. British Prime Minister Lord Frederick North, figured that when dealing with the rebellious American colonies in 1774, "Four or five frigates will do the business without any military force."

1772. Edmund X. DeJesus, editor of BYTE magazine thought that the Y2K crisis would be "without precedent in human history.

1773. "The automobile will never, of course, come into as common use as the bicycle," said the *Literary Digest* in 1899.

1774.

Silent movie director D. W. Griffith wrote in *Collier's* magazine in 1924 that, "We do not want now and never shall want the human voice with our films."

1775. Charles Darwin wrote in his *The Origin of Species* in 1869, "I see no good reason why the views given in this volume should shock the religious feelings of any one." He was being ironic.

1776. IBM Chairman Thomas Watson predicted in 1943 that "there is a world market for maybe five computers."

1777. *Time*, in a 1966 article looking ahead to the year 2000, wrote, "Remote shopping, while entirely feasible, will flop." Why? "Because women like to get out of the house."

1778. *Time* also predicted in the same articles that, "By 2000, the machines will be producing so much that everyone in the US will, in effect, be independently wealthy."

1779. In 1876, Sir William Preece of the British Post Office said, "The Americans have need of the telephone, but we do not. We have plenty of messenger boys."

1780. In 1903, the president of the Michigan Savings Bank once advised Horace Rackham, Henry Ford's lawyer, not to invest in the Ford Motor Company. He said, "The horse is here to stay but the automobile is only a novelty—a fad."

1781. This 1955 prediction from vacuum cleaner company president Alex Lewis proclaimed that, "Nuclear powered vacuum cleaners will probably be a reality within 10 years."

1782. In 1959, Arthur Summerfield, Postmaster General in the US, envisioned that "before man reaches the moon, your mail will be delivered within hours from New York to Australia by guided missiles. We stand on the threshold of rocket mail."

1783. "Displays no trace of imagination, good taste or ingenuity. I say it's a stinkeroo." —Film critic Russell Maloney on *The Wizard of Oz*, 1939

1784. "There are not enough Indians in the world to defeat the Seventh Cavalry." —General George Custer, 1876

1785. "If anything remains more or less unchanged, it will be the role of women." —David Riesman, social scientist, 1967

1786. In 1933, First Lady Eleanor Roosevelt left a formal dinner early with Amelia Earhart and enjoyed a plane ride from DC to Baltimore—each taking turns at the controls at one point.

1787. In 2007, a nurse named Barbara Hillary (1931–2019) became the first Black woman to reach the North Pole. She was 75 years old.

1788. Hillary reached the South Pole in 2011 at the age of 79, becoming the first Black woman to reach both poles.

1789. A Banyan tree in northwestern Pakistan was placed under arrest by a drunk British army officer in 1898.

1790. British officer James Squid even had the tree put in chains, which remain on the tree to this day to show the oppression of British rule.

1791. A sign on the tree reads: "I am under arrest. One evening a British officer heavily drunk thought that I was moving from my original location and ordered mess sergeant to arrest me; since then I am under arrest."

1792. The first Nobel Peace prize was awarded in 1901 to Jean Henry Dunant, the founder of the Swiss Red Cross.

1793.

St. Patrick didn't drive any snakes out of Ireland. Instead, he drove the pagans out of Ireland.

1794. In 200 BCE, there were 20 slaves for every citizen in the Greek city of Sparta.

1795. The total number of Americans killed during the Civil War is greater than the total of Americans killed in all other wars combined.

1796. Vlad Drakulya III, Prince of Wallachia (a region in what is now Southern Romania) ruled on and off from 1448 to 1476 and is considered a national hero of Romania.

1797. His name comes from his father, Vlad Dracul, or Vlad the Dragon.

1798. In modern Romanian, "dracul" means "the devil."

1799. Vlad III was also known as Vlad the Impaler since impalement was his favorite method of execution.

1800. Vlad would attach each of his victim's legs to a horse, place a sharpened stake you know where, and . . . you can figure out the rest.

1801. One story of Vlad's cruelty contends that when Turkish messengers refused to take off their turbans, Vlad nailed the turbans to their heads with spikes.

1802. After ruling Wallachia for a mere 2 months in 1448, Vlad was overthrown. He returned in 1456, killing the man who had taken his place.

1803. One of his first steps was to enslave the boyars (local aristocracy) who had opposed him and force them to rebuild his castle. The ones who didn't die from exhaustion were killed.

1804. For his fight against crime, he devised some simple deterrents. If you were caught stealing, you had the skin of your feet removed, and then your feet were sprinkled with salt. Goats licked the salt off.

1805. One story reports that Vlad was so confident that his punishments worked that he placed a golden cup in the central square of Tirgoviste . . . where it remained untouched for years. Other stories report that Vlad also enjoyed burning or boiling people and cutting off limbs.

1806. He would impale thousands of people at a time and arrange the stakes in geometric patterns around one his cities. One of the most famous woodcuts of Vlad shows him feasting with dozens of impaled victims in the background.

1807. Vlad's name, if not his deeds, inspired the name of Bram Stoker's vampire, Count Dracula.

1808. In the 13th century, a young shepherd claimed to have been visited by Jesus, who told him to go on a Crusade to liberate the Holy Land. Thousands of French children followed him to the docks where French merchants agreed to take them all to Jerusalem. The merchants then sold all the children into slavery.

1809. Sure, Paul Revere played a part in the American Revolution. But why is he the one (and only one) remembered for the midnight ride when it was actually up to 40 different messengers raising the alarm about the Redcoats coming?

1810. On the night of April 18, 1775, he and another man, William Dawes, were told to ride from Boston to Lexington to warn John Hancock and Samuel Adams that British troops were heading out to arrest them and then capture weapons stored in Concord.

1811. Both Revere and Dawes made it to Lexington, warning patriots along the way, although Revere did not yell, "the British are coming!"

1812. On the way to Concord, Revere was captured by the British. Dawes and Samuel Prescott (who joined them on the ride) both escaped, but only Prescott made it to Concord in time to alert the militia.

1813. Revere didn't become the hero of the midnight ride until nearly 40 years after his death. In fact, his obituary didn't even mention it.

1814. When Henry Wadsworth Longfellow wrote the poem, "Paul Revere's Ride" in 1861, everything changed: Listen, my children, and you shall hear / Of the midnight ride of Paul Revere, / On the eighteenth of April, in Seventy-Five; / Hardly a man is now alive / Who remembers that famous day and year.

1815. Longfellow's poem was treated as history for nearly 100 years. It appeared in textbooks and historians referred to it. Unfortunately, Longfellow made a lot of it up.

1816. Using his poetic license, he got the lantern signals mixed up; sent Revere all the way to Concord, even though he never made it that far; and perhaps worst of all, he neglected to mention any of the other heroes from that night. So, basically, he used Revere's name because it rhymed better than Dawes's or Prescott's.

1817.

Napoleon was not as short as history suggests. Yes, he was listed at 5'2", but that is using the old French foot, which was longer than the English foot. He was actually 5'6" tall—a perfectly respectable height for the 18th and 19th centuries.

1818. The "Pledge of Allegiance" was written by Francis Bellamy, a Baptist minister and devout socialist.

1819. The poem appeared in a popular children's magazine in 1892 as a way to sell flags to public schools and boost the magazine's circulation.

1820. The original hand instructions for the pledge called for the right hand to be removed from the heart at the mention of the word "flag" and extended outward toward the flag. This ended during World War II because it looked too much like a Nazi salute.

1821. In 1794, General Jean-Charles Pichegru, a French general, led his forces in an invasion of the Netherlands. Upon entering Amsterdam, his scouts learned that the Dutch fleet was stationed nearby. However, it was frozen in the bay. Pichegru dispatched a cavalry brigade, which marched onto the ice and surrounded the entire fleet.

1822. The song "Yankee Doodle Dandy" was written by a British surgeon during the French and Indian War to ridicule the colonial militiamen who were fighting alongside British soldiers.

1823. As the American Revolution drew near, the song became a popular insult the British soldiers used— often making up new verses that mocked the colonists.

1824. On April 19, 1775, as British troops marched toward Lexington and Concord, Redcoats played the song on fife and drum and sang it heartily. However, as rebels battled with the British, eventually turning them back, the Redcoats were surprised to hear the colonists singing "Yankee Doodle." One British soldier later said, "Damn them, they made us dance it till we were tired."

1825. From that moment on, the colonists sang the song in battle, taking delight in the self-mockery. They even played it while the British surrendered at Saratoga and Yorktown. Lieutenant Thomas Anburey wrote: ". . . the name [Yankee] has been more prevalent since the commencement of hostilities . . . The soldiers at Boston used it as a term of reproach, but after the affair at Bunker's Hill, the Americans gloried in it. Yankee Doodle is now their paean, a favorite of favorites, played in their army, esteemed as warlike as the Grenadier's March—it is the lover's spell, the nurse's lullaby . . . it was not a little mortifying to hear them play this tune, when their army marched down to our surrender."

1826.

The term "yankee" may have come from the Dutch word "jahnke," which was used to describe an uncultured person.

1827. The word "doodle" referred to uneducated farmers and backwoodsmen—hicks.

1828. "Macaroni" referred to certain young foppish British men and women who at the time wore outlandish clothing and spoke Italian in an affected way to show that they were cultured. They were called "Macaronies."

1829. During the First Liberian War in the 1992, General Joshua Milton Blahyi would lead his troops wearing only his shoes. He says the devil telephoned him at age 11 and told him that running into battle naked would make him impervious to bullets. Sometimes he and his soldiers would also don colorful wigs and dainty purses.

1830. In 1889, Tit-Bits, a British magazine offered prizes to single female readers who sent in the best answers to the question, "Why Am I a Spinster?"

1831. Miss Emaline Lawrence of St. John's Wood replied, "Because men, like 3-cornered tarts, are deceitful. They are very pleasing to the eye, but on closer acquaintanceship prove hollow and stale, consisting chiefly of puff, with a minimum of sweetness, and an unconquerable propensity to disagree with one."

1832. Miss Sparrow of Paddington, wrote, "Because I do not care to enlarge my menagerie of pets, and I find the animal man less docile than a dog, less affectionate than a cat, and less amusing than a monkey."

1833. Miss Lizzie Moore of Upper Tooting wrote, "My reason for being a spinster is answered in a quotation from the Taming of the Shrew: 'Of all the men alive I never yet beheld that special face which I could fancy more than any other.'"

1834. Miss Sarah Kennerly of Lancashire responded, "Like the wild mustang of the prairie that roams unfettered, tossing his head in utter disdain at the approach of the lasso which, if once round his neck, proclaims him captive, so I find it more delightful to tread on the verge of freedom and captivity, than to allow the snarer to cast around me the matrimonial lasso."

1835. Miss Florence Watts of Fulham wrote, "Because I have other professions open to me in which the hours are shorter, the work more agreeable, and the pay possibly better."

1836. Miss A. Wood of Stepney, wrote, "Because after carefully studying the following advertisement I could not conscientiously apply for 'an angel's' place!"

1837. The ad read, "Wanted, a wife who can handle a broom, / To brush down the cobwebs and sweep up the room. / To make decent bread that a fellow can eat, / Not the horrible compound you often meet. / Who know how to broil, and to fry, and to roast, / Make a good cup of tea, and a plate of toast. / A wife who washes, cooks, irons, and stiches, / and sews up rips in a fellow's old britches; / And makes her own garments, an item that grows / Quite highly expensive, as everyone knows. / a common-sense creature, and still with a mind / To teach and to guide, exalted, refined, / A sort of angel and housewife combined."

1838. In England, before the Married Women's Property Act of 1870, married women were not allowed to keep their earnings. If she worked, her husband would receive her paycheck.

1839. The native ancient laws of Ireland are Brehon Law. This body of law operated in Ireland until the early 17th century English conquest.

1840. These laws were named after the Bretons, who were a class of lawyers in ancient Ireland who also served as jurists.

1841. These laws were first written on parchment in the 7th century.

1842.

"Brehon" is the Irish word for "judge."

1843. By the time of Elizabeth I, the Brehon laws were considered to be old, lewd, and unreasonable. They were banned and English common law was introduced.

1844. The 1603 Proclamation by King James I ended the time of Brehon Law. This proclamation extended the King's protection to the Irish people. After this, Ireland was administered by English law.

1845. The Great Pyramids of Giza are located on a plateau on the west bank of the Nile on the outskirts of modern-day Cairo.

1846. The oldest and largest is the Great Pyramid and is the only surviving structure of the famed Seven Wonders of the Ancient World.

1847.

The Great Pyramid was built for Pharaoh Khufu who reigned from 2589 to 2566 BCE.

1848. The sides of the pyramid's base average 755.75 feet.

1849. Its original height was 481.4 feet, making it the largest pyramid in the world.

1850. Approximately 2.3 million blocks of stone (averaging about 2.5 tons each) were cut and transported for the Great Pyramid.

1851. Archeological evidence suggests that it took around 20,000 laborers to build the Great Pyramid.

1852. The middle pyramid at Giza was built for Khufu's son Pharaoh Khafre (2558 to 2532 B.C).

1853. The Pyramid of Khafre is the second tallest pyramid in Giza.

1854. A unique feature built inside Khafre's pyramid complex was the Great Sphinx, a guardian statue carved in limestone with the head of a man and the body of a lion.

1855. It was the largest statue in the ancient world, measuring 240 feet long and 66 feet high.

1856. The southernmost pyramid at Giza was built for Khafre's son Menkaure (2532 to 2503 B.C.). It is the shortest of the 3 pyramids (218 feet).

1857. Excavations from the area show that native Egyptian agricultural laborers worked on the pyramids. The popular theory that slaves built the pyramids is wrong.

1858. By the time of Ramses II, the most famous king of Egypt (1250 BCE), the pyramids were already 1,300 years old, and a large part of them were buried under the sand.

1859. For Cleopatra, the pyramids were 2,500 years old.

1860. The oldest known sentence ever written was found engraved on an ivory comb. The Canaanites script appears on a double-edged comb from approximately 1700 BCE.

1861. The sentence on the comb reads, "May this tusk root out the lice of the hair and the beard."

1862. Analysis of the markings confirmed the writing to be Canaanite script, the earliest alphabet, which was invented about 3,800 years ago.

1863. The shortest war in history lasted 44 minutes and occurred on August 27, 1896.

1864. Known as the Anglo-Zanzibar War, it was caused by the death of the pro-British Sultan Hamad bin Thuwaini and the succession of Sultan Khalid bin Barghash. The British were not in favor of succession, and bombarded the palace until the flag at the palace was shot down.

1865.

When flour and feed manufacturers in the Great Depression realized families were using leftover sacks to make clothing, they redesigned their sacks with various patterns so families could have fashionable clothing.

1866. It is estimated that up to 3.5 million women and children wore clothing made from sacks.

1867. Some of the sacks even came with instructions on how to wash away the company logo as well as instructions for sewing techniques.

1868. Americans have invaded Canada twice, in 1775 and 1812. They lost both times.

1869. The first Christmas Tree at Rockefeller Center appeared on Christmas Eve in 1931.

1870. Workers at the Rockefeller Center construction site pooled their money to buy a 20-foot balsam fir that they decorated with handmade garland and strings of cranberries.

1871. Two years later, a 50-foot tree was put up, which started the tradition.

1872. The tree is usually a Norway spruce and up to 100 feet tall.

1873. After a tree is taken down, it is milled into 2-by-4s and 2-by-6 and donated to Habitat for Humanity.

1874. In 2020, a female northern saw-whet owl was found in the branches of a tree that had been transported from Oneonta, New York. It was released on the grounds of a wildlife center in Saugerties, New York.

1875. The epic reign of Ancient Rome took place between the founding of Rome in the 8th century BCE and the fall of the Western Empire in the 5th century CE.

1876. At its height, Rome ruled over more than 45 million people.

1877. The Roman Empire covered parts of Europe, Asia, and Africa.

1878. Three periods make up the history of the Roman Empire. First is the Period of Kings between 753 and 510 BCE.

1879. Seven kings ruled Rome during this time. The first is Romulus, and the last is Tarquinius Supurbus.

1880. The Period of Kings ended when a group of Roman Senators led a revolt and banished King Tarquinius and his family from Rome, and then abolished the Roman monarchy.

1881. The second period is the Republican Period between 510–31 BCE.

1882.

The Roman Republic is one of the first examples of representative democracy.

1883. The Law of the Twelve Tables was created in 451 and 450 BCE. Inscribed on 12 bronze tablets, these were a set of laws based on the morals and values of Ancient Rome.

1884. These laws served as the basis for all following Roman Law, and for the laws of many societies that followed Rome. Many American laws today are based on the Twelve Tables.

1885. The Roman Republic functioned for over 300 years without political violence.

1886. In 133 BCE, Roman Tribune Tiberius Gracchus initiated an agrarian reform that led to his Senate adversaries rioting against him and clubbing he & his followers to death.

1887. This violence initiated the downfall of the Roman Republic. In the years following Gracchus's murder, disputes among political factions took over the government.

1888. The final period of the Roman Empire is Imperial Rome, from 31 BCE to Rome's fall in the 5th century.

1889. The Roman Empire was divided into East and West in 286 CE.

1890. The eastern Roman Empire, known as the Byzantine Empire, survived until the 15th century.

1891. Emperor Caligula's real name was Gaius Caesar Augustus Germanicus.

1892. Caligula was a childhood nickname given by his father's soldiers because of the tiny soldier outfit the young boy wore when he accompanied his father.

1893. Caligula means "little boot."

1894. Caligula ruled the Roman Empire from 37 CE to 41 CE.

1895. Caligula once commanded merchant ships to create a 3-mile floating bridge over the Bay of Naples.

1896. Adorned in a golden cape he rode back and forth over the bridge of ships astride his horse Incitatus for many days.

1897. According to ancient historians, Caligula lavished gifts on his horse, Incitatus, including a marble stable and oats with flakes of gold.

1898. Caligula would host lavish parties at Incitatus' grand stables, in which the horse was called "the host."

1899. Although it is a widely held story, Caligula did NOT name Incitatus a Roman Senator. He spoke of his plan to do so but was murdered before he made it happen.

1900. All of this "horsing around" by Caligula is seen today as attempts at humor and mockery.

1901. Caligula had hundreds of ships tied together to make a nearly 3-mile temporary floating bridge so he could ride across the Bay of Naples on horseback, which he did for 2 straight days. Why? Supposedly as a child, a seer said he had no more chance of becoming emperor than of crossing the bay on horseback.

1902. He declared war on Poseidon, god of the ocean, and brought back chests full of worthless seashells as booty.

1903. After 4 years of brutal rule, Caligula was assassinated by the Praetorian Guard, who stabbed him over 30 times.

1904. Caligula's wife and infant daughter were also murdered.

1905. Caligula used spectators as lion bait when the games he was throwing ran out of criminals.

1906. His uncle, Claudius, succeeded him.

1907. In ancient Rome, a runaway slave was considered a criminal because he had stolen himself.

1908. Roman women enjoyed when their husbands went to war against Germany because the naturally blond hair of Germans captured in battle would be used to make wigs.

1909.

In early Rome, a father could legally execute any member of his household.

1910. It has been estimated that about 500,000 people and over 1,000,000 wild animals died in the Roman Colosseum.

1911. One popular event at the Colosseum was the ship battle. The Colosseum would be flooded and great reenactments featuring miniature warships were held.

1912. The Roman Colosseum was completed in 85 CE.

1913. It was named for the Colossus statue of Nero that once stood nearby.

1914. At 98 feet tall and cast in bronze, the Colossus was most likely destroyed during the sack of Rome and scavenged.

1915. All that remains are some concrete blocks that made up the foundation of its pedestal.

1916. The Roman Colosseum was partially destroyed during an earthquake in 847.

1917. Parts of the Colosseum have actually been disassembled and used in other buildings. The great marble facade that used to grace the outside of the Colosseum has been carried away and used to construct St. Peter's Basilica.

1918. The Colosseum could seat 50,000 people.

1919.

President Harry Truman signed into law the Presidential Succession Act of 1947, which placed the Speaker of the House second in line for the presidency after the vice president if the president dies or is removed from office.

1920. If the VP and then the Speaker aren't available, the line of succession follows thusly: President Pro Tempore of the Senate, Secretary of State, Secretary of the Treasury, Secretary of Defense, Attorney General, Secretary of the Interior, Secretary of Agriculture, Secretary of Commerce, Secretary of Labor, Secretary of Health and Human Services, Secretary of Housing and Urban Development, Secretary of Transportation, Secretary of Energy, Secretary of Education, Secretary of Veterans Affairs, and Secretary of Homeland Security.

1921. These presidents owned slaves: George Washington, Thomas Jefferson, James Madison, James Monroe, John Tyler, William Henry Harrison, Andrew Jackson, James Polk, Zachary Taylor, and Martin Van Buren.

1922. Richard III, King of England from 1483 to 1485, was not a hunchback.

1923. Paintings of him were touched up after his death to make it look like he was.

1924. He also didn't murder his brother, his son, or his wife. He can thank Tudor slander and William Shakespeare for turning him into a villain.

1925. In 1943, during World War II, the Allies were planning to invade Sicily but wanted the Germans to think they were, instead, planning to invade Sardinia and Greece. The British decided to find a dead body, give it a Royal Marine's uniform, and a briefcase full of top-secret documents chained to his wrist, and then threw it from a submarine off the coast of Spain.

1926. The body washed ashore, the briefcase was opened (they found money, love letters, and a cryptic letter outlining an invasion of either Sardinia or Greece), and the Germans bought it. They pulled thousands of troops from Sicily to defend Sardinia and Greece, and the British parachuted into Sicily.

1927. In North Africa in August 1942, the British placed a corpse in a blown-up scout car with a map showing the locations of non-existent British minefields. The Germans found the map, and routed their Panzers to a new location where they got bogged down in sand.

1928. Henry Kissinger and Yassir Arafat both won the Nobel Peace Prize. Gandhi didn't.

1929. On June 28, 1914, Archduke Franz Ferdinand and his wife were in a motorcade in Sarajevo, Bosnia and Herzegovina, where tensions were high and Ferdinand wasn't very popular. At one point, a bomb was thrown at his open-topped car. It bounced off and detonated behind them.

1930. Ferdinand shouted, "So, this is how you welcome your guests—with bombs!" Later, while attempting to visit aids injured in the blast earlier in the day, Ferdinand's driver made a wrong turn and began backing up right near one of the conspirators, Gavrilo Princip, a 19-year-old Slavic Nationalist. While the car slowly backed up not 5 feet away, and with a second chance just fallen into his lap, Princip drew his pistol and shot the Archduke and his wife . . . all which led to World War I.

1931. The Archduke was such a perfectionist about the cut and fit of his military uniform that he had a 1-piece garment sewed onto him each day. So, when doctors attempted to examine his wounds after he was shot, they realized the buttons didn't work, and by the time they figured out they had to cut the uniform off, the Archduke was dead.

1932. The 19th Amendment to the US Constitution gave women the right to vote in 1920.

1933. The Amendment needed 36 of the 48 states to ratify the Amendment, and it was one vote shy.

1934. Harry Burn, a Republican from Tennessee, was firmly in the antisuffragist camp until receiving a letter from his mother.

1935. It said, "Hurrah and vote for Suffrage and don't keep them in doubt . . . I've been watching to see how you stood but have not seen anything yet . . . Don't forget to be a good boy and help Mrs. 'Thomas Catt' (suffrage leader) with her 'Rats.' Is she the one that put rat in ratification, Ha! No more from mama this time."

1936. Burns changed his vote, and had written in the record, "I knew that a mother's advice is always safest for a boy to follow, and my mother wanted me to vote for ratification."

1937. On July 4, 1776, the Continental Congress, meeting in the Pennsylvania State House in Philadelphia, approved the Declaration of Independence.

1938. Ben Franklin did not add to an early version of the document, "kiss our collective arse."

1939. The Declaration not only severed ties to the British Crown and set in motion the American Revolution, but it was also meant as more as a press release for the colonists since the Lee Resolution (a.k.a. the Resolution of Independence), which was passed on July 2, 1776, declared the United Colonies to be independent of the British.

1940.
John Adams thought July 2 would be the day future Americans celebrated.

1941. He wrote to his wife: "The second day of July 1776, will be the most memorable epoch in the history of America. I am apt to believe that it will be celebrated by succeeding generations as the great anniversary festival. . . . It ought to be celebrated with pomp and parade, with shows, games, sports, guns, bells, bonfires, and illuminations. . . ."

1942. Most historians say the Declaration was signed on August 2, 1776, and not on July 4th, even though Thomas Jefferson, Ben Franklin, and John Adams all wrote that it was signed on July 4th.

1943. In 1796, one of the signers disputed this by pointing out that some of the signers weren't even in Philadelphia on July 4th—including some who weren't even elected to Congress at that time.

1944. The most famous version of the Declaration is a hand-written copy that's signed by all the delegates.

1945. It's generally regarded as the official document, and it's the one on display at the National Archives in Washington DC. It's important to note that this wasn't the original document.

1946. Thomas Jefferson loved telling people that the final vote on the Declaration was approved quickly because a swarm of flies from a nearby stable invaded the session, forcing a quick vote.

1947. Other stories state Jefferson actually complained about the flies at the Graff House, where he wrote the Declaration.

1948. The Dunlap broadsides were the first published copies of the Declaration.

1949. They were printed on July 4, 1776, and around 200 were printed.

1950. Only 26 are known to survive.

1951. In 1989, a flea-market bargain hunter found one inside a framed painting he bought for $4.00.

1952. It was sold for more than $8 million.

1953. The original handwritten Declaration (signed by John Hancock as president of the Continental Congress) was used by the printer to set type to print copies. It hasn't been seen since.

1954. On the back of the Declaration, it says, "Original Declaration of Independence, dated 4th July 1776." Nobody knows who wrote it.

1955. Henry Brown, a slave in Virginia, with the help of Samuel Smith, a White shopkeeper sympathetic to his cause, mailed his way to freedom.

1956. Brown paid $86 to have himself shipped to Philadelphia abolitionist James Miller McKim.

1957. On March 23, 1849, Brown had himself packed into a 3' x 2' x 2.6' box along with a bottle of water.

1958. He was loaded onto a wagon, and then a train . . . a steamboat . . . another wagon . . . another train . . . and finally, the delivery wagon, which dropped him off at McKim's residence approximately 27 hours later.

1959. Brown went on to have a successful career as a speaker for the Anti-Slavery Society and was given the not-so-clever nickname "Box" at a Boston antislavery convention in 1849.

1960. Outrage over his and other slaves' escape stories led to the Fugitive Slave Act of 1850, which declared that all runaway slaves must be brought back to their owners.

1961. This forced Brown to move to England, where he toured an antislavery panorama he called "Mirror of Slavery" for 10 years.

1962. He returned to the US after the Civil War (in 1875) with a family magic act.

1963. In 1914, 4-year-old May Pierstorff of Grangeville, Idaho, was to visit her grandmother in Lewiston. Her parents, figuring it was cheaper to mail her than put her on a train, pinned 53 cents to the young girl's coat (they were charged the chicken rate—it was legal to mail chickens back then) and handed her to the mailman.

1964. May traveled the entire distance in the train's mail compartment and was delivered safely to her grandmother by the mail clerk on duty.

1965. It took another 6 years after this for mailing your kid to be declared illegal.

1966.

As a lawyer, Francis Scott Key successfully prosecuted Richard Lawrence, the first man to ever try to assassinate a US president.

1967. Francis Scott Key and author F. Scott Fitzgerald were distant cousins.

1968. The Black Death reduced the population of Europe by one third in the period from 1347 to 1351.

1969. Fourteenth-century doctors didn't know what caused the plague, but they knew it was contagious. Doctors wore protective suits that included a large-beaked headpiece.

1970. The beak of the headpiece, which made them look like birds, was filled with vinegar, oils, and other strong-smelling herbs to keep away the bad smells of the victims, which doctors believed caused the disease.

1971. The Hundred Year War actually lasted for 116 years, from 1337 to 1453.

1972. The Great Fire of London started on September 2, 1666, and ended 4 days later. It began at a bakery.

1973. The fire swept through central London and destroyed 13,200 houses and 87 churches, including St. Paul's Cathedral, which had to be demolished.

1974. There were only 6 recorded deaths from the fire.

1975. A 2003 *New York Times* article by Chris Hedges defined war as "an active conflict that has claimed more than 1,000 lives."

1976. The article then claimed, "Of the past 3,400 years, humans have been entirely at peace for 268 of them, or just 8 percent of recorded history."

1977. Other stats from the article include: At least 108 million people were killed in wars in the twentieth century.

1978. Estimates for the total number killed in wars throughout all of human history range from 150 million to 1 billion.

1979.

The reduced birthrate during World War II is estimated to have caused a population deficit of more than 20 million people.

1980. In 2001, due to its economic collapse, Argentina had 5 presidents in just 10 days.

1981. At the height of prohibition in the 1920s, literary critic Edmund Wilson published a list of terms for drunkenness that he arranged "in order of the degrees of intensity of the conditions which they represent." The list includes terms such as "lit," "squiffy," "oiled," "piffed," "half-cooked," "fried," "hooted," "pickled," "lit up like a church," and more.

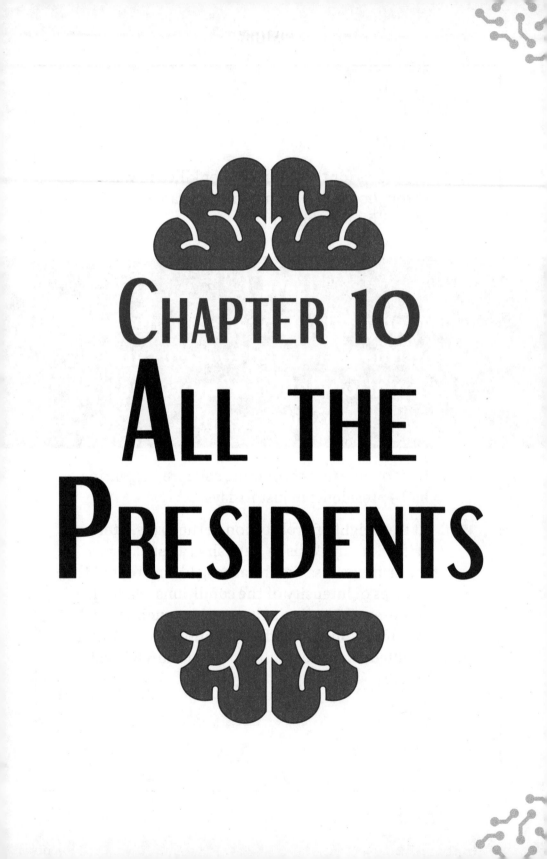

CHAPTER 10
ALL THE
PRESIDENTS

1982. George Washington (served 1789–1797) helped choose the design and location of the White House, but he passed away before it was finished.

1983. Washington had several pairs of fake teeth made out of springs and animal tusks, whale bones, and antlers . . . but not wood. Disturbingly, other people's teeth were also used, including those of slaves.

1984. Another myth about Washington was that he cut down a cherry tree and then refused to lie about it. This story was invented by Mason L. Weems. Weems was writing a biography of Washington in the early 1800s and didn't have a lot of information about Washington's childhood. So, he made up some stories.

1985. There are more than 30 cities, towns, and villages named after Washington in the US . . . as well as the nation's capital.

1986. During the battle of Germantown in 1777, during the Revolutionary War, Washington found a dog that belonged to the British general he was fighting against, General Howe. Soldiers wanted to keep the dog, but Washington sent it back, telling his troops that the dog was not their enemy.

1987. Alexander Hamilton, then Washington's aide, wrote the following note with the dog: "General Washington's compliments to General Howe, does himself the pleasure to return him a Dog, which accidentally fell into his hands, and by the inscription on the Collar appears to belong to General Howe." General Howe called this "an honorable act."

1988. Washington opened a whiskey distillery at his Mount Vernon home in 1797. At the time of his death in 1799, it was producing nearly 11,000 gallons a year. The distillery is still in operation, although it only produces a limited number of bottles.

1989.

Washington inherited his first slaves at the age of 11.

1990. At the time of his death, he had 123 slaves along with another 153 that were from Martha Washington's first husband's estate.

1991. Although Washington promised in his will to free all of his slaves, only one of them gained freedom right away. One of the reasons was that he also stipulated that they remain with his wife, Martha, until the end of her life.

1992. Erica Armstrong Dunbar's book *Never Caught: The Washingtons' Relentless Pursuit of Their Runaway Slave, Ona Judge*, tells the true story of Washington's attempts to force an escaped slave to return.

1993. John Adams (served 1797–1801) and his wife moved into the White House in 1800, even though only 6 of the 20 rooms were finished.

1994. Adams's wife, Abigail, hung laundry in the unfinished East Room.

1995. The population of the nation's capital at this time was 8,000.

1996. Abigail Adams called Washington "the dirtyest hole I ever saw."

1997. Adams served as Washington's vice president and called the role, the "most insignificant office that ever the invention of man contrived." He wasn't wrong.

1998. Although George Washington was against political parties, John Adams was the first president to belong to one: the Federalists. His rival and vice president, Thomas Jefferson, belonged to the Democratic-Republicans.

1999. Adams signed the Aliens and Sedition Acts, which allowed the president to deport any foreigner he thought dangerous to the country and made it a crime to publish "false, scandalous, and malicious writing" against the government.

2000. George Washington, Thomas Jefferson, and John Adams were all avid collectors and players of marbles.

2001. Adams died on July 4, 1826, which was the 50th anniversary of the signing of the Declaration of Independence. He died the same day as his friend and rival Thomas Jefferson.

2002. If you think dirty campaigning is a relatively recent phenomenon, Thomas Jefferson (served 1801–1809) vs. John Adams became one of the most contentious elections in US history. Adams's Federalists charged that Jefferson cheated his creditors, robbed a widow of her pension, and was a coward during the American Revolution.

2003. The Federalists also spread rumors that Jefferson would burn all the Bibles, make marriage illegal, and force all women to become prostitutes.

2004. Meanwhile Jefferson's camp spread the rumor that Adams was going to marry one of his sons off to King George III's daughters and turn the US into a dynasty and declare himself King John I.

2005.

Jefferson's daughter, Martha, gave birth to the first baby in the White House in 1806. He was named James Madison Randolph.

2006. Jefferson once received as a gift 2 grizzly bear cubs. They lived in a cage on the White House lawn until they grew too big for the cage. Jefferson would walk them on a leash.

2007. Jefferson doubled the size of the nation with his $15 million Louisiana Purchase.

2008. Thomas Jefferson once introduced a compromise bill in Congress that would have barred slavery in all future states admitted to the Union. It could have prevented the Civil War, but it was defeated by a single vote.

2009. Jefferson was the first president to propose the idea of a formal Native American removal plan. According to historian Richard Morris, Jefferson "detested intellectual women." (Abigail Adams, not included.)

2010. While officially against slavery and the slave trade, he not only kept slaves but most likely fathered children with 1 of them.

2011. Jefferson fathered at least 6 of Sally Heming's children, with 4 surviving into adulthood. This is based on DNA test results.

2012. Jefferson freed Heming's children—2 in 1822, and the other 2 after his death in 1826.

2013. Jefferson's accomplishments during his lifetime include writing the Declaration of Independence; designing the Virginia State Capitol and Monticello (his home); founding the US Military Academy at West Point and the University of Virginia; completing the Louisiana Purchase; serving as President, Vice President (under John Adams), Secretary of State (under Washington), and Governor of Virginia; and inventing the dumbwaiter, swivel chairs, and the folding ladder.

2014. James Madison (served 1809–1817) was only 5 feet 4 inches tall and weighed only around 100 pounds.

2015. Known as the Father of the Constitution, Madison represented Virginia at the Constitutional Convention of 1787, where he and the other delegates created the US government.

2016. He was the youngest delegate at only 29 years old.

2017. He also, along with Alexander Hamilton and John Jay, wrote the anonymous articles that became known as the Federalist Papers. These convinced states to ratify the new constitution. Madison drafted and helped secure passage of the Bill of Rights.

2018. As president, he got his new country into its first war . . . with England. The War of 1812 lasted until 1815, and his most embarrassing moment was when the British burned the White House to the ground.

2019. Madison borrowed a pair of dueling pistols and attempted to rally troops during a battle against British forces. Upon almost running into British troops and hearing rockets overhead, he told his secretaries that accompanied him that it "would be proper to withdraw to a position in the rear."

2020. One of Madison's slaves, Paul Jennings, wrote the first memoir of life in the White House. *A Colored Man's Reminiscences of James Madison* includes a firsthand account of the evacuation of the White House during the War of 1812, and Dolley Madison's rescue of George Washington's portrait.

2021.

James Monroe (served 1817–1825) was the last of the Founding Father presidents.

2022. Monroe served under George Washington during the Revolutionary War and was wounded during the Battle of Trenton. Shrapnel from the injury couldn't be removed from his shoulder.

2023. Monroe studied law with Thomas Jefferson.

2024. One of his nicknames was "the Last Cocked Hat," because he continued to dress in the old-fashioned style that hadn't been "in" since the Revolutionary War.

2025. The Monroe Doctrine, which warned European nations that the US would not tolerate further colonization in the Americas, wouldn't be named after Monroe until 1850.

2026. The first White House wedding took place in 1820, when Monroe's daughter, Maria, married one of his secretaries, Samuel Lawrence Gouverneur. Maria was only 16, and her husband was her first cousin.

2027. In the 1820 presidential election, James Monroe received every Electoral College vote except for one. A New Hampshire delegate voted for someone else because he wanted George Washington to be the only president ever elected with 100 percent of the Electoral College vote.

2028. John Quincy Adams (served 1825–1829) was the eldest son of President John Adams. Before becoming president, he was one of America's greatest diplomats and was responsible for formulating the Monroe Doctrine.

2029. Adams ran against 4 others for president in 1824. With no clear majority, the election was sent to the House of Representatives, where he was elected on the first ballot. Andrew Jackson had, however, received the popular vote.

2030. Adams's adult son lived at the White House after getting expelled from college for "rioting."

2031. John Quincy Adams received an alligator as a gift from France. It lived in the East Room bathroom for a few months before being returned.

2032. Adams liked to swim in the Potomac River in the mornings—without any clothes on. There are a few reports of his clothes not being on the riverbank when he got out.

2033. After Adams lost reelection, he won a seat in the House of Representatives and focused his attention on abolishing slavery.

2034. When Andrew Jackson (served 1829–1837) became president, he invited the public to his inauguration party held at the White House.

2035. Thousands of citizens showed up and proceeded to storm the White House to see the "People's President." They broke dishes and ripped curtains for souvenirs. Servants lured people out of the White House with tubs of alcohol.

2036. This earned Jackson the nickname of "King Mob."

2037. Before becoming president, Jackson had been in at least 7 duels. One duel left him with a bullet lodged in his chest. He killed that man after he was shot.

2038. As a teenager, he and his brother Robert were captured by the British during the Revolutionary War.

2039. During his captivity, he received sword wounds on his hand and head for refusing to shine a soldier's boots.

2040. Jackson was the first president who lived outside of Massachusetts or Virginia.

2041. He was the first president to veto a bill.

2042. On January 30, 1835, Richard Lawrence, an unemployed house painter, attempted to assassinate Jackson. When both of his guns misfired, Jackson snared him and beat Lawrence with his cane. Jackson was 67 years old.

2043. When his opponents for president in 1828 started calling him a jackass, Jackson began using images of the strong-willed donkey in his campaign posters. Years later, cartoonist Thomas Nast used the Democratic donkey in newspaper cartoons, which made the symbol famous.

2044. Jackson signed and implemented the Indian Removal Act of 1830. This gave him the power to make treaties with tribes, most of which made the tribes move west of the Mississippi River.

2045. Around the same time, he supported the state of Georgia, which had seized 9 million acres from the Cherokee tribe. Jackson made a deal in which the Cherokees would leave their land for territory west of Arkansas.

2046. This resulted in the Trail of Tears, as 15,000 Cherokee Indians were forced from their land, with 4,000 dying of starvation and illness.

2047. Jackson never had children of his own, but he adopted 3 sons, including a pair of Native American orphans.

2048. His death in 1845 at the age of 78 was attributed to lead poisoning caused by the 2 bullets he had in his chest.

2049. At Jackson's funeral, his African Grey parrot had to be removed from his funeral because it wouldn't stop swearing.

2050. Martin Van Buren (served 1837–1841) was the first president born a US citizen since he was born after the Revolutionary War.

2051. As a child, he worked in his father's tavern, which served lawyers and politicians such as Alexander Hamilton and Aaron Burr.

2052. William Henry Harrison (served 1841) gave the longest acceptance speech ever. It lasted 1 hour and 40 minutes, and he didn't wear a coat or hat, even though it was cold and raining.

2053. Subsequently, Harrison became the first president to die while in office, 32 days after his inauguration.

2054. Although many think he caught pneumonia because of his refusal to wear a coat, researchers now believe he died from enteric fever, caused by drinking contaminated drinking water.

2055. John Tyler's (served 1841–1845) nickname was "His Accidency" since he was the first vice president elevated to the office because of the president's death.

2056. Tyler's wife died in the White House in 1842. They had 8 children together.

2057. Two years later, Tyler married a woman 30 years younger than he was. She was also 6 years younger than Tyler's oldest daughter. They had 7 children, making Tyler the president with the most children ever.

2058. In 1861, Tyler voted in favor of Virginia seceding from the US, and he was elected to the Confederate House of Representatives. He died before being able to serve.

2059. President Abraham Lincoln did not publicly acknowledge Tyler's death as he was seen as a traitor.

2060. When James Polk (served 1845–1849) became president, his wife, Sarah, banned hard liquor and dancing from the White House.

2061. Invoking Manifest Destiny, the idea that the US is destined by God to expand its dominion across the whole continent, Polk won his election with the slogan "54° 40' or fight." This was a reference to the northern boundary of Oregon, which he claimed for the US in his inaugural address.

2062. This spirit of Manifest Destiny led to war with Mexico, which added 525,000 square miles to US territory, including all or parts of California, Wyoming, Utah, Nevada, New Mexico, Colorado, and Arizona.

2063. This rapid expansion led to further dislocation and brutal mistreatment of Native Americans. Historians also state that the question of whether these new states would be allowed slavery sparked the country's spiral toward the Civil War.

2064. Historians point to Zachary Taylor (served 1849–1850) as the first of the "weak" presidents leading up to the Civil War, partly because he died suddenly while in office, and also because of his passivity in the face of the question of slavery.

2065.

President Zachary Taylor let his horse Old Whitey roam the White House lawn. For good luck, tourists would pull a strand or 2 from the horse's tail . . . until it had none left.

2066. Taylor got sick while attending a ceremony at the unfinished Washington Monument on July 4, 1850. His sudden death on the 9th led many to believe he was poisoned.

2067. His body was exhumed in 1991, and this theory was disproven.

2068. His treatment by doctors could have led to his untimely demise as they gave him a mercury compound called calomel and induced bleeding and blisters, which was customary at the time.

2069. President Millard Fillmore (served 1850–1853) established the first permanent library at the White House.

2070.

Fillmore was the last president to be neither a Democrat nor Republican. He belonged to the Whig party.

2071. During his lifetime, and afterwards, Fillmore is rated as one of the worst presidents.

2072. The *American History Review* said that he had "neither brains nor gall."

2073. In 1988, a Yale professor wrote in *American Heritage* magazine said that "even to discuss Chester Arthur or Millard Fillmore is to overrate them."

2074. Even the White House's official website could find little to recommend: "Millard Fillmore demonstrated that through methodical industry and some competence an uninspiring man could make the American dream come true." Ouch.

2075. Franklin Pierce (served 1853–1857), a northern Democrat, believed that the growing abolitionist movement was a threat to unity.

2076. During the election in 1852, his Whig opponents called him the "Hero of Many a Well-Fought Bottle," in reference to his alcoholism.

2077. Pierce tried to buy Cuba from Spain, and suggested aggressive action if they didn't.

2078. Pierce was arrested in office for running over an old lady with his horse. The case was dropped due to insufficient evidence.

2079. Pierce's campaign slogan when running for president was, "We Polked you in 1844; we shall Pierce you in 1852."

2080. Pierce was considered a traitor during the Civil War.

2081. James Buchanan (served 1857–1861) was the only president who never married, leading to speculation that he was our first gay president. No proof has been found to prove or disprove this.

2082. Buchanan's ineptitude and pro-slavery doctrines split the Democratic Party and led to the formation of the abolitionist Republican Party. With the 2 sections of the Democratic Party both nominating a candidate for the 1860 race, the Republican's nomination, Abraham Lincoln, won the election, even though his name didn't appear on any ballots in the South.

2083. During Buchanan's inaugural speech, he described the territorial slavery issue as "happily, a matter of but little practical importance."

2084. Abraham Lincoln (served 1861–1865) was the first president born outside of the original 13 colonies.

2085. Lincoln only had 12 to 18 months of formal education.

2086. Before becoming president, he had lost the election for Illinois General Assembly. He also lost 1 race for Congress, 2 for Senate, and 1 campaign for the nomination for vice president.

2087. Lincoln thought women should be allowed to vote as early as 1836.

2088. He won the election with only 40 percent of the vote.

2089. Illinois is known as the land of Lincoln, but he was born in Kentucky and grew up in Indiana. He didn't move to Illinois until he was 21.

2090. Lincoln is in the National Wrestling Hall of Fame. He was an accomplished wrestler as a young man and was defeated only 1 time in 300 matches.

2091. Lincoln let his 2 younger sons keep several pets in the White House, including 2 goats named Nanny and Nanko. They had a habit of chewing up the furniture.

2092. During the Civil War, President Lincoln was annoyed at general George McClellan's hesitancy to engage the enemy. Lincoln wrote to him, "If you don't want to use the army, I should like to borrow it for a while."

2093. President Lincoln was the first president to be photographed at his inauguration. The photo was taken at his second inauguration in 1865. In the photo, John Wilkes Booth, the man who would assassinate him, can be seen standing close to Lincoln.

2094.

In 1862, with the Civil War waging, Lincoln's 2 young sons, Tad and Willie, both got typhoid fever. Willie died.

2095. Typhoid fever is caused by contaminated drinking water, and soldiers were using the river the White House got its water from as a toilet.

2096. At 6'5" inches tall, Lincoln is the tallest president to date.

2097. Lincoln never slept in the Lincoln Bedroom in the White House. He did sign the Emancipation Proclamation there, though.

2098. A few hours before his death, Lincoln signed legislation that created the Secret Service.

2099. The mission of the agency was to combat counterfeiting. It wasn't assigned to protect presidents until 1901.

2100. In 1863 or 1864, Lincoln's older son, Robert Todd Lincoln, fell while boarding a train that had started moving. A firm hand grasped his coat collar and pulled him to safety. That firm hand belonged to actor Edwin Booth, John Wilkes Booth's brother.

2101. Robert Lincoln was in Washington DC when his father was shot. (He had declined an invitation to see a performance of *Our American Cousin*, where his father was shot.) He was present when Lincoln died. He was also at the scene when President Garfield was shot in 1881. He said to a *New York Times* reporter, "How many hours of sorry I have passed in this town."

2102. Robert Lincoln's train was pulling into Buffalo, New York, in 1901 when President McKinley was shot. Lincoln visited and thought the President was going to survive.

2103. Andrew Johnson (served 1865–1869) and his brother were indentured servants to a tailor. After 2 years, they both ran away.

2104. During the Civil War, Johnson was the only southern senator to remain loyal to the Union.

2105. The conspiracy to assassinate Abraham Lincoln originally also included killing Johnson. His assassin backed out of the plan.

2106.

The US bought Alaska from Russia for $7.2 million during Johnson's administration.

2107. Johnson was the first president impeached by the House of Representatives. He survived by one vote.

2108. Before becoming a Civil War general and national hero, Ulysses S. Grant (served 1869–1877) was an average student at West Point, a failed farmer, store clerk, rent collector, and realtor. He was a failed president too.

2109. The S. in his name doesn't stand for anything, but having the initials US isn't a bad thing for a politician.

2110. Rutherford B. Hayes (served 1877–1881) was the first president to use a telephone in the White House. It was connected to the Treasury Department. The telephone number was 1.

2111. He was 1 of 7 presidents to serve in the Civil War, but he was the only one to be wounded in action.

2112. In fact, Hayes was injured several times, including once when he was hit by a musket ball and assumed to be dead.

2113. Hayes's election to the presidency was rife with intrigue and back-room dealing. He ended up with a 185 to 184 advantage in the Electoral College and was elected with 250,000 fewer popular votes than his rival.

2114. Rutherford B. Hayes's wife, Lucy, began the beloved tradition of the Easter Egg Roll at the White House.

2115. James Garfield (served 1881) appointed 4 black men to his administration, including activist Frederick Douglass.

2116.
Garfield was the first of many left-handed presidents.

2117. The left-handed presidents are Garfield, Herbert Hoover, Harry Truman, Gerald Ford, Ronald Reagan, Bill Clinton, George H.W. Bush, and Barack Obama.

2118. Garfield was shot at a train station in Washington DC. Doctors first thought he would survive the bullet in his abdomen. However, as was customary, doctors didn't wash their hands before sticking their fingers in his gunshot wound. He died 80 days after being shot.

2119. Chester Arthur's (served 1881–1885) nickname was "Elegant Arthur" because he owned more than 80 pairs of pants.

2120. Arthur ended the spoils system in DC when he signed the Pendleton Act in 1883, which required government jobs to be given based on merit. The Act also forbade federal workers from being fired for political reasons.

2121. Arthur sold 24 wagonloads of furniture and other items from the White House in order to pay for all new furnishings. Among the items there were a pair of Abraham Lincoln's pants and a hat belonging to John Quincy Adams.

2122. Grover Cleveland (served 1885–1889 and 1893–1897) served 2 non-consecutive terms.

2123. Cleveland was the only president to get married in the White House. He married Frances Folsom on June 2, 1886, in the Blue Room.

2124. His daughter, Ether, was the only child of a president born in the White House.

2125. When running for president, opponents came up with the line "Ma, Ma, Where's My Pa? Gone to the White House, ha, ha, ha!" when news that he had fathered a child out of wedlock was leaked.

2126. Instead of lying, Cleveland admitted what happened, and his honesty actually helped him win the election.

2127. Benjamin Harrison's (served 1889–1893) grandfather was President William Henry Harrison.

2128. Harrison's father was a US Congressman, and his great-grandfather signed the Declaration of Independence.

2129. Electric lights were installed during Harrison's time as president. He thought the lights were dangerous and never touched a light switch.

2130. Harrison was the first president to attend a baseball game. He watched the Cincinnati Reds beat the Washington Senators 7–4 on June 6, 1892.

2131. One of his nicknames was "the human iceberg" because he was so formal and stiff.

2132. Harrison was the first president to have his voice recorded. A 36-second speech of his was recorded on a wax phonograph cylinder in 1889.

2133. Harrison's loss in the election of 1892 marked the first (and only) time an incumbent president was defeated by a former president.

2134. William McKinley (served 1897–1901) was the first president to ride in a car.

2135. President William McKinley's wife, Ida, hated the color yellow and banned it from the White House. She even ordered gardeners to pull up all the yellow flowers.

2136. McKinley was shot by an anarchist, 6 months into his presidency, while greeting the public.

2137. McKinley was shot right after giving his lucky red carnation to a 12-year-old girl. A few minutes later, another person in line shot him. He wore red carnations in his lapel and kept a bouquet of them on his desk in the Oval Office.

2138. Theodore Roosevelt (served 1901–1909) was often sick and weak as a child but overcame this through serious exercise and sport.

2139. There is a photograph of the young Roosevelt in a window watching the Abraham Lincoln funeral procession in New York City. The photo surfaced in the 1950s.

2140.

Roosevelt's first wife and mother both died on the same day on Valentine's Day in 1884. His wife had given birth just 2 days prior.

2141. During the Spanish-American War in 1898, Roosevelt created the Rough Riders, a collection of cowboys, football players, police officers, and Native Americans, who became famous for their church near San Juan Hill in Cuba.

2142. He is the youngest president in US history—becoming president at the age of 42.

2143. During a hunting trip in Mississippi in 1902, 1 of Roosevelt's assistants tied a bear to a tree and suggested Roosevelt shoot it. He considered it unsportsmanlike and refused. (He had someone else shoot it.)

2144. The story morphed into one in which Roosevelt saved a bear cub, and soon after, stuffed bears were being sold as teddy bears, with Roosevelt's permission.

2145. President Teddy Roosevelt's teenage daughter, Alice, kept a green garter snake named Emily Spinach around her neck and up her sleeve. She liked to surprise guests with it.

2146. The Roosevelts kept at least 40 pets in the White House, including a one-legged rooster.

2147. Roosevelt would invite former professional boxers to the White House to spar. He stopped in 1908, when a punch left him nearly blind in 1 eye.

2148. Roosevelt created the US Forest Service and established 150 national forests and 5 national parks.

2149. In 1905, he became the first president to win the Nobel Peace Prize when he helped Russia and Japan end their war against each other.

2150. Roosevelt was the first sitting president to leave the country when he went to personally inspect the building of the Panama Canal in 1906.

2151. Roosevelt was a proponent of eugenics, the pseudoscience of improving the genetic composition of the population of the world. In other words, he believed in improving the gene pool through forced sterilization, abortions, and more. He said, "Society has no business to permit degenerates to reproduce."

2152.

In 1912, while challenging his successor President Taft for their party's nomination for president, he was shot in Milwaukee, Wisconsin, just before giving a speech.

2153. The bullet lodged in his chest after passing through a jacket pocket that held his steel eyeglass case and a copy of his long speech that had been folded in half.

2154. Roosevelt gave his 90-minute speech before going to the hospital. He began his speech by saying, "I don't know whether you fully understand that I have just been shot; but it takes more than that to kill a Bull Moose. But fortunately, I had my manuscript, so you see I was going to make a long speech, and there is a bullet—there is where the bullet went through—and it probably saved me from it going into my heart. The bullet is in me now, so that I cannot make a very long speech, but I will try my best."

2155.

William Howard Taft (served 1901–1913) is the only president who also was Chief Justice on the Supreme Court, or in other words, he's the only person to ever hold a position in both the executive and judicial branches of the US.

2156. Taft much preferred law over politics and said being Chief Justice was his greatest honor. "I don't remember that I ever was President," he said.

2157. Taft was the first president to throw out the first pitch at a baseball game to start the season. Every president, except for Jimmy Carter, has opened at least one season with a first pitch.

2158. Wilson won his first election when Taft and Roosevelt split the Republican vote, giving the victory to Wilson, a Democrat.

2159. Wilson won reelection with the slogan, "He kept us out of the war."

2160. Woodrow Wilson (served 1913–1921) is known, however, as the president who brought our country into World War I. However, he really didn't want to do it. He tried hard to stay out of the conflict, but once Germany started threatening the US, Wilson believed he had no other choice. Wilson kept sheep on the White House lawn to trim the grass.

2161. Wilson's wife Edith continued her husband's administration after he suffered a debilitating stroke. She lied to Congress and said Wilson was only suffering from "temporary exhaustion," and then set it up so that all memos and correspondences from the president's cabinet went through her. This went on until the end of Wilson's presidency.

2162. Warren G. Harding (served 1921–1923) once gambled away a set of china that had been in the White House for over 30 years.

2163. Harding was also particularly fond of his Airedale Laddie Boy. Laddie had his own servant and sat in his own chair during Cabinet meetings.

2164. Calvin Coolidge (served 1923–1929) is the only president born on the Fourth of July.

2165. Coolidge was called "Silent Cal," as he was taciturn to a fault. When asked what she thought of Coolidge, Teddy Roosevelt's daughter Alice replied, "Coolidge! Oh, he's all right. The only trouble with Coolidge is that he was weaned on a pickle."

2166. Alice claims she heard the phrase from her dentist and employed it.

2167.

Coolidge was gifted an electric horse, the brainchild of John Harvey Kellogg, inventor of corn flakes. Coolidge rode it 3 times a day as a form of exercise. His doctor even said, "It is great for the liver and fine for reducing flesh."

2168. The horse was kept a secret until the White House had to send out for an electrician to fix it when it short-circuited and threw Coolidge from the saddle.

2169. The horse resides in the Calvin Coolidge Presidential Library and Museum.

2170. Coolidge was the first president to officially visit an American Indian reservation.

2171. When Coolidge received a raccoon for a Thanksgiving dinner, instead of eating it, he kept it as a pet. Rebecca the Raccoon ran around the hallways of the White House, stealing money and ripping curtains and clothing.

2172. Coolidge liked playing pranks on the Secret Service agents sworn to protect him. One trick he played was to ring for the agents and then hide under his desk, hoping they'd think he had been kidnapped.

2173. President Calvin Coolidge, the perfect model of the do-nothing president (he believed a free society should run itself), liked to take naps in the middle of the workday. He'd even change into his pajamas for his afternoon siestas. After he woke up, he liked to ask his aides, "Is the country still here?"

2174. How unpopular was President Herbert Hoover (served 1929–1933)? His granddaughter, Peggy, lost a good friend whose mother wouldn't let her play with her anymore because "the Depression was [his] fault."

2175. Hoover was the first president born west of the Mississippi River.

2176. While running for president, Hoover promised every American a chicken in every pot and a car in every garage.

2177. Hoover signed a bill in 1931 that made "The Star-Spangled Banner" America's national anthem.

2178. Both Hoover and his wife, Lou, spoke Chinese (Lou could speak 8 languages), and they would speak Chinese in the White House when they needed a private conversation with people around.

2179. While not up to the challenge of the Great Depression, Hoover was nominated for a Nobel Peace Prize 5 times for his humanitarian work. He saved 10 million lives from starvation during World War I, and later, during World War II, he was tasked with coordinating efforts to stop global starvation.

2180.

The shantytown camps that arose as the Great Depression sent the country spiraling were known as Hoovervilles.

2181. In 1933, Franklin D. Roosevelt (served 1933–1945) became the first president to hire a woman when he hired Frances Perkins to be secretary of labor.

2182. FDR was elected to 4 terms as president—the most of any other president. It was an unwritten rule that presidents only serve 2 terms—based on George Washington's belief that 8 years was enough.

2183. FDR died less than 3 months into his fourth term.

2184. The 22nd amendment was ratified in 1951, declaring that "no person shall be elected . . . president more than twice."

2185. Each of FDR's elections were electoral landslides. In 1932, it was 472–59 against Hoover. In 1936, it was 532 to 8 against Alf Landon. In 1940, it was 449 to 82 against Wendell Wilkie. In 1944, it was 432 to 99 against Thomas Dewey.

2186. FDR had been mostly paralyzed from the waist down since 1921, but the public never knew the extent of his disability, mostly because the media didn't mention it often, and images of the President that appeared in newspapers and magazines showed him standing at a podium (with the help of leg braces) or sitting.

2187. FDR cheated on his wife, Eleanor, with Lucy Mercer, whom Eleanor had hired as her social secretary in 1914.

2188. Harry S. Truman (served 1945–1953), much like Ulysses S. Grant, had a middle initial that didn't stand for anything.

2189. Truman didn't know about the atomic bomb until minutes after being sworn in as president. FDR kept him in the dark on this and most war matters.

2190. Four months later, Truman gave the order to drop atomic bombs on Hiroshima and Nagasaki. He later told his sister that he "made the only decision I ever knew how to make."

2191. Truman raised the minimum wage from $0.40 to $0.75.

2192. *Golf Digest* reported that Dwight D. Eisenhower (served 1953–1961) managed to squeeze in more than 800 rounds of golf during his 8 years as president.

2193.

Even though Eisenhower spent 35 years in the military and served during both world wars, he never saw any combat.

2194. At West Point, Eisenhower played football against the legendary Jim Thorpe. Eisenhower injured his knee and that ended his sporting career.

2195. As Supreme Commander of the Allied Expeditionary Force in Europe, and 5-star General of the army, Eisenhower believed Japan was about to surrender and hence, opposed the use of the atomic bombs. Truman ignored him.

2196. Both the Democrats and Republicans asked Eisenhower to run for president for their party.

2197. Although presented as the embodiment of good health, John F. Kennedy (served 1961–1963) suffered from many medical issues. As a child he spent time in the hospital with ulcers, scarlet fever, whooping cough, and colitis. He had crippling back pain throughout his life and also had Addison's disease, which causes fatigue, joint pain, depression, confusion, and more.

2198. Kennedy's health was so bad that he had received the sacramental last rites of the church on 3 separate occasions before becoming president.

2199. Kennedy had to use his family's connections and influence to get admitted to the Navy during World War II. He couldn't pass the physical.

2200. Kennedy is the only president to have received a Purple Heart.

2201. As a war correspondent for *Hearst* magazines, Kennedy toured Germany and wrote in his diary that Hitler, "had in him the stuff of which legends are made" and that "Hitler will emerge from the hatred that surrounds him now as one of the most significant figures who ever lived."

2202. Kennedy's Pulitzer-Prize-winning book, *Profiles in Courage*, had a ghostwriter. Ted Sorenson admitted in 2008 that he "did a first draft of most chapters . . . "[and] helped choose the words of many of its sentences."

2203. Kennedy was the first Roman Catholic president.

2204. Kennedy had several alleged extra-marital affairs. Some of the women included Judith Exner, who supposedly served as a conduit between JFK and mobster Sam Giancana; Marilyn Monroe, whose "instability" caused problems; Mary Pinchot Meyer, whose handwritten love letter from JFK surfaced in an online auction and who was mysteriously murdered in 1964; Mimi Alford, then a 19-year-old intern; actresses Anita Ekberg and Marlene Dietrich; Ellen Rometsch, an East-German call girl; and more.

2205. Lyndon B. Johnson (served 1963–1969) owned an Amphicar, a car that could float and turn into a boat. He liked to trick friends who came to his ranch by taking them for a ride and then pretending the brakes didn't work as they headed for a lake.

2206. Johnson's opponent for the 1964 run for president was Republican Barry Goldwater, whose campaign slogan was "In Your Heart, You Know He's Right." Johnson's campaign replied with, "In Your Guts, You Know He's Nuts."

2207. Johnson made sure everyone in his family had the same initials. His wife was already Claudia "Lady Bird" Johnson. They named their daughters Lynda Bird and Luci Baines. Their dog was Little Beagle Johnson.

2208. Johnson's 1948 primary victory for US Senate was rigged. He won by 87 votes out of 988,295 cast, and these among many others were cast fraudulently. For this, he earned the nickname "Landslide Lyndon."

2209.

The Kennedys didn't like Johnson and called him and his wife "Uncle Cornpone and his Little Pork Chop."

2210. Only 4 people have ever been a congressperson, senate majority leader, vice president, and president: John Tyler, Andrew Johnson, Lyndon Johnson, and Richard Nixon.

2211. Richard Nixon (served 1969–1974) is the only president to resign from office.

2212. Richard Nixon's brother Don dreamed of starting a fast-food chain called Nixonburgers. He accordingly accepted and never repaid a $200,000 loan from Howard Hughes.

2213. Nixon visited China in 1972, the first president to visit a nation not recognized by the US government. (Taiwan was recognized as the legitimate government of mainland China at the time.)

2214. Nixon successfully achieved voluntary desegregation of schools in 7 Southern states.

2215. Nixon radically reoriented the Federal Native American policy, becoming the first President to encourage tribal self-determination.

2216. Nixon abolished voter discriminatory tests by extending the Voting Rights Act in 1970.

2217. Nixon was also the first president to visit the Soviet Union.

2218. Nixon established the Environmental Protection Agency.

2219. Nixon's daughter Julie married David Eisenhower, President Eisenhower's grandson.

2220. A photograph of Nixon meeting Elvis Presley at the White House in 1970 is the most requested image in the National Archives.

2221. Nixon was the first president to visit all 50 states. Presidents George H. W. Bush, Clinton, and Obama all did it too after him.

2222. Richard Nixon was deathly afraid of hospitals. In 1974, he initially refused to go to a hospital to get treatment for a blood clot. He said at the time, "If I go into the hospital, I'll never come out alive."

2223. Gerald Ford (served 1974–1977) was never elected vice president or president yet served as both.

2224. Ford was House minority leader in 1973, when Vice President Spiro Agnew resigned over tax evasion and money-laundering charges, and was nominated to take Agnew's spot. Less than a year later, President Richard Nixon resigned, and Ford assumed the presidency.

2225.
Ford was a football standout at the University of Michigan and could have played professionally.

2226. Ford got himself locked out of the White House once when he took his dog for a walk.

2227. Ford's daughter, Susan, had her senior prom at the White House.

2228. Ford had 2 assassination attempts against him and they were both by women.

2229. Lyndon Johnson once commented that Ford "played too much football without a helmet."

2230. Jimmy Carter (served 1977–1981) was considered the first "bubba" president ("bubba" is a term used to refer to uneducated Southern men); however, not only did he study nuclear physics in college, but he could read 2,000 words a minute.

2231. In 1969, while governor of Georgia, Carter claims that he and several other men were standing outside the Lion's Club in Leary, Georgia, when they saw a strange red and green orb in the sky.

2232. This was part of his speech at the 1976 Southern Governors Conference while campaigning for president: "I don't laugh at people anymore when they say they've seen UFOs. It was the darndest thing I've ever seen. It was big, it was very bright, it changed colors, and it was about the size of the moon. We watched it for 10 minutes, but none of us could figure out what it was. One thing's for sure: I'll never make fun of people who say they've seen unidentified objects in the sky. If I become president, I'll make every piece of information this country has about UFO sightings available to the public and the scientists."

2233. During Jimmy Carter's presidency, his younger brother, Billy, cashed in by endorsing Billy Beer, the first (and only) beer named after a president's family member.

2234. Billy was also caught urinating on an airport runway in full view of the press and foreign dignitaries.

2235. In what became known as Billygate, Billy accepted money from the Libyan government in return for his influence with his brother. He was eventually registered as a foreign agent of the Libyan government.

2236. Jimmy Carter, in an interview in *Playboy*, admitted to having "committed adultery in my heart" and that he "looked on a lot of women with lust."

2237.

Jimmy Carter's daughter, Amy, had a unique name for her Siamese cat: Misty Marlarky Ying Yang.

2238. Ronald Reagan's (served 1981–1989) love for jellybeans (his favorite was licorice) was well-known. He started this habit in 1966 in order to try and give up pipe smoking. As governor of California and president, he received a monthly shipment from the Herman Glitz Candy Company.

2239. More than 3 tons of red, white, and blue Jelly Belly jellybeans were delivered for Reagan's 1981 inauguration.

2240. The actor-turned-politician's last movie role was in 1964's *The Killers*. It was the only time he appeared as a villain, and it was the first made-for-TV movie, though it ended up being too violent for TV and ended up in theaters.

2241. On March 30, 1981, Reagan narrowly escaped becoming the fifth president to be assassinated. A bullet missed his heart by an inch, and as he arrived at the hospital, he told his wife, Nancy, "Honey, I forgot to duck."

2242. He then put his surgeons at ease by joking, "I hope you're all Republicans." One of the surgeons, who was a liberal Democrat, replied, "Today, we're all Republicans."

2243.

Reagan was the first president to talk about the world uniting against a threat from "a power from outer space."

2244. Reagan reported seeing UFOs 2 different times. Once, before he was governor of California, he saw a strange light in the sky while on his way to actor William Holden's home. Then again in 1974 while aboard the governor's private plane.

2245. In October 1982, while doing a sound check for his weekly radio address, he called the Polish government a "bunch of no-good lousy bums." The remarks were meant to be off the cuff (and off the record!), but they made it as part of the public record. Poland wasn't happy.

2246. In November 1982, he did it again, saying, "My fellow Americans. I've talked to you on a number of occasions about the economic problems and opportunities our nation faces. And I am prepared to tell you, it's a hell of a mess—we're not connected to the press room yet, are we?" Yes, he was.

2247. "My fellow Americans, I'm pleased to tell you today that I've signed legislation that will outlaw Russia forever. We begin bombing in five minutes." He said this in August 1984, before another radio address. The comment was leaked to the press, and the Soviet Far East Army was reportedly placed on alert until the Kremlin found out it was a joke. Reagan apologized by saying, "You get tired, sometimes, counting to 10 as a voice check and so forth."

2248. George H. W. Bush (served 1989–1993) banned broccoli aboard Air Force One in 1990. "I don't like broccoli," he said, when asked about it. "And I haven't liked it since I was a little kid and my mother made me eat it. And I'm president of the US, and I'm not going to eat any more broccoli."

2249. Bush actually served as president for 8 hours while President Reagan was in surgery after being shot.

2250. On January 8, 1992, Bush fainted after throwing up in Prime Minister of Japan Kiichi Miyazawa's lap. While still on the floor, he said to his personal physician, "Roll me under the table until the dinner's over."

2251. Bush celebrated his 90th birthday by skydiving.

2252. Bill Clinton (served 1993–2001) was considered the second "bubba" president after President Carter. Like Carter, Clinton was also extremely intelligent, and was a Rhodes scholar who studied at the University of Oxford—becoming the only president to become one.

2253. In 1963, 16-year-old Clinton met President Kennedy at the White House during a Boys Nation event, just 4 months before Kennedy's assassination. He decided then that he wanted to be president someday.

2254. During his time in office, women made up 44 percent of Clinton administration appointees.

2255. His Secretary of State, Madeline Albright, was the first woman to serve in this position.

2256. His Attorney General, Janet Reno, also was the first woman to serve in this position.

2257. During his first term, Republicans gained control of both the House of Representatives and Senate for the first time in 40 years. Many blamed his decision to place his wife, Hillary, in charge of a health-care task force that failed to lead to anything.

2258. Two months later, facing questions about possible conflicts of interest between her law firm and her then-governor husband, Clinton said, "You know, I suppose I could have stayed home and baked cookies and had teas, but what I decided to do was fulfill my profession." Clinton offered a cookie recipe as way of apology.

2259. Hillary Clinton was the first First Lady to ever be subpoenaed.

2260. She was also the first First Lady to run for public office, becoming New York's first female senator.

2261. While investigating a failed business deal the Clintons were part of while he was governor, independent prosecutor Kenneth Starr discovered that Bill Clinton might have had an inappropriate relationship with a White House intern.

2262. Accused of lying under oath and obstruction of justice, Clinton was impeached but like Andrew Johnson before him, he was acquitted.

2263.

George W. Bush (served 2001–2009) is the only president to have twins.

2264. During the 2000 election for president, it came down to Florida, with Bush winning the state by 537 votes. Democrats sued for a recount, but the US Supreme Court ruled in favor of halting it.

2265. Barack Obama (served 2009–2017) was the first African American president.

2266. He was the fourth president to receive the Nobel Peace Prize, but he and others believed the award to be a "call to action" rather than an award.

2267. Donald Trump (served 2017–2021) was the first president who had no prior government or military experience.

2268. Dwight Eisenhower had no political experience but was Supreme Commander of Allied Forces during WWII.

2269. Trump was the first president to have been divorced twice and married 3 times.

2270. Trump was the first president to be impeached twice while in office. He was acquitted both times.

2271. Trump was the first president in over 100 years to not have a pet in the White House.

2272. First Lady Melania Trump was the first non-native English speaker in this role and only the second born outside of the US (Louisa Adams, wife of John Quincy Adams, was born in London.)

2273. Melania Trump speaks Slovenian, English, French, German, and Serbian.

2274. Ronald Reagan is the only other US President to have been divorced.

2275. Trump was the first president in 152 years to not appear at the swearing in of his successor.

2276. In 2022, the *New York Post*, perhaps announcing they will no longer support former President Donald Trump, buried his announcement to run for the 2024 presidency on page 26 of the paper. The small headline at the bottom of the front page read, "Florida Man Makes Announcement."

2277. Joe Biden's (served 2021–) vice president, Kamala Harris, is the first African American, first Asian American, and first female vice president.

2278.

Biden had a stutter growing up, and said, "I can think of nothing else that has ever stripped me of my dignity as quickly and as profoundly and as thoroughly as when I stuttered in grade school."

2279. In his 2008 autobiography, Biden wrote that one of his teachers, a nun, called him, "Mr. Bu-bu-bu-Biden."

2280. Biden said he overcame his stutter by reciting Irish poems in front of a mirror.

2281. Biden is the oldest president in American history.

2282. Biden received more than 81 million votes during the presidential election of 2020, which is the highest received by any president.

CHAPTER 11
MUSIC

2283. In a 2016 study published by St. Andrews University in Scotland, scientists unveiled the formula that makes a song catchy. It doesn't matter if you love it or hate it—it's whether or not you can get it out of your head! The recipe is: Receptiveness + (predictability-surprise) + (melodic potency) + (rhythmic repetition x 1.5) = earworm.

2284. An earworm is a piece of music that's catchy and stays in your head after it is no longer being played.

2285.

The catchiest song according to the researchers is "We Will Rock You," from Queen's 1977 album, *News of the World.*

2286. Next on the list is Pharrell's "Happy," followed by Queen's "We Are the Champions" (which follows "We Will Rock You" on the same album), "I'm Gonna Be (500 Miles)" by the Proclaimers, "YMCA" by the Village People, Queen's "Bohemian Rhapsody," Europe's "The Final Countdown," Bon Jovi's "Living on the Prayer," "Jingle Bells" (any version), and finally, "Who Let the Dogs Out?" by Baha Men.

2287. However, researchers from The Museum of Science and Industry in England did an online test called Hooked on Music. It contained 1,000 samples from pop hits and asked participants to identify songs as quickly as possible. Most songs were recognized in about 5 seconds. "Wannabe" by the Spice Girls was recognized on average in 2.3 seconds, making this song the "catchiest" ever.

2288. Research by the American Psychological Association states that earworms usually have a fast-paced tempo and an easy-to-remember melody. This research indicated that "Bad Romance" by Lady Gaga was the most frequently named earworm by study participants.

2289. Some obsessive-compulsive traits, such as intrusive thoughts, can play a role in experiencing earworms.

2290. Researchers in the US found that the greater the airtime devoted to country music in 49 metropolitan areas, the higher the suicide rate.

2291. A 16-year-old high school student studying the effect of different types of music on mice, concluded that hard rock music "has a major negative effect."

2292. The first time the student tried his experiment, the mice listening to heavy metal music killed each other.

2293. Even plants hate rock and roll. In Dorothy Retallack's 1973 book, *The Sound of Music and Plants*, she recounts that plants that listened to jazz bent toward the radio.

2294. Plants that listened to country had no reaction.

2295. Plants liked classical and tabla music as well.

2296.

Plants that listened to hard rock grew very tall, but then died within 2 weeks.

2297. Research has shown that listening to music can reduce blood pressure, pain, and anxiety while improving sleep, mood, mental alertness, and memory.

2298. In order to see which parts of the brain "light up" when playing music, researchers at Johns Hopkins had dozens of jazz performers and rappers improvise music while lying down in an MRI machine.

2299. Scientists at the Royal College of Music found that men's performance in the game Operation deteriorated when they listened to the rock group AC/DC. Women, however, were not distracted by the music. The researchers said this is part of a wider investigation into how music affects doctors doing real operations.

2300. A Finnish researcher, studying reviews online, determined that the band Nickelback is hated mostly because they weren't "authentic" enough. "Overall, the descriptions imply that the songs are not genuine self-expression written willingly, but instead forced and made for commercial reasons," the researcher wrote.

2301. In a study called "Stairway to Hell: Life and Death in the Pop Music Industry," a University of Sydney professor found that musicians' lifespans are 20 years shorter than for the general population.

2302. Joe "King" Carrasco of Joe "King" Carrasco & the Crowns is believed to be the first musician to crowd surf in a music video. He did so in the 1981 video for the song "Party Weekend."

2303. Cornell scientists, in their physics paper called "Collective Motion of Moshers at Heavy Metal Concerts" discovered that concertgoers who mosh (in a mosh pit at the front of the stage) behave like molecules in a gas as they move and bump into each other at high speeds.

2304. Rod Stewart's New Year's Eve concert in 1993 on Copacabana Beach in Rio de Janeiro, Brazil, had the biggest crowd for a free concert ever. Approximately 4.2 million people attended.

2305. The first album recorded entirely in space was *Space Sessions: Songs for a Tin Can* by Canadian astronaut Chris Hadfield, who spent 144 days at the International Space Station.

2306. Released in 2015, this project went viral with Hadfield's cover of David Bowie's "Space Oddity."

2307. Barry Manilow's 1976 hit, "I Write the Songs," was not written by Barry Manilow.

2308. Captain & Tennille recorded the song in 1975. They didn't write it either.

2309. How about David Cassidy, when he recorded it? Nope.

2310. The song was written by Bruce Johnston, a songwriter who was also a member of the Beach Boys.

2311. Johnston stated that the "I" in the song is God.

2312. In 2013, Metallica became the first (and only) musical act to play a concert on all 7 continents.

2313. They did so by playing in front of 120 scientists in a transparent dome at Carlini Station in Antarctica. The show was dubbed "Freeze 'Em All."

2314.

The longest concert is set to last 639 years and will conclude in 2640. John Cage's "As Slow as Possible" is played by an automated organ and progresses so slowly that months pass between chord changes.

2315. The iconic song "Wild Thing" was written and composed in 1964 in less than a day by Chip Taylor.

2316. Chip Taylor is actor Jon Voight's brother and hence, Angelina Jolie's uncle.

2317. "Wild Thing" was originally recorded by a band called the Wild Ones.

2318.

The Troggs recorded "Wild Thing" in 10 minutes, and it hit #1 in the US and #2 in the UK in 1966.

2319. The song's publisher has issued 7,500 licenses for recordings.

2320. Performers from Hank Williams Jr. to Prince, to Jimi Hendrix to Kermit the Frog, have recorded versions of the song.

2321. The song features an ocarina solo.

2322. The ocarina is a type of submarine-shaped flute invented in Italy in 1853 by a 17-year-old Italian man named Giuseppe Donati.

2323. Donati made his first ocarinas out of clay, with 7 to 10 holes and a spout for a mouthpiece.

2324. Ocarina means "little goose."

2325. The ocarina is also known as a sweet potato pie in the US, and the bologna sausage in Italy.

2326. The most valuable instrument in the world is the MacDonald Stradivarius viola (1701), which was put up for auction in 2014 for a minimum bid of $45 million. It's still available if you want it.

2327. The "Lady Blunt" Stradivarius violin sold for $15.9 million in 2011. It was sold to raise money for the victims of the 2011 Tohoku earthquake and tsunami.

2328. The Duport Stradivarius cello (1711), which sold for $20 million in 2008, has a dent, which may have been made by Napoleon when he tried it out in 1812.

2329. Preserving valuable musical instruments such as Stradivarius's can actually cause the sound of the instruments to worsen over time. In order to maintain sound quality and volume, an instrument needs to be played regularly. The wooden bodies of instruments need to be "stimulated with regular and comprehensive vibrations" or the instrument will start to sound dull.

2330. John Lennon's Steinway Model Z piano sold for $2.37 million in 2000. The lucky buyer was popstar George Michael.

2331. Lennon purchased the "unremarkable" piano for 1,000 pounds in 1970, and it is known for its visible cigarette burns caused by Lennon leaving his smokes to smolder on it.

2332. Kurt Cobain's acoustic Martin D-18E became the most expensive guitar when it was sold at auction in 2020 for $6 million.

2333. Cobain's "Smells Like Teen Spirit" Fender Mustang sold in 2022 for $4.55 million, making it the most expensive electric guitar.

2334. The oldest musical instrument found is the 60,000-year-old Neanderthal flute. It was made from the thighbone of a young cave bear.

2335. The fastest guitarist in the world is Russian guitarist Sergei Putyatov, who set the record in 2011 by playing 27 notes in 1 second.

2336.

A violin bow is made from horsehair.

2337. The fastest pianist in the world is Portuguese American pianist Domingos-Antonio Gomes, who in 2017, played 824 key strikes in 1 minute. He broke the record by hitting the high B key with alternating fingers.

2338. Guitarist Pat Metheny has a 42-string guitar. Built by luthier Linda Manzer, it was inspired by the paintings of Pablo Picasso. It has 4 necks, 2 sound holes, and it took 1,000 hours to build. And yes, Metheny can play it.

2339. In 1761, Benjamin Franklin invented an instrument called a glass armonica. He had a glass blower create glass bowls tuned to notes. He attached them and color-coordinated them, and to use the instrument, you turned a foot pedal to make the bowls spin and you played the bowls with your wet fingers—sort of like making music with crystal wine glasses.

2340. The glass armonica was such a hit in the latter half of the 18th century that Beethoven, Mozart, and Donizetti all wrote music for it.

2341. By the time of Franklin's death in 1790, 5,000 armonicas had been sold.

2342.

Franklin himself never made any money from the instrument and refused to apply for a patent.

2343. However, some armonica players became ill, suffering from muscle spasms, nervousness, dizziness, and cramps, and even worse, listeners also started complaining. When a child in the audience of an armonica show died, it was banned in some places. No one could ever say for certain what was causing the illnesses.

2344. The subcontrabass flute uses 15 feet of tubing and looks like a giant paperclip. It produces a dark, gentle tone.

2345. The theremin was one of the first electronic instruments. It has 2 metal antennas that can sense a player's hands, which control volume and pitch.

2346. Leo Fender, one of the world's greatest electric guitar inventors, created the first mass-produced sold-body electric guitar. Fender had no formal electrical engineering training.

2347. Fender majored in accounting at Fullerton Junior College and worked as a bookkeeper. Then, he became a radio repairman.

2348. Even though Fender played a little bit of piano and saxophone as a child, he never learned to play the guitar. In fact, he probably never learned to tune one.

2349.

Buddy Holly was one of the first top-name rock 'n' roll performers to play a Fender Stratocaster. You can see it when his band played on *The Ed Sullivan Show* on December 1, 1957.

2350. According to the manager of his record company, Jimi Hendrix switched out his Stratocaster for a cheaper guitar, which is the one he smashed and burned at the 1967 Monterey Pop Festival.

2351. Like Leo Fender, Laurens Hammond, the engineer who designed and built the famous Hammond organ, didn't know how to play the instrument he created.

2352. Ireland is the only country to have a musical instrument as its national emblem.

2353. Since 1922, the Irish harp has appeared on seals of state, coins, and the coat of arms.

2354. A kora is a long-necked harp lute of the Malinke people of western Africa.

2355. A kora consists of a long neck that passes through a calabash gourd resonator that is covered by leather. Twenty-one strings are attached to the top of the neck with leather tuning rings.

2356. Traditionally played by men, Sona Jobarteh is the first female professional kora player from 1 of the 5 principal kora-playing griot families.

2357. Traditional Andean musicians play what's called a charango, which is a 10-stringed instrument that used to be made from an armadillo carapace (hard upper shell). Today, it's made from wood or a gourd.

2358. Justin Bieber was the first act to hold the top 3 positions on the UK singles chart simultaneously.

2359. Bieber had the first music channel viewed 3 billion times on YouTube.

2360. At one point, Bieber held the record for most disliked video online for his song "Baby."

2361. The "Baby" video currently has 14.25 million dislikes and is sixth on the list.

2362. Beyoncé has won the most Grammy Awards in a single year (6 in 2012) by a female artist and the most Grammy's (28) of all time won by a female artist.

2363. Beyoncé and Jay-Z have the most Grammy Awards (51) won by a married couple.

2364. Beyoncé holds the record for most Grammy nominations with 79.

2365. BTS was the first K-pop act to reach number one on the US albums chart.

2366. BTS has the most watched YouTube video in 24 hours with their video for the song "Dynamite" with 101,000,000 views on August 22, 2020.

2367. BTS also has the most watched music video of all time with their video of "Butter."

2368.

In "Rap God," Eminem says 97 words in 15 seconds. The song has 1,560 words, making it the world record holder for hit song with the most words.

2369. Twenty One Pilots has the longest music video ever with a 177-day, 16-hour, 10-minute, and 25-second-long video for their song "Level of Concern."

2370. Taylor Swift has broken records including most weeks at number 1 on Billboard's artist 100 chart, fastest-selling digital album in the US by a female artist, most American Music Awards won by an artist, and biggest-selling album worldwide for a solo artist.

2371. Taylor Swift grew up on a Christmas tree farm.

2372. Taylor Swift appeared on a 2009 episode of CSI: *Crime Scene Investigation*. Her character got murdered.

2373. Taylor Swift wrote the song "This Is What You Came For" for artist Calvin Harris. She wrote it under the pseudonym Nils Sjoberg.

2374. Taylor Swift is the youngest person to be named Entertainer of the Year at the Country Music Association Awards.

2375. February 22 is Rihanna Day in her home country of Barbados.

2376. Rihanna's hit song "Umbrella" was originally written for Britney Spears.

2377. Rihanna's full name is Robyn Rihanna Fenty.

2378. Rihanna actually pronounces her name "ree-ANN-uh" not "ree-AH-nuh."

2379. In 2019, Rihanna became the first woman to create an original fashion line with her luxury fashion house LVMH, Moet Hennessy Louis Vuitton.

2380. Rihanna has sold over 250 million records worldwide and has released 75 singles and 8 albums.

2381. Josephine Baker (1906–1975) was an American-born French dancer, singer, and actor, who was the first Black woman to star in a major motion picture, 1927's *Siren of the Tropics*.

2382. Baker was born Freda Josephine McDonald in St. Louis, Missouri.

2383. Baker, a celebrated performer at the Folies Bergere in Paris, refused to perform for segregated audiences in the US.

2384. Author Ernest Hemingway called Baker "the most sensational woman anyone ever saw."

2385. During World War II, Baker was a spy for the French Resistance. She pinned top-secret information to her undergarments and wrote messages in invisible ink on her sheet music.

2386. After the war, she was awarded the Resistance Medal by the French Committee of National Liberation, the Croix de Guerre by the French military, and was named a Chevalier of the Légion d'honneur by General Charles de Gaulle.

2387. Michael Jackson's "Bad" was originally intended as a duet with Prince. However, Prince said no because the first line of the song was "your butt is mine." He said, "Now who gonna sing that to who, 'cause you sure ain't singing that to me, and I sure ain't singing it to you."

2388. In 1972, Stevie Wonder's "Superstition" was originally written for guitar god Jeff Beck. But when Motown's Berry Gordy heard the demo, he had Wonder release it first.

2389. Six months later, Jeff Beck released "Superstition" with his group Beck Bogert Appice.

2390. The unforgettable riff in "Superstition" is played by Wonder on a clavinet, which is an amplified clavichord.

2391.
A clavichord is a stringed keyboard instrument used in the late Middle Ages through the Renaissance and beyond.

2392. Of the 16 total tracks on "Superstition," 8 of them are Wonder playing slightly different riffs with the clavinet.

2393. The Yardbirds were an English blues/rock band from London formed in 1963 that had quite the revolving door of amazing guitarists. The original lead guitarist was Anthony "Top" Topham. In October 1963, Topham was replaced by guitar great Eric Clapton. In 1965, guitar great Jeff Beck replaced Eric Clapton. Later, guitar great Jimmy Page joined the band on bass and then guitar.

2394. After the Yardbirds, Eric Clapton joined John Mayall & the Bluesbreakers, quitting a few months later. Clapton jammed with Jimmy Page in a band retroactively credited to The Immediate All-Stars, before joining a band called the Glands in 1965. Clapton rejoined the Bluesbreakers before leaving again to form Cream in 1966. They disbanded in 1968.

2395. In 1968, Clapton played the guitar solo on George Harrison's "While My Guitar Gently Weeps," which is from the Beatles' self-titled double album (also known as the *White Album*.)

2396. The Yardbirds' rhythm guitarist, Chris Dreja, recalled that whenever Clapton broke a guitar string during a concert, he would stay on stage and replace it. The English audiences would wait and do a slow handclap. Clapton's nickname "Slowhand" came from Giorgio Gomelsky, a pun on this slow handclapping.

2397. The original photograph of the graffiti on a wall in London that said, "Clapton is God," which became a slogan about Clapton and his guitar abilities, also included a dog peeing on it.

2398. Clapton's next group, Blind Faith, formed in 1969. They broke up after one album.

2399. Clapton then went on to play with Delaney & Bonnie and Friends in 1969.

2400. Derek and the Dominos, Clapton's next band, made it through one album and one live album before disbanding. From this time forward, Clapton went solo.

2401. Paul McCartney, tired of critics (including ex-bandmate John Lennon) accusing him of writing lightweight love songs, wrote the #1 song of 1976: "Silly Love Songs."

2402. "Silly Love Songs" includes a chorus that repeats the sentence, "I love you," 18 times. "What's wrong with that?"

2403.

Diddy's tribute to his friend Notorious B.I.G., "I'll Be Missing You," sampled the Police's song "Every Breath You Take."

2404. Unfortunately for Diddy, he never cleared the sample with Sting and the Police ahead of time. Sting claimed 100 percent of Diddy's song and receives 100 percent of the song's royalties, earning upwards of $730,000 per year for the sample.

2405. If Diddy had gotten permission beforehand, he would have only had to pay 25 percent of the royalties.

2406. Meanwhile, Andy Summers, the guitarist of the Police, who is heard on the sample, doesn't get any of the credit or any of Sting's money for the song. Summers called this, "The major rip-off of all time."

2407. In 1982, Clash drummer Topper Headon was noodling around in the studio while waiting for the rest of his bandmates to show up. While there, he came up with and recorded the drum track, piano track, and bass track for "Rockin' the Casbah."

2408. The "Dixie" sample used in the song was from Headon's *Dukes of Hazzard* wristwatch.

2409.

In 1980, Prince opened up for Rick James on his *Fire It Up* tour. The 2 didn't get along, with James accusing Prince of stealing his moves and licks.

2410. To get him back, James stole Prince's programmed synthesizers and used them on his next album. He then sent it back to Prince with a thank you card that read, "Thanks MF."

2411. "Weird Al" Yankovic got permission to parody "Smells Like Teen Spirit" only after promising lead singer Kurt Cobain that the parody wouldn't be about food. Famous for the parody songs "Eat It," "Lasagna," and "I Love Rocky Road," he told Cobain that the parody would be about the fact that you can't understand the lyrics to the song.

2412. Stevie Nicks, upon hearing Prince's "Little Red Corvette," on her car radio, pulled the car over and bought a cassette recorder to record her own melody over the song—which eventually became "Stand Back." Nicks gave Prince 50 percent of the songwriting credit because of this inspiration.

2413. Prince is the only person credited on his first album *For You*, except for a cowriter on one song. He sang all the parts, produced every song, and played all the instruments.

2414. Prince has sold over 100 million records worldwide and won 7 Grammy Awards, a Golden Globe, and an Academy Award.

2415. In 1984, a national dispute over offensive lyrics began when Tipper Gore, wife of Senator Al Gore, bought a copy of Prince's album *Purple Rain* for her 11-year-old daughter.

2416. In her book *Raising PG Kids In An X-Rated Society*, Gore related what happened as they listened to the song "Darling Nikki," which includes a line about a "sex fiend masturbating with a magazine."

2417. Gore wrote, "The vulgar lyrics embarrassed both of us. At first, I was stunned, but then I got mad."

2418. Gore formed the Parents Music Resource Center with Susan Baker (wife of Treasury Secretary James Baker), Pam Howar (wife of Raymond Howar, a real-estate developer who was active in the Republican Party), and Sally Nevius (whose husband, John, was appointed Washington City Council Chairman by President Nixon).

2419. Together, they put together a list called the Filthy Fifteen—songs they found most offensive.

2420. At number one, was Prince's "Darling Nikki" (1984).

2421. The album the song came from, *Purple Rain*, has been certified 13-times platinum and has sold more than 25 million copies worldwide.

2422.

By 1985, 19 record companies agreed to put stickers that said "Parental Guidance: Explicit Lyrics" on albums with suggestive lyrics.

2423. The PMRC devised its own porn rock rating system.

2424. An X rating was for profane or sexually explicit lyrics.

2425. An O was for occult references.

2426. D/A was for lyrics about drugs and alcohol.

2427. V was for violent content.

2428. On September 19, 1985, the Senate's Committee on Commerce, Science and Transportation held a hearing about the labels.

2429. Frank Zappa testified, saying, "If it looks like censorship and it smells like censorship, it is censorship, no matter whose wife is talking about it."

2430. Dee Snider, lead singer of Twisted Sister, recalled the testimony of pop star and American good guy John Denver: "Gotta give John Denver credit," Snider said. "His testimony was one of the most scathing because they fully expected . . . he was such a mom's, American pie, John Denver Christmas special, fresh-scrubbed guy . . . that he would be on the side of censorship. When he brought up, 'I liken this to the Nazi book burnings,' you should've seen them start running for the hills. His testimony was the most powerful in many ways."

2431. In 2009, a musician named Dave Carroll was flying on United to play a show. Sitting on the tarmac before takeoff, he looked out the window and saw baggage handlers throwing guitars around. When he picked up his guitar after the flight, it was broken.

2432. It cost him $1,200 to fix the guitar, and United refused to pay. So, Carroll wrote a song called "United Breaks Guitar" and posted it on YouTube.

2433. The lyrics include, "United, United / You broke my Taylor guitar. / United, United / Some big help you are."

2434. Carroll's video went viral and became a public relations nightmare for United.

2435. Folk musician Tom Paxton had a similar experience, which he recounted in his 1985 song, "Thank You Republic Airlines."

2436. Elizabeth Cotten (1893–1987) taught herself to play the 5-string banjo and guitar left-handed without changing the strings. In other words, she played the instruments upside down.

2437. Her alternating bass style of playing is called Cotten picking.

2438. As a young teen (some reports say she was 12), she wrote and composed the song "Freight Train," which became a big song during the American folk revival and British skiffle scene in the 1950s and 1960s.

2439. Chas McDevitt, a British skiffle singer, recorded "Freight Train" in 1956.

2440. His version influenced many British groups, including the Quarrymen, who frequently performed it live.

2441. The Quarrymen later changed their name to the Beatles.

2442. While working in a department store years after giving up playing, Cotten helped a young girl find her mother. The young girl was future folk performer Peggy Seeger, and her mother, the composer Ruth Crawford Seeger.

2443. Cotten then worked for the Seeger family (a family of musicians and musicologists) as a housekeeper, where she then picked up a guitar that was in the home and relearned how to play.

2444. Mike Seeger, Peggy's brother, began recording Cotten in 1952, and produced her first album in 1957, and in 1960, at the age of 68, she began her music career.

2445. It was Peggy Seeger who brought the song "Freight Train" to England, where some performers took credit for the song and copyrighted it.

2446. Cotten played her last concert, a tribute to her arranged by her peers at City College in Harlem, on February 22, 1987. She died on June 29th of the same year.

2447. Mike Seeger said, "Who would have known that my mother and Elizabeth, both musicians, would have met in a department store. I think that after a couple of minutes, they recognized each other. For her to come into our house, and at that time, when recorded documentation was just beginning . . ."

2448. In April of 1964, the Beatles had songs in all the top 5 spots on the Billboard Hot 100 chart.

2449. Billy Joel's *52nd Street* was the first album released on CD in 1982.

2450. However, the first CD produced was ABBA's *The Visitors*.

2451. The CD was released alongside Sony's CD players.

2452.

The first artist to sell a million copies on CD was Dire Straits, with its 1985 album *Brothers in Arms*.

2453. The first major artist to have his entire catalog converted to CD was David Bowie, whose 15 studio albums were made available by RCA Records in February 1985.

2454. By 2007, 200 billion CDs were sold worldwide.

2455. More than 900 million CDs were shipped to the US in 2000.

2456. In 2020, that number was down to 31.6 million copies.

2457. Ludacris's "Coming 2 America" samples Mozart's "Requiem."

2458. Coolio's "C U When U Get There" samples Pachelbel's "Canon in D."

2459. Kid Rock's "All Summer Long" samples "Warren Zevon's "Werewolves of London" and Lynyrd Skynyrd's "Sweet Home Alabama."

2460. Katy Perry's real name is Katheryn Elizabeth Hudson.

2461. Vanilla Ice's name is Robert Van Winkle.

2462. Michael Jackson had his final #1 hit in 1995 with "You Are Not Alone."

2463. Elvis Presley hated John Lennon and wanted to beat him up for his anti-war views.

2464. The band Aerosmith wrote one of their biggest hits after watching the movie *Young Frankenstein*.

2465. When Marty Feldman's character, Igor, meets Gene Wilder's character, Dr. Frederick Frankenstein, he hands him his walking stick and instructs him to "Walk this way," while limping down the stairs. Frankenstein follows him, also limping.

2466. The song didn't chart when it was first released in September 1975.

2467. It became a top-10 hit when it was rereleased the following year.

2468. The city of Boston used the song in a 1999 publicity campaign to cut back on jaywalking. They used it in commercials encouraging people to use crosswalks.

2469. "Walk This Way" became the first rap song to be played on mainstream rock radio when Steven Tyler and Joe Perry of the band performed it with the rap trio Run-D.M.C. in 1986.

2470. It hit #4 on the Billboard chart in the US.

2471. This was Run-D.M.C.'s first big hit, and the collaboration revived Aerosmith's career.

2472. Producer Rick Rubin first wanted Run-D.M.C. to cover the song by themselves.

2473. Run-D.M.C. didn't like the lyrics and explained in *Rolling Stone* in 2009, that "We said, this is hillbilly gibberish."

2474. Celine Dion once covered AC/DC's "You Shook Me All Night Long." It was voted the worst cover of all time by *Total Guitar* magazine.

2475. Although many like to argue who was the "fifth Beatle," The Beatles consider it to be Billy Preston (1946–2006).

2476. A self-taught prodigy, Preston was playing organ professionally with Mahalia Jackson and Nat King Cole by the time he was 10 years old.

2477. He played in Little Richard's band as a teenager in 1962. He first met The Beatles in Hamburg, Germany, while on tour with Little Richard.

2478. Preston joined the Beatles during the recording of the *Let It Be* album.

2479. He played organ on "Let It Be" and "Dig It." He played electric piano on "Dig a Pony," "I've Got a Feeling," "One After 909," "The Long and Winding Road," "Get Back," and "Don't Let Me Down."

2480.

When "Get Back" was released on April 11, 1969, it was credited to The Beatles with Billy Preston. He is the only person ever to get a joint credit with the band.

2481. After a run through in the studio of the song "I've Got a Feeling," John Lennon looked at Billy and famously said, "You're in the group."

2482. Preston went on to play with George Harrison, Eric Clapton, and the Rolling Stones.

2483. The line "If you can't be with the one you love, love the one you're with," from Stephen Stills's song "Love the One You're With," came from Preston. He gave permission for Stills to use it.

2484. Preston was the first musical guest on *Saturday Night Live* in 1975.

2485. Preston had 2 number-one songs of his own: "Will It Go Round in Circles" in 1973 and "Nothing from Nothing" in 1974.

2486. The Beach Boys' song "Never Learn Not to Love," was written by Charles Manson.

2487. Drummer Dennis Wilson was friends with Manson, until the band reworked and recorded the song, which was originally called "Cease to Exist." Wilson didn't credit Manson for the song.

2488. Manson pulled a knife on Wilson and his producers. Wilson in an interview with *Rolling Stone* said of his relationship with Manson, "As long as I live, I'll never talk about that."

2489. "Weird Al" Yankovic once proposed creating a polka medley of Led Zeppelin songs. Lead guitarist Jimmy Page was not a fan of the plan, so Yankovic didn't pursue it.

2490. Yankovic also wanted to do a parody of Prince's "Purple Rain" called "Yellow Snow." Prince refused.

2491. The Velvet Underground got its name from a title of an S&M book they found on the sidewalk.

2492. Benny Mardones recorded a song called "Into the Night" in 1980. Meant as a song about a poor family he knew, the opening lyrics caused some confusion: "She's just 16 years old / leave her alone / they said."

2493. Radio stations wouldn't play the song until Mardones's record company sent a letter explaining what the song was about.

2494. The Grateful Dead's biggest hit was 1987's "Touch of Grey," which peaked at number 9 on the Billboard pop chart.

2495. In 1992, the Dead financially supported Lithuania's national basketball team so they could make it to the 1992 Olympics. The team wore tie-dyed uniforms and won the bronze medal.

2496. The Who's biggest Billboard charter was their 1967 song "I Can See for Miles." It only reached number 9.

2497. Buddy Holly & the Crickets were the first White band to play at the Apollo Theater in Harlem.

2498. They were booked for 6 nights, and they were booed at first because the crowd thought they were seeing the R&B group The Crickets.

2499.

The Apollo opened in Harlem, New York in 1914, and has played a major role in history of jazz, swing, bebop, R&B, gospel, blues, and soul.

2500. When it first opened, it was called Hurtig and Seamon's New Burlesque Theater. African Americans were not allowed to attend or perform.

2501. By 1937, the Apollo was the largest employer of Black theatrical workers in the US, and the only theater in New York hiring African Americans for backstage positions.

2502. Billie Holiday, Lena Horne, and the Count Basie Orchestra all made their debuts at the Apollo.

2503. Ella Fitzgerald won Amateur Night at the Apollo in 1934.

2504. Other Amateur Night winners include Pearl Bailey, Sarah Vaughn, Ruth Brown, Dionne Warwick, James Brown, Gladys Night, King Curtis, Ronnie Spector, and Jimi Hendrix.

2505. Fitzgerald was there to dance, but at the last moment, decided to sing. She and her best friends put their name in a hat, and Fitzgerald was called.

2506. Fitzgerald was Marilyn Monroe's favorite singer, and they became friends in the 1950s.

2507. When Fitzgerald couldn't get a gig at Mocambo, a famous L.A. nightclub, Monroe promised the owner she would sit in the front every night and bring along some of her friends. Frank Sinatra and Judy Garland showed up on opening night.

2508. Fitzgerald said of the experience, "After that, I never had to play a small jazz club again."

2509. On New Year's Eve 1961 at Carnegie Hall in New York City, you could have paid $3.00 (for the cheap seats) to see Sonny Rollins & Co., John Coltrane, Nina Simone, and Thelonious Monk and his band.

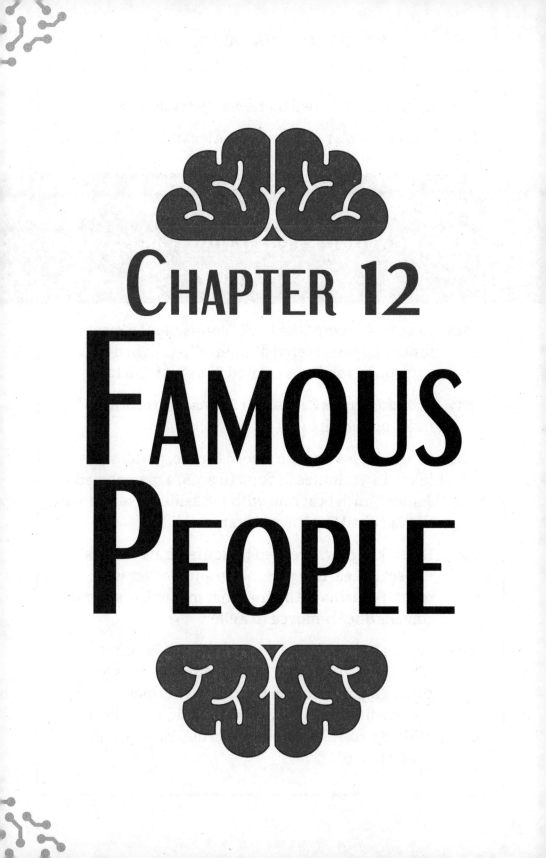

CHAPTER 12
FAMOUS PEOPLE

2510. Lauren Bacall's real name was Betty Jo Perske.

2511. Joan Rivers's real name was Alexandra Molinsky.

2512.
Natalie Wood's real name was Natalia Zakharenko.

2513. In 2017, Dwayne "the Rock" Johnson set a record for the largest layered dip. The dip weighed 540 pounds and was created in a giant fish tank.

2514. In 2020, Bush's Beans beat Johnson's record with a 1,087-pound dip.

2515. Johnson also had the record for most selfies (105) taken in 3 minutes in 2015. In 2018, a man named James Smith beat him with 168 selfies taken aboard the Carnival Dream cruise ship.

2516. Helen Keller was related to Confederate General Robert E. Lee. Her paternal grandmother was second cousins with him. That makes Lee second cousins once removed to Keller.

2517. Sisters Dakota (*The Alienist*) and Elle Fanning (*The Great*) are related to King Edward III, who ruled England from 1327 to 1377. This makes them twenty-first cousins with Kate Middleton, Princess of Wales, as Kate's mother, Carole, is also related to King Edward.

2518. Brooke Shields (*The Blue Lagoon*) and Glenn Close (*Fatal Attraction*) are second cousins once removed. Shields's great-grandmother was Close's grandfather's sister.

2519. Tom Hanks (*Big*) is related to Abraham Lincoln through his mother, Nancy Hanks. He is third cousin, 4 times removed from Abe.

2520. Oona Chaplin (*Game of Thrones*) is Charlie Chaplin's (*The Kid*) granddaughter.

2521. Actor Jason Schwartzman's (*Moonrise Kingdom*) mother is Talia Shire (*Rocky*). Talia Shire is director Francis Ford Coppola's (*The Godfather*) sister. Coppola's daughter is director Sofia Coppola (*Lost in Translation*). Actor Nicolas Cage (*Raising Arizona*) is Coppola's brother's son. This makes Schwartzman, Sofia Coppola, and Cage all first cousins.

2522. Francis Ford Coppola's father was composer Carmine Coppola.

2523. Original scream queen Janet Leigh (*Psycho*) is scream queen Jamie Lee Curtis's (*Halloween*) mother.

2524. Actor, model, and singer Emma Roberts is Julia Roberts's (*Pretty Woman*) niece.

2525. *Moby Dick* author Herman Melville and alt-rock musician Moby are related.

2526. Warren Beatty (*Reds*) is Shirley MacLaine's (*Terms of Endearment*) younger brother.

2527. In 2012, while receiving the American Film Institute Life Achievement Award, Maclaine said in her acceptance speech that Beatty was the person "she'd known the longest and the person she'd loved the longest on this planet."

2528.

Novelist Jane Austen is an 8-times great aunt of actor Anna Chancellor. In 1995, Chancellor starred as Caroline Bingley in an adaptation of Austen's *Pride and Prejudice*.

2529. Helena Bonham Carter's (*Harry Potter* series) great-grandfather was Herbert Henry Asquith, Prime Minister of the UK during World War I.

2530. Actors Jonah Hill (*Superbad*) and Beanie Feldstein (*Booksmart*) are siblings.

2531. Actor Lily Collins (*Extremely Wicked, Shockingly Evil and Vile*) is legendary musician Phil Collins's daughter.

2532. John David Washington (*BlackKklansman*) is Denzel Washington's (*Glory*) son.

2533. Jason Sudeikis (*Ted Lasso*) is George Wendt's (*Cheers*) nephew.

2534. Elvis Presley and Napoleon are eighteenth cousins 4 times removed. Elvis is ninth cousins 6 times removed with George Washington.

2535. Franklin Delano Roosevelt and his wife, Eleanor Roosevelt were fifth cousins once removed.

2536. President Theodore Roosevelt was Eleanor's uncle and Franklin's fifth cousin. He officiated their wedding and gave the bride away. After the wedding, Teddy said, "It is a good thing to keep the name in the family."

2537. Motown founder, Berry Gordy, is Redfoo's father. Redfoo was a rapper in LMFAO, whose song "Party Rock Anthem" topped the charts in several countries in 2011.

2538. Redfoo's partner in LMFAO was Sky Blu, who is Berry Gordy's grandson and son of Redfoo's half-brother, Berry Gordy IV.

2539. This makes Sky Blu Redfoo's nephew . . . half-nephew technically.

2540. Charles Dickens's great-great-grandson is Harry Lloyd (*Game of Thrones*). Lloyd's acting debut came at the age of 16, in a theatrical version of Dickens's *David Copperfield*.

2541. Yara Shahidi (*Grown-ish*) is second cousins with rapper Nas (Nasir Jones). She was a flower girl at his 2005 wedding.

2542. Original rocker Jerry Lee Lewis ("Great Balls of Fire") was first cousins with televangelist Jimmy Swaggart. Swaggart's grandmother was sister to Lewis's dad.

2543. In 1976, Jerry Lee Lewis celebrated his birthday by shooting his bass player in the chest. The band member survived but sued Lewis.

2544. Comedian Conan O'Brien is third cousins with Denis Leary (*The Ref*).

2545. Amy Schumer (*Trainwreck*) and US senator Chuck Schumer are second cousins. Chuck is Amy's father's first cousin.

2546.

Singers Whitney Houston and Dionne Warwick were first cousins.

2547. News anchor Anderson Cooper is the late heiress and designer Gloria Vanderbilt's son.

2548. *Succession* star Kieran Culkin is Macaulay Culkin's (*Home Alone*) little brother.

2549. Activist Gloria Steinem is Christian Bale's (*The Dark Knight*) stepmom.

2550. Stanley Tucci (*The Devil Wears Prada*) is married to Emily Blunt's (*A Quiet Place*) sister.

2551. The rapper Snoop Dogg and singer Brandy are first cousins.

2552. Rashida Jones (Black AF and The Office) is music producer Quincy Jones's youngest daughter. Her mother is Peggy Lipton from Mod Squad.

2553. Actor Tippi Hedren (The Birds) is actor Melanie Griffith's (Working Girl) mother.

2554. Dakota Jackson (Fifty Shades of Grey) is Melanie Griffith's daughter. Her dad is actor Don Johnson (Miami Vice).

2555. Tracee Ellis Ross (Black-ish) is singer Diana Ross's daughter.

2556. Jurassic World star Bryce Dallas Howard is Oscar-winning director Ron Howard's daughter.

2557. Minka Kelly's (Friday Night Lights) dad is Rick Dufay, former guitarist for Aerosmith.

2558. Country singer George Strait is first cousin to Amazon founder Jeff Bezos.

2559. Today star Al Roker and rocker Lenny Kravitz are second cousins.

2560. Roxie Roker, from The Jeffersons, is Kravitz's mother and Roker's cousin.

2561. A genealogical survey in 2007 found that former President Obama is a distant cousin of former Vice President Dick Cheney.

2562. Queen Elizabeth II was 3rd cousins with her husband, Prince Philip. Queen Victoria and Prince Albert of Britain are their great-great-grandparents.

2563. Researchers at the New England Historic Genealogical Society found that President Obama is related to former presidents George W. Bush (10th cousins, once removed), George H.W. Bush, Gerald Ford, Andrew Johnson, Truman, and James Madison. And . . . Winston Churchill.

2564. Melissa McCarthy (*Ghostbusters*) and Jenny McCarthy (*The View*) are first cousins.

2565. Hillary Clinton is a distant cousin of Madonna, Alanis Morissette, and Celine Dion.

2566.

Singer-songwriter Carly Simon's father co-founded Simon and Schuster.

2567. In 1989, The Rolling Stones bassist Bill Wyman married Mandy Smith. He was 52 and she was 18. In 1993, Wyman's son Stephen, from his first marriage, married Mandy Smith's mother, Patsy. If Bill Wyman and Mandy Smith had still been married in 1993, Stephen would have been his own step-step-grandfather.

2568. Magician Penn Jillette named his daughter Moxie CrimeFighter. Penn said that he and his wife "chose her middle name because when she's pulled over for speeding, she can say, 'But officer, we're on the same side. My middle name is CrimeFighter.'"

2569. Actor Jason Lee named his son Pilot Inspektor Riesgraf Lee. Supposedly, Lee was inspired by the Grandaddy song, "He's Simple, He's Dumb, He's the Pilot."

2570. Spice Girl Geri Halliwell named her daughter Bluebell Madonna.

2571. Australian actor Rachel Griffiths named her son Banjo.

2572. Actor Rob Morrow named his daughter Tu Morrow.

2573. Tu's mother's name is Debbon Ayer. Say it out loud.

2574. Gwyneth Paltrow named her daughter Apple.

2575. Erykah Badu and Andre 3000 have a son named Seven Sirius.

2576. Seven Sirius has a half-sister named Mars Merkaba.

2577. Musician the Edge named his daughters Blue Angel and Arran.

2578. Gwen Stefani named her son Zuma Nesta Rock.

2579. Sylvester Stallone named his son Sage MoonBlood.

2580. Elon Musk and the musician Grimes named their son X AE A-12. They call him X.

2581. Mariah Carey named her son Moroccan Scott.

2582. Ashlee Simpson and Pete Wentz named their son Bronx Mowgli.

2583. Musician Jermaine Jackson named his son Jermajesty.

2584. Actor David Duchovny named his son Kyd.

2585. Kim Kardashian and Kanye West named their daughter North West.

2586. Musician Bob Geldof named his daughter Peaches Honeyblossom Michelle Charlotte Angel Vanessa Geldolf.

2587.

Jenn Berman, a clinical psychologist in Beverly Hills, California, claims that celebrities name their children weirdly because of an unconscious feeling that they are a sort of "American aristocracy," and that the exotic names serve as a sort of royal title.

2588. Stuart Fischoff, a psychologist who has worked with Hollywood clients, believes it shows that stars not only need to feel different, but they also fear being thought of as normal.

2589. In April 2011, actor Nicolas Cage was arrested for domestic abuse in New Orleans. His Saturday evening was a special one. First, he visited a tattoo parlor, demanded a tattoo, and began throwing his clothes around. He then asked employees of the shop to call police because "he didn't remember where he lived."

2590. Afterward, he argued with his wife over the correct address of their rental house. He grabbed her roughly by the arm to pull her to where he thought they were staying. Then, he started hitting parked cars. The cops were called, and Cage began yelling at them and daring them to arrest him. They did.

2591. Snoop Dogg was convicted of felony narcotics possession in 1990, charged with illegal firearms in 1993, and acquitted of murder in 1996. In 2006, Snoop was banned from British Airways after he started a brawl at Heathrow Airport in London in which several police officers were injured.

2592. Dr. Dre was sentenced to house arrest after breaking the jaw of a record producer. He pleaded no contest to a 1991 assault charge in which he attacked the host of the show *Pump It Up*, picking her up by her hair and ear and smashing her face and kicking her in the ribs. The civil lawsuit was settled quietly.

2593. In the early 2000s, Eminem was charged with 2 felonies: carrying a concealed weapon without a license and assault with a deadly weapon. He received probation and community service.

2594. Jay-Z pleaded guilty to a misdemeanor charge that resulted in 3 years of probation for the 1999 stabbing of a record executive at a nightclub.

2595. Kanye West was arrested in 2008 after getting into a fight with a photographer outside of a nightclub in England. He was released with "no further action."

2596. Johnny Cash was arrested for picking flowers on private property.

2597. Naomi Campbell has been arrested for assault a few times, with her most famous being the 2006 arrest for assaulting her housekeeper with a jewel-encrusted mobile phone. The housekeeper ended up requiring several stitches, and Campbell was charged with second-degree assault.

2598.

In 1982, Ozzy Osbourne was arrested in San Antonio, Texas, for lifting up his dress and urinating on the Alamo.

2599. When arrested for shoplifting thousands of dollars' worth of merchandise from a Saks Fifth Avenue in Beverly Hills, Winona Ryder said, "I was told that I should shoplift. The director said I should try it out." Ryder was convicted of grand theft and given 3 years of probation.

2600. After being arrested for driving the wrong way on a highway while high, Nicole Richie explained to officers that she only took Vicodin because of bad menstrual cramps.

2601. After cocaine was found in Lindsay Lohan's pockets in 2007, she exclaimed, "These aren't my pants."

2602. When tennis pro Richard Gasquet tested positive for cocaine, leading to his suspension by the International Tennis Federation, he claimed the cocaine got in his system after French-kissing a woman in a nightclub.

2603. Actor Tim Allen once served time in jail for drug trafficking.

2604. Microsoft co-founder Bill Gates has been arrested twice—once in 1975 for driving without a license and speeding, and again in 1977 for driving without a license and failing to stop for a stop sign.

2605. Celebrity chef Julia Child was 6'2", and her height actually got her turned away from joining the military during World War II.

2606. Child worked as a spy during the war, working in the Office of Strategic Services (OSS), a precursor to the CIA. During the war, she was a top-secret researcher who worked in Sri Lanka and China.

2607. One of her biggest projects for the OSS involved developing a shark repellant that would keep sea creatures from setting off underwater explosives. It's still in use today.

2608. Child didn't start cooking until her mid-30s.

2609. According to historian David Strauss, Child's book *Mastering the Art of French Cooking*, written with Simone Beck and Louisette Bertholle, "did more than any other event in the last half century to reshape the gourmet dining scene." The book featured more than 500 recipes, and was abandoned by its original publisher, who stated that "Americans don't want an encyclopedia."

2610. The book hit bestseller lists for the first time in 2009 when the movie *Julie & Julia* was released.

2611. Child donated her entire kitchen to the Smithsonian Institute.

2612. Child's last meal before her death was homemade French onion soup.

2613. Frank Sinatra (1915– 1998), the famous crooner, never learned to read music.

2614. Sinatra was born in his parents' Hoboken, New Jersey apartment. He weighed 13 pounds and was thought to be stillborn. His grandmother ran cold water over him to get him to start breathing.

2615. The forceps the doctor used to deliver Sinatra left scarring on his left cheek that earned him the nickname "Scarface" as a youth. As an adult, he used makeup to hide the scars, but he never liked being photographed on his left side.

2616. Sinatra was only 5'7" and wore elevated shoes to look taller.

2617. After attaining dramatic success in the 1940s, his star dimmed in the 1950s, leading him to attempt suicide at least once.

2618. His rocky relationship with actress Ava Gardner let to three suicide attempts. At one point, Gardner struggled to get a gun from Sinatra, and the gun fired. The bullet missed them both.

2619.

Sinatra hated rock 'n' roll, calling it, "the most brutal, ugly, degenerate, vicious form of expression it has been my displeasure to hear."

2620. The cartoon dog Scooby-Doo was named after scat Sinatra performs at the end of the song *Strangers in the Night*: "Shooby-dooby-doo."

2621. In 1963, Sinatra's son was kidnapped. The kidnappers demanded to talk to Sinatra but only on a pay phone. Sinatra's son was released unharmed, but the traumatic event led to him carrying 10 dimes in his pocket for the rest of his life. In fact, he was even buried with 10 dimes in his pocket.

2622. The engraving on Sinatra's tombstone reads, "The Best Is Yet to Come."

CHAPTER 13
TV & MOVIES

2623. Zoe Saldaña is the first actor to star in 4 films that made over $2 billion at the box office.

2624. The movies are *Avatar*, *Avatar: The Way of Water*, *Avengers: Infinity War*, and *Avengers: Endgame*.

2625. Jennifer Lawrence is the highest-grossing female action movie star after the successes of the Hunger Games and X-Men franchises.

2626. Scarlett Johansson is the biggest female box office star, with a lifetime revenue of $5.2 billion over 32 movies.

2627. The male actor with the highest lifetime revenue is Samuel L. Jackson with $5.7 billion at the box office over 6 movies.

2628.

The male actor with the highest average revenue is Leonardo DiCaprio, with $97.5 million per movie.

2629. The female actor with the highest average revenue is Angela Bassett at $97.2 million per movie.

2630. Director Martin Scorsese holds the record for the most Oscar nominations for a living director with 9.

2631. Hedy Lamarr (1914–2000) was an Austrian-American actor and inventor who was inducted into the Inventors Hall of Fame for her development of frequency hopping technology.

2632. This technology led to the formation of WiFi, GPS, and Bluetooth communication systems.

2633. Discovered at the age of 16 by director Max Reinhardt, Lamarr gained fame as an actor, but also her dating life.

2634. Lamarr escaped her Nazi husband by disguising herself as her own maid.

2635. Lamarr dated Howard Hughes, and during that time, Hughes encouraged her curious mind, giving her a small set of equipment to use on her inventions between takes.

2636. When Hughes was trying to create faster planes for the US military, Lamarr bought a book of fish and a book of birds and looked at the fastest of each kind. She combined the fins of the fastest fish and the wings of the fastest bird to sketch a new wing design. Upon showing the design to Hughes, he said, "You're a genius."

2637. Lamarr invented an upgraded stoplight and a tablet that carbonated water.

2638. The first female filmmaker, Alice Guy Blaché, made a 1-minute film called *The Cabbage Fairy*. It's considered one of the first films that told a made-up story.

2639. Vanna White, cohost of *Wheel of Fortune*, claps an estimated 606 times per show, making her the most frequent clapper according to the Guinness World Records.

2640. Guinness World Records report that White has clapped an estimated 3,721,446 times over the 32 seasons of the game show.

2641.

Betty White was an actor for over 80 years.

2642. When White died in 2021, her last word was "Allen," the name of her third and beloved husband.

2643. Ingrid Bergman spoke Swedish, German, English, Italian, and French, and acted in all 5 languages.

2644. Bergman won 3 Academy Awards, 2 Primetime Emmy Awards, a Tony Award, 4 Golden Globe Awards, and a BAFTA Award.

2645. In 1932, Walt Disney won an Oscar for creating Mickey Mouse, when in fact, the character was created by animator Ub Iwerks.

2646. In the movie *Indiana Jones: Raiders of the Lost Ark*, Indiana Jones at one point wields a rocket launcher that was designed in the 1940s. The movie takes place in 1936.

2647. In the movie *Titanic*, Jack Dawson talks about going ice fishing on Lake Wissota in Minnesota. The dam that created the lake was built in 1917. The *Titanic* sank in 1912.

2648. Armed men in the American West were called "shootists." The term "gunslinger" was coined for a 1920 movie.

2649. Women screenwriters of the silent movie era wrote between one-third and one-half of all American silent films.

2650. The most influential movie writer between 1914 and the late 1930s was a woman named Frances Marion. Frances Marion was named after the famous Revolutionary War hero Francis Marion.

2651. Marion wrote over 300 films and became known for her great film adaptations, writing both scenarios and formal screenplays in a career ranging from silent film through the talkie era.

2652. Marion was the highest-paid member of her profession in the US from 1915 to 1934. From 1916 to 1919 Marion wrote exclusively for megastar Mary Pickford, and she earned $50,000 a year, which is about $1 million in today's dollars.

2653. Marion was awarded the Oscar for Best Adapted Screenplay for *The Big House*.

2654. In recalling her Oscar win, Marion said, "I saw it as a perfect symbol of the picture business: a powerful athletic body clutching a gleaming sword with half of his head, that part which held his brains, completely sliced off."

2655. MGM art director Cedric Gibbons drew the original design for the Academy Award statue in 1928.

2656. He imagined a knight standing on a reel of film holding a sword. The statue today still holds the sword, although it is pointed downward. George Stanley, a Los Angeles artist, sculpted the statue.

2657. Gibbons was nominated for an Oscar 39 times for art direction, winning 11.

2658.

Oscar statues were once made of a metal called britannia, an alloy that was easy to buff to a smooth finish.

2659. In 2016, the Academy switched to solid bronze with 24-karat gold plating.

2660. John Wayne was born in 1907 in Winterset, Iowa.

2661. His birth name was Marion Robert Morrison.

2662. He got his nickname "Duke" as a youth. It was his dog's name. His family called the dog "Big Duke" and Marion was "Little Duke."

2663. After being rejected by the US Naval Academy, Wayne accepted a scholarship to play football at the University of Southern California.

2664. In 1926, Wayne injured his shoulder body surfing in the ocean and lost his scholarship.

2665. Wayne's football coach found him a job as an assistant prop boy on the set of a John Ford movie.

2666. From there, Wayne became an extra before finding larger roles.

2667. Wayne's big break came in the 1939 John Ford movie, *Stagecoach*.

2668. His first leading role was in the 1930 movie *The Big Trail*.

2669. The film's director, Raoul Walsh, recalled, "The problem was that this particular up-and-coming actor was named Marion Morrison, and having a macho Western leading man named Marion Morrison simply wouldn't do."

2670. Walsh and studio head Winfield Sheehan came up with "John Wayne," partly because Sheehan admired American Revolution Gen. Anthony Wayne, and partly because the name seemed masculine.

2671. John Wayne hated Clint Eastwood's 1973 film *High Plains Drifter*. Eastwood starred in and directed the film.

2672. Wayne sent a mean letter to the star. Eastwood said, "He [Wayne] said it wasn't really about the people who pioneered the west. I realized that there's 2 different generations, and he wouldn't understand what I was doing."

2673. During World War II, Wayne starred in a number of western films as well as World War II movies, including 1942's *Flying Tigers* and 1944's *The Fighting Seabees*.

2674. In his 2014 book, *American Titan: Searching for John Wayne*, author Marc Eliot contends that John Wayne was having an affair with actress Marlene Dietrich and didn't want to enlist to serve in World War II because he feared losing the relationship.

2675.

Marlene Dietrich smuggled Jewish people out of Europe, entertained troops on the front lines (she crossed into Germany alongside Gen. George S. Patton), and might have even been an operative for the Office of Strategic Services.

2676. According to Eliot, Wayne told friends the best thing he could do for the war was make movies to support the troops.

2677. The first Best Picture winner was *Wings* (1927).

2678. *Wings* was a silent movie that starred Clara Bow, Charles "Buddy" Rogers, Richard Arien, and the then unknown Gary Cooper.

2679. Sylvester Stallone was nominated for his portrayal of the boxer in his film *Rocky* in 1977. Nearly 40 years later, he was nominated for best supporting actor for playing Rocky in the film *Creed*.

2680. Kathryn Bigelow became the first woman to win the best director Oscar in 2010 for her movie *The Hurt Locker*. She beat out her ex-husband, James Cameron (*Avatar*).

2681. Only 3 women in cinema history had been nominated for directing before Bigelow's win.

2682. The Academy honored Walt Disney with 1 standard-sized Oscar and 7 miniature ones to celebrate his first full-length animated film, *Snow White and the Seven Dwarfs*.

2683. Walt Disney received a total of 26 Academy Awards, the most by any individual.

2684. Disney had 59 nominations, also a record.

2685. In 1973, Marlon Brando sent Indigenous activist Sacheen Littlefeather to the Academy Awards in his place. When he won best actor for his role in *The Godfather*, she took the stage, refused his Oscar, and read a prepared statement condemning Hollywood's portrayal of Native Americans.

2686. John Wayne had to be restrained from rushing the stage.

2687. Shortly after being slapped by Will Smith onstage during the 94th Academy Awards ceremony, presenter Chris Rock said, "That's gotta be illegal, right?"

2688. Will Smith won the best actor Oscar later that night. He was later banned from the Oscars for 10 years because of the incident.

2689.

In 2016, *La La Land* was mistakenly announced as the 2016 best picture instead of the real winner, *Moonlight*.

2690. Two partners at PricewaterhouseCoopers, the Academy's vote-tallying firm, have identical sets of winners' envelopes in case some misfortune should befall one of them. Best picture presenters Faye Dunaway and Warren Beatty were handed the duplicate envelope for a previous award—best actress, won by Emma Stone for her role in *La La Land*, which led to the confusion.

2691. At the 2014 Academy Awards, John Travolta introduced Idina Menzel as "the wickedly talented, one and only Adele Dazeem."

2692. The following year, Menzel returned the favor, introducing Travolta as "Glom Gazingo."

2693. *Ben-Hur* (1959) was nominated for 12 of the 15 available categories. It won 11.

2694. *Titanic* (1997) was nominated for 14 of the available 17 categories, and also won 11.

2695. *The Lord of the Rings: The Return of the King* (2003) was nominated for 11 of 17 categories and won all 11.

2696. This is the largest sweep ever—winning in every category it was nominated in!

2697. It was awards for Best Picture, Director, Adapted Screenplay, Art Direction, Makeup, Costume Design, Film Editing, Original Score, Original Song, Sound Mixing, and Visual Effects.

2698. Three movies received 14 nominations (a record).

2699. *All About Eve* (1950) won 6 awards out of 14 nominations.

2700. *Titanic* (1997) won 11 of its 14 nominations.

2701. *La La Land* (2016) won 6 awards out of its 14 nominations.

2702. Edith Head holds the record for most awards by a woman with 8—all for costume design.

2703. Head won 3 of her awards in consecutive years (1949, 1950, and 1951).

2704. Katharine Hepburn holds the record for most acting awards with 4, all for best actress.

2705. John Ford has the most directing Oscars with 4.

2706. John Williams holds the record for most nominations by a living person at 52. He has won 5 times.

2707. Alfred Newman holds the record for composition and songwriting with 9 awards.

2708. Roger Edens won 3 consecutive awards for composing the scores for *Easter Parade* (1948), *On the Town* (1949), and *Annie Get Your Gun* (1950).

2709. Italy holds the record for most awards by a country for Best Foreign Language Film with 14.

2710. France has the most nominations with 40, with 12 wins.

2711. Israel has been nominated 10 times without winning.

2712.

As of 2022, no movie has won Oscars for best actor, best actress, best supporting actor, and best supporting actress.

2713. Only 3 films have received the Big Five Academy Awards (Best Picture, Director, Actor, Actress, and Screenplay [original or adapted]: *It Happened One Night* (1934), *One Flew Over the Cuckoo's Nest* (1975), and *The Silence of the Lambs* (1991).

2714. Two actors have won 2 consecutive best actor awards: Tom Hanks for *Philadelphia* (1993) and *Forrest Gump* (1994), and Spencer Tracy for *Captains Courageous* (1937) and *Boys Town* (1938).

2715. Two actresses have won 2 consecutive awards: Luise Rainer for *The Great Ziegfeld* (1936) and *The Good Earth* (1937), and Katharine Hepburn for *Guess Who's Coming to Dinner* (1967) and *The Lion in Winter* (1968).

2716. Jason Robards won 2 consecutive supporting actor awards for *All the President's Men* (1976) and *Julia* (1977).

2717. Heath Ledger and Joaquin Phoenix both won best actor awards for their portrayals of the Joker.

2718. Jimmy Stewart was one of Hollywood's most popular leading men from the 1930s through the 1950s.

2719. Stewart had a degree in architecture from Princeton University.

2720. With little work to be had as an architect during the Great Depression, Stewart joined a theater group in Falmouth, Massachusetts with fellow aspiring actor Henry Fonda.

2721. After a brief turn on Broadway, Stewart landed a contract with MGM for motion picture work.

2722. His film debut, as a cub reporter in *The Murder Man*, was released in 1935.

2723. At 6'3" and 138 pounds, Stewart was 5 pounds under the minimum weight for enlistment in the draft during World War II.

2724. Stewart drank beer and gorged himself with food until he met the minimum weight.

2725. Even though he was already a pilot, he was sidelined for 2 years stateside until he insisted he be sent overseas.

2726. He was sent to England, where he participated in more than 20 combat missions over Germany.

2727. He earned the Distinguished Flying Cross with 2 Oak Leaf clusters, making him the most decorated actor to participate in the war.

2728. Stewart's Oscar for *The Philadelphia Story* (1940) was displayed at his father's hardware store for 25 years.

2729. In 1987, Stewart sent a letter to Congress protesting the practice of colorizing *It's a Wonderful Life* and other films on the premise that it violated what directors like Frank Capra had intended.

2730. Chuck Jones in his 1999 autobiography *Chuck Amuck: The Life and Times of an Animated Cartoonist*, revealed the rules for creating and writing *Wile E. Coyote and the Road Runner* cartoon shorts. They include:

2731. The Road-Runner cannot harm the Coyote except by going "beep-beep!"

2732. No outside force can harm the Coyote—only his own ineptitude or the failure of Acme products.

2733. The Coyote could stop anytime—if he were not a fanatic. (Repeat: "A fanatic is one who redoubles his effort when he has forgotten his aim." –George Santayana)

2734. No dialogue ever, except "beep-beep!"

2735. The Road-Runner must stay on the road—otherwise, logically, he would not be called Road-Runner.

2736. All action must be confined to the natural environment of the 2 characters—the southwest American desert.

2737. All materials, tools, weapons, or mechanical conveniences must be obtained from the Acme Corporation.

2738. Whenever possible, make gravity the Coyote's greatest enemy.

2739. The Coyote is always more humiliated than harmed by his failures.

2740. Cartoon physics or animation physics is the term for the system of physics that supersedes normal laws, which are used in animation for laughs.

2741. These "laws" usually involve things behaving in accordance with how they appear to the cartoon characters, or what the characters expect, rather than how they objectively are.

2742. A few of these cartoon laws that defy physics include: A body suspended in space will remain suspended in space until made aware of its situation. A character steps off a cliff but remains in midair until looking down. Then he falls!

2743. A body passing through solid matter will leave a perforation conforming to its perimeter. Also called the silhouette of passage.

2744. The time required for an object to fall 20 stories is greater than or equal to the time it takes for whoever knocked it off the ledge to spiral down 20 flights to attempt to capture it unbroken. Such an object is inevitably priceless; the attempt to capture it inevitably unsuccessful.

2745. Psychic forces are sufficient in most bodies for a shock to propel them directly away from the surface. A spooky noise or an adversary's signature sound will introduce motion upward, usually to the cradle of a chandelier, a treetop, or the crest of a flagpole.

2746. The feet of a running character or the wheels of a speeding auto need never touch the ground, ergo fleeing turns to flight.

2747. As speed increases, objects can be in several places at once.

2748. Certain bodies can pass through a solid wall painted to resemble tunnel entrances; others cannot. . . . Whoever paints an entrance on a wall's surface to trick an opponent will be unable to pursue him into this theoretical space.

2749. Any violent rearrangement of feline matter is impermanent. Cartoon cats can be sliced, splayed, accordion-pleated, spindled or disassembled, but they cannot be destroyed. After a few moments of blinking self-pity, they reinflate, elongate, snap back, or solidify.

2750. The first reference to cartoon physics appeared in an *Esquire* article in 1980.

2751. In *High Diving Hare* (1948), when Yosemite Sam cuts through a high diving board Bugs Bunny is standing on, the ladder and platform that Sam is on falls, leaving the cut plank suspended in mid-air. Bugs turns to the camera and cracks: "I know this defies the law of gravity, but, you see, I never studied law!"

2752. The ACME Corporation is a fictional corporation that appears in many Warner Bros. cartoon shorts, which provides dangerous, unreliable, or preposterous products.

2753. The Looney Tunes Golden Collection DVDs have a disclaimer at the beginning given by Whoopi Goldberg. She explains that the cartoons are a product of their time and contain racial and ethnic stereotypes that have not been censored because "editing them would be the same as denying that the stereotypes existed."

2754.

The producers of n the classic 1938 Errol Flynn film *The Adventures of Robin Hood* wanted a realistic look when people were killed by arrows. So, they just hired an expert archer to shoot extras who were wearing padding.

2755. Extras were paid $150 each time they were shot.

2756. Pixar founder John Lasseter was a Jungle Cruise captain at Disneyland.

2757. Songwriter and pianist Randy Newman had been nominated for 14 Oscars, losing them all, before finally winning for the song, "If I Didn't Have You" from *Monsters, Inc.*

2758. Merida, from *Brave*, is the only Disney princess who doesn't sing.

2759. Pixar had to create new software to create Merida's bouncy, curly red hair. They used 1,500 individually sculpted curves.

2760. Mulan is the only Disney princess who never technically became a princess by bloodline or marriage.

2761. *Mulan* was based on the ancient Chinese legend of Hua Mulan, a female warrior who secretly takes her father's place in war.

2762. Pocahontas is the only Disney princess based on a real person.

2763. Pocahontas is not the first Native American to appear in a Disney movie. That distinction belongs to Tiger Lily from *Peter Pan*.

2764. The inspiration for Belle in *Beauty and the Beast* was partly based on Katharine Hepburn's portrayal of Jo March in *Little Women*.

2765. Belle's yellow gown is based on Audrey Hepburn's in *Roman Holiday*.

2766. A study in 2016 found that Disney princesses get less dialog than the male characters in their movies.

2767. The study found that princesses speak 40 percent less than the men.

2768. In *Frozen*, the female leads only get 41 percent of the dialog.

2769. Tiana, the first African American princess, from *Princess and the Frog*, spends 8.9 percent of her screen time as a child, 34.7 percent as an adult human, and 56.4 percent as a frog.

2770. Tiana was the first Disney princess to hold down a job (besides being a slave to an evil stepmother).

2771.

Aurora, of *Sleeping Beauty* fame, only has 18 minutes of screen time, and only speaks 18 lines.

2772. There were no new Disney princesses from 1959 to 1989.

2773. The famous Michael Myers mask from the *Halloween* movies is just a Captain Kirk (William Shatner) mask painted white with the eye holes cut bigger and the hair brushed out.

2774. A film critic named David Manning called Heath Ledger "this year's hottest new star" while reviewing *A Knight's Tale* in 2000. He also called Rob Schneider's comedy *The Animal*, "Another winner," which was the movie's only positive review.

2775. Turns out Manning was a pseudonym used by a marketing executive from Sony subsidiary Columbia Pictures.

2776. It also came out that Sony used employees posing as moviegoers in TV commercials to praise Mel Gibson's *The Patriot*.

2777. On August 3, 2005, Sony made an out-of-court settlement and agreed to refund $5 each to dissatisfied customers who saw *Hollow Man*, *The Animal*, *The Patriot*, *A Knight's Tale*, or *Vertical Limit* in theaters as a result of Manning's reviews.

2778. E.T., the alien in the 1982 film, was voiced by Pat Welsh, an actor who chain-smoked. This gave the alien his signature sound.

2779. The necklace Nicole Kidman wore in *Moulin Rouge!* was worth upwards of $3 million.

2780. It was the most expensive piece of jewelry ever made for a movie.

2781. The scene where the Duke pulls it off Satine's neck is a "stunt double."

2782. Filming was halted for 2 weeks in November 1999, after Nicole Kidman fractured 2 ribs and injured her knee while falling down a flight of stairs while rehearsing a dance routine.

2783. Some of the scenes where she is seen only from the chest up were shot while she was in a wheelchair.

2784. Her injuries cost her the lead in the movie *Panic Room*.

2785. John Leguizamo, who played Toulouse-Lautrec, had to wear special leg braces and walk on his knees.

2786. *Napoleon Dynamite* was filmed for $400,000. It grossed $44.5 million.

2787.
Jon Heder was paid $1,000 to play Napoleon Dynamite.

2788. Mike Varshavski, DO, who goes by Doctor Mike on social media, is a family medicine physician who ranked medical television shows from least medically accurate to most accurate.

2789. Varshavski says *Attaway General* is the least accurate medical drama. Just above that is *Doogie Howser*.

2790. What about the most popular medical drama of all time, *Grey's Anatomy*? "It's not that accurate," he says.

2791. The most accurate, according to Varshavski, is ER, which he calls "king of medical dramas, at least in medical accuracy."

2792. Baby Yoda from the TV series *The Mandalorian* is not Yoda from the Star Wars universe.

2793. Baby Yoda's name is Grogu.

2794. The scene in 2002's *Spider-Man* where Tobey Maguire as Peter Parker catches Mary Jane's lunch on a cafeteria tray took 156 takes. No CGI was used.

2795. The iconic line from *Jaws*, "You're gonna need a bigger boat," wasn't in the script. Roy Scheider, who played Chief Brody, said the line during various moments while filming.

2796. 1994's *Pulp Fiction* revitalized John Travolta's career, although the role was written specifically for actor Michael Madsen. Madsen dropped out before filming to star in *Wyatt Earp*.

2797. Travolta was nominated for a Best Actor Oscar.

2798. The f-word is used 265 times in the film.

2799. Travolta's character, Vincent Vega, drove a 1964 Chevy Malibu in the movie. It belonged to Tarantino and was stolen soon after the film was released. It wasn't found until 20 years later.

2800. The scene where Vincent Vega plunges the adrenaline shot into Mia's chest was filmed backwards, so Travolta was actually pulling the needle out. The scene was then reversed so it looked like he was plunging it in.

2801. The highest-earning R-rated film is 2019's *Joker*. It brought in a worldwide gross of $1 billion.

2802. The highest-earning NC-17-rated movie is 2007's *Lust, Caution*. It grossed $67 million.

2803. *Blonde* (2022) was the first Netflix Original to get an NC-17 rating.

2804. In 1990, *Henry & June* became the first NC-17-rated movie to be shown in theaters.

2805. A month before its release, the Motion Picture Association of America (MPAA) debuted the NC-17 to replace the X rating.

2806. While filming *Avatar*, director James Cameron used a nail-gun to nail cellphones that went off during filming to a wall.

2807.

Ryan Gosling and Rachel McAdams hated each other at first while filming *The Notebook*.

2808. At one point, with 150 waiting to do a scene, Gosling told Nick Cassavetes, "I can't. I can't do it with her. I'm just not getting anything from this."

2809. Cassavetes put them in a room with a producer to work out their differences. And they did . . . to the point that they then engaged in a 2-year romantic relationship.

2810. The movie *Boyhood* was filmed over a 12-year period, with the same actors playing the same roles for all 12 years.

2811. The main character's older sister was played by director Richard Linklater's daughter, mostly because she had been pestering him to star in one of his movies.

2812. After 3 or 4 years of shooting, his daughter asked Linklater to kill her off.

2813. Patricia Arquette, the mom in the movie, was asked by Linklater not to get plastic surgery during filming.

2814. In *Interview with a Vampire*, the actors, including Brad Pitt and Tom Cruise, had to hang upside down for make-up for 30 minutes at a time.

2815. As the blood rushed to their heads, making their veins bulge, the make-up crew would quickly draw them in.

2816.

Production of the film *Gone Girl* had to be halted for 4 days when star Ben Affleck refused to wear a New York Yankees cap.

2817. A die-hard Red Sox fan from Boston, Affleck finally compromised and wore a New York Mets hat.

2818. Director David Fincher jokingly describes Affleck's actions as "entirely unprofessional" in the DVD's audio commentary.

2819. Jim Caviezel, the actor who played Jesus in *Passion of the Christ*, was struck by lightning during filming.

2820. *Dallas Buyers Club* was a 2013 biographical movie about Ron Woodroof, an AIDS patient diagnosed in the mid-1980s when the disease was highly stigmatized and under-researched.

2821. Matthew McConaughey played Woodroof and lost 47 pounds for the role. At one point, he weighed only 114 pounds.

2822. Jared Leto, who plays Rayon, a fictional trans woman with HIV, lost 30 pounds, shaved off his eyebrows, and waxed his whole body for the role. He also refused to break character during the 25 days of filming.

2823. Both would win Academy Awards for acting.

2824. The film's budget was so low that the makeup budget was $250.

2825. The film's makeup and hairstyling won an Oscar.

2826. Sylvester Stallone had Dolph Lundgren really hit him during the filming of *Rocky IV*. He said, "Just go out there and try to clock me. For the first minute of the fight, it is going to be a free-for-all."

2827. An uppercut to the ribs that hit his heart sent Stallone to the ICU for 9 days.

2828. Stallone said later, "I knew I was in trouble when I showed up and nuns met you at the ICU."

2829. In *The Hangover*, Ed Helms's character wakes up with a missing tooth. Helms himself is missing that tooth, and he wears a fake tooth, which he removed for the movie.

2830. Actor Jonah Hill got sick snorting so much vitamin powder, which was the fake cocaine used in *Wolf of Wall Street*.

2831. "We were literally doing fake coke for 7 months," Hill said.

2832.

For the 1992 movie *Batman Returns*, Michelle Pfeiffer played Catwoman. Pfeiffer recounted that she had to be vacuum-sealed into her suit for each scene. They had to constantly take her out of it and put her back in because if she stayed in it for too long, she would pass out.

2833. Isla Fisher almost drowned in *Now You See Me*. Fisher's character was chained and in a tank of water. When her quick-release chains failed to work, she began banging on the tank for help. The crew thought she was acting.

2834. The unofficial record for most fake blood used in a movie goes to *It: Chapter Two*. One 2-minute scene used 5,000 gallons of blood.

2835. Chris Farley was the original Shrek for the movie. He recorded most of his lines before dying in December 1997.

2836. Mike Myers replaced him and created Shrek's Scottish accent.

2837. Writer-director Jordan Peele revealed that the single leather glove each Tethered person wore in *Us* was a nod to 3 key figures: O.J. Simpson, Freddy Krueger, and Michael Jackson.

2838. In *The 40-Year-Old Virgin*, Steve Carell had never had his chest hair waxed before the infamous scene. He didn't think it was going to hurt. The reactions in the movie are genuine.

2839. The most famous line from *Thor: Ragnarök*, "He's a friend from work," was improvised by a child from Make-A-Wish.

2840. While filming *African Queen* in 1951 in the Congo, everyone got sick from dysentery from drinking contaminated water . . . except for director, John Huston, and Humphrey Bogart, who only drank Scotch on set.

2841. Bogart later said, "Whenever a fly bit Huston or me, it dropped dead."

2842. While filming *The Hateful Eight*, Kurt Russell's character smashes a guitar to stop Jennifer Jason Leigh's character from playing it.

2843. The guitar smashed ended up being a priceless, 145-year-old Martin on loan from the Martin Guitar Museum.

2844. The guitar was supposed to be swapped out before the smashing, but no one told Kurt Russell.

2845. Leigh's reaction in the scene is genuine, as she knew the 1870 guitar hadn't been switched out yet.

2846. Dick Boat from the museum said, "As a result of the incident, the company will no longer loan guitars to movies under any circumstances."

2847. The 1954 movie *The Conqueror*, starring John Wayne as Genghis Khan, was filmed near a nuclear weapons testing site in the Utah desert.

2848. The government said it would be safe, but the cast and crew were still exposed to radiation.

2849. The director also had tons of dirt from the location shipped to Hollywood for reshoots.

2850. Of the 220 cast and crew members, 91 developed some type of cancer, including the director, actor Susan Hayward, and John Wayne.

CHAPTER 14
ART, FASHION, & ARCHITECTURE

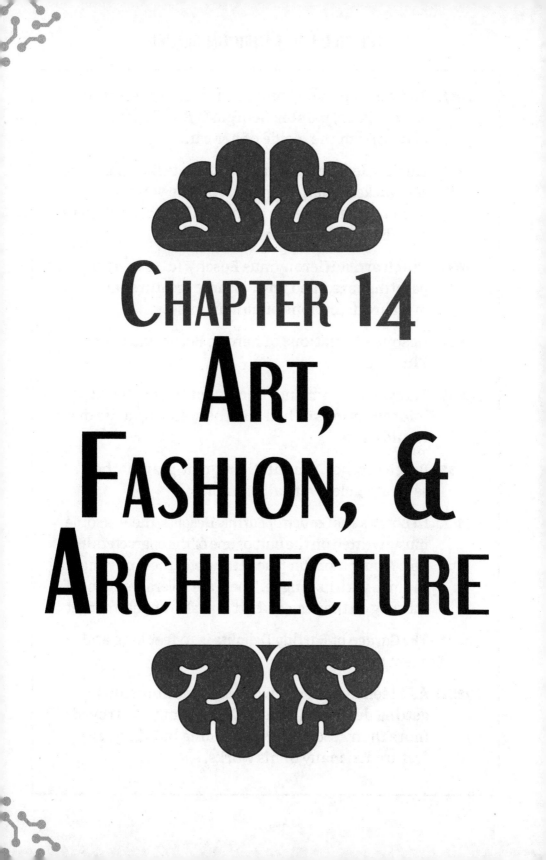

2851. To protect herself from the sun in the deserts of New Mexico, painter Georgia O'Keeffe painted nature from the inside of her car.

2852. Earning lead roles in famous ballets like *The Nutcracker*, Yuan Yuan Tan was the youngest principal dancer ever in the San Francisco Ballet— and the first from Asia.

2853. Dutch artist Hieronymus Bosch's (c. 1450–1516) paintings are filled with bizarre creatures and macabre depictions of human misery.

2854. Despite accusations of heresy, Bosch was a devout Christian.

2855. Many of his paintings document the medieval interpretations of hell and the suffering a life of sin would cause.

2856. Bosch's father, grandfather, great-grandfather, and several uncles were all painters.

2857. In Bosch's *The Garden of Earthly Delights*, there is some music written on the butt of one of the characters in hell. A pink monster placed the notes there by whipping the man with its tongue. There are several versions of the song on the person's butt available on the internet.

2858. *The Garden of Earthly Delights* is 10 feet long and 7 feet tall.

2859. As a teenager, Bosch witnessed his hometown getting destroyed by a fire. The flames destroyed more than 4,000 homes. Burning buildings are featured in many of his works.

2860. Bosch's real first name was Jereon or Jerome.

2861. Only 20 or so of his works survive.

2862.

Famous left-handed artists include Leonardo da Vinci (okay, he was ambidextrous), Henri de Toulouse-Lautrec, Raphael, LeRoy Neiman, Michelangelo, Paul Klee, M.C. Escher, and Alice Neel.

2863. The Leonardo da Vinci painting *Salvator Mundi* sold for $450,300,000 in 2017, making it the highest price paid for a painting.

2864. In March 2021, the blockchain company Injective Protocol bought a $95,000 original screen print entitled *Morons (White)* from English graffiti artist Banksy.

2865. The company then filmed somebody burning it with a cigarette lighter. They uploaded and sold the video as a non-fungible token for $380,000.

2866. The original *Morons (White)* print was a critique of the art market that depicted an auctioneer at Christie's pointing at paintings.

2867. In 2018, Banksy's *Girl with Balloon*, was sold at Sotheby's London for $1.36 million; however, the framed piece self-destructed as soon as it was sold. The piece lowered itself through a shredder that was built into the bottom of its frame. The shredding was accompanied by the sound of a siren.

2868. The bottom half of the painting was shredded, in what Sotheby's has called "instant art world history."

2869. They also called it "the first artwork in history to have been created live during an auction."

2870. The piece has been renamed *Love Is in the Bin*.

2871. Banksy said that he intended to shred it completely, but it stopped halfway through.

2872. *Love Is in the Bin* sold at Sotheby's in 2021 for $25.4 million. More than 3 times its original estimate.

2873. Very few people know Banksy's real identity, but he was born in Bristol, England, in 1974.

2874. Rumors say he is either Robert del Naja of the band Massive Attack; Thierry Guetta, subject of Banksy's documentary *Exit Through the Gift Shop*, or street artist Robin Gunningham.

2875. In 2008, *The Daily* reported that Robin Gunningham was Banksy. They are both from Bristol, and a photo of Gunningham showed 2 Banksy stencils in the background. When a journalist went to visit Gunningham's parents to gather proof, the parents said they didn't recognize the person in the photograph.

2876. In 2016, investigators tried to use geographic profiling to try to prove Banksy is Gunningham.

2877. During an interview in June 2017, the British DJ Goldie, a good friend of Robert del Naja, was talking about contemporary art that he critiqued when he said, "Give me a bubble letter and put it on a T-shirt and write Banksy on it and we're sorted. We can sell it now. No disrespect to Robert, I think he is a brilliant artist. I think he has flipped the world of art over."

2878.

During his 2005 exhibition *Crude* Oils, Banksy not only displayed famous paintings with his remixes added to them, but he also let 200 live rats roam freely in the space.

2879. One of the most famous works from this exhibition was *Show Me the Monet*. Here he paid tribute to Monet's *Bridge Over a Pond of Water Lilies* by adding upside-down, half-submerged shopping carts and other garbage to the painting.

2880. In 2010, when named one of *Time* magazine's 100 most influential people, Banksy was asked for a photograph for the article. He sent a famous image of himself wearing a paper bag over his head.

2881. In 2004, he printed a bunch of spoof £10 notes. The Queen was replaced by Princess Diana's face and instead of "Bank of England," the note read "Banksy of England."

2882. In 2015, Banksy opened a theme park / temporary art project called Dismaland.

2883. Held in the seaside resort of Weston-super-Mare in Somerset, England, Dismaland was, in Banksy's own words, a "family theme park unsuitable for children."

2884. Dismaland featured 58 different artists.

2885. One art piece was a fake payday loan shop for kids called *Pocket Money Loans* by Darren Cullen. It was next to the children's sandpit and offered kids an "advance on their pocket money at 5000 percent interest." The floor had a trampoline so the children could jump high enough to read the small print on their credit agreements.

2886. In 2007, Banksy painted a huge mural on the side of a house in England. When the owners were trying to sell the house, they didn't want to sell it to anyone who would paint over the mural. Their solution was to sell the mural and throw in the house for free.

2887. Edvard Munch's 1893 *The Scream*, one of the most recognizable artworks, has been called "a *Mona Lisa* for our time" by journalist Arthur Lubow.

2888. Munch created 4 versions of *The Scream*: 2 in paint and 2 in pastels.

2889. There are also approximately 45 prints made from a lithograph stone. A few were hand-colored by Munch.

2890. The first painted version is at the National Gallery of Norway in Oslo.

2891. A barely visible pencil inscription on this version reads, "Could only have been painted by a madman."

2892.

The ghost mask used in the *Scream* movies was inspired by Munch's *The Scream*.

2893. Munch said in his diary in 1892, "One evening I was walking along a path, the city was on one side and the fjord below. I felt tired and ill. I stopped and looked out over the fjord—the sun was setting, and the clouds turning blood red. I sensed a scream passing through nature; it seemed to me that I heard the scream. I painted this picture, painted the clouds as actual blood. The color shrieked. This became *The Scream*."

2894. Lucy Gafford from Mobile, Alabama, is a shower hair artist.

2895. Instead of letting her hair from her shower go down the drain, she puts it on the wall of the shower and makes contour drawings.

2896. She has done portraits of Van Gogh and Stephen Hawking, and each drawing takes from 15 minutes to 2 hours.

2897. She uses her teeth to cut hair as needed, and no, she doesn't leave the water on the whole time.

2898. In 2014, 2 brothers from Girona, Spain, tried to sell a fake Francisco de Goya painting to a sheikh. They got 1.7 million Swiss francs from the man, but when they brought the money to the bank, they were told the bills were photocopies.

2899. In 2012, Polish art student Andrzej Sobiepan hung one of his own paintings in the National Museum of Wroclaw.

2900. The painting lasted 3 days before being noticed. The museum director let the painting stay . . . in the cafeteria!

2901. *Le Bateau*, a famous Henri Matisse piece, was hung upside down in the Museum of Modern Art in New York for 47 days until a stockbroker pointed out the error.

2902. In 2022, a major lost painting from the Italian Renaissance was found in the home of a 95-year-old woman living in a London bungalow.

2903. Frida Kahlo (1907–1954) was a central figure in the Neomexicanismo Art Movement in Mexico that emerged in the 1970s.

2904. Her birth name was Magdalena Frida Carmen Kahlo y Calderón.

2905. Kahlo contracted polio when she was 6 years old, leaving her right leg weaker and smaller than her left leg. She limped for the rest of her life.

2906. Kahlo taught herself to paint while on her back after a serious bus accident in 1925. Kahlo was in a full-body cast for 3 months, underwent around 30 operations, and she spent a year recovering.

2907. Before the accident, Kahlo was in a pre-med program. She quit the program to focus on her art.

2908. Her painting *The Broken Column* shows her shattered spine as a fissure from an earthquake.

2909. Kahlo married painter Diego Rivera in 1929. He was 20 years older than Frida and nearly a foot taller than her. The couple was referred to as the Elephant and the Dove.

2910. Their marriage was tumultuous with both having multiple affairs. Kahlo had affairs with men and women, and Rivera had an affair with Kahlo's younger sister.

2911. Kahlo only produced 143 paintings during her lifetime, of which 55 are self-portraits.

2912. In 1939, the Louvre bought Kahlo's painting *The Frame*, making it the first work by a 20th-century Mexican artist to be bought by an international museum.

2913. Kahlo had a brief affair with Russian revolutionary Leon Trotsky while he was in exile in Mexico. She painted a self-portrait for him as a birthday gift.

2914. During her life, she was known more as painter Diego Rivera's wife than she was for her own work. Today, it's the opposite.

2915. Her face is on the 500-peso bill in Mexico. The other side of the bill features her longtime partner, Diego Rivera.

2916. Kahlo's openness about her sexuality—she was bisexual—has made her an iconic figure in the LGBTQI community.

2917. André Breton, the founder of Surrealism, called Frida Kahlo's fierce self-portraits "ribbon(s) around a bomb."

2918. Kahlo hated being lumped in with the Surrealists. She said, "It's not right. I've never sketched a dream. What I depicted was my experience."

2919. She said of the Surrealists, "I'd sooner sit on the ground of the Toluca market peddling tacos than have anything whatsoever to do with those awful Parisian intellectuals."

2920. Elaine Sturtevant (1924–2014) appropriated the forms and techniques of male painters such as Andy Warhol and Jasper Johns in order to question the hierarchy of gender, originality, and authorship.

2921. Warhol let Sturtevant use his screen maker to produce the same Marilyn screen that he used.

2922.

Andy Warhol (1928–1987), the prolific avant-garde artist, began his career as a commercial illustrator for *Glamour* magazine.

2923. His last name was Warhola, but he dropped the "a" to make it sound more American.

2924. In 1962, he exhibited his paintings of Campbell's soup cans, causing quite the stir in the art world. The subject was prompted by his mother's choice of lunch.

2925. Warhol opened his own art studio called The Factory and quickly became the scene for parties for socialites and celebrities.

2926. In 1968, Warhol was shot by a radical feminist named Valerie Solanas. She was an aspiring writer who was upset that Warhol didn't use one of her scripts for a movie he was filming.

2927. Warhol spent weeks in the hospital and had to wear a special corset for the rest of his life.

2928. Warhol's 6-hour movie *Sleep* depicts poet John Giorno sleeping for 6 hours. That's it.

2929. *Eat* is Warhol's movie showing a man eating a mushroom for 45 minutes.

2930. In his book *The Philosophy of Andy Warhol*, he stated that "making money is art and working is art, and good business is the best art."

2931. Warhol was known for his white hair, but he was actually bald. He lost his hair in his 20s, most likely due to a form of the disease Alopecia Areata.

2932. Warhol managed and produced the Velvet Underground.

2933. He wanted to open a series of vending machine restaurants called Andy-Mat.

2934. For his *Oxidations* series, Warhol painted canvases with iridescent copper paint, and then invited his colleagues to pee on the canvases. A chemical reaction caused the paint to bubble and clump and turn different colors.

2935. Pablo Picasso (1881–1973), perhaps the most dominant and influential artist of the 20th century, pioneered Cubism alongside Georges Braque.

2936. He one said, "I paint objects as I think them, not as I see them."

2937. Pablo Picasso's (1881–1973) full name was Pablo Diego José Francisco de Paula Juan Nepomuceno María de los Remedios Cipriano de la Santísima Trinidad Martyr Patricio Clito Ruíz y Picasso.

2938. When the *Mona Lisa* was stolen from the Louvre in 1911, Picasso was suspected of the crime when his friend, the poet Guillaume Apollinaire, was also a suspect. They were both cleared of any wrongdoing.

2939. Picasso produced approximately 147,800 pieces, including 13,500 paintings, 100,000 prints and engravings, 300 sculptures and ceramics, and 34,000 illustrations.

2940.
Picasso burned most of his early work to keep his apartment warm because he was poor.

2941. Picasso's painting *Guernica* was his response to the bombing of the Basque town named Guernica on April 26, 1937, during the Spanish Civil War.

2942. Picasso often painted the women he was in love with, so his tumultuous personal life is well represented on canvas. He was married twice but was said to have kept many mistresses.

2943. Picasso died the richest artist in history; however, he didn't leave a will.

2944. In her memoir, *Picasso, My Grandfather*, Marina Picasso writes of his treatment of women, "He submitted them to his animal sexuality, tamed them, bewitched them, ingested them, and crushed them onto his canvas. After he had spent many nights extracting their essence, once they were bled dry, he would dispose of them."

2945. When Yoko Ono once asked Salvador Dalí for a hair from his mustache, instead of saying no—he thought she might be a witch and use the hair in a spell—he sent her a dry blade of grass in a nice box . . . for $10,000.

2946. This story comes from Dali's muse and lover Amanda Lear. She said, "Dali could never resist it when someone waved a check under his nose . . . Dali loved swindling people."

2947. French painter Paul Gauguin (1848–1903) was a leading Post-Impressionist painter even though he never studied painting.

2948. Gauguin served as a pilot's assistant in the merchant marine for 3 years before serving in the French Navy for 2 years. At this point, he was painting in his spare time.

2949. At the age of 23, he took a job in finance, and within 8 years, he was making the equivalent of $150,000 a year.

2950. It wasn't until the 1882 stock market crash that Gauguin came up with a plan to paint full-time.

2951. Gauguin was good friends with Vincent Van Gogh.

2952. They even painted together at Van Gogh's now famous Yellow House in Arles for 9 weeks.

2953. Gauguin decided to leave on December 23, 1888, because of Van Gogh's unpredictable behavior and depression. That, and Van Gogh confronted him with a straight razor.

2954. Later that same day, Van Gogh cut off his ear, wrapped it in newspaper, and gave it to a woman who worked at a brothel. He asked the woman to "keep this object carefully, in remembrance of me."

2955. Gauguin and Van Gogh never saw each other again, although they wrote to each other.

2956.

There is a crater on Mercury named after Gauguin.

2957. It's tradition for the International Astronomical Union to name craters on Mercury after deceased artists.

2958. There are craters named after Italo Calvino, André Derain, Ernest Hemingway, Dorothea Lange, Alvin Ailey, Maya Angelou, Franz Schubert, and more.

2959. Gauguin's Primitivism heavily influenced Picasso's pre-Cubist work.

2960. Vincent van Gogh wrote almost 900 letters, many of which were first published in 1914 by Johanna van Gogh-Bonger, his sister-in-law.

2961. In 2022, Terrelle Brown, a college student, bought a $10 ashtray at Goodwill. Turns out it was a Yoshitomo Nara original piece called *Too Young to Die*. Brown sold it for nearly $3,000.

2962. An antiques enthusiast spotted a $35 bowl at a New Haven, Connecticut yard sale. It was sold at auction in 2021, for $721,800. Ends up it was 1 of only 7 Ming Dynasty-era bowls to exist and dates back to the 15th century.

2963. Jacob Lawrence (1917–2000) was an American painter known for his portrayal of African American historical subjects as well as everyday life.

2964. At the age of 23, he gained national recognition with his 60-panel *The Migration Series*, which depicted the Great Migration of African Americans from the rural South to the urban North.

2965. Between 1954 and 1956, Lawrence produced a 30-panel series called *Struggle: From the History of the American People* that depicted historical scenes from 1775 to 1817. A collector bought the set and sold the pieces individually for as little as $100 each, and as of this writing, 3 remain unaccounted for.

2966. Soon after the Metropolitan Museum of Art in New York's 2020 exhibition of Lawrence's *Struggle* series, 2 of the missing paintings were found within 6 months.

2967. The first one was recovered after a museum visitor noticed the similarity between Lawrence's work and a painting that was on her neighbor's wall. Soon after that, a Ukrainian nurse heard the news of the first lost painting being found and took a closer look at a painting in her apartment. She lived just a few blocks away from where the first lost painting was found.

2968. The painting was a gift from the woman's mother-in-law. The woman said of the painting, "It didn't look like anything special, honestly . . . I passed by it on my way to the kitchen a thousand times a day."

2969. Gustav Klimt's 1916–1917 masterpiece *Portrait of a Lady* was found by gardeners clearing ivy. It was hidden in a wall of Ricci Oddi Modern Art, which is where it had been stolen from.

2970. Rembrandt's *Unconscious Patient* was found in a New Jersey basement.

2971. Vincent Van Gogh's *Sunset at Montmajour* was found in an attic in Norway.

2972. King Charles III of the UK owns the largest private art collection in the world, which consists of 7,000 paintings and 450,000 photographs.

2973.
Brothers Ezra and David Nahmad have a $3 billion art collection.

2974. They treat artwork like stock and purchase art to hold and then sell for maximum value.

2975. Their 5,000 works are in a 15,000 square-foot building in Geneva.

2976. Their 300 Picasso paintings alone are worth $1 billion.

2977. The most stolen piece of art ever is the Ghent Altarpiece called *Adoration of the Mystic Lamb*, painted by Jan van Eyck Hubert and his brother, Hubert, in 1432. This 2-ton masterpiece was the first major oil painting and is a representation of the transition from the Middle Ages to the Renaissance. It has been stolen 7 times. In 1794, Napoleon's troops stole 4 panels of it.

2978. Hitler especially wanted this painting for a new museum he was planning. Some have speculated that Hitler wanted the artwork because he believed it was a coded map to lost Christian relics that would give him supernatural powers.

2979. In 1990, 2 men posing as police officers with fake mustaches conned their way into the Isabella Stewart Gardner Museum in Boston, tied up the security guards, and stole 13 pieces of art valued at $500 million.

2980. One of the stolen pieces, a Vermeer masterpiece called *The Concert*, is worth upwards of $200 million. It is the most valuable unrecovered stolen artwork in the world.

2981. The art has yet to be found and the empty frames are still hanging in the museum.

2982. In 2003, the Whitworth Art Gallery in Manchester, England, realized that 3 of its most famous paintings were missing.

2983. The paintings were found a few days later in a public restroom. They were rolled up in a soggy cardboard tube.

2984. A note from the robbers stated, "We did not intend to steal these paintings, just to highlight the woeful security."

2985. In 1911, Vincenzo Peruggia, an odd-job man working at the Louvre, removed the *Mona Lisa* from its frame, and walked out with it under his clothes.

2986. Thinking it had been stolen by Napoleon (it wasn't), the Italian wanted to return the painting to Italy.

2987. The theft was only noticed a day later when a visitor asked where it was.

2988. Peruggia was caught 2 years later when he tried to sell it to a gallery in Florence, Italy.

2989.

At 1,046 feet, the Chrysler Building in New York City is the tallest brick building in the world with a steel framework.

2990. When completed in 1930, it was the tallest building in the world for 11 months.

2991. It lost its title when the Empire State Building was completed in 1931.

2992. Today, the Chrysler Building is the 11th-tallest building in New York City.

2993. Seen as a paragon of the Art Deco architectural style of the early 20th century, it was named after Walter Chrysler, the head of the Chrysler Corporation, who financed the building himself.

2994. The 31st floor has gargoyles and replicas of radiator caps, hood ornaments, fenders, and hubcaps from 1929 Chryslers, while the 61st floor is adorned with eagles.

2995. The Empire State Building was also built in the Art Deco style and stands 1,454 feet tall.

2996. The Empire State Building was the world's tallest building until 1970.

2997. Today, it is the 7th tallest building in New York City, and the 54th tallest in the world.

2998. New York City had the world's tallest building from 1908 until 1974.

2999. The tallest building in the world today is the 2,717-foot tall Burj Khalifa in Dubai.

3000. Neuschwanstein Castle, an eclectic 19th-century palace on a rugged hill above the village of Hohenschwangau near Füssen in southwest Bavaria, Germany, was commissioned by King Ludwig II of Bavaria (1864–1888) as a retreat and tribute to Richard Wagner, the German composer.

3001. Ludwig paid off the palace with his personal fortune and through large loans.

3002. The king didn't hire an architect to lead the project. Instead, he used a theatrical stage designer named Christian Jank.

3003. The castle was built in 17 years (1869–1886) at a cost of 7.5 million gold marks (about $172 million in today's money).

3004. Following the death of the "Fairy King," as Ludwig was known, the castle was opened to the public to offset the budget expenses of its construction. Although the king himself wanted the castle destroyed after his death.

3005. The castle served as the inspiration for Disneyland's Sleeping Beauty Castle.

3006. More than 1.3 million people visit Neuschwanstein Castle annually, with up to 6,000 visitors a day in the summer.

3007. Neuschwanstein was still incomplete when Ludwig II died in 1886.

3008. The king only lived in the castle for 172 days. He never intended to make the palace accessible to the public.

3009. However, Prince Regent Luitpold ordered the palace to be opened to paying visitors weeks after Ludwig's death.

3010. Westminster Palace, located in London, United Kingdom, is the home of the House of Lords, the House of Commons, and other offices.

3011. In 1970 the building was inscribed on the Class I monument list and in 1987 the UNESCO World Heritage List.

3012. Construction of the palace, which was supposed to serve as the royal headquarters, began in 1016.

3013. The building's neogothic appearance is the result of rebuilding that commenced after a fire in 1834.

3014. The most famous elements of the palace are the towers: Elizabeth Tower, known as Big Ben and Victoria Tower, which is the only entrance used by the monarch on his way to the House of Lords.

3015. The shortest of the 3 is the Central Tower, which stands over the middle of the building above the central lobby.

3016. Elizabeth Tower is the largest at 323 feet.

3017. The palace has 1,100 rooms and the total length of the halls is over 3 miles.

3018. Westminster Hall is the oldest existing part of the Palace.

3019. It was erected by King William II in 1097.

3020. Filippo Brunelleschi was a Renaissance architect, an engineer, and an artist who lived in Florence, Italy, between 1377 and 1446.

3021. Brunelleschi designed the famous dome of the Florentine Cathedral of Santa Maria del Fiore, known as the Duomo.

3022. The Duomo does not rely on flying buttresses because there was not enough wood in Tuscany to construct them.

3023. Brunelleschi's solution proposed building 1 dome inside of another dome. The inner dome had 4 stone and chain hoops to support the octagonal exterior dome.

3024. To aid in the creation of the dome, Brunelleschi invented machines for the construction. No mechanical crane existed, and Brunelleschi needed to get heavy materials to great heights.

3025. He created a new machine using a 3-cog wheel system with connected oxen walking in a circle. The new machine had the power to lift and lower the heavy materials.

3026.
Brunelleschi's Dome remains the tallest brick dome in the world.

3027. While Brunelleschi was superintendent of the Duomo project, his rival Lorenzo Ghiberti was named his co-superintendent. The 2 had been rivals since the competition for the bronze doors of the Baptistry of the Florentine Cathedral in 1401, which Ghiberti had won.

3028. Brunelleschi was also a great artist. His use of linear perspective was revolutionary and became preferred practice for accuracy and realism in drawing and painting until the 19th century.

3029. Another dome that still holds as the largest is the ancient Pantheon, completed in Rome in 126 CE. It remains the largest unreinforced concrete dome in the world.

3030. The Pantheon was built by the Emperor Hadrian, but the inscription on the frieze translated from the Latin reads, "Marcus Agrippa, the son of Lucius, 3 times consul, built this."

3031. Marcus Agrippa did build the first Pantheon in 27 CE in the same location as Hadrian's. The original Pantheon was destroyed by fire, then rebuilt by Emperor Domitian in 80 CE. It burned to the ground after a lightning strike in 110 CE. Hadrian rebuilt it again in 126 CE, a building which still stands.

3032. It is not known why Hadrian credited Agrippa with the building. The inscription caused great confusion and it was not until the 19th century that Hadrian was confirmed as the builder, after excavations found bricks marked with dates from Hadrian's time.

3033. Another great ancient dome is at Hagia Sophia in Istanbul, Turkey. Completed in 537, the Hagia Sophia was the largest cathedral in the world for a thousand years until 1520, when the Sevilla Cathedral in Spain was completed.

3034. The Byzantine emperor Justinian oversaw the Hagia Sophia's construction in what was then Constantinople. Following the fall of Constantinople to the Turks in 1453, the Hagia Sophia served as a mosque.

3035. The dome of the Hagia Sophia is ribbed and rests on triangular sphere segments called pendentives. The pendentives taper to become columns that carry the dome's weight to piers beneath.

3036.

The dome of St. Peter's Basilica dominates the Rome skyline. Construction lasted for more than 100 years, beginning in 1506, when it was commissioned by Pope Julius II until it was completed in 1615.

3037. A church had stood on the site since the Roman Emperor Constantine in 333 CE.

3038. Serving as an architect of St. Peter's was Michelangelo's final commission.

3039. Over the century of construction there were at least 5 architects involved.

3040. Until 1989, St. Peter's Basilica was the largest church in the world.

3041. It can hold 20,000 seated worshippers or 60,000 standing.

3042. In 1989, Yamoussoukro Basilica, in Yamoussoukro, Côte d'Ivoire, became the largest Christian church in the world.

3043. Yamoussoukro Basilica's dome is 489 feet. St. Peter's dome is 452 feet.

3044. It was the first domed sports stadium in the world with more than 20,000 seats.

3045. Chase Field in Phoenix, Arizona is the first MLB stadium in the US with a natural grass playing field and a retractable roof.

3046. In Europe during the 1300s, the aristocracy began wearing shoes with long, pointed tips. (The best were shaped to look like male genitals and stuffed with fabric.)

3047. Always seeking to outdo each other, the shoes got longer and longer until everyone at court was tripping all over the place.

3048. They took care of the problem by tying the tips of their shoes to their legs with rope.

3049. High heels have been around for quite some time. In 16th-century Europe, women's heels reached the incredible height of 2 to 3 feet!

3050. These shoes, called *chopines*, proved useful since they kept women's dress hems clean when walking along the streets, which were muddy and littered with horse poop.

3051. This fashion statement literally fell out of favor eventually as women needed something to hold onto (a maid or a long cane) at all times, and they kept falling over and severely hurting themselves.

3052.

Louis XIV reigned France from 1643 until 1715. Although at the height of his powers in the early 1700s, the diminutive Louis wore high heels to make himself appear taller.

3053. Soon, it was all the rage, and all the aristocracy was wearing them. Louis's heels were often up to 5 inches high, and as the Royal Court made theirs bigger, so did he.

3054. Soon everyone was tottering around until Louis decreed that no one else's heels could be bigger than his.

3055. Foot binding was utilized in China for around 1,000 years to emulate fashionable tiny feet. It involved breaking the arch and then wrapping the foot, resulting in an approximately 3-inch foot from toe to heel as well as a lifelong disability.

3056. By the 19th century, nearly 100 percent of upper-class women had bound feet. It was outlawed by the Communist party in 1949.

3057. France loved Benjamin Franklin's lightning rod so much that a Parisian designer in the 1770s began making hats with lightning rods attached to them—complete with grounding wire.

3058. The ancient Egyptians and Romans used cosmetics containing mercury and lead.

3059. It was fashionable during the 17th and 18th centuries for women to have pale white skin and red rouged cheeks. They achieved the pale look with white lead, which caused skin eruptions. They then covered up the eruptions with more lead. Lady Mary Coventry, a famous London society hostess, died at the age of 27 of lead poisoning.

3060. In the early 20th century, women used arsenic to give their skin a luminous glow and the deadly nightshade to brighten their eyes and enlarge their pupils.

3061. 18th-century Europe saw the advent of gigantic wigs decorated with all sorts of things: stuffed birds, fruit, sculptures, and more. These wigs often attracted bugs, mice, and other critters. The highlight was most probably Marie Antoinette's giant, 4-foot-high ship wig.

3062. Corsets have been used for hundreds of years. In the 1550s, Catherine de Medici, wife of King Henry II of France, ordered her ladies in waiting to keep their waists extremely thin. They used corsets made of steel, wood, or ivory to keep their queen happy.

3063. According to many historians, the whole myth of women as the weaker sex was due to the fact that their corsets were restricting their lung capacity. So, when excited, unable to breathe adequately, they fainted.

3064. Lungs weren't the only body parts affected by waist-reducing corsets. The stomach, bladder, ribs, and more were all compressed—causing great discomfort and poor health.

3065. Limping was a fad in Victorian England. Alexandra of Denmark, the bride of the Prince of Wales, walked with a pronounced limp. Young women all over London went around faking a limp in an effort to copy her. They called it the Alexandra Limp, and shopkeepers sold mismatched shoes with one low heel and one high.

3066. The Padaung tribe of Burma (Myanmar) and Thailand view long necks as beautiful. So, beginning at age 5, a brass coil is added to a girl's neck. Over the years, the coil is replaced with longer ones, as it slowly pushes the collarbone down and compresses the rib cage. This gives the illusion of the giraffe neck that's been all the rage for hundreds of years.

3067. Margaret Bourke-White (1904–1971), one of the preeminent documentary photographers of the 20th century, was the first foreign photographer allowed to take photographs of Soviet industry.

3068. Bourke-White was the first known female war correspondent, and the first woman allowed to work in combat zones during World War II.

3069. She was also the first female photographer to fly on a combat mission.

3070. Bourke-White was the only foreign photographer in Moscow when Germany invaded in 1941. She captured the bombardment of the Kremlin.

3071. Bourke-White was the first female staff photographer for *Life* magazine.

3072. She developed a magnesium flare that allowed her to capture incredible architectural details.

3073. The staff at *Life* magazine called her "Maggie the Indestructible" after repeatedly coming under fire and surviving being torpedoed on a ship, stranded on an Arctic island, and surviving a helicopter crash.

3074. Bourke-White had a reputation for being relentless in her pursuit of the perfect picture. "I feel that utter truth is essential, and to get that truth may take a lot of searching and long hours."

3075. Born Gabrielle Bonheur Chanel on August 19, 1883, Coco Chanel was not born into glamour. Her mother died when Chanel was 11 and her father put she and her 2 sisters in an orphanage.

3076. The nuns at the orphanage taught young Chanel how to sew.

3077. She gained her nickname, "Coco," during her brief stint as a singer in clubs in Moulins and Vichy, France.

3078. Chanel opened her first shop in Paris in 1910, where she sold hats.

3079. Chanel's first moment of clothing success came when she made a dress out of an old jersey on a cold day. Many people asked where she got it, so she began making the dresses.

3080. In the 1920s, her clothing business was thriving. Chanel broke into the perfume market with her first perfume.

3081. Chanel No. 5 debuted at Chanel's boutique on the Rue Cambon in Paris on May 5, 1921.

3082. This was the first perfume to bear a designer's name.

3083.

In 1925, Coco Chanel introduced her well-fitted suit with a collarless jacket. Chanel's suit and other designs focused heavily on comfort above the constrictive popular clothing. This allowed women to move on from the corsets they had worn for 400 years.

3084. Coco Chanel also introduced the world to the little black dress.

3085. Before Chanel's revolutionary design, black was a color only for mourning and funerals. It was considered indecent to wear at other times.

3086. Chanel's plain black dress in crepe de Chine appeared in *American Vogue* magazine in 1926, and changed all the rules.

3087. During World War II, when the Germans occupied France, Chanel's relationship with a Nazi officer, Hans Gunther con Dincklage, enabled her to stay in her apartment in Paris' Hotel Ritz. The hotel was also the German military headquarters of Paris.

3088. In 2009, Hungarian art historian Gergely Barki was watching the 1999 movie *Stuart Little* with his 3-year-old daughter, when he recognized a painting by Róbert Berény that hadn't been seen in public since 1928. The painting was lost during World War II and had been sold several times for prices ranging from $40 to $500 and used as a set dressing in movies and TV shows until Barki was able to confirm it was the original. It sold at auction in 2014 for $285,700.

3089. In 1999, a painting bought from a furniture sale and hung on a wall in an Indiana home to cover up a hole was discovered to be by the American artist Martin Johnson Heade. It sold for $1.25m.

3090. Teri Horton bought a painting at a thrift shop for $5.00, only to find out later it may be a Jackson Pollock original painting. A documentary was made that followed Horton as she tried to get it authenticated and sold. She died in 2019 without selling the painting.

CHAPTER 15
LITERATURE

3091. The American author Mark Twain (Samuel Clemens) said in his 1904 autobiography that he was the first author to use a typewriter to author a book—claiming that *The Adventures of Tom Sawyer* was typewritten. Written in 1876, *The Adventures of Tom Sawyer* was published from a handwritten copy, not a typewritten one. Mark Twain did, however, submit a typewritten manuscript for *Life on the Mississippi*, which was the actual first-ever submitted typewritten book.

3092. *The Adventures of Tom Sawyer* was originally a commercial failure. It only sold 24,000 copies in its first year—compared to the 70,000 copies sold for his book *Innocents Abroad*. It has since sold 12 million copies.

3093. Samuel Clemens began his career as a printer in 1848, at the age of 12. In 1857, he became an apprentice steamboat pilot on the Mississippi River.

3094. Samuel Clemens worked on a boat called the *Pennsylvania* with his brother, Henry. In 1857, the boat's boiler exploded, killing several people, including Clemens's brother.

3095. In 1861, as the Civil War began, Samuel Clemens joined the Marion Rangers, a pro-Confederate militia. The Rangers only lasted two weeks before disbanding upon learning General Ulysses Grant was heading their way. Clemens then headed west to try silver mining.

3096. In 1885, Samuel Clemens published Ulysses Grant's memoir.

3097. Samuel Clemens first used his pen name "Mark Twain" in 1862, as a reporter for a newspaper in Virginia City, Nevada. Other pen names he tried included W. Epanimondas Adrastus Blad and Thomas Jefferson Snodgrass.

3098. Samuel Clemens based the character of Huckleberry Finn on a real person named Tom Blankenship, who grew up in Clemens's hometown. Clemens wrote of Blankenship, "He was ignorant, unwashed, insufficiently fed; but he had as good a heart as ever any boy had."

3099. Clemens lost a large part of his earnings as an author when he invested in an automatic typesetting machine. He lost up to $200,000. Yet, he passed when offered to invest in Alexander Graham Bell's new invention, the telephone.

3100. Clemens, himself, was an inventor— he invented the self-pasting scrapbook and the elastic-clasp brassiere strap.

3101. Clemens almost always wore a white suit, which he called his "dontcaradam" suit.

3102. In 1909, Twain allegedly said "I came in with Halley's Comet in 1835. It is coming again next year, and I expect to go out with it. It will be the greatest disappointment of my life if I don't go out with Halley's Comet. The Almighty has said, no doubt: 'Now here are these two unaccountable freaks; they came in together, they must go out together.'" He was born one day before the comet arrived in 1835 and died of a heart attack in 1910, one day after the comet's closest approach to Earth.

3103. English author Evelyn Waugh (1903–1966) wrote novels, biographies, and book reviews. He was also known for his strong opinions, calling William Faulkner's writing "intolerably bad," accusing James Joyce of being a "lunatic," but claimed that Raymond Chandler was America's most important author.

3104. O. Henry (1862–1910) was the pen name for William Sydney Porter. He was a licensed pharmacist, then a mapmaker, and then a banker. He fled the US for Honduras when he was charged with embezzlement.

3105. O. Henry ended up spending 3 years in a federal penitentiary when he returned, and this is where he published his first story in 1899.

3106. After his release from prison, O. Henry wrote 381 short stories, including *The Gift of the Magi*.

3107. Virginia Woolf's *A Room of One's Own*, is a book-length essay published in 1929. In it, Woolf states that if women had the same advantages as men, including access to education, they would be on equal footing.

3108. Virginia Woolf suffered from depression and hallucinations throughout her life. When she was 22, she had an episode in which she heard the birds chirping in Greek, and that, "King Edward was using the foulest possible language among [the] azaleas."

3109. Playwright Edward Albee, while writing a play in the early 1950s, found the perfect title for the play written in soap on the bathroom mirror of bar in New York City: "Who's afraid of Virginia Woolf?"

3110. J.R.R. Tolkien (1892–1973) meant for the Lord of the Rings series to be for children at first. The sweeping epic took him 12 years to write and has sold more than 150 million copies.

3111. The J.R.R. stands for John Ronald Reuel.

3112. In the lead-up to World War II, a German publisher was hoping to publish a German edition of Tolkien's *The Hobbit*. When asked to confirm his Aryan credentials, Tolkien replied, "If I am to understand that you are enquiring whether I am of Jewish origin, I can only reply that I regret that I appear to have no ancestors of that gifted people." He also called Hitler a "ruddy little ignoramus."

3113. Tolkien was a linguist and Old English and Old Norse literature expert, and was a professor at Oxford University for nearly 35 years.

3114. In 1936, half of the original manuscript of John Steinbeck's novel, *Of Mice and Men*, was eaten by his dog, Toby. Steinbeck wrote of the event: ". . . the poor little fellow may have been acting critically."

3115. John Steinbeck wrote a werewolf novel called *Murder at Full Moon*. It has never been published, and it's currently stored in the archives of the University of Texas at Austin.

3116.

John Steinbeck started every writing day with 24 sharpened pencils, using them until they were all dull before sharpening them again. He used up to 100 pencils a day.

3117. Before becoming a famous short-story writer and novelist, John Cheever (1912–1982) would wake up each morning in his apartment, put on his only suit, take the elevator to a windowless room in the basement, undress, hang his suit on a hanger, and write until evening in his underwear.

3118. English author G.K. Chesterton liked to shoot arrows out of his window while writing.

3119. Victor Hugo would tell his servants to take his clothes away from him and not return them until he had met his deadline.

3120. Friedrich von Schiller kept rotten apples under his desk to inspire him. The smell reminded him of his youth.

3121. D. H. Lawrence, best known for his novel *Lady Chatterley's Lover*, stimulated his imagination by climbing mulberry trees in the nude.

3122. *Lolita* author Vladimir Nabokov wrote his novels on index cards.

3123. In a 1974 interview, science-fiction author Arthur C. Clarke (2001) predicted the internet. He said that by 2001 we would have a console in our homes with a screen and keyboard that would have everything we need for everyday life, and that we could use it to talk to anyone we wanted.

3124. In 2006, author Margaret Atwood (*The Handmaid's Tale*) unveiled her LongPen, which is a remote-controlled pen that lets writers sign books anywhere in the world.

3125. The media baron Conrad Black used the LongPen to sign books while he was under house arrest for mail fraud and obstruction of justice.

3126. Black was pardoned by President Donald Trump after penning the book *Donald J. Trump: A President Like No Other*.

3127. Ian Fleming, creator of James Bond, also wrote *Chitty Chitty Bang Bang*, which he wrote for his son.

3128. In 1982, author and book packager Byron Preiss published a mysterious book titled *The Secret: A Treasure Hunt*. The book was a puzzle that combined 12 short verses and 12 elaborate fantasy paintings. Readers had to pair each painting with a verse that would then provide clues to finding 1 of 12 plexiglass boxes buried in various parks in the US.

3129. Each box had a key that could be redeemed for a $1,000 jewel.

3130. One of the boxes was found in 1983, one in Cleveland in 2004, and a third in Boston in 2019. The remaining boxes have yet to be found. Supposedly, Preiss was the only one who knew where the boxes were, and he died in 2005.

3131.

J.K. Rowling doesn't actually have a middle name.

3132. The "J" stands for Joanne.

3133. J.K. Rowling's publisher suggested using initials instead of her first name in order to attract boy readers.

3134. The "K" is a tribute to her grandmother, Kathleen.

3135. Rowling said, "It was the publisher's idea, they could have called me Enid Snodgrass. I just wanted it [the book] published."

3136. J. K. Rowling is the first billion-dollar author.

3137. She's also only 1 of 5 self-made female billionaires.

3138. Her Harry Potter books have sold more than 500 million copies and are published in 55 languages, including Latin and Ancient Greek.

3139. Twelve publishers rejected the first Harry Potter book, *Harry Potter and the Philosopher's Stone*.

3140. The character Hermione is based on the author. J. K. Rowling said, "Hermione is a bit like me when I was 11, though much cleverer."

3141. Rowling's own depression helped her create the Dementors, creatures who feed on happiness.

3142. Rowling told Oprah Winfrey, "I know sadness. Sadness is to cry and to feel. But it's that cold absence of feeling—that really hollowed-out feeling. That's what Dementors are."

3143. Rowling's parents met on a train from King's Cross Station, which is where she placed the magical gateway into the wizarding world.

3144. The first print run of *Harry Potter and the Philosopher's Stone* was 1,000 copies.

3145. Rowling based Quidditch, the game played at Hogwarts on her favorite sport, basketball.

3146. Quidditch has itself become a real sport, with teams on several university campuses.

3147.

The Harry Potter movie series is the second highest-grossing movie series in cinema history.

3148. In June 2020, Rowling faced backlash for a series of tweets that suggested she didn't believe trans women are women.

3149. In response to a headline referencing "people who menstruate," Rowling wrote: "I'm sure there used to be a word for those people. Someone help me out. Wumben? Wimpund? Woomud?"

3150. Stieg Larsson's main character in his Millennium series, Lisbeth Salander, is based on Larsson's imaginings of what a grown-up Pippi Longstocking (from the Astrid Lindgren books) might be like.

3151. A book challenge is a documented request by a person or group to remove a book from a library or from a student reading list.

3152. A book ban is a successful book challenge.

3153. The top reasons books are challenged include offensive language, sexual content, and unsuitability for the age group.

3154. Other reasons books are challenged include violence, homosexuality, religious viewpoint, satanism, nudity, racism, drugs, alcohol, smoking, and anti-family sentiments.

3155. Merriam Webster's 10th edition dictionary was removed from classrooms in Southern California in 2009, after a parent complained about a child reading the definition for "oral sex," and that the "sexually graphic" entry is "just not age appropriate."

3156. Betti Cadmus, a district spokeswoman said, "It's hard to sit and read the dictionary, but we'll be looking to find other things of a graphic nature."

3157. In the 1920s, The New York Society for the Suppression of Vice successfully worked toward the banning of James Joyce's *Ulysses* after an excerpt from the book was published in which the main character pleasured himself.

3158. The book was considered contraband for over a decade until the landmark obscenity court case *United States* v. *One Book Called Ulysses* in 1933 lifted the ban.

3159. The UK banned *Ulysses* until the mid-1930s for its explicit sexuality and graphic depiction of bodily functions.

3160. In 1983, some parents in Ohio challenged *Harriet the Spy* because it taught children to lie, spy, and back-talk. The challenge failed.

3161. In the 1990s, 5 Judy Blume books for young adults were on the most frequently banned list. The books were *Forever*; *Blubber*; *Deenie*; *Tiger Eyes*; and *Are You There, God? It's Me, Margaret*.

3162.

Judy Blume donated 3 copies of *Are You There, God? It's Me, Margaret* to her children's school, but the "male principal decided that the book was inappropriate because of the discussion of menstruation."

3163. A small image of a topless sunbather caused trouble for the first 1987 edition of *Where's Waldo?* In 1992, a parent in New Hampshire, didn't find Waldo with her 5-year-old daughter, but she did find a topless sunbather being poked in the back by a boy with an ice cream cone. The book was removed from shelves where the woman bought the book.

3164. *Where's Waldo?* originated in the UK, where it is known as *Where's Willy?* and where it is also legal to sunbathe topless at beaches.

3165. In 2020, a liberal California school district ruled that the novels *The Cay*; *Roll of Thunder, Hear My Cry*; *To Kill a Mockingbird*; *The Adventures of Huckleberry Finn*; and *Of Mice and Men* were no longer mandatory reading because they were racially insensitive.

3166. In 2021, a San Antonio school district removed 414 books from libraries in response to lawmakers investigating inappropriate content in schoolbooks.

3167. This came in response to Texas governor Greg Abbott's directive to the Texas Education Agency to develop statewide standards for keeping "pornography and other obscene content" and any books that "make students feel discomfort, guilt, and anguish" out of public schools.

3168. The majority of the more than 800 books listed in the investigation are written by women, people of color, and LGTBQ writers.

3169. Shel Silverstein's book of humorous poems for children, *A Light in the Attic*, was banned in a school in Wisconsin because one of the poems would "encourage children to break dishes, so they won't have to dry them."

3170. A school in Wisconsin challenged *A Light in the Attic* because it "glorified Satan, suicide, and cannibalism, and also encouraged children to be disobedient."

3171. In 2006, E.B. White's children's classic *Charlotte's Web* was challenged by parents in a Kansas school district because they thought it was unnatural for animals to talk. They also said that "showing lower life forms with human abilities is sacrilegious and disrespectful to God."

3172. Members of the Alabama State Textbook Committee wanted to ban Anne Frank's *Diary of a Young Girl*, because in their own words, it was "a real downer."

3173.

Soviet dictator Joseph Stalin banned George Orwell's *1984* as he viewed the book as an attack on his ruling style. That ban lasted until 1990.

3174. Banned Book Week is an annual celebration of the freedom to read. It began in 1982.

3175. The "Top" Banned and/or Challenged Book from 2000 to 2009 were all the books in the Harry Potter series.

3176. The most challenged book from 2001–2013 is the Captain Underpants series by Dav Pilkey.

3177. Through the Looking Glass was banned in China in 1931, because the Censor General Ho Chien felt that attributing human intelligence to animals was an insult to humanity.

3178. The 2005 picture book And Tango Makes Three by Justin Richardson (the true story of 2 gay penguins in New York's Central Park Zoo) was challenged and/or banned by several school districts in the US due to the fact that it challenged conservative views of adoption and same-sex marriage, and spreading the idea of homosexuality in animals.

3179. To Kill a Mockingbird is one of the most challenged classics of all time, according to American Library Association. Why? Because of racial slurs, profanity, and blunt dialog.

3180. Suzanne Collins, author of the Hunger Games series, began her writing career in children's television.

3181. Collins worked on several Nickelodeon shows, including Clarissa Explains It All and The Mystery Files of Shelby Woo.

3182. Suzanne Collins also wrote multiple stories for the Emmy-nominated Little Bear and cowrote the Rankin/Bass Christmas special Santa, Baby! and many episodes of Clifford's Puppy Days.

3183. The Maltese Falcon, written by Dashiell Hammett, was published in book form in 1930. It was originally published as a series of stories in the pulp detective and adventure magazine, Black Mask.

3184. Hammett's character, Sam Spade, is based on Hammett's time as a Pinkerton Detective Agency operative from 1917 to 1922. Spade became the archetype of the hard-boiled, misunderstood detective. The Pinkerton Detective Agency was established around 1850 in the US and became famous for foiling a plot to assassinate president-elect Abraham Lincoln.

3185. Hammett's stories often used a MacGuffin: an object, event, or character in a film or book that drives the plot, but in the end, has no intrinsic value to the story. It's simply there to set the plot in motion and give the characters something to care about. *The Maltese Falcon* is considered a classic example of this device. Other MacGuffins include the briefcase in *Pulp Fiction*, Colonel Kurtz in *Apocalypse Now*, and Doug (the guy they leave on the casino roof) in *The Hangover*.

3186. The term "MacGuffin" was coined by screenwriter Angus MacPhail and popularized by Alfred Hitchcock in movies such as *The 39 Steps* (plans for a silent plane engine) and *Notorious* (radioactive uranium). Hitchcock once said, "The MacGuffin is the thing the spies are after, but the audience doesn't care."

3187. *Fear and Loathing* author Hunter S. Thompson would shoot his books as an autograph.

3188. Author Dan Brown (*The Da Vinci Code*) started his career off as an unsuccessful pop singer.

3189. James Baldwin (1924–1987) was born in Harlem during the Jazz Age. He was a celebrated novelist, essayist, and playwright who focused on issues of race, class, and sexuality.

3190.

After World War II, Baldwin left for Paris and then Switzerland. In a 1948 interview, Baldwin talked about leaving the US: "My luck was running out. I was going to jail; I was going to kill somebody or be killed."

3191. Baldwin also worked as a film critic. His 1976 book, *The Devil Finds Work*, is a book-length essay about his life watching movies, politics of art in America, and more.

3192. His take on *The Exorcist*: "The mindless and hysterical banality of evil presented in *The Exorcist* is the most terrifying thing about the film. The Americans should certainly know more about evil than that; if they pretend otherwise, they are lying, and any Black man, and not only Blacks—many, many others, including White children—can call them on this lie, he who has been treated as the devil recognizes the devil when they meet."

3193. Romantic poet Percy Bysshe Shelley was vegan. He wrote pamphlets promoting the benefits of not eating meat or dairy products.

3194. Jack Kerouac (1922–1969) wrote *On the Road* over a 3-week period on one scroll of several 12-foot-long sheets of paper that he taped together. The whole book is one continuous paragraph.

3195. *On the Road* chronicles the adventures of Dean Moriarty and his pals as they restlessly crisscross the US. The characters in the book are based on real Beat Generation people. For example, Dean Moriarty is Neal Cassady, who was once described as "the real genius behind the Beat movement."

3196. William S. Burroughs's novel *Naked Lunch* was supposed to be called *Naked Lust*, but he changed the title when Jack Kerouac mispronounced it. The mispronunciation stuck.

3197. *Naked Lunch* was the last important book in the US to be prosecuted for obscenity.

3198. William S. Burroughs shot and killed his common-law wife, Joan Vollmer, in the head while at a friend's apartment in Mexico. Burroughs allegedly pulled out a handgun and said, "It's time for our William Tell act." Vollmer then put a glass on her head.

3199. *The Great Gatsby* by F. Scott Fitzgerald, often dubbed "the great American novel," was published in 1925 to lukewarm reviews.

3200. The book went through only 2 printings, and years later, many copies remained unsold. Today, more than 25 million copies have been sold worldwide.

3201. F. Scott Fitzgerald's father was the first cousin, once removed, of Mary Surratt, a woman hanged in 1865 for conspiring to assassinate Abraham Lincoln.

3202.

In 2010, using an algorithm, Google stated that in the history of humankind, 129,864,880 books have been published.

3203. Since its publication in 1960, To Kill a Mockingbird has never been out of print in hardcover or paperback. It won the Pulitzer Prize in 1961.

3204. To Kill a Mockingbird, which took on topics of racial inequality and rape, was Harper Lee's first and only published novel . . . until the publication of Go Set A Watchman in 2015.

3205. Promoted as a sequel, Watchman was actually a first draft of To Kill a Mockingbird, with many passages being used in both books. The plot follows an adult Scout Finch (who is a child in To Kill a Mockingbird), who returns to her Alabama hometown to visit her father, Atticus.

3206. The character of Dill is modeled on famed writer Truman Capote, her childhood friend who at the time was known as Truman Persons. Capote lived next door to Lee with his aunts while his mother visited New York City.

3207. Meanwhile, in Capote's 1966 book *A Christmas Memory*, the character Nelle is based on Harper Lee, whose first name is Nelle.

3208. In 1960, Capote and Lee traveled to Kansas together to investigate the multiple murders that were the basis for Capote's nonfiction novel *In Cold Blood*.

3209. A *bildungsroman* is a literary genre that focuses on the psychological and moral growth of a protagonist from childhood to adulthood. The term comes from the German words "bildung" (education) and "roman" (novel).

3210. A *künstlerroman* is a narrative of an artist's coming of age.

3211. A *Roman á clef* is a novel about real-life events that is overlaid with a façade of fiction with fictitious names for real people.

3212. Madeleine de Scudéry created the *roman à clef* in the 17th century to provide a forum for her thinly veiled fiction featuring political and public figures.

3213. The small penis rule is a strategy used by authors to evade potential libel lawsuits. It was described in the 1998 *New York Times* article thusly: "For a fictional portrait to be actionable, it must be so accurate that a reader of the book would have no problem linking the 2. Thus, libel lawyers have what is known as 'the small penis rule.' One way authors can protect themselves from libel suits is to say that a character has a small penis. Now no male is going to come forward and say, 'That character with a very small penis, that's me!'"

3214.

In 2004, when Oprah named *Anna Karenina* by Leo Tolstoy as the next book for her book club, it shot to number one on the *New York Times'* bestseller list—126 years after its initial publication.

3215. Tolstoy revolutionized novel writing with a stream-of-consciousness writing style used in this novel, which went on to influence writers such as James Joyce and Virginia Woolf.

3216. While writing his 1857 novel, *Madame Bovary*, Gustave Flaubert was so sickened by his main character that he had to take time off from writing the novel to recover his health.

3217. One of the first realist novels (as opposed to his Romantic predecessors), *Madame Bovary* features a main character who is difficult to like. She fantasizes about escaping her dull husband. She cares more about her window treatments than her family. She has an affair.

3218. Before deciding on a raven to quote "nevermore" in his famous poem "The Raven," Edgar Allan Poe (1809–1849) played with having an owl say the word . . . and a parrot.

3219. The Baltimore Ravens (football) is the only example of a major sports team being named after a work of literature.

3220. Edgar Allan Poe married his 13-year-old cousin when he was 26.

3221. In 1844, Poe published a story in *The Sun*, a New York newspaper, which tells of a man crossing the Atlantic Ocean in a hot-air balloon in 3 days. Poe admitted it was a hoax, and the paper retracted the story—but not before causing a lot of excitement.

3222. Edgar Allan Poe's prose poem "Eureka" predicts the Big Bang theory.

3223. Poe wrote Gothic horror, ghost stories, science fiction, and detective stories—pioneering each of these genres. He was also the first to coin the term "short story."

3224. In 1863, 14 years after his death, psychic medium Lizzie Doten published a book called *Poems from the Inner Life*. The book included poems she claimed to have gotten from the ghost of Edgar Allan Poe.

3225. Poe invented the word "tintinnabulation" to describe the sound of ringing bells. It appears in his poem "The Bells."

3226. Poe liked cryptography and wrote the first story that involves decoding a document. The story is called "The Gold-Bug."

3227.

Poe died penniless at the age of 40. He was found on the streets of Baltimore, Maryland.

3228. The only book successful enough to be republished in Poe's lifetime was a book he edited on mollusks.

3229. No one knows for certain how Edgar Allan Poe died, but theories include, suicide, murder, cholera, hypoglycemia, rabies, syphilis, and the flu.

3230. The first edition of the *Oxford English Dictionary*, the definitive historical dictionary of the English language, was 10 volumes and 15,490 pages and took 70 years to complete.

3231. Stephen King's advance for his first novel, *Carrie*, was $2,500. His paperback advance, however, was $400,000.

3232. Stephen King actually threw the manuscript for *Carrie* away, out of frustration. His wife, Tabitha King, retrieved it and encouraged him to finish it.

3233. Tabitha King encouraged King to change his second novel's title from *Second Coming* (which she said read like a "bad sex story") to *'Salem's Lot*.

3234. King's 1977 novel *Rage* was put out of print at King's request after it was associated with a school shooting in 1997.

3235. Between 1977 and 1985, Stephen King wrote 7 novels under the name Richard Bachman. He did this because his publishing company didn't want to oversaturate the market with King's books.

3236. King wanted to answer the question of whether his success as a writer was talent or luck. Writing as Richard Bachman, King had the books released with little marketing in order to "load the dice" against Bachman. King has since said he was "outed" too soon to know if Bachman would have sold as many books as King himself.

3237. The Richard Bachman book *Thinner* sold 28,000 copies, and then 10 times that when it was revealed King was the actual author.

3238. King used a bogus author photo on the jackets of his Bachman books. The photo was actually Richard Manuel, his literary agent.

3239. King had Bachman die of "cancer of the pseudonym."

3240. Stephen King was hit by a van not far from his summer home in Maine in 1999. He suffered multiple injuries. Later, he bought the van that hit him for $1,500, and he said, "I'm going to take a sledgehammer and beat it." His lawyer said he bought it "to prevent it from appearing on eBay."

3241. Stephen King's wife, Tabitha, is a writer and has published several novels. The Kings' oldest son is Joe Hill, a bestselling author. Their youngest, Owen, wrote a collection of short stories and a novella. Their daughter, Naomi, is a minister.

3242. British author Doris Lessing sent 2 novels to her publisher under a pen name. They were both rejected. Lessing used this episode to show how difficult it is for new authors to get published.

3243. The first English edition of Aesop's fables was published in 1484. The fables were meant for adults and were cautionary tales about politics and society. It wasn't until the 1700s that the fables were used to teach moral values to children.

3244. Ernest Hemingway (1899–1961) earned the Italian Silver Medal of Valor while serving as an ambulance driver in Italy during World War I. He was badly wounded by mortar fire but managed to save another soldier's life.

3245. Hemingway also won a US Bronze Star, 30 years later, for courage displayed as a journalist covering World War II.

3246. A *Farewell to Arms*, published in 1929, is a semi-autobiographical novel. Like the soldier in this book, Ernest Hemingway was an ambulance driver on the Italian front during World War I. And, like his protagonist, Hemingway was injured in the line of duty and fell in love with his caregiver.

3247.

Hemingway rewrote the last page of his bestselling A *Farewell to Arms* 39 times.

3248. Sharpening pencils helped Hemingway think when he was writing.

3249. As a war correspondent, Hemingway led a band of French Resistance fighters in a French town following D-Day in 1944. As a civilian (not allowed to lead armed troops), Hemingway found himself charged with war crimes.

3250. Hemingway was charged with stockpiling weapons in his hotel room, commanding Resistance operatives, and removing items from his clothing that identified him as a journalist. He was eventually cleared.

3251. In 1954, Hemingway and his fourth wife, Mary Welsh, survived back-to-back plane crashes. The first was a sightseeing charter flight in Belgian Congo that hit a pole and crashed. Hemingway and Walsh then boarded another flight for medical care and crashed upon takeoff. They both survived but got to read their obituaries after it was assumed they had died.

3252. In 1928, Hemingway stored 2 trunks of notebooks detailing the years he lived in Paris. He returned to the trunks in 1956, and transcribed the notebooks into his memoir, *A Moveable Feast*.

3253. In 1922, Hemingway's wife lost a bag that contained all of his manuscripts—including copies. The bag was never found.

3254. Nine years after Thomas Wolfe's death, Ernest Hemingway wrote to his publisher, Charles Scribner, and said, "Tom Wolfe was a one-book boy and a glandular giant with the brains and the guts of three mice."

3255. In the same letter, Hemingway called F. Scott Fitzgerald "a rummy and a liar . . . with the inbred talent of a dishonest and easily frightened angel."

3256. Hemingway and author James Joyce were drinking buddies in Paris in the 1920s. Whenever Joyce got into a fight, he'd jump behind Hemingway and yell, "Deal with him, Hemingway! Deal with him."

3257. Modernist author James Joyce (1882–1941) (*Dubliners, A Portrait of the Artist as a Young Man, Ulysses* and more) was intensely afraid of thunder and lightning (astraphobia). His Catholic governess told him when he was a child that thunder was God being angry with him.

3258. James Joyce created the word "tattarrattat" to describe a knock at the door.

3259. James Joyce created a 100-letter word in his book *Finnegans Wake* to represent the sound thunder made at the beginning of the world: *Babababadalgharaghtaka-mminarronnkonnbronnton nerronntuonnthunntrovarrhounawnskawntoohooh oordenenthurnuk.* It is made up of different words for "thunder" in French (*tonnerre*), Italian (*tuono*), Greek (*bronte*), and Japanese (*kaminari*).

3260. A more popular word from *Finnegans Wake* was "quark." In the book, three seabirds say, "Three quarks for Muster Mark!" Physicist Murray Gell-Mann liked the word, so proposed using it to name a subatomic particle.

3261. Joyce liked to joke that the title of his book of poems, *Chamber Music*, was referencing the sound of urine hitting the side of a chamber pot.

3262. Joyce's contemporary Virginia Woolf was not a fan. She called his writing "a queasy undergraduate scratching his pimples." Woolf hoped he would grow out of it, but "as Joyce is 40 this scarcely seems likely."

3263. Joyce's lifetime partner and muse, Nora Barnacle, once asked him, "Why don't you write sensible books that people can understand?"

3264. One of Joyce's erotic letters to Nora Barnacle sold for $446,422 at an auction in 2004.

3265. Joyce set his novel *Ulysses*, on the date of June 16, 1904—which is thought to be the day he had his first date with Nora. Today, this date is celebrated as Bloomsday after a character in the book.

3266. Joyce had horrible eyesight, which didn't improve even after up to 12 surgeries. This forced him to write and edit on large sheets of paper or cardboard using different colored crayons.

3267. Joyce's last words were said to have been, "Does nobody understand?"

3268. Marcel Proust's *Remembrance of Things Past* is considered the longest book in the world, coming in at 1.3 million words. His longest sentence in the book is 958 words.

3269. Tolstoy's mammoth *War and Peace* was copied by hand by his wife, Sophia Tolstaya, a total of 7 times. She worked by candlelight after the children had gone to bed.

3270. Rudyard Kipling (1865–1936) was the first English-language writer to win the Nobel Prize in Literature. And at 41 years old, he was also the youngest recipient.

3271. The bestselling book of all time—barring books whose sales can't easily be tracked such as *The Bible*, *Quran*, and *Quotations from Chairman Mao*—is *Don Quixote* by Miguel de Cervantes, with 500 million copies sold.

3272.

Guinness World Records names L. Ron Hubbard the most prolific writer of all time, with 1084 published works between 1934 and 2006.

3273. Despite what Guinness World Records says, Spanish romance writer Corín Tellado has published 4,000 books.

3274. Corín Tellado has sold anywhere from 600 million to 1 billion books.

3275. Charles Dickens showed signs of obsessive-compulsive behavior. For instance, he combed his hair 20 times a day and rearranged the furniture of any hotel room he stayed in.

3276. The famously reclusive author J.D. Salinger (1919–2010) published only one novel in his lifetime: *The Catcher in the Rye*, despite the fact he wrote every day until his death.

3277. Salinger wrote several chapters of *The Catcher in the Rye* while fighting on the front lines in World War II.

3278. While in Paris after the Germans surrendered the city in 1944, Salinger drove a jeep to the Ritz hotel, where he knew he'd find Ernest Hemingway (who was a war correspondent at the time). They talked about writing over drinks, and Salinger called him "a really good guy."

3279. Salinger suffered a nervous breakdown—now labeled as PTSD—after the war and was hospitalized.

3280. Salinger refused to allow his publisher to use an author photo for publicity.

3281. After the publication of *The Catcher in the Rye* and its immediate success, Salinger only gave one interview—to a high school student. When the interview ended up in a local paper, he put up a 6'6" fence around his property.

3282. In 1948, Salinger sold the rights to his story "Uncle Wiggily in Connecticut," to movie producer Darryl Zanuck. It was released in 1949 as *My Foolish Heart*. Salinger hated it.

3283. Salinger once dated Eugene O'Neill's daughter, Oona. She dumped Salinger for Charlie Chaplin.

3284.

According to his daughter, Salinger drank his own urine and spoke in tongues.

3285. Maurice Sendak's (1928–2012) famous children's book *Where the Wild Things Are* was originally going to be called *Where the Wild Horses Are*. However, Sendak realized that he couldn't draw horses. When his editor asked what he could draw, Sendak replied, "things."

3286. Sendak's "wild things" were inspired by his immigrant relatives from his childhood. They would come for Sunday lunch each week and say things like, "You look so good we could eat you up."

3287. When first released, psychologists feared *Where the Wild Things Are* would be too traumatizing for young children. One said the book would cause a fear of desertion, and that Max's tantrum in the book glorifies unacceptable behavior.

3288. Sendak worked for 3 years as a window dresser at F.A.O. Schwarz (where he met his future editor). He also illustrated a textbook called *Atomics for the Millions* in 1947.

3289. In 2003, Sendak illustrated a book, *Brundibar*, written by the playwright Tony Kushner. The book was based on an opera by Hans Krása that was performed by children in the concentration camp Theresienstadt.

3290. Sendak's brother Jack was also a children's book author, 2 of which Maurice illustrated.

3291. In one of his last public appearances, Sendak went on *The Colbert Report* to teach comedian Stephen Colbert how to write a picture book. The book, *I Am a Pole (And So Can You!)*, was released on May 8, 2012—the day Maurice Sendak died.

3292. The phrase, "Elementary, my dear Watson," never appears in any Sherlock Holmes stories.

3293. Sir Arthur Conan Doyle wrote the very first Sherlock Holmes novel, *A Study in Scarlet*, in just 3 weeks.

3294. Nathanael West's 1939 novel *The Day of the Locust* features a character named Homer Simpson. But it's not where *The Simpsons* creator got the name from. (Homer was his father's name.)

3295. Roald Dahl, author of *Charlie and the Chocolate Factory*, was once a taste-tester for Cadbury's chocolates.

3296. The Ford Motor Company asked the poet Marianne Moore to come up with inspirational names for their new 1955 cars. They did not use any of the names she came up with: Mongoose Civique, Resilient Bullet, the Intelligent Whale, the Ford Fabergé, Ford Silver Sword, Varsity Stroke, or Utopian Turtletop. They went with Edsel instead.

3297.

In early 1939, advertising copywriter Robert May was tasked with writing a "cheery children's book" to give to holiday shoppers at the department store Montgomery Ward, where he worked. The book he wrote was called *Rudolph the Red-Nosed Reindeer*.

3298. Montgomery Ward gave out 2.4 million copies of *Rudolph the Red-Nosed Reindeer* during the 1939 holiday season.

3299. Before landing on the name "Rudolph" for his main character, May flirted with calling him Rodney, Roddy, Roland, Reggy, Reginald, or Romeo.

3300. *The Power of Sympathy* by William Hill Brown was published in 1789 and is considered the first American novel. Brown's novel was based on true events, and follows 2 young lovers who realize they are siblings.

3301. Thomas Wolfe (1900–1938), the author of *Look Homeward, Angel*, was 6'6' tall and his hands were too big to use a typewriter. So, he used the top of his refrigerator as his desk.

3302. Czech novelist and short-story writer Franz Kafka (1883–1924) never earned income as a writer. He worked for insurance companies. Today, he is regarded as one of the major figures of 20th-century literature.

3303. He wrote in his spare time and burned 90 percent of all his writings due to self-doubt. He instructed his friend Max Brod to destroy all of his unpublished works after his death. Brod ignored the instructions and had much of the work published, including Kafka's most famous novel *The Trial*.

3304. Kafka suffered from clinical depression, social anxiety, insomnia, and tuberculosis.

3305. Kafka's father, Hermann, was a business owner and frequently tormented his son. Kafka later admitted to his father, "My writing was all about you." He believed that his father broke his will and caused him lifelong insecurity and guilt.

3306. The 1998 Ig Nobel Prize award in Literature was presented to Dr. Mara Sidoli of Washington, D.C., for her report, "Farting as a Defense against Unspeakable Dread."

3307. Edgar Rice Burroughs, author of the Tarzan series of books, was a pencil sharpener salesman until he decided to give writing a try.

3308. The author of *Goodnight Moon*, Margaret Wise Brown, requested that her tombstone read, "Writer of songs and nonsense."

3309. Robert Frost's epitaph is, "I had a lover's quarrel with the world."

3310. John Keats's epitaph reads, "Here lies one whose name was writ in water."

3311.

H.G. Wells wanted his epitaph to read, "Goddamn you all: I told you so." It was not included on any of his memorial plaques.

3312. William Shakespeare's grave includes a curse: "Good friend for Jesus sake forbear, / To dig the dust enclosed here. / Blessed be the man that spares these stones. And cursed be he that moves my bones." He was afraid his grave might be robbed.

3313. Jonathan Swift's epitaph reads, "Here is laid the body of Jonathan Swift . . . where savage indignation can no longer tear his heart."

3314. F. Scott Fitzgerald's tombstone reads, "So we beat on, boats against the current, borne back ceaselessly into the past." It's the last line from *The Great Gatsby*.

3315. Emily Dickinson's gravestone reads, "Called back."

3316. Dorothy Parker (1893–1963) wrote fiction, poetry, and plays, and was a founding member of the Algonquin Round Table, a group of writers known as much for their drinking as for their literary output.

3317. In 1925, Harold Ross started a tiny start-up magazine called *The New Yorker* and hired Dorothy Parker as one of his first staff writers. One day, when Ross demanded to know why she didn't show up for work, Mrs. Parker replied, "Someone was using the pencil." Parker wrote for the magazine for 30 years.

3318. In 1928, Dorothy Parker wrote a satirical article in *The New Yorker* making fun of A. A. Milne's *The House at Pooh Corner*." After quoting several passages from the book, she wrote that she "fwowed up."

3319. Dorothy Parker's epitaph read "Excuse my dust."

3320. After Parker's death, her ashes were left unclaimed in a filing cabinet for 20 years.

3321. With no descendants, Parker left her estate (including future royalties) to Martin Luther King Jr. When he was assassinated, the estate was inherited by the NAACP. The organization approves all uses of Parker's writing to this day.

CHAPTER 16
COMICS

3322. The first newspaper comic strips appeared in the 1890s.

3323. The *Chicago Inter Ocean* was the first newspaper in the US to feature a color supplement in 1892. Joseph Pulitzer added a color supplement to the *New York World* in 1893.

3324. The Yellow Kid in the cartoon strip called *Hogan's Alley* by Richard F. Outcault was one of the most famous early comic characters. The Yellow Kid was an Irish immigrant street urchin in New York City.

3325. The Yellow Kid's dialog appeared on his yellow gown.

3326. *Hogan's Alley* first appeared in the *New York World* (Joseph Pulitzer's newspaper).

3327. Richard Outcault moved to William Randolph Hearst's paper, *New York Journal*, soon after, bringing the Yellow Kid with him. Pulitzer simply kept publishing the strip with a new artist. This led to two different strips with the same character appearing in competing newspapers.

3328. The term "yellow journalism," meaning a sensational style of journalism, was coined due to the two newspapers and their competing Yellow Kid strips.

3329. Richard Outcault moved on from the Yellow Kid and created Buster Brown.

3330. In 1904, Buster Brown became the mascot of the Brown Shoe Company.

3331. Charles Schulz's comic strip *Peanuts* ran from 1950 to 2000 and is considered the most influential and beloved strip of all time.

3332. Schulz created 17,897 strips.

3333. Schulz died at the age of 77, the day before his last original strip ran.

3334. At its peak, *Peanuts* ran in 2,600 newspapers in 75 countries.

3335.

Peanuts was first called L'il Folks.

3336. When Schultz signed with United Feature Syndicate in 1950, they changed the name to *Peanuts*. Schultz hated the name.

3337. The first *Peanuts* strip in 1950 featured Charlie Brown, Shermy, and Patty.

3338. It ran in 7 newspapers.

3339. Charlie Brown isn't quite bald—he has a few strands of hair.

3340. Charlie Brown never did get to kick the football.

3341. Schulz's son Craig said that Charlie Brown represents Charles Schulz and Snoopy represents the way Schulz wished he could be.

3342. The first character to pull the football away from Charlie Brown wasn't Lucy. Violet did it first in a 1951 strip. When Schulz was asked if Charlie Brown will ever get to kick the football, he said, "Definitely not. I couldn't have Charlie Brown kick that football; that would be a terrible disservice to him after nearly half a century." However, when recounting signing the panel of his final strip, he said, "All of a sudden, I thought, 'You know, that poor, poor kid, he never even got to kick the football. What a dirty trick—he never had a chance to kick the football.'"

3343. A *Charlie Brown Christmas* is the first Peanuts TV special and the first 30-minute Christmas TV special ever.

3344. Linus has a younger brother named Rerun.

3345. Linus appeared as Lucy's security-blanketed younger brother in September 1952, but didn't get a line in the comic until 1954.

3346. In 1954, Schulz introduced Charlotte Braun, a female counterpoint to Charlie Brown. Negative feedback from fans led to Schulz abandoning the character a few months later.

3347. Schulz wrote back to one fan, "You . . . will have the death of an innocent child on your conscience . . ." He also drew an image of Charlotte Braun with an axe in her head. The letter is now at the US Library of Congress.

3348. A young Stacey Ferguson, a.k.a. musician Fergie, voiced Sally Brown from 1983 to 1985.

3349. Fergie's voice can be heard in *The Charlie Brown and Snoopy Show* and in the special *Snoopy's Getting Married*.

3350. Franklin Armstrong, the first and only African American *Peanuts* character, made his comic strip debut on July 31, 1968.

3351. Franklin's inclusion in the comic came about after a correspondence between Charles Schulz and Harriet Glickman, a retired schoolteacher. Glickman wrote, "Since the death of Martin Luther King, I've been asking myself what I can do to help change those conditions in our society which led to the assassination and which contribute to the vast seas of misunderstanding, fear, hate, and violence."

3352. Schulz first replied that by introducing an African American character, he was "faced with the same problem that other cartoonists are who wish to comply with your suggestion. We all would like very much to be able to do this, but each of us is afraid that it would look like we were patronizing our Negro friends . . . I don't know what the solution is."

3353. One editor protested against a strip where Franklin sat in the same row of with Peppermint Patty at school. The editor said, "We have enough trouble here in the South without you showing the kids together in school."

3354. When asked to change the strip, Schulz told the president of United Features, "Either you print it just the way I draw it or I quit. How's that?"

3355. Schulz originally wanted to call Snoopy the dog Sniffy. But a dog with the same name was already in another comic strip.

3356.
Charlie Brown's unrequited love, the Little Red-Headed Girl, was inspired by an accountant Schulz had fallen in love with. He proposed to her in 1950, but she said no.

3357. Peanuts has won 2 Grammys, 4 Emmys, and 2 Tonys. A Boy Named Charlie Brown was nominated for an Oscar for best original song score, but it did not win.

3358. Schulz took only 1 vacation while Peanuts was running. His 5-week vacation in 1997 was the only time reruns were published before his death.

3359. According to Psychology Today, Charlie Brown is a model neurotic, prone to depression and anxiety and "paralyzing fits of over-analysis."

3360. Others say Charlie Brown suffers from avoidant personality disorder (APD), in which a person has a lifelong pattern of feeling shy, inadequate, and sensitive to rejection.

3361. In 2022, a school board in Tennessee voted 10 to 0 to ban the teaching of the Pulitzer Prize-winning Holocaust graphic novel *Maus*. Why? Because it contained swear words and a depiction of a naked character.

3362. Art Spiegelman, the author of *Maus*, said "This is disturbing imagery, but you know what? It's disturbing history."

3363. Nirvana Comics, a Knoxville comic bookstore, raised more than $100,000 in order to give any student who wanted one a free copy of *Maus*.

3364. Sales of *Maus* soared 753 percent following the ban, according to NPD Bookscan.

3365. In the 1940s, Dr. Fredric Wertham, a German-born psychiatrist, worked in a charitable hospital in Harlem treating juvenile delinquents. He noticed that many of the delinquents he worked with read comic books. He concluded that comic books inspired children to become criminals.

3366. Wertham presented symposiums and wrote articles condemning comic books, which led to a moral panic and to comic book burnings in several communities . . . just a few years after defeating the Nazis in World War II.

3367. In 1954, the Comics Magazine Association of America formed the Comics Code Authority (CCA) in response to widespread public concern over graphic violence and horror imagery. The code didn't become fully defunct until 2011.

3368. Examples of Comics Codes include: Crimes shall never be presented in such a way as to create sympathy for the criminal, to promote distrust of the forces of law and justice, or to inspire others with a desire to imitate criminals; and policemen, judges, government officials, and respected institutions shall never be presented in such a way as to create disrespect for established authority.

3369. *The Far Side* by Gary Larson first appeared in *The San Francisco Chronicle* in 1979 and was always a single-panel comic. Its original name was *Nature's Way*.

3370. Larson wrote a letter to his followers in October 1994, that explained he was ending *The Far Side* due to "simple fatigue" and to avoid having it fall into the "Graveyard of Mediocre Cartoons."

3371. During its 15-year run, Larson produced a total of 4,337 *Far Side* cartoons.

3372. By the time of its conclusion, the series was carried in more than 1,900 papers and translated into 17 languages.

3373. *Calvin and Hobbes* creator Bill Watterson didn't want any merchandise to be created based on his characters.

3374.

The term "comic book" originally referred to comic strips that were compiled into book form.

3375. Marvel was originally called Timely Comics. Its creator, Martin Goodman, changed the name to Atlas Magazines in 1951. It became Marvel Comics in the early 1960s.

3376. Timely's first comic book was *Marvel Comics no. 1* (October 1939), which featured several superheroes, including the Human Torch and the Sub-Mariner.

3377. Captain America first appeared in *Captain America Comics no. 1* (March 1941).

3378. Marvel went bankrupt in 1996.

3379. Marvel became a wholly owned subsidiary of the Disney Company in 2009. Disney paid $4 billion.

3380. Marvel introduced a character named Jihad 11 days before the 9-11 attacks. Jihad was bent on world destruction. He was quickly written off.

3381. Marvel created an amphibian named Throg who wields the Frog Mjolnir, which was a sliver of Thor's hammer, which transformed into a mini hammer that gave Throg the powers of Thor.

3382. During the early 1990s, Michael Jackson attempted to buy Marvel Comics. Jackson's reason for wanting to buy Marvel was that he wished to star as Spider-Man in his version of the movie.

3383. DC Comics is a wholly owned subsidiary of WarnerMedia. DC is short for Detective Comics.

3384. In 1938, DC published the first Superman story in *Action Comics no. 1*.

3385. *Archie Comics #1* set a record for the highest price paid for a non-superhero comic book.

3386. *Gasoline Alley* was the first comic strip where its characters aged.

3387. According to the comic character Cathy, the 4 basic guilt groups are Food, Love, Mother, and Career.

3388. Archie Comics sued the band the Veronicas for infringing on its trademark.

3389. Stan Lee's (1922–2018) original name was Stanley Martin Lieber.

3390. Stan Lee was hired as an editorial assistant for Timely Comics at the age of 16. Before that, he was writing celebrity obituaries.

3391. Stan Lee got his first writing opportunity one week into his tenure at Timely Comics. He wrote a 2-page comic called, "Captain America Foils the Traitor's Revenge."

3392. During World War II, Stan Lee worked in the army's Training Film Division with eight other men, including director Frank Capra (*Mr. Smith Goes to Washington* and *It's a Wonderful Life*), Pulitzer Prize-winning author William Saroyan, cartoonist Charles Addams (creator of *The Addams Family*), and Theodor Geisel, better known as Dr. Seuss.

3393. Stan Lee's first major success was *The Fantastic Four*.

3394. The Fantastic Four was the story of 4 astronauts who gain superpowers after a cosmic incident.

3395. In 1972, Stan Lee became publisher and editorial director of Marvel.

3396. In the 1960s, Marvel asked Stan Lee for a new superhero. He came up with Spider-Man, which Marvel head Martin Goodman initially rejected because people hate spiders.

3397. Martin Goodman was Stan Lee's uncle by marriage.

3398. Stan Lee appeared in over 30 Marvel movies. Before the movies, his artists often drew him into the comics as a joke.

3399. Stan Lee received the American National Medal of the Arts from President George W. Bush in 2008.

3400. Stan Lee worked with illustrator Steve Ditko to create Spider-Man, who made his first appearance in August 1962, not in his own comic series, but in *Amazing Fantasy #15*.

3401. Spider-Man was the first teenaged superhero who wasn't a sidekick.

3402.

"Spider-Man" is spelled with a hyphen to avoid confusion with other superheroes such as Superman.

3403. Spider-Man's parents were S.H.I.E.L.D. agents who died in a plane crash soon after Peter Parker was born.

3404. Spider-Man's first love wasn't Mary Jane. It was Betty Brant.

3405. In an alternate reality, Peter Parker was once bitten by a radioactive sheep, turning him into a hero named Sheep-Boy.

3406. The first masked crime fighter in comic books was the Clock, who was introduced in 1936 by Centaur Publications.

3407. The Clock was a hypnotist with an underground lair. He wore a tuxedo and a black face mask. His cane could launch a projectile.

3408. The Clock's motto—the note he left for police along with the bad guys tied up was, "The Clock Has Struck."

3409. The first costumed superhero was Superman, who appeared in *Action Comics* #1 in June 1938.

3410. Jack Kirby (1917–1994) is regarded as one the most influential comic book artists of all time. He worked for both Marvel and DC Comics and created or co-created the X-Men, the Fantastic four, Captain America, Thor, Iron Man, and the Hulk.

3411. One of Jack Kirby's early jobs was as an artist for cartoons such as *Popeye the Sailor* and *Betty Boop*.

3412. Working for Timely Comics (later Marvel) in 1941, Jack Kirby created Captain America with artist Joe Simon.

3413. Jack Kirby based the personality of the Thing (from the Fantastic Four) on his own "gruff-but-lovable" personality. The Thing's real name, Benjamin Jacob Grimm comes from Kirby's father's name (Benjamin) and Jack's birth name (Jacob).

3414. In the 1960s, Jack Kirby, upon realizing that he had no diversity in his strips, decided to create a Black superhero.

3415. Jack Kirby's original sketch for the Black Panther was revealed by his grandson in 2019. Called the Coal Tiger, the look was completely revamped, and the character was renamed the Black Panther.

3416. Jack Kirby left Marvel for DC Comics over creative differences with Stan Lee. He returned 5 years later, but then left again after 3 years.

3417. Jack Kirby's heirs sued Marvel Entertainment and the Walt Disney Company over copyright claims for the comics and character Jack Kirby created. A federal judge declared that Kirby's contributions were "work for hire," and could not be claimed by Kirby's family. The 2 sides reached an out-of-court settlement agreement just before the Supreme Court was to hear the case.

3418. The first comic to lampoon superheroes was Harvey Kurtzman's and Wally Wood's 1953 *Superduperman* in *Mad* magazine. It follows the story of Clark Bent, a copy boy's assistant at *The Daily Dirt* who fights crime as Superduperman. His foe was Captain Marbles.

3419. Alan Moore, author of the *Watchmen* comic book series, credits *Superduperman* as a major inspiration.

3420. *Mad* magazine began as a comic book in 1952. It was converted to a magazine in 1954. It satirizes movies, politics, celebrities, TV, and more.

3421. Mad's mascot Alfred E. Neuman wasn't created by the staff at Mad. The magazine's editor, Harvey Kurtzman, found the image on a postcard. The face had been used in the late nineteenth century for advertisements for a form of painless dentistry and for Atmore's Mince Meat, Genuine English Plum Pudding.

3422. Alfred E. Neuman appears on all but a handful of the magazine's 550 covers.

3423. Alfred E. Neuman's signature phrase, "What, me worry?" was originally punctuated "What? Me worry?"

3424. After the partial meltdown of the Three Mile Island nuclear reactor on March 28, 1979, Mad's next issue changed Alfred E. Neuman's phrase to "Yes, me worry."

3425. The most famous cover not featuring Alfred E. Neuman was the April 1974 issue that instead featured a big hand giving the "middle finger."

3426. For a brief time in the 1950s, a female version of Alfred E. Neuman was featured. Her name was Moxie Cowznofski.

3427. In 1958, Mad published letters from readers that said Alfred E. Neuman looked like England's Prince Charles (now King). He was nine years old at the time. Charles replied on official royal letterhead: "Dear Sirs No it isn't a bit—not the least little bit like me. So jolly well stow it!"

3428. Garfield's owner's name is Jon. The dog is Odie.

3429.

Garry Trudeau (creator of *Doonesbury*) was the first comic strip artist to win a Pulitzer Prize for editorial cartooning (1975).

3430. President Ford commented, "There are only 3 major vehicles to keep us informed as to what is going on in Washington: the electronic media, the print media, and *Doonesbury*, not necessarily in that order."

3431. The term "graphic novel" has come to mean a type of text combining words and images that tells a complete story as a book.

3432. The term gained popularity in the late 1970s and was coined by historian Richard Kyle.

3433. One of the first graphic novels is said to be Will Eisner's *A Contract with God, and Other Tenement Stories*, which was published in 1978.

3434. The different types of graphic novels include manga, superhero stories, non-superhero stories, personal narratives, and nonfiction.

3435. A 1997 DC Comics miniseries by Neil Gaiman named *The Books of Magic* is about a dark-haired English 12-year-old boy who discovers his potential as a powerful wizard and receives a gift of a pet owl. Not to be confused with Harry Potter, the 11-year-old boy who discovers his potential as a powerful wizard and receives a gift of a pet owl.

3436. *The Adventures of Dean Martin and Jerry Lewis* was a 40-issue comic book series featuring the 2 comedians that ran from 1952 to 1957.

3437. When the real Jerry Lewis and Dean Martin duo broke up, Jerry Lewis got his own comic books where he met up with Batman, Bob Hope, Lex Luthor, Superman, the Flash, and Wonder Woman.

3438. The anti-superhero Deadpool knows that he is a fictional character in a comic book.

3439. In the comic book *Deadpool Kills the Marvel Universe*, Deadpool kills most of Marvel's superhero roster. He then escapes the comic book world and kills his writers. He threatens to go after the readers, too.

3440. In 2013's *Deadpool Killustrated*, Deadpool murders literary figures such as Huckleberry Finn, Sherlock Holmes, and even Moby Dick.

3441. In the 1970s, DC Comics published a comic book in which Superman loses a fight against boxer Muhammad Ali.

3442. In the Marvel universe, Santa Claus is actually an Omega-level mutant, one of the most powerful ever registered by the X-Men.

3443. In the 1940s, the Green Lama was a powerful Buddhist monk who fought crime while dressed in a green robe.

3444.

Nicolas Coppola took his stage name Nic (Nicolas) Cage from the Marvel comic book character Luke Cage.

3445. Squirrel Girl is a Marvel Comics superhero who first appeared in 1991. She has a squirrel sidekick named Monkey Joe. Squirrel Girl has the ability to communicate with squirrels.

3446. Madame Fatal was a male superhero who dressed up as an elderly woman to fight crimes. He debuted in *Crack Comics* #1 in 1940 and made his way to DC Comics in the '50s.

3447. The 1940's superhero Red Bee fought Nazis with trained bees. His bee Michael lived in his belt buckle.

3448. According to writer Stan Lee, the Incredible Hulk was originally gray. Marvel Comics changed him to green after problems with the consistency of the ink.

3449. In the DC Batman storyline "*A Death in the Family*," The Joker serves as the Iranian ambassador for the United Nations.

3450. In 1965, Archie from Archie Comics is given super strength as Pureheart the Powerful when he invoked the Pure Heart factor from a book he got from the library. In fact, the whole Archie gang got superpowers.

3451. Jughead of Archie Comics actually has a real name: Forsythe Pendleton Jones III.

3452. Stan Lee based the character of Tony Stark (Iron Man) on Howard Hughes. Lee described him as "one of the most colorful men of our time. he was an inventor, an adventurer, a multi-billionaire, a ladies' man, and finally, a nutcase."

3453. Due to a miscommunication between Stan Lee and an illustrator Iron Man's mask had a nose for a short time in the 1970s.

3454. In the 1970s, Iron Man had roller skates.

CHAPTER 17
GAMES & LEISURE

3455. The earliest reference to playing cards is in 10th-century Chinese literature.

3456. Playing cards appeared in Europe in the 1370s, and they were hand-painted.

3457. The suits on these 14th-century Mamluk decks were swords, batons, goblets, and coins.

3458. German cards from later in the 14th-century used acorns, leaves, hearts, and bells.

3459. Today's hearts, spades, diamonds, and clubs are French symbols and didn't become popular until the 1480s.

3460. The markings in the center of a numbered playing card (hearts, spades, diamonds, and clubs) are called pips.

3461. The deck most used today is referred to as the international deck.

3462.

The word "spade" is from the old Spanish "spado" meaning "sword."

3463. The word "club" is a direct translation from the Spanish word "basto."

3464. The court cards were originally depicted full length. This caused problems as opponents could tell when you had a face card when you turned it right side up. Double-headed courts cards were developed to correct this problem in the 1800s.

3465. Every time you shuffle a deck of cards properly, you are creating a sequence of cards that has most likely never happened before in the history of the universe.

3466. The number of ways a standard deck of cards can be ordered (when shuffled) is 52! That's 52 factorial, which means the number of ways is found by multiplying 52 by 51 by 50 by 49 . . . all the way to 1. The answer is 8×10^{67} (8 with 67 zeros after it). That's more than the number of atoms on Earth.

3467. If everyone on Earth shuffled a deck of cards every second since the Big Bang, there would be only a 1 in a trillion, trillion, trillion chance of 2 decks matching.

3468. In 1990, Dr. Persi Diaconis, a former magician-turned-statistics professor at Harvard University, concluded that it takes only 7 shuffles (using the riffle method) to mix a deck of cards thoroughly. Five is not enough, and more than 7 doesn't significantly improve the mix.

3469. During World War II, the US government worked with a card company to make decks of cards for prisoners of war that, when peeled apart, revealed maps to help with escaping.

3470. The Cloisters set of cards is considered the oldest complete deck of playing cards in the world, printed between 1470 and 1480 in the Netherlands.

3471. The suit symbols on the Cloisters set include hunting horns, dog collars, hound tethers, and game nooses.

3472. The image of the King of Hearts, known as the suicide king, since he is seemingly stabbing himself in the head is actually the result of poor copying by card printers. The sword is actually an axe, which lost its head over the years.

3473. The King of Hearts' mustache (he's the only one without one) was also lost due to poor copying methods of card printers.

3474. Poker has been around since the 10th century, but the modern game is said to have sprung up in New Orleans in 1829.

3475.

Poker used to be played with 20 cards until the mid-1800s.

3476. Poker is 1 of the most lucrative sports in the world for participants.

3477. The first televised poker event was the CBS broadcast of the World Series of Poker in 1973.

3478. The Bird Cage Theatre in Tombstone, Arizona, boasts the longest poker game ever. It took place in 1881 and lasted 8 years, 5 months, and 3 days.

3479. The highest hand in poker is a royal flush, which is the ace, king, queen, jack, and 10 of the same suit.

3480. The odds of getting a royal flush are 649,740 to 1.

3481. The second-highest hand is a 4 of a kind, which is all 4 cards of the same rank.

3482. There are approximately 133 million possible 7-card combinations in Texas Hold 'em.

3483. A Dead Man's Hand is when you're holding 2 aces and 2 eights, because those are the cards Wild Bill Hickok was allegedly holding when he was shot dead by John McCall.

3484. A *cruciverbalist* is someone who creates crossword puzzles.

3485. In Connect Four, if you go first and play it right, you can win 100 percent of the time.

3486. A Connect Four board has more than 4 trillion possible outcomes.

3487. In the early 2000s, Life tile awarding the player $100,000 for winning a Nobel Prize was replaced with a new tile providing the same amount for appearing on a reality TV show.

3488. In the 1990s, a convicted murderer in the UK was granted a new trial when it was discovered that 4 of the jurors used a Ouija board to ask 1 of the murdered victims who the killer was.

3489. Alfred Mosher Butts, the inventor of Scrabble, was an architect.

3490. Butts originally named the game Lexico. Then, he changed it to Criss-Cross Words.

3491. James Brunot, Butts's friend and an early producer of the game, came up with the name Scrabble.

3492. Butts determined how many tiles of each letter there should be and how much each letter should be worth by calculating letter frequency on the front pages of issues of the *New York Times.*

3493. If you play all 7 of your letters in 1 play in Scrabble you get 50 extra points.

3494. "Scrabble" is an acceptable Scrabble word.

3495. There are 100 tiles in a Scrabble set.

3496. According to Merriam-Webster, the top words to win at Scrabble include qi, za, phoney, retinas, xu, zloty, hook, gyoza, bingo, and amigo.

3497. A bottle of poison was added as an extra murder weapon in the 50th anniversary edition of Clue.

3498. There are 32 houses and 12 hotels in a Monopoly game.

3499. According to the rules of Monopoly, you do not collect money from the center of the board when you land on Free Parking.

3500. There are 40 spaces on a Monopoly board and 28 properties (22 streets, 4 railroads, and 2 utilities).

3501. Illinois Avenue is the space on the Monopoly board most landed on.

3502. Rich Uncle Pennybags officially had his name changed to Mr. Monopoly by Parker Brothers.

3503.

An economics professor trying to illustrate the virtues of a free market over monopolies published a game called Anti-Monopoly in 1973. In fact, in 1903, an American anti-monopolist, Lizzie Magie, created the original Monopoly as an educational tool that illustrated the negative aspects of private monopolies.

3504. Magie's game was called The Landlord's Game, and she self-published it in 1906.

3505. Parker Brothers bought the rights to Magie's patent for $500.

3506. The streets are based on the streets of Atlantic City, New Jersey.

3507. Marvin Gardens, the farthest yellow property, is a misspelling of its actual name, Marven Gardens.

3508. In 1995, Parker Brothers acknowledged the misspelling and formally apologized to the residents of Marven Gardens.

3509. Hasbro, which owns Parker Brothers, states that the longest game of Monopoly ever played lasted 70 days.

3510. A ringer in horseshoes is worth 3 points.

3511. A close shoe is worth 1 point.

3512. A horseshoe has to be 6 inches from the stake to be considered a close shoe.

3513. A leaner is worth 1 point.

3514. Cornhole was first described in an 1883 patent for Parlor Quoits. The patent called for a square hole instead of a round one.

3515. A bag that falls in the hole is worth 3 points.

3516. A bag on the board is worth 1 point.

3517. A bag partially on the board and partially on the ground is called a dirt bag and doesn't count for any points.

3518. In 1987, the US government banned the sale of lawn darts after a child died when hit by a dart, and there were an estimated 670 related injuries per year.

3519. Ladder toss is a yard game played by throwing bolas, which are 2 balls connected by a string, at a ladder.

3520. Ladder toss is also called ladder golf, goofy balls, testicle toss, dingle balls, cowboy golf, and hillbilly golf.

3521. Word Search puzzles were first published in the 1960s.

3522. The name mah-jongg signifies a mythical "bird of 100 intelligences." The game originated in China, as does its name.

3523.

The ancient Aztec and Mayan Indians of Central America played a game that looked a lot like lacrosse. Except, if your team lost, your captain had his heart removed and passed around for fans to eat.

3524. Another game they played was called *ullamaliztli*, which was played with a heavy, solid rubber ball. Like soccer, you couldn't use your hands to control the ball, but neither could you use your feet. Instead, teams batted the ball around with their hips and buttocks. What happened to the losing team? See above.

3525. The game of ullamaliztli is over 3,000 years old and was banned by the Spanish conquistadors.

3526. Organizers brought the game of ullamaliztli back to Mexico in 2006 and again in 2017.

3527. Giant ullamaliztli ball courts can be seen in ruins throughout the region.

3528.

The Viking name for tug-of-war is *toga honk*, which means "tugging on a loop."

3529. After ransacking a village, the Vikings would sometimes resort to a game of tug-of-war using tied-together animal skins to decide who got the plunder. In the middle, was a roaring fire pit.

3530. *Buzkashi* is an ancient every-man-for-himself polo game played in Afghanistan. Instead of fighting over a ball, however, they used a goat carcass.

3531. During the Tang Dynasty (618 to 907 CE) in China, Emperor Xuanzong promoted tug-of-war as a war game using a 550-foot rope with shorter ropes attached with more than 500 people on either side.

3532. The North American Algonquin tribe played a game in the 17th century that was somewhat like soccer; however, there were up to 1,000 players, and the goals could be a mile away from each other. No yellow cards here, though, as this was a violent game with kicks, fouls, punches, etc.

3533. La soul was a popular game played by peasants in Normandy, Brittany, and Picardy from the twelfth through the nineteenth centuries. The rules were simple: 2 villages or parishes had to get a ball into the opponent's net or onto their side. The game usually got violent and could last for several days—especially since the goals could be separated by miles of farmland, forests, meadows, rivers, etc.

3534. Venetian stick battles date from 1369. These mock battles consisted of mobs of men with shields and helmets, beating each other up on a bridge. Injuries and death were common, but the Venetian government took pride in the games and would invite dignitaries to watch.

3535. In 1574, King Henry III of France called the stick battle he witnessed, "too small to be a war and too cruel to be a game."

3536. Nathan's Famous hot dog eating contest is held every Independence Day in Coney Island, New York, at the corner of Surf and Stillwell.

3537. Contestants have 10 minutes to eat as many hot dogs (along with their buns) as possible. Women and men have separate competitions.

3538. The men's world record is 76 hot dogs, which Joey Chestnut logged in the 2021 contest, breaking his own world record.

3539. Chestnut has won the contest a record 14 times.

3540. The women's record was set in 2020, by Miki Sudo. She ate 48¼ hotdogs.

3541. The first ever Nathan's hot dog eating contest was on July 4, 1926.

3542. The most popular method of eating hot dogs is the dunking method, where contestants dip the buns in water and squeeze out the water before eating. This allegedly helps it slide down their throat.

3543. Another method is called the Solomon Method, which was created by Takeru Kobayashi. Here, you break the hot dogs in half, eat both halves at once, and then eat the bun.

3544.

Bowling dates back to the ancient Egyptians. Miniature pins and balls were found in an Egyptian child's grave that are about 7,200 years old.

3545. Bowling began in Germany around 400 CE as a religious ritual to cleanse oneself from sin by rolling a rock into a pin that represented the heathen.

3546. In 1299, the oldest-surviving known bowling green for target-style bowling was built: Master's Close (now the Old Bowling Green of the Southampton Bowling Club) in Southampton, England, which is still in use.

3547. In 1366, English King Edward III banned bowling because it was a distraction from archery practice.

3548. In 1511, English King Henry VIII was an avid bowler. He banned bowling for the lower classes and imposed a tax for private lanes to limit them to the wealthy.

3549. Protestant Reformation founder Martin Luther had a bowling lane built next to his home for his children.

3550. Bowling balls are about 8.59 inches in diameter and weigh between 6 and 16 pounds.

3551. In bowling, a strike is when you knock all the pins down on the first throw.

3552. A spare is knocking down all the pins on the second throw.

3553. A turkey is 3 strikes in a row.

3554. A 4-bagger is 4 strikes in a row, while a 5-bagger is 5 strikes in a row, and so on.

3555. In the late 1970s, over 9 million Americans belonged to bowling leagues. As of 2018, that number is 1.34 million.

3556.

If a bowling ball bounces out of the gutter and knocks over a pin, the pin does not count for the bowler. This is called an illegal pinfall.

3557. There are 8 holes in a standard wiffle ball.

3558. You don't need bases in an official wiffle ball game.

3559. The Four Square World Championship is held in Maine.

3560. There are 9 wickets in a standard backyard game of croquet. A wicket is a small hoop in the ground you hit your ball through.

3561. Students at Manchester College played Four Square for 30 hours to set a world record in 2011.

CHAPTER 18

SPORTS

3562. Footballer Cristiano Ronaldo is the most-followed person on Instagram with more than 530 million followers.

3563. The first (and to this day only) woman to race and complete the Giro d'Italia was Italian cyclist Alfonsina Strada (1891–1959).

3564. Strada won her first bike race at the age of 13 in 1904. Her prize was a pig.

3565. According to a *Wall Street Journal* report, in baseball, 90 percent of the game is spent standing around.

3566. The report contends that a baseball game, which can last longer than 3 hours, features 17 minutes and 58 seconds of actual action. And 42 minutes and 41 seconds of between-inning inactivity is pure commercial time.

3567.

A football game can last over 3 hours and averages 11 minutes of live action according to the *Wall Street Journal*.

3568. Soccer games last 1 hour and 55 minutes with 57.6 minutes of live action, with only an average of 38 commercials.

3569. NBA games average 2 hours and 18 minutes in actual time and have 48 minutes of playing time.

3570. NHL hockey games last 2 hours and 20 minutes and have 60 minutes of action with 60 commercials.

3571. A reporter once counted 152 ads during a 2014 NFL game.

3572. Another reporter tracked one quarter of an NFL playoff game, and in 50 minutes of clock time there was 250 seconds of action (4 minutes, 10 seconds).

3573. The longest tennis match lasted for 11 hours and 5 minutes over 3 days. John Isner and Nicolas Mahut's 2010 Wimbledon opening-round matchup started on June 22, 2010, and they finished 4 sets before darkness set in.

3574. The following day, they played the fifth set, with each holding serve before play was suspended again due to darkness. The electronic scoreboard couldn't keep up as it was only programmed to keep score up to 47-47.

3575. When the game resumed on the 24th, Isner held serve in the 137th game of the fifth set, and then broke Mahut in the 138th to win. Isner won 6-4, 3-6, 6-7, 7-6, 70-68. The fifth round alone lasted 8 hours and 11 minutes.

3576. Isner lost in the second round in straight sets.

3577. This record won't be broken as Grand Slam events have tie-breaking rules to avoid super-long games.

3578. In 1947, Austrian tennis player Hans Redl made it to the fourth round of Wimbledon even though he had had his left arm amputated during World War II.

3579. Instead of throwing the ball up with his free hand, he would rest the ball on the racquet face, flipping it in the air before serving.

3580. The Kentucky Derby is the oldest sporting event in the US and is usually run on the first Saturday in May at Churchill Downs in Louisville, Kentucky.

3581. Known as the "Greatest 2 minutes in sports," the Derby first began in 1875.

3582.

The Kentucky Derby was started by Lewis Clark Jr., who was the grandson of William Clark, of Lewis and Clark fame.

3583. Only 3-year-old horses are allowed to compete.

3584. No Derby has ever been postponed or cancelled due to bad weather.

3585. The Derby has been postponed twice, once for World War II and again in 2020 due to COVID.

3586. In 1892, only 3 horses ran the race.

3587. In 1973, Secretariat won with a time of 1:59.40 minutes, setting the record for fastest time.

3588. The slowest winning time is credited to Kingman, the 1891 winner that had a time of 2:52.25.

3589. To this day, the derby is held annually and first began in 1875. The second oldest sports event in the US is the Westminster Kennel Club Dog Show which began in 1876.

3590. The traditional drink of the Derby is a mint julep. More than 120,000 are consumed each year at the race.

3591. The first female jockey to ride in the Derby was Diane Crump in 1970.

3592. Bill Shoemaker was the oldest jockey to win a Derby in 1986—he was 54.

3593. Shoemaker has also ridden the most Derby horses with 26.

3594. The movie *The Mighty Ducks* came before the actual hockey team the Anaheim Ducks.

3595. The word gymnasium comes from the Greek "gymnazo," which means to train naked.

3596. Boxer George Foreman named all 5 of his sons George Foreman. They are George Jr., George III (Monk), George IV (Big Wheel), George V (Red), and George VI (Little Joey).

3597. In 1983, more people watched the final episode of the TV series M*A*S*H than the Super Bowl.

3598. The 1972 Miami Dolphins are the only team in the Super Bowl era to have a perfect season. They went 14–0 during the regular season before winning 3 playoff games, and then winning Super Bowl VII over Washington.

3599. That year, Miami led the league in total offense, total defense, scoring offense, and scoring defense . . . the only team ever to do so.

3600. On August 20, 2013, 4 decades after the perfect season, President Barack Obama hosted the surviving members of the 1972 Dolphins, noting they "never got their White House visit."

3601. In 1948, the Cleveland Browns went 15–0 to win its third of 4 championships in the All-America Football Conference (AAFC).

3602. The records of the defunct league are not recognized in the NFL record book.

3603. Carl Weathers, who played Apollo Creed in the Rocky movies, was once a professional football player.

3604. Peyton and Eli Manning are the only brothers to both be drafted with the #1 pick.

3605. Jim Brown led the NFL in rushing yards for every year between 1957 to 1965, except for one.

3606. O.J. Simpson's first and middle names are Orenthal James.

3607. Because of fears that the Japanese, who had attacked Pearl Harbor less than a month earlier, might attack California, the Rose Bowl game of 1942 between Oregon State and Duke University was moved east to Duke's hometown in Durham, North Carolina. It didn't, however, help the home team. Oregon won, 20–16.

3608.

The 2007 New England Patriots were the first NFL team to win 18 games in a season.

3609. This was the first time since the NFL had 16 games in a season that a team went undefeated. After 2 post-season victories, the Patriots lost in the Super Bowl to the New York Giants.

3610. The Detroit Lions were the first NFL team to go 0–16 in a season.

3611. During World War II, the Pittsburgh Steelers and the Philadelphia Eagles had to combine to make one team, the Steagles, as many players were called to duty.

3612. Officially they were the Phil-Pitt Combine, but history remembers them as the Steagles.

3613. Prairie View A&M's football game had a 9-year losing streak, losing 80 straight games.

3614. The NFL Tampa Bay Buccaneers lost 26 straight games from 1976 to 1977.

3615. The Bucs were new to the NFL in 1976, and not only lost all 14 games, but they didn't score a touchdown until their fourth game.

3616.

The Chicago Cardinals lost a total of 29 games in a row from 1942 through 1945.

3617. The Buffalo Bills were in the Super Bowl for 4 straight years from 1990 through 1993. They lost all 4 times.

3618. Colorado won a share of the 1990 National Championship after officials mistakenly gave them a fifth down.

3619. Scott E. Entsminger of Mansfield, Ohio, was a lifelong, long-suffering Cleveland Browns football fan. When he died at the age of 55 in 2013, the family requested that everyone wear their Browns clothing to the funeral.

3620. According to his obituary in the *Columbus Dispatch*, Entsminger also "respectfully requests 6 Cleveland Browns pall bearers so the Browns can let him down one last time."

3621. Quarterback Tom Brady is the only player to have won 5 Super Bowl MVP awards. The closest is Joe Montana with 3.

3622. On October 7, 1916, Georgia Tech beat Cumberland College 222 to 0, which stands to this day as the highest scoring college football game ever.

3623. Dick Hoyt and his son Rick competed in 1,130 endurance events, including 257 triathlons, 72 marathons, and 6 Ironman Triathlons from 1977 to 2014.

3624. They also ran 32 Boston Marathons and biked and ran across the US in 1992.

3625. Rick has cerebral palsy, and his dad would pull Rick in a boat for swimming, ride him in a special seat for cycling, and push him in a wheelchair for running.

3626. Known as Team Hoyt, they were inducted to the Ironman Hall of Fame in 2008.

3627. In 2013, a bronze statue honoring the Hoyts was dedicated near the start of the Boston Marathon in Hopkinton, Massachusetts.

3628. In 1894, 2 Boston men bet each other that a woman couldn't cycle around the world. They chose Annie Kopchovsky to give it a shot and help them settle their bet. Kopchovsky was married and had 3 children. She learned how to ride a bicycle only a few days before she started her journey.

3629. Kopchovsky covered the entire distance in 15 months and received a reward of $10,000. The terms of the bet included her starting the journey without any money. She started out by advertising a spring water brand on her bicycle and earning $100.

3630. Kopchovsky left on June 25, 1894, from Boston. She made it to Chicago in September, where she almost stopped. She was encouraged to keep going when she traded in her 42-pound ladies' bicycle for a men's one that weighed half as much. From there, she rode to New York, before setting sail to France and completing her circumnavigation in just under 15 months. She earned $10,000 for her achievement.

3631. From 2015 to 2016, Englishman Ben Smith ran 401 marathons in 401 days.

3632. Toe wrestling is a sport that originated in Staffordshire, UK in 1976, by 4 patrons of Ye Olde Royal Oak Inn.

3633. The World Toe Wrestling Championship has been held annually since 1994.

3634. Author Norman Mailer was a passionate thumb wrestler.

3635. Shovel racing's origins can be traced back to ski resorts in New Mexico in the 1970s.

3636. Shovel racing started off as ski resort workers using shovels as sleds to move from one location to another. It was included in the Winter X Games in 1997, but it was removed as organizers felt it wasn't athletic enough.

3637. The top speed of a shovel racer can reach 70 miles per hour.

3638.

Cycleball, also called radball, is like soccer but played on bicycles.

3639. It was introduced in 1893 by Nicholas Edward Kaufmann, and the first world championships were held in 1929. The bicycles have no gear or brakes.

3640. Sepak Takraw originated in Asia. Essentially, it's volleyball, but you can't use your arms or hands to get the ball over the net.

3641. The World Mountain Bike Bog Snorkeling Championship is held every year in Llanwrtyd Wells, Wales.

3642. Competitors don masks, snorkels, and scuba fins, and then ride a bike over a nearly 100-yeard trench cut through a peat bog.

3643. The sport was invented in order to create "more dirty fun around our famous Waen Rhydd Bog."

3644. Bossaball is a sport that combines soccer tricks, volleyball skills, and extreme gymnastics . . . accompanied by music.

3645. Bossaball is played on an inflatable court with a trampoline on each side of a net.

3646. Headis is table tennis using a lighter version of soccer ball and your head.

3647. Two players at a regulation ping-pong table use their heads to hit the ball clear of the net and onto the other player's side of the table.

3648. Three-sided football is a variation of soccer played with 3 teams instead of 2 and is played on a hexagonal pitch.

3649. Unlike conventional football, where the highest scoring team is the winner, in three-sided football, it's the team that concedes the fewest goals that wins.

3650.
Archery tag is dodgeball with bows and arrows.

3651. In archery tag, arrows are tipped with giant pieces of foam. The objective of the game is to hit members of the other team with arrows as well as to knock down their targets.

3652. *Joggling* is the competitive sport of juggling and jogging. There's a World Joggling Championship every year.

3653. In 2019, the French Fencing Federation recognized lightsaber dueling as a sport.

3654. Since 1992, Finland has been the home of the official Wife Carrying World Championship. Men basically have to carry their wives through an obstacle course. The winner receives his wife's weight in beer.

3655. Golfer Tiger Woods's name is Eldrick Tont Woods. Tont is a traditional Thai name.

3656. In 2017, Chau Smith celebrated her 70th birthday by running 7 marathons on 7 continents in 7 consecutive days.

3657. Smith ran marathons in Perth, Australia; Singapore; Cairo, Egypt; Amsterdam, Netherlands; Garden City, New York; Punta Arenas, Chile; and King George Island, Antarctica.

3658. Boxer Peter Buckley once suffered a 5-year losing streak, losing 88 fights in a row (with a draw thrown in).

3659. Buckley boxed against 42 future national and world champs over his career.

3660. He retired with 32 wins, 256 losses, and 12 draws.

3661. American Samoa's national soccer team lost every international match for 17 years until beating Tonga in 2014.

3662. American Samoa once lost to Australia 31 to 0—in 2001.

3663. Detroit, Michigan, is the only American city to win 3 major sports (baseball, football, basketball, and/or hockey) in the same year. This happened in 1935 when the Lions won the NFL title, the Tigers won the World Series, and the Red Wings won the Stanley Cup.

3664. Roger Bannister broke the 4-minute mile in on May 6, 1954—a feat thought impossible.

3665. He ran the mile in 3:59.4 minutes.

3666. His world record lasted for 46 days, when on June 21, 1954, Australian John Landy ran the mile in 3.58.0 minutes.

3667. Hicham El Guerrouj's 1999 record of 3:43.13 has stood since 1999.

3668. The only 2 days where there are no professional sports games (MLB, NBA, NHL, or NFL) are the day before and after the baseball All-Star Game.

3669. In 1955, at the age of 67, Emma Rowena Gatewood (1887–1973) became the first woman to hike the entire 2,168-mile Appalachian Trail. She completed the trek wearing Keds sneakers and carrying a homemade bag that she slung over 1 shoulder. She carried with her only an army blanket, a raincoat, a shower curtain, and a change of clothes. For food, Gatewood foraged for wild plants and had with her dried meat, cheese, nuts, and dried fruit. She averaged 14 miles a day, outpacing younger hikers who were also on the trail, and completed her hike in 146 days.

3670. Gatewood also hiked the trail in 1960 and 1963, becoming the first person to hike the trail three times. She also hiked 2,000 miles of the Oregon Trail from Missouri to Oregon, averaging 22 miles a day.

3671. In 1967, Kathrine Switzer made history by becoming the first woman to run the Boston Marathon with an official race number. She did so despite the efforts of a race director who tried to remove her from the course.

3672. The average player's career in the NFL is only 3.3 years. For quarterbacks it's 4.4 years, kickers make it 4.87 years, and running backs are at the bottom at 2.57 years.

3673.

The average NBA player's career is 4.9 years.

3674. The average NHL player's career is 4.5 years. The top 25 percent of players played an average of 12 years, while the bottom 75 percent played an average of 2 years.

3675. Abner Doubleday was involved in many key battles as a Union officer during the Civil War. He is also one of the biggest names in baseball—known far and wide as the inventor of the game.

3676. Too bad he had nothing whatsoever to do with its invention. A committee was formed in the early 20th century to determine the origins of baseball. Instead of attempting to find the truth, the committee wanted a feel-good story that proved baseball was a red-blooded American sport.

3677. The report stated, "The first scheme for playing baseball, according to the best evidence obtainable to date, was devised by Abner Doubleday at Cooperstown, New York, in 1839." Their only evidence was a single letter from a man named Abner Graves, who was a mentally unstable person who later killed his wife.

3678. In 1953, Congress set out to correct this inaccuracy by officially crediting the invention of the modern day of baseball to Alexander Joy Cartwright, a volunteer firefighter and member of the New York Knickerbocker Base Ball Club.

3679. Cartwright supposedly was the first to draw a diagram of a baseball diamond and write down the rules on which baseball is based.

3680. Legend has it he also taught the game to people he met while traveling to California during the Gold Rush.

3681. Though he did play for the Knickerbockers, there is written proof that the rules for the game already existed, and that Cartwright's descendants simply exaggerated his role.

3682. In fact, the 1744 children's book *A Little Pretty Pocket-Book* by John Newbery, features a poem and illustration about baseball. Posts mark the bases in the picture.

3683.

On September 28, 1919, at the Polo Grounds, the New York Giants beat the Philadelphia Phillies by 6-1 in 51 minutes, the fastest recorded Major League game.

3684. The longest game in terms of time lasted was between the Chicago White Sox and Milwaukee Brewers. It took 2 days to complete and lasted 8 hours and 6 minutes.

3685. The 1984 game was called after 17 innings and tied at 3–3. The next day, they played 8 more innings, with neither team scoring. The game resulted in a tie.

3686. The longest game in terms of innings was on May 1, 1920, when the Brooklyn Robins and Boston Braves ended up tied after 26 innings. The game would have continued, but the game was called due to darkness.

3687. In 1917, Red Sox pitcher Earnie Shore threw a perfect game with 27 straight outs without allowing a baserunner. However, he is only credited with a combined no-hitter because he pitched in relief of starter Babe Ruth, who was ejected after walking the first batter and then punching the umpire.

3688. On December 11, 1951, Joe DiMaggio announced his retirement from baseball. He played his entire career with the NY Yankees.

3689.

DiMaggio was a 3-time Most Valuable Player Award winner and an All-Star in each of his 13 seasons.

3690. During his tenure with the Yankees, the club won 10 American League pennants and 9 World Series championships. His 9 World Series rings is second only to fellow Yankee Yogi Berra, who won 10.

3691. A baseball signed by Joe DiMaggio and his then wife Marilyn Monroe sold for $191,200 in 2006.

3692. A baseball signed by 11 of the greatest players in early MLB history sold for $623,369 in 2018.

3693. It was signed at the induction weekend during the opening of the National Baseball Hall of Fame and Museum in Cooperstown, New York.

3694. The players who signed the ball were Grover Cleveland Alexander, Ty Cobb, Eddie Collins, Walter Johnson, Nap Lajoie, Connie Mack, Babe Ruth, George Sisler, Tris Speaker, Honus Wagner, and Cy Young.

3695. In June 2019, a jersey worn by Babe Ruth sometime between 1928 and 1930 sold for $5.6 million.

3696. Mark McGwire's 70th home run ball from 1998 was sold at auction in 1999 for just over $3 million.

3697. A Honus Wagner T206 baseball card sold for $6.6 million in August 2021, making it the most expensive baseball card ever.

3698. Wagner was a shortstop who broke into the Major Leagues in 1897 with the Louisville Colonels.

3699. After 3 seasons, Wagner joined the Pittsburgh Pirates, where he played for 17 seasons.

3700. He won 8 batting championships, had a lifetime batting average of .328, and had 3,420 hits.

3701. His hit number ranks in the top-10 of all time, even more than 100 years after his retirement.

3702. On December 26, 1919, Babe Ruth of the Boston Red Sox was sold to the New York Yankees by owner Harry Frazee, allegedly establishing the Curse of the Bambino superstition.

3703. In his 15 years with the Yankees, Ruth helped the team win 7 American League (AL) pennants and 4 World Series championships.

3704. As part of the Yankees' vaunted Murderers' Row lineup of 1927, Ruth hit 60 home runs, which extended his MLB single-season record by a single home run.

3705. Ruth's last season with the Yankees was 1934, and he retired from the game the following year, after a short stint with the Boston Braves.

3706. During his career, Ruth led the American League in home runs during a season 12 times.

3707.
Jackie Robinson was the first rookie of the year.

3708. Casey Stengel is the only man to play on or manage the Brooklyn Dodgers, New York Giants, New York Mets, and New York Yankees.

3709. Joe Torre reached 14 straight postseasons as a manager, but never played a postseason game as a player.

3710. The 1972 World Series between the A's and Reds and the 1984 World Series between the Tigers and Padres featured the same 2 managers.

3711. Cito Gaston was the first Black manager to win a World Series.

3712. The Green Bay Packers won the first 2 Super Bowls.

3713. The 1991 Twins were the first to win the World Series after finishing last the previous season.

3714. Sparky Anderson was the first manager to win the World Series with teams from both leagues.

3715. The New York Yankees have won more World Championships than any other team. The Cardinals come in second.

3716. In 1970, Dock Ellis, a 25-year-old pitcher for the Pittsburgh Pirates, threw a no-hitter while tripping on LSD.

3717. He struck out 6 batters, but he also walked 8. He also hit 1 batter and allowed 3 stolen bases.

3718. At one point during the game, Ellis believed that Richard Nixon was the home plate umpire.

3719. At another, he believed he was pitching to Jimi Hendrix, who was swinging his guitar instead of a bat.

3720. Ellis said, "The ball was small sometimes, the ball was large sometimes, sometimes I saw the catcher, sometimes I didn't."

3721. Ellis also claimed that he pitched all his games under the influence of something, be it alcohol, uppers, or something else.

3722. On September 1, 1971, Ellis was pitching when the Pirates fielded the first all-Black/Latino lineup in MLB history.

3723. There was only 1 media mention of the historic lineup. Bill Conlin of the *Philadelphia Daily News* called it an "all-soul lineup," without any further explanation.

3724. The 1971 Pirates won the World Series.

3725. Eighteen players have hit 4 homeruns in one game.

3726. In the 1920s, the New York Yankees became the first team to wear numbers on their backs. The numbers corresponded to the order the players batted.

3727.

The first father-son combo to play in the Major Leagues at the same time was Ken Griffey Sr. and Ken Griffey Jr.

3728. They both played for the Seattle Mariners in 1990.

3729. The Griffeys hit back-to-back home runs on September 14, 1990.

3730. There have been 255 father-son combinations in Major League history.

3731. No father-son pairs are in the Hall of Fame, although 14 of the fathers and 2 of the sons have been inducted.

3732. In 1931, the Chattanooga Shortstop traded Jonny Jones to the Charlotte Hornets for a turkey.

3733. From 1939 to 1960, Ted Williams had a career Triple Crown.

3734. During this timeframe, Williams had the highest batting average, the most home runs, and the most runs batted in of all MLB players.

3735. Nolan Ryan also threw 7 no-hitters, the most of any Major League player.

3736. He also threw 12 one-hitters and 18 two-hitters.

3737. Ryan has more strikeouts (5,714) and walks (2,795) than any other pitcher in history and 324 wins.

3738. Ryan led the league in strikeouts 11 times. Only Walter Johnson did it more (12).

3739. Ryan holds the all-time record for lowest hits-per-9-innings mark, allowing 3,923 hits in 5,386 innings.

3740. Ryan's 383 strikeouts in 1973 is the modern-day record.

3741. On June 14, 1974, Ryan threw 235 pitches against the Red Sox over 13 innings. He recorded 19 strikeouts, 10 walks, 58 batters faced, and 3 runs allowed.

3742. Ryan started his next game on only 3 days' rest and pitched 6 scoreless innings against the Yankees.

3743. Ryan pitched in 4 decades, debuting for the Mets in 1966 at 19 years old. He played his last game for the Rangers at the age of 46 in 1993. He pitched his last no hitter at the age of 44, becoming the oldest pitcher to do so.

3744. The popular seventh inning-stretch song, "Take Me Out to the Ball Game," was written in 1908 by Jack Norworth and Albert Von Tilzer. Neither had ever attended a game before writing the song.

3745. "Take Me Out to the Ball Game" was played at a ballpark for the first known time in 1934, at a high-school game in Los Angeles. It was then played later that year during the fourth game of the 1934 World Series.

3746. "Take Me Out to the Ball Game" was selected by the National Endowment for the Arts and the Recording Industry Association of America as one of the 365 top "Songs of the Century."

3747. On August 17, 1957, during a game between the Philadelphia Phillies and the New York Giants, future Hall of Famer Richie Ashburn fouled off a ball that hit a woman in the stands. The game was paused to help the woman. Play was resumed as medics were in the process of removing her from the stands in a stretcher. Ashburn hit another foul ball, and it hit the same woman.

3748. The fan was the wife of the sports editor for *The Philadelphia Bulletin*.

3749. The first foul ball hit the woman in the face, breaking her nose. The second broke a bone in her knee.

3750. In baseball, the Boston Red Sox are the only team to lose the first 3 games of a postseason series and then come back to win the series.

3751. They did it against the New York Yankees during the 2004 ALCS.

3752. The Red Sox went on to win their first World Series since 1918 in 2004.

3753. In 1920, Babe Ruth hit 54 home runs, more than any American League team other than his own.

3754.

In 2004, Barry Bonds walked 232 times, breaking the record of 198 that he had set in 2002. Of those walks, 120 of them were intentional.

3755. Barry Bonds has won the National League Most Valuable Player Award 7 times.

3756. The 1986 Red Sox are the first team to come within 1 strike of winning the World Series and not win it.

3757. Roger Clemens had 0 no-hitters, and only 1 one-hitter during his career.

3758. In 1993, N.Y. Mets pitcher Anthony Young lost 23 games in a row—a dubious record.

3759. In June and July 1968, St. Louis Cardinal pitcher Bob Gibson started 12 games. He not only won all 12 of them, but they were all complete games. Eight of these games were shutouts, and he only gave up 6 runs during this streak.

3760. In 1952, Ron Necciai, a minor league pitcher for the Bristol Twins struck out all 27 batters he faced. A feat no one else has ever accomplished. Necciai never made it to the Major Leagues.

3761. Rickey Henderson played 24 seasons in the Major Leagues, from 1979 to 2003. Nicknamed the "Man of Steal," he holds the records for stolen bases, with 1,406. That's 50 percent higher than the previous record of 938 held by Lou Brock.

3762. Henderson holds the single-season record for steals with 130 in 1982. He is the only player in American League history to steal 100 bases in a season, and he did so 3 times.

3763. Henderson had 3 seasons with 100 runs, 100 stolen bases, and 100 walks in a season. No other modern player has done it once.

3764. He also holds the records for runs, unintentional walks, and leadoff home runs.

3765. Rickey Henderson walked 796 times in his career leading off an inning (when he was the first batter up at the start of an inning). According to journalist Joe Posnanski, that was more times than 50 other Hall of Famers walked in their entire careers.

3766. Henderson was so proud of a $1 million signing bonus that he framed it instead of cashing it, thus losing several months' interest.

3767. Jimmy Piersall played 17 seasons in the Major Leagues from 1950 to 1967. He is best known for his battle with bipolar disorder.

3768. In 1963, he ran the bases facing backward to celebrate his 100th career home run. His manager cut him from the team 2 days later.

3769. There's an exhibit at the Negro Leagues Baseball Museum named after Canadian rock bassist Geddy Lee. Lee had bought a collection of 400 baseballs signed by African American stars and then donated them to the museum.

3770. In 1867, the National Association of Amateur Base Ball Players elected to reject applications from African American clubs.

3771. In 1876, the professional National League was formed by owners' intent on keeping it a White man's game.

3772. In 1884, catcher Moses Fleetwood Walker of the Toledo Blue Stockings became the first African American to play in what was then considered a major league.

3773. Cap Anson of the Chicago White Stockings once threatened to cancel a game if Walker was in the lineup. Walker played, but Black people were quickly forced out of the league afterwards.

3774. Before the Negro National League formed in 1920, Black players had to settle for playing on traveling teams.

3775. The first "Colored Championship of the World" was held in 1903, with pitcher Rube Foster leading the Cuban X-Giants to victory over the Philadelphia Giants.

3776. The Negro National League operated until the early 1960s.

3777. The first teams were the Chicago American Giants, Chicago Giants, Cuban Stars, Dayton Marcos, Detroit Stars, Kansas City Monarchs, Indianapolis ABCs, and the St. Louis Giants.

3778.

Jackie Robinson broke the color barrier when he took the field at first base on April 15, 1947, for the Brooklyn Dodgers.

3779. On July 5, 1947, Larry Doby became the second Black Major Leaguer, when he signed with the Cleveland Indians.

3780. One of the greatest pitchers—Black or White—Satchel Paige, made his Major League debut at the age of 42.

3781. He signed with the Cleveland Indians, went 6–1 and helped the team claim the American League pennant.

3782. Paige then became the first African American to pitch in the World Series. He came out of the bullpen for game 5.

3783. According to Paige himself, before his debut he had pitched more than 2,500 games and won 2,000 of them, with 250 or so shutouts, a personal-best of 22 strikeouts in a game, 50 no-hitters, a 21-game winning streak, a 62-inning scoreless streak, and a day in which he notched 3 separate victories.

3784. Paige earned All-Star Game selections in both 1952 and 1953, when he was 45 and 46 years old.

3785. Joe DiMaggio called Paige the "best and fastest" pitcher he ever faced.

3786. After going back to barnstorming (playing exhibition games around the country), he got another crack at the big league when in 1965, at the age of 59, Paige started a game for the Kansas City Athletics. He pitched 3 scoreless innings against the Red Sox and gave up only 1 hit.

3787. As late as 1953, only 6 of 16 teams fielded Black players.

3788. In 1959, the Boston Red Sox became the last team to integrate.

3789. In 1966, when Ted Williams was inducted into the Baseball Hall of Fame, he said, "I hope that some day the names of Satchel Paige and Josh Gibson in some way could be added [to the Hall] as a symbol of the great Negro [Leagues] players that are not here only because they were not given the chance."

3790. Satchel Paige was elected to the Hall of Fame 5 years later.

3791. On December 16, 2020, Major League Baseball Commissioner Rob Manfred declared that the 7 Negro leagues would be recognized as official major leagues, with their players' records and statistics counted in baseball's record books.

3792. A 2004 article in *Slate.com* revealed that Chicago Cubs outfielder Moises Alou urinated on his hands to toughen them up.

3793. Yankees catcher Jorge Posada, who also did this, said, "You don't want to shake my hands during spring training."

3794. Urine actually softens the skin.

3795. Pitcher George "Doc" Medich earned both his undergraduate and medical degree from the University of Pittsburgh. Throughout his career, there were two incidents at the ballpark where he was called upon for his expertise. In 1976, he performed CPR on a fan who later died. In 1978, he went into the stands at Baltimore's Memorial Stadium to administer mouth-to-mouth resuscitation to a fan who had had a heart attack.

3796. The Metropolitan Museum of Art has a collection of 31,000 baseball cards.

3797. They were collected by Jefferson R. Burdick and represented the most comprehensive collection outside the Baseball Hall of Fame.

3798. The game of basketball was conceived by Canadian American physical education teacher James Naismith in 1891.

3799. Naismith was teaching at Springfield College in Massachusetts and was asked to create indoor games that could replace the boring exercises used during the winter months.

3800. Since Naismith's physical education class had 18 students, the first basketball teams had 9 players per side.

3801. Naismith based his new game, in part, on a childhood game he played back in Canada called "Duck on a Rock." It used a ball and a goal that was high enough so that the ball had to be tossed in.

3802. Naismith asked the school's janitor to find 2 square boxes for his new game; however, the janitor came back with half bushel peach baskets instead.

3803. Naismith nailed the baskets to balcony rails on either side of the gymnasium that happened to be 10 feet from the ground. A person was placed at each end of the balcony to retrieve the ball after each score.

3804. From the beginning, women played the game as well. In 1893, the *Boston Globe* stated basketball to be a "very fair feminine substitute for football."

3805. In a 1939 radio interview, Naismith admitted he had made a mistake by not making the sport non-contact: "The boys began tackling each other, and punching in the clinches, and they ended up in a free-for-all in the middle of the gym floor. Before I could pull them apart, one boy was knocked out, several of them had black eyes, and one had a dislocated shoulder. It certainly was murder."

3806. This radio interview is thought to be the only recording of his voice in existence.

3807. String baskets weren't used until the early 20th century.

3808. Backboards were introduced at first to keep spectators from disrupting shots.

3809. In 1898, Naismith was hired to be the University of Kansas's first men's basketball coach.

3810. Naismith is the only men's coach in that program's history to have a losing record.

3811. The game was so successful that by 1905, basketball was officially recognized as a permanent winter sport.

3812. Dribbling was not in Naismith's original rules. Players caught the ball, took a few steps to slow down, stopped, and either passed the ball or shot it from that spot.

3813. Naismith's original 13 rules can be viewed at the University of Kanas.

3814. David Booth, an alumnus, bought the 2 yellowing pages of rules at auction in 2010 for $4.3 million.

3815. Games were low-scoring affairs until the 1954–1955 season, when the 24-second shot clock was adopted. The offense could no longer hold onto the ball as long as they wanted.

3816. Basketball first became an official Olympics event during the 1936 Berlin Summer Olympics. Grass and dirt tennis courts were used for the games, which caused problems when it started raining during the final game.

3817. James Naismith awarded the medals to the US (gold), Canada (silver), and Mexico (bronze).

3818. On March 2, 1961, Wilt Chamberlain of the Philadelphia Warriors scored 100 points against the New York Knicks. Philadelphia won the game 169 to 147.

3819.
Wilt Chamberlain never fouled out of a game.

3820. Wilt Chamberlain grabbed 55 rebounds in 1960 in a game against the Boston Celtics. Wilt's Philadelphia Warriors still lost.

3821. Denise Long was the first woman drafted by an NBA team when the San Francisco Warriors picked her in the 13th round of the NBA draft in 1969. The NBA commissioner voided the pick, however, because at that time, teams weren't allowed to draft players straight from high school. Also, no women were allowed.

3822. The voided Denise Long pick makes Lusia Harris the first and only woman officially drafted by an NBA team. She was drafted in the seventh round of the 1977 draft by the New Orleans Jazz. She declined to try out for the team.

3823. During the Washington Bullets 1987–1988 season, they had both the tallest player and the shortest. Manute Bol stood 7'7", with an 8'4" wingspan. (He is tied with Gheorghe Muresan.) Muggsy Bogues was 5'3".

3824. In 1962, Suleiman Ali Nashnush became the tallest ever to play basketball professionally (for a Libyan team). He was 8 feet tall.

3825. The first college basketball game with 5 players took place on January 18, 1986. The University of Chicago took on the University of Iowa. Chicago won 15 to 12.

3826. A 2-handed push shot was the most common perimeter shot used up until the late 1930s, when Stanford University player Hank Luisetti introduced the 1-hand shot, which evolved into today's jump shot.

3827. The Boston Celtics have 17 NBA championships, the most of any team, including 7 straight from 1960 to 1966.

3828. The Harlem Globetrotters were created in 1926 as a touring team of African American players.

3829. They formed on the South Side of Chicago, Illinois . . . not Harlem.

3830. Featuring a team of all Black players before professional basketball integrated (during the 1950–1951 season), they beat the best White basketball teams in the country in 1948, including the Minneapolis Lakers. Historians cite this as one of the reasons pro basketball decided to integrate a couple years later.

3831. NBA hall of famer Wilt Chamberlain played a full season with the Harlem Globetrotters in 1958–1959.

3832. In 1959, the Globetrotters played 9 games in the USSR, where they met Premier Nikita Khrushchev. The Soviet spectators were confused at first as they didn't understand that the Globetrotters were more of a show than a competition.

3833. The Globetrotters travel with their competition, who always lose. Serving as the "straight man" to the Globetrotters' antics, the Washington Generals actually try to win their games, and 6 times, they have.

3834. The Globetrotters didn't play a game in Harlem until 1968.

3835. Corey "Thunder" Law holds the record for longest successful basketball shot at 109 feet, 9 inches.

3836. He also holds the record for longest blindfolded shot at 69 feet, 6 inches.

3837. The NBA introduced the 3-point line in 1986.

3838. As of 2021, only 28 slam dunks have been scored in the WNBA. Brittney Griner has 23 of them.

3839. By second grade, WNBA star Lisa Leslie was already taller than her second-grade teacher.

3840. Leslie didn't begin playing basketball until she was 12. (She was already 6' tall!)

3841. In high school, Lisa Leslie once scored 101 points in 16 minutes. The other team refused to play the second half.

3842. Leslie, who is listed at 6' 5", is the first woman to dunk in the WNBA.

3843. The website (spacejam.com) for the movie *Space Jam* (1996) hasn't been changed since the movie was released.

3844.

Between 1967 and 1976 it was illegal to dunk a basketball in an NBA game.

3845. The reason for this ban was Kareem Abdul Jabbar.

3846. Kareem Abdul-Jabbar (Lew Alcindor until 1971) was a 7'2" center who dominated the game from high school through his career in the NBA.

3847. As Abdul-Jabbar entered college, the collegiate basketball rules committee outlawed dunking.

3848. Even without dunking, Abdul-Jabbar scored 56 points in his first college game for UCLA.

3849. He helped lead UCLA to 3 NCAA championships. During his career there, the team only lost 2 games.

3850. By the end of his career in the NBA, he had set NBA records for most points (38,387), most field goals made (15,837), and most minutes played (57,446).

3851. He also had the most blocked shots in league history (3,189) and the third most career rebounds (17,440).

3852. He was voted NBA MVP a record 6 times and won 6 NBA championships.

3853. Abdul-Jabbar hit one 3-pointer in his career.

3854. The average height in the NBA is 6'6" with a weight of 219 pounds.

3855. Shaquille O'Neal and Tacko Fall both have size 22 feet—the biggest ever in the NBA.

3856.

Tacko Fall, at 7'7", is not only one of the tallest humans alive, but he has the longest wingspan at over 8 feet. His standing reach is over 10 feet—meaning he doesn't have to jump to touch the rim.

3857. The National Basketball Association was formed by a merger of the National Basketball League and the Basketball Association of America.

3858. Chris Dudley played 15 years in the NBA and averaged 45.8 percent from the free-throw line. During a 1990 game against the Indiana Pacers, Dudley missed 13 consecutive free throws—a record.

3859. In 2014, billionaire Warren Buffett and Dan Gilbert's Quicken Loans offered $1 billion for the perfect March Madness bracket.

3860. When filling out a March Madness bracket, you have a 1 in 9.2 quintillion chance of filling it out perfectly. If you know what you're doing, your odds are more like 1 in 120.2 billion.

3861. The NCAA Division I men's basketball tournament, called NCAA March Madness, began in 1939 and has been held every year since then except for the 2019–2020 season when it was canceled due to the COVID pandemic.

3862. The term "March Madness" was first used on TV by Brent Musburger in 1982.

3863. In 2018, 16 seed University of Maryland upset 1 seed Virginia 74 to 54. It was the first time in tournament history that a 16 seed beat a 1 seed, making it the greatest upset in March Madness history.

3864. One year later, Virginia would storm back to win the 2019 NCAA championship.

3865. Kentucky as the most appearances with 59. North Carolina has 52.

3866. UCLA has 11 championships, the most of any team. Kentucky follows with 8 and North Carolina has 6.

3867. All four 1 seeds made it to the Final Four only once. It occurred in 2008 when Kansas, Memphis, North Carolina, and UCLA qualified. Kansas won.

3868. The lowest seed to win a championship was the 1985 Villanova team. They were an 8 seed.

3869. The NCAA Division I women's basketball tournament began in 1982.

3870. The University of Connecticut has the most championships with 11. Tennessee follows with 8 wins.

3871. Jim Thorpe (1888–1953) was one of the most accomplished athletes in history.

3872. Thorpe was a Native American member of the Sauk and Fox Nation.

3873. His native name was Wa-Tho-Huk, which means "bright path."

3874.

Jim Thorpe had a twin brother who unfortunately died when they were just 9 years old.

3875. In 1911 and 1912 he won All-American honors playing football for the Carlisle Indian Industrial School in Pennsylvania, where he was discovered by famed football coach Glenn "Pop" Warner.

3876. He was also on the school's track team, played baseball, basketball, and lacrosse, and even won a championship for ballroom dancing!

3877. During the 1912 Olympics in Stockholm, Sweden, Thorpe won gold medals for the pentathlon and decathlon competitions, becoming the first Native American to win a gold medal for the US at the Olympics.

3878. Thorpe finished first in 4 of 5 pentathlon events. He won the broad jump (23 feet, 3 inches); the 200 meters (22.9); the discus (168 feet, 4 inches); and the 1,500 meters (4:40). He finished second in the javelin.

3879. His score was triple the score of the silver medal winner.

3880. In the decathlon, Thorpe finished first in 4 events (shot put, high jump, 110-meter hurdles, 1,500 meters), second in 4 others (broad jump, 100 meters, 400 meters, discus) and third in the last 2 (pole vault and javelin).

3881. Thorpe scored 8,413 points out of a possible 10,000, an Olympic record that stood for 20 years. He finished 700 points ahead of the silver medalist.

3882. King Gustav V, said to Thorpe, "You, sir, are the greatest athlete in the world." Thorpe replied, "Thanks, king."

3883. In 1913 an investigation by the Amateur Athletic Union showed that he had played semiprofessional baseball in 1909 and 1910, which should have disqualified him from Olympic competition. He had to return his medals, even though he was only paid $2.00 per game.

3884. Thorpe went on to play professional baseball, football, and basketball.

3885. In 1920–21 he served as the first president of the American Professional Football Association (later the National Football League [NFL]).

3886. He is enshrined in the Pro Football Hall of Fame, as well as several other halls of fame: college football, US Olympic teams, and national track and field.

3887. In 1950, Thorpe was selected by American sportswriters and broadcasters as the greatest American athlete and the greatest football player of the first half of the twentieth century.

3888. In 1973, the Amateur Athletic Union restored his amateur status, but the International Olympic Committee did not recognize his amateur status until 1982.

3889. Thorpe was reinstated as cowinner of the decathlon and pentathlon of the 1912 Olympic Games (along with the second-place finishers in those events).

3890. Replicas of his Olympic gold medals were returned to his family in 1983.

3891. Thorpe was reinstated as the sole winner of the 2 events in 2022.

3892. Edson Arantes do Nascimento (1940–2022), better known as Pelé, is regarded as one of the greatest soccer players of all time.

3893. His parents named him after Thomas Edison. Pelé got his nickname from classmates as a child. He had no idea what the name meant, and neither did his old friends.

3894.

Pelé made the Santos club of the Campeonato Paulista league as a 15-year-old.

3895. He made the Brazilian national team at 16 years old.

3896. As a 16-year-old, he was the top scorer in the league.

3897. In 1958, he scored 58 goals for Santos, a record that stands to this day.

3898. In 1961, the government in Brazil made Pelé an "official national treasure" in order to prevent him from being transferred to a club in another country.

3899. He won 3 FIFA World Cups with Brazil: 1958, 1962, and 1970—the only player to ever do so.

3900. In 1969, the 2 factions in the Nigerian Civil War agreed to a 48-hour ceasefire so they could watch Pelé play an exhibition game in Lagos.

3901. Pelé's 643 goals for Santos were the most goals scored for a single club until it was surpassed by Lionel Messi of Barcelona in December 2020.

3902. On October 1, 1977, Brazilian soccer great Pelé played his final game for the New York Cosmos in an exhibition against Santos, his Brazilian team from 1956 to 1974.

3903. The match was played at Giants Stadium in New Jersey in front of 75,000 spectators.

3904. Pelé, in a message to the crowd before the game said, "Love is more important than what we can take in life."

3905. He played the first half with the Cosmos, and the second half with Santos.

3906. The Cosmos won 2 to 1, with Pelé's 30-yard free-kick for the Cosmos being the final goal of his career.

3907. In 1999, he was named Athlete of the Century by the International Olympic Committee and was included in the Time list of the 100 most important people of the 20th century.

3908. In 2000, Pelé was voted World Player of the Century by the International Federation of Football History & Statistics (IFFHS) and was one of the 2 joint winners of the FIFA Player of the Century. His 1,279 goals in 1,363 games, which includes friendlies, is recognized as a Guinness World Record.

CHAPTER 19
THE OLYMPICS

3909. From 1900 to 1920, tug-of-war was an Olympic sport.

3910. The first tug-of-war Olympic gold medal went to a combined team from Sweden and Denmark, after they defeated France in the final.

3911. The French tug-of-war team included Constantin Henriquez de Zubiera, who became the first Black medalist in the history of the Olympic Games.

3912. He went on to win gold with the French Rugby Union team.

3913. The US won the tug-of-war gold in 1904.

3914. Great Britain has 5 gold medals in tug-of-war.

3915. Art competitions used to be a part of the Olympics from 1912 to 1948. Medals were awarded in 5 categories: architecture, literature, music, painting, and sculpture.

3916. The art competitions were dropped from the Olympic program because of the difficulty of determining the amateur status of the artists.

3917. *Pankration* was an ancient Greek mixed martial arts (MMA) match with a twist: there were no rules, other than no biting and no eye-gouging, and you couldn't wear clothes.

3918. The word "pankration" means total victory.

3919. With no time limit, the winner of a pankration match was sometimes the one who didn't die. Although it was considered bad form to kill your opponent.

3920.

In 1928, 18-year-old Elizabeth "Betty" Robinson Schwartz became the first woman ever awarded an Olympic gold medal for track and field.

3921. She was and still is the youngest runner to win an Olympic gold in the 100 meters race.

3922. In 1931, Schwartz was in a plane crash. Rescuers, thinking she was dead, put her in the trunk of a car and drove her to a man who knew the local undertaker.

3923. It was discovered that she was actually in a coma, and when she awoke, she was told she'd never race again, let alone walk.

3924. It took 2 years for Schwartz to walk again, but in the 1936 Olympics, even though she couldn't kneel for the 100-meter race start, she was part of the US women's 4 x 100-meter relay. The team won the gold.

3925. Nine-time Olympic champion swimmer Mark Spitz swam without goggles or a swim cap. He swam with his eyes closed.

3926. At the 1972 Summer Olympic games in Munich, while Spitz was practicing in the pool, some Russian coaches approached and asked about his mustache, which he had been planning on shaving before the races began. They asked, "Isn't it going to slow you down?" Spitz jokingly responded, "This moustache deflects the water away from my mouth and allows me to get a lot lower and more streamline in the stroke and therefore [makes me] less likely to swallow water, and it allows me to swim faster and helped me break a couple of world records last month." By 1973, the Russian men's swimming team had, according to Spitz, all grown mustaches.

3927. In 1904, the Olympics were held in St. Louis, Missouri. It was America's first Olympics, and perhaps the most bizarre Olympics ever.

3928. One of the issues was that the games were running concurrently with that year's World Fair.

3929. One of the fair's events included Anthropology Days, where a group of "savages" competed in athletic feats such as greased-pole climbs, "ethnic" dancing, and mudslinging.

3930. Gymnast George Eyser earned 6 medals, including 3 gold, despite his wooden leg.

3931. The highlight of the Olympic games, the marathon, created such scandal that the event was nearly abolished for good. The race began at 3:00 p.m., during the hottest part of the day, and temperatures reached 90°F. The marathon featured 10 Greek athletes, none of whom had ever run a marathon. Three of them finished the race, with 1 coming in fifth place. The route featured cracked roadways and the runners had to dodge crosstown traffic, wagons, trains, and trolley cars. There were only 2 water stations—a water tower at the 6-mile mark and a well at the 12-mile mark.

3932. The chief organizer of the 1904 Olympic games, James Sullivan, wanted to minimize fluid intake to test the limits and effects of purposeful dehydration, a common area of research at the time.

3933. Cars carrying coaches and physicians motored alongside the runners, kicking the dust up and causing coughing spells.

3934. William Garcia was found lying in the road and nearly died due to the kicked-up dust that was covering his esophagus and ripping his stomach lining.

3935. John Lordan, who had won the 1903 Boston Marathon, got violently ill after 10 miles and had to quit.

3936. Thomas Hicks, one of the leaders, was denied water and instead fed a mixture of brandy and egg whites. He was also given *strychnine*, which was used as rat poison, and in small doses, could be used as a stimulant. This was perhaps the first case of doping at the Olympics.

3937. Len Tau, from South Africa, was chased a mile off course by wild dogs.

3938. One of the race favorites, Frederick Lorz, got cramps and decided to hitch a ride in a car. He waved at spectators and other runners as he rode by—covering 11 miles before the car broke down and he reentered the race. Lorz finished the race first, with a time just over 3 hours. Alice Roosevelt, daughter of President Theodore Roosevelt, placed a wreath on Lorz's head, but she was stopped from giving him his medal when, "someone called an indignant halt to the proceedings with the charge that Lorz was an impostor."

3939. Meanwhile, Hicks was still running, although he was suffering from hallucinations and thought he was still 20 miles from the finish line, even though he was less than 2 miles from it. His handlers gave him more brandy and more egg whites, and his trainers then carried him over the finish line, where he was declared the winner. Hicks lost 8 pounds during the race and nearly died.

3940. A Cuban postman named Andarín Carvajal had joined the marathon at the last minute. After losing all of his money gambling in New Orleans, he hitchhiked to St. Louis and had to run the event in street clothes. He cut his pants to make them into shorts. Not having eaten in 40 hours, he stole 2 peaches from a spectator and ran away. Later, he stopped at an orchard to eat some apples, which turned out to be rotten. This gave him stomach cramps and he had to lie down and take a nap. Carvajal still managed to finish in fourth place.

3941.

Only 14 of the 40 runners finished the race.

3942. Jesse Owens (1913–1980) was one of the greatest Olympic athletes ever despite the adversity he faced in the US because of the color of his skin.

3943. Born on September 12, 1913, in Oakville, Alabama, James Cleveland Owens was the tenth and last child of Henry and Mary Emma Owens.

3944. At the age of 5, his mother performed a home operation on him, removing a growth on his chest. He lost a lot of blood but survived.

3945. Owens was the first Black captain of an Ohio State University sports team. Despite that, Black athletes were not allowed to stay in the campus during that time.

3946. As an Ohio State sophomore at the Big Ten Championships in Ann Arbor, Michigan, Owens set 3 world records and tied a fourth within a span of 45 minutes, despite an injured tailbone that prevented him from even bending over to touch his knees.

3947. First, Owens tied the world record in the 100-yard dash. Fifteen minutes later he beat the world long jump record by nearly 6 inches. Within the next 30 minutes, he also set world records in the 220-yard dash and 220-yard low hurdles.

3948. Hitler intended the 1936 Berlin Games to be a showcase for the Nazi ideology of Aryan racial supremacy. Jesse Owens, however, won 4 gold medals in the games, including gold for the 100-meter sprint, the 200-meter sprint, the 4x100 meter relay, and the long jump.

3949. This feat would not be matched until Carl Lewis did the same in the 1984 Olympics in Los Angeles, California.

3950. When a myth arose that Hitler snubbed Owens at the games for racist reasons, Owens replied that they had actually exchanged congratulatory waves, and that the German leader gave him a "friendly little Nazi salute."

3951. Owens said, "Hitler didn't snub me—it was our president who snubbed me. The president didn't even send me a telegram."

3952. German shoemaker Adolf Dassler convinced German athletes and Jesse Owens to wear his leather track shoes with extra-long spikes. Owens's success at the Games helped Dassler launch his business: Adidas.

3953. Institutional racism in the US made Owens's return home a tough one. At one point, he had to file for bankruptcy and worked as a gas station attendant.

3954. Owens also participated in stunt races between doubleheaders of Negro League baseball games and during halftime of soccer matches.

3955. Owens would race against dogs, horses, and even motorcycles.

3956. "People said it was degrading for an Olympic champion to run against a horse," Owens said, "but what was I supposed to do? I had 4 gold medals, but you can't eat 4 gold medals."

3957. Owens returned to Berlin in 1951 while touring with the Harlem Globetrotters. Owens received a rousing ovation before speaking to 75,000 fans at the Olympic Stadium.

3958. The Jesse Owens Award is given out annually to the top track and field athlete in the US.

3959. From 1992 to 2008, baseball was an Olympic sport.

3960. The Olympic rings were designed by Baron Pierre de Coubertein in 1912, and he stated that, together with the white background, their colors also represented the flags of every nation competing at that year's event.

3961. Usain Bolt is the only non–drug offender in the list of the 30 fastest 100-meter sprints.

3962.

During the Olympic Games in China, Usain Bolt ate only chicken nuggets, as it was the only meal he recognized from home.

3963. Michael Phelps, arguably the best swimmer in history, won 23 gold medals across 5 Olympics Games (2000, 2004, 2008, 2012, 2016).

3964. If Michael Phelps were a country, he'd rank number 39 on the all-time Olympic gold medal list.

3965. Phelps won a total of 28 medals (3 silver and 2 bronze) making him the most decorated athlete in the history of the Summer Games.

3966. Eddie Eagan and Gillis Grafstrom are the only 2 athletes to win gold medals in both the Summer and Winter Olympics.

3967. Eddie Eagan (1897–1967) was an American boxer and bobsledder. He won a gold at the Summer games in boxing. And then he won a gold in the 1932 Winter Olympics as a member of the bobsled team.

3968. Gillis Grafstrom is the only person to have won an individual gold medal in both the Summer (1920) and Winter (1924, 1928) Olympics. Grafstrom won his medals in figure skating. (Figure skating was a Summer game until 1924.)

3969. There have been 3 Olympics held in countries that no longer exist. The countries are West Germany (1972), USSR (1980), and Yugoslavia (1984).

3970. The Cotswold Olimpick Games is an annual public celebration of games and sports now held on the Friday after Spring Bank Holiday near Chipping Campden, in the Cotswolds of England. The games likely began in 1612 and ran (through a period of discontinuations and revivals) until they were fully discontinued in 1852. They were revived in 1963 and continue to this day.

3971. One of the games at Cotswold was shin-kicking, also known as shin diggings or purring.

3972. It involves 2 contestants attempting to kick each other on the shin to force the other to the ground. It's been around since the early 17th century.

3973. During each round, the combatants face each other and hold on to each other's collar or shoulders. The combatants then attempt to strike their opponent's shin with the inside of the foot as well as their toes. The loser cries out "Sufficient" when he has had enough.

3974. Robert Wilson, organizer of the game in 2011, said, "It was vicious in those days, there was a lot of inter-village rivalry and lads used to harden their shins with hammers and were allowed to wear iron-capped boots."

3975. In modern competitions, the combatants are required to wear soft shoes and stuff their trouser legs with straw for padding.

3976. The World Games are an international multi-sport event that features sports that aren't in the Olympic Games.

3977. They've been held every 4 years since 1981 and include up to 34 sports.

3978. Up to 3,500 participants from 100 nations take part.

3979. Games at various World Games have included baton twirling, bowling, dancesport, American football, fistball, flying disc, trampoline, parkour, kickboxing, lacrosse, pool and beach lifesaving, minigolf, racquetball, roller hockey, inline skating, rugby, squash, tug-of-war, and more.

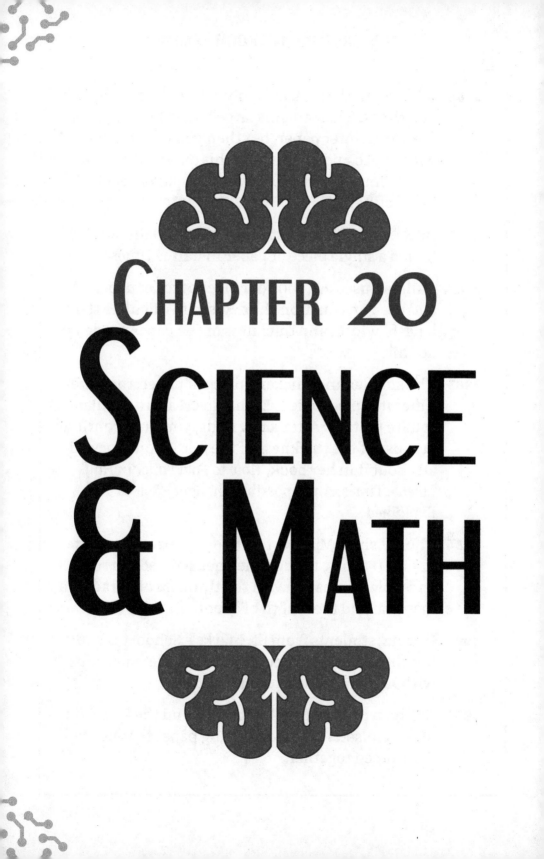

CHAPTER 20
SCIENCE & MATH

3980. It is a myth that you can only fold a piece of paper 7 or 8 times. This remains largely true for a regular piece of printer paper, but then you play around with width and length, and this question of how many times you can fold a piece of paper gets interesting.

3981. In 2002, high school student Britney Gallivan folded a single piece of paper in half 12 times.

3982. Gallivan used a 4,000-foot piece of toilet paper and used an equation she devised to calculate the length, width, and thickness of the paper needed to do this.

3983. The smaller and thicker a piece of paper, the fewer times it can be folded. Each fold creates a smaller square footage. After a few folds, you can't continue because of the thickness of the folds. You can read all about it in her book, *How to Fold Paper in Half Twelve Times: An Impossible Challenge Solved and Explained.*

3984. The TV show *Mythbusters* folded a piece of paper in half 11 times, though they needed a steam roller and a piece of paper with the thinness of parachute material and the length of a football field.

3985. In 2012, students from St. Marks's School in Southborough, Massachusetts, completed 13 folds with help from their teacher at MIT.

3986. Gallivan claims that *Mythbusters* and the kids from Massachusetts cheated by using paper that needed to be taped together.

3987. According to mathematicians, if your piece of paper could be folded 50 times, it would be thicker than the distance between the Earth and the sun.

3988. At 80 folds, your paper would be as thick as the Andromeda galaxy, which is approximately 141,000 light years wide.

3989.

Pure water has a neutral pH of 7. Pure water doesn't exist in nature.

3990. Pure water does not conduct electricity. Water becomes a conductor once it dissolves substances.

3991. Rainwater contains sodium, potassium, calcium, magnesium, chloride, and sulfate, as well as the dissolved carbon dioxide, oxygen, and nitrogen from the atmosphere. Its pH level is around 5.6.

3992. Water is called the universal solvent because it is able to dissolve a large number of different chemical compounds.

3993. Water dissolves more substances than any other liquid.

3994. Water can carry chemicals, minerals, and nutrients through runoff, groundwater flow, and living organisms.

3995. Water has a high surface tension, meaning it is adhesive and cohesive and forms in drops rather than spreading out over a surface as a thin film.

3996. This surface tension allows water to stick to the sides of vertical objects and allows for the creation of droplets and waves. It is the most cohesive of the non-metallic liquids.

3997. This is responsible for capillary action, which allows plants to move water, along with its dissolved nutrients, from their roots to their leaves.

3998. Water has a high heat index. This means it absorbs a lot of heat before getting hot. It also releases heat energy slowly.

3999. This high specific heat means that water moderates Earth's climate as well as helps organisms regulate body temperature.

4000. Water conducts heat more easily than every other liquid other than mercury. This means that large bodies of water have a uniform vertical temperature.

4001. Frozen water expands by about 9 percent by volume, but water has a maximum density at 4°C while still liquid. This is the only substance that has a maximum density as a liquid and not a solid.

4002. Air pressure affects the boiling point of water. The higher the altitude, the lower the air pressure, and the lower the boiling point.

4003. Sound waves travel longer distances through water than air due to the fact that water has a higher density.

4004. Most of the world's drinking water comes from underground aquifers.

4005. In 2013, forensic psychiatrist Samuel Leistedt and a colleague spent 3 years watching 400 movies featuring psychopaths, looking for the most realistic portrayal of a psychopath. After several viewings and enlisting a team of 10 forensic psychiatrists to help, they came to the conclusion that Javier Bardem's performance as Anton Chigurh in *No Country for Old Men* was the most realistic depiction of a psychopath.

4006. Chigurh's diagnosis was primary, classic/idiopathic psychopath.

4007. Leistedt said Chigurh is his favorite portrayal of a psychopath. "He does his job and he can sleep without any problems. In my practice I have met a few people like this."

4008. The second place "winner" was the child-murdering Hans Beckert from the 1931 movie M. Diagnosis: Secondary, pseudopsychopath, additional diagnosis of psychosis.

4009. Third place was Henry in the 1991 *Portrait of a Serial Killer*.

4010. The researchers wrote of Henry: "the main, interesting theme is the chaos and instability in the life of the psychopath, Henry's lack of insight, a powerful lack of empathy, emotional poverty, and a well-illustrated failure to plan ahead."

4011. Henry's diagnosis is primary, classic/idiopathic psychopath.

4012.

A paper published in the journal *Psychiatry Research* found that Anakin Skywalker / Darth Vader of *Star Wars* fame had borderline personality disorder.

4013. Anakin Skywalker had problems with impulsivity, violent outbursts, illusions of invincibility, and crises of identity . . . all of which are in line with a borderline personality disorder.

4014. The absence of a father and his early separation from his mother helped set the stage for his issues . . . along with the violent, dissociative events he experienced.

4015. Created as a parody of the Nobel Prizes, the Ig Nobel Prizes are given each year to scientists, inventors, and others who, in the words of the magazine sponsoring the awards, the Annals of Improbable Research, "first make people laugh, and then make them think."

4016. Each year, prizes are awarded to people whose achievements "cannot or should not be reproduced."

4017. Robert Matthews of Aston University in England won the Ig Nobel Physics prize for his work attempting to discover why buttered toast tends to fall on its buttered side. His study, called "Tumbling Toast, Murphy's Law and the Fundamental Constants," was published in the European Journal of Physics in 1995.

4018. The 2009 Ig Nobel Medicine prize was awarded to Dr. Donald Unger of Thousand Oaks, California. Every day for 60 years, Dr. Unger cracked the knuckles on his left hand, but never the knuckles on his right hand, in order to see whether or not cracking your knuckles causes arthritis. According to the patient doctor, it doesn't.

4019. Buck Weimer was awarded the Ig Nobel Biology prize in 2001 for his invention, which is described as "Protective Underwear with Malodorous Flatus Filter." In other words, airtight underwear with a filter that removes gas before it escapes. He invented it for his wife who suffers from Crohn's disease.

4020. Swedish scientists Susanne Schötz, Robert Eklund, and Joost van de Weijer won the 2021 Ig Nobel Biology prize for analyzing variations in purring, chirping, chattering, trilling, tweedling, murmuring, meowing, moaning, squeaking, hissing, yowling, howling, growling, and other modes of cat–human communication.

4021.

Takeshi Makino won the 1999 Ig Nobel Chemistry award for his involvement with S-Check, an infidelity detection spray that wives can apply to their husband's underwear.

4022. The 2001 Ig Nobel Astrophysics award was presented to Dr. Jack Van Impe and Rexella Van Impe for their discovery that black holes fulfill all the technical requirements for the location of hell.

4023. The 2002 Ig Nobel Peace prize was presented to Keita Sato, Dr. Matsumi Suzuki, and Dr. Norio Kogure for promoting peace and harmony between species by inventing Bow-Lingual, a computer-based, automatic, dog-to-human, language-translation device.

4024. Nine Polish scientists won the 2022 Ig Nobel Medicine prize for showing that when patients undergo some forms of toxic chemotherapy, they suffer fewer harmful side effects when ice cream replaces one traditional component of the procedure.

4025. An international group of scientists won the 2022 Ig Nobel Peace prize for developing an algorithm to help gossipers decide when to tell the truth and when to lie.

4026. The 2021 Ig Nobel Peace prize went to Ethan Beseris, Steven Naleway, and David Carrier, for testing the hypothesis that humans evolved beards to protect themselves from punches to the face. The results? The scientists concluded that yes, beards protect against punches to the face.

4027. German researchers won the 2016 Ig Nobel Medicine prize for discovering that if you have an itch on the left side of your body, you can relieve it by looking into a mirror and scratching the right side of your body.

4028. A team of international researchers won the 2014 Ig Nobel Biology prize for carefully documenting that when dogs defecate and urinate, they prefer to align their body axis with Earth's north-south geomagnetic field lines.

4029. Here are some scientific names for things! A trilobite: *Aegrotocatellus* jaggeri.

4030. Another trilobite: *Funkotriplogynium* iagobadius (named after James Brown: iago = James, badius = Brown).

4031. A fossilized mollusk: *Anomphalus* jaggerius.

4032. A spider: *Myrmekiaphila* neilyoungi.

4033. A fly: *Scaptia* beyonceae

4034. A snail: *Ba* humbugi.

4035. A protozoan: *Chaos* chaos.

4036. A moth: *La* cucuracha.

4037. A moth: *Leonardo* davincii.

4038. A snail: *Zyzzyxdonta* (with characteristics opposite to those of the Aaadonta snail).

4039. A molecule: Arsole.

4040. A molecule: Moronic acid.

4041. A bird: *turdus* maximus.

4042. In 1982, Ferdinando Boero, an Italian scientist, came up with a smart plan to meet his hero, musician Frank Zappa. He named a new species of jellyfish *Phialella* zappai and informed him. Zappa said, "There is nothing I'd like better than having a jellyfish named after me." He then dedicated a live show to Boero and his jellyfish.

4043. There is also a spider named after Frank Zappa: *Pachygnatha zappa.*

4044. And a minor planet: Zappafrank.

4045. Meanwhile, Frank Zappa, who wasn't a scientist, named his children Moon Unit, Dweezil, Ahmet Emuukha Rodan, and Diva Thin Muffin Pigeen.

4046.
The largest volcano in the solar system is Olympus Mons on Mars.

4047. It is also tied as the tallest mountain in our solar system and nearly 3 times larger than Mount Everest.

4048. Rheasilvia on the asteroid Vesta is 90% the diameter of the whole asteroid. It is 314 miles in diameter (around the same size as the state of Arizona) and 16 miles high.

4049. The entire chain of Hawaiian Islands could fit inside Olympus Mons.

4050. An asteroid is a small, rocky object that orbits the sun, while a meteor is a piece of rock or metal from outer space that speeds into Earth's atmosphere, creating a streak of light.

4051. NASA reports that there are currently 1,113,527 asteroids in our solar system, with the majority lying between Mars and Jupiter.

4052. NASA tracks over 28,000 asteroids for possible threats to earth.

4053. A meteorite is a solid piece of debris from a comet, asteroid, or meteoroid that reaches the surface of Earth.

4054. Our solar system takes 230 million years to complete one orbit of the Milky Way's center.

4055. Hang time is the amount of time someone stays in the air after jumping.

4056. The Hyper-Physics site at Georgia Tech contends that to attain a vertical airtime of 1 full second, a person would have to have a vertical launch velocity of almost 11 miles per hour and have the bottoms of their feet reach just over 4 feet off the ground at the peak of flight.

4057. Michael Jordan's maximum hang time was .92 second.

4058. An average human's hang time is .53 second.

4059. DNA has a 521-year half-life, meaning that genetic material can't be recovered from dinosaurs. That means that after 521 years, half of the bonds between nucleotides in a sample would have broken. After another 521 years, half of the remaining bonds would have broken . . . and so on, until there is no DNA recoverable.

4060. The team at the University of Copenhagen and Michael Bunce at Murdoch University in Perth contend that even in a bone that has been perfectly preserved, the DNA would stop being readable after roughly 1.5 million years.

4061. DNA half-life makes the actions of the movie *Jurassic Park* impossible.

4062. The oldest authentic DNA sequence is a half a million years old.

4063.

Jupiter can have a triple eclipse, in which 3 moons cast shadows on the planet simultaneously.

4064. The most expensive man-made object ever is the International Space Station. Its final cost will be over $100 billion.

4065. At the age of 90, William Shatner, who played Captain Kirk in the original *Star Trek* TV series, went to space for the first time in a capsule created by Jeff Bezos's company Blue Origin.

4066. Shatner thought he would experience "a deep connection with the immensity around us." Instead, he felt overwhelming grief.

4067. He said, "The strongest feeling, that dominated everything else by far, was the deepest grief that I had ever experienced."

4068. Space philosopher Frank White, in his 1987 book called *The Overview Effect*, called this feeling of grief a "cognitive and emotional shift in a person's awareness . . . they're at a distance and they're seeing the Earth . . . in the context of the universe."

4069. According to White, everyone who travels to space feels this strong reaction that's strong enough to change a person's perspective and assumptions about humanity.

4070. Many astronauts report becoming much more sensitive to climate change after being in space.

4071. They often return with "a greater distaste for war and violence, and a desire to do something to improve life back on the surface."

4072. Bart Sibrel, a conspiracy theorist who believes the US faked the Apollo Moon landings, once lured Apollo astronaut Buzz Aldrin to a hotel to interview him.

4073. Sibrel tried to coerce Aldrin to swear an oath on a Bible that he had been on the Moon. Aldrin refused, and after being called a thief and a liar, the 72-year-old Aldrin punched the much younger Sibrel.

4074. Mary Anning (1799–1847) was the first to note that bezoar stones that were found in the abdominal region of ichthyosaur skeletons contained fossilized fish bones, scales, and other bones.

4075. Mary Anning never attended formal school and hunted for fossils to support her family. She taught herself geology, anatomy, and illustration.

4076. When Mary Anning was a baby, a woman who was holding her was struck by lightning. Mary survived—making her only 1 of 2 of her parents' 10 children to do so.

4077. Mary Anning discovered the first ever Plesiosaur skeleton as well belonging to a Pterodactyl.

4078. William Buckland (1784–1856) was a theologian, rock and mineral expert, and the first professor of geology at Oxford in the 1820s who first described coprolites, which are fossilized dinosaur poop.

4079. Buckland not only studied coprolites, but also had a side table built utilizing 64 sliced nodules of fossilized poop.

4080. Buckland's real claim to fame, however, was his attempt to eat as many creatures of the animal kingdom as possible, including crocodile, mice, hedgehogs, moles, jackals, puppies, and more.

4081. Buckland and his son, Frank, had an arrangement with the Regent's Park Zoo in which Frank would retrieve dead zoo animals to cook.

4082. Frank devoted his life to leading the Society for the Acclimatization of Animals, which worked to bring exotic animals into the United Kingdom to use as food.

4083. Other dishes included elephant trunk soup, roast giraffe, and partially rotted panther.

4084. Researchers at the University of California, Berkeley estimate that 2.5 billion T. rexes lived on Earth across more than 127,000 generations (so, not at the same time!).

4085.
The sun is 400 times larger than the moon, but is also 400 times farther from Earth, making the 2 bodies appear the same size in the sky.

4086. The surface of the sun is 10,000°F (5,500°C), which is hot enough to boil diamonds. Its core is even hotter, with temperatures topping 27 million °F (15 million °C).

4087. The aurora borealis and aurora australis are caused by sun particles from solar winds hitting the Earth's upper atmosphere and releasing electricity. These particles are attracted to the North and South Poles because the Earth is a giant magnet that's strongest at the poles, which attract the material from the sun.

4088. There are currently 26 spacecrafts from around the world, all pointed at the sun right now, and there are 13 new missions in development.

4089. The Big Bang theory states that our universe began as a point of infinite gravity and density. This is called a singularity.

4090. Then, in a trillionth of a trillionth of a trillionth of a second, it exploded outward, doubling and redoubling at a rate that was faster than the speed of light. This is called inflation.

4091. According to a 2019 article in *Discovery*, there are a lot of theories about what was going on before the Big Bang.

4092. The Big Bounce is a theory that states an earlier universe collapsed into the singularity that started our universe.

4093. Big Bounce theorists believe that the universe is infinite and forever expanding and collapsing.

4094. The inflation hypothesis contends that there was no singularity and all the energy in the universe was bound in the fabric of space. Fluctuations of this led to a "huge swell" of energy in 1 place that made it expand quickly, creating the universe.

4095. The US's first lunar program was named after Apollo, the ancient Greek god of music, healing, and the sun. The country's new lunar missions are named after Artemis, Apollo's twin sister and the goddess of the moon.

4096. No human has stepped on the moon since 1972.

4097. The Artemis mission plans to send astronauts back to the moon—including the first person of color and the first woman.

4098. Artemis 3 will land on the moon's South Pole—the first manned mission to do so.

4099. Later Artemis missions are planned to set up a permanent base on the moon.

4100. In May 2022, scientists at the University of Florida successfully grew plants from seeds that were planted in sample material from the moon called regolith.

4101. In 2009, there were 13 crew members in the International Space Station—a record.

4102. The International Space Station has been continuously occupied since November 2000.

4103.

Peggy Whitson set the US record for spending the most total time living and working in space at 665 days on Sept. 2, 2017.

4104. There have been 266 individuals from 20 countries on the International Space Station.

4105. Human bodies change in microgravity. Muscles, bones, the cardiovascular system, and eyes are all affected. Astronauts work out up to 2 hours a day to mitigate this.

4106. NASA's space shuttles have traveled 542,398,878, making 21,152 Earth orbits.

4107. The space shuttle program flew 135 missions.

4108. The space shuttle program, officially called the Space Transportation System (STS), began its flight career with *Columbia* roaring off Launch Pad 39A at NASA's Kennedy Space Center in Florida on April 12, 1981.

4109. *Atlantis* flew the final space mission, STS-135, in July 2011.

4110. *Atlantis* was named after the primary research vessel for the Woods Hole Oceanographic Institute in Massachusetts from 1930 to 1966.

4111. As the world's first reusable spacecraft to carry humans into orbit, the shuttles possessed a 60-foot-long payload bay and robotic arm that could carry several satellites into low Earth orbit on one flight, service them, and even bring them back for future use.

4112. The shuttle fleet, which was designed to reach orbits ranging from about 115 to 400 miles high, also carried laboratories into orbit for unique experiments.

4113. The fleet was also called on to build the International Space Station (ISS), the largest spacecraft ever, which was assembled in orbit.

4114. Each shuttle was named after influential ships of science and exploration.

4115. *Enterprise* was the first space shuttle, although it never flew in space.

4116. It was used to test critical phases of landing and other aspects of shuttle preparations.

4117. *Enterprise* was mounted on top of a modified 747 airliner for approach and landing tests in 1977. It was released over the vast dry lakebed at Edwards Air Force Base in California to prove it could glide and land safely.

4118. *Columbia* was named after a sloop captained by Robert Gray, who on May 11, 1792, maneuvered his ship through dangerous inland waters to explore British Columbia and what are now the states of Washington and Oregon.

4119. *Columbia* was the first shuttle to fly into orbit.

4120. *Columbia* and its 7 astronauts were lost on February 1, 2003, when it broke apart during re-entry on its 28th mission.

4121. *Challenger* was named after the British Naval research vessel HMS *Challenger* that sailed the Atlantic and Pacific oceans during the 1870s.

4122. *Challenger* and its 7 astronauts were lost Jan. 28, 1986, when a seal on one of its boosters failed and hot gas burned through the external tank, igniting the propellants and causing the shuttle to break up in the resulting explosion.

4123. *Discovery* was named after 1 of the 2 ships used by the British explorer Captain James Cook when he discovered Hawaii and explored Alaska and northwestern Canada in the 1770s. *Discovery* flew more than any other shuttle with 39 missions.

4124. *Discovery* deployed NASA's Hubble Space Telescope.

4125. *Endeavour* was named by students in elementary and secondary schools across the nation after a ship chartered to traverse the South Pacific in 1768.

4126. The first and second people to fly on the shuttle were John Young and Bob Crippen.

4127. People representing 16 different countries have flown on shuttle flights and 306 men and 49 women have flown aboard shuttles.

4128. Story Musgrave is the only astronaut to have flown on all 5 space-worthy shuttles.

4129.

Sally Ride became the first American woman in space when she flew aboard *Challenger* in 1983.

4130. Astronauts Jerry Ross and Franklin Chang-Diaz have flown the most shuttle missions with 7 each.

4131. On May 30, 2020, NASA astronauts Doug Hurley and Robert Behnken launched to the International Space Station (ISS) aboard a SpaceX Crew Dragon spacecraft, marking the first crewed spaceflight launched from American soil since NASA retired the space shuttle.

4132. The search for extraterrestrial life is known by its acronym SETI.

4133. On June 24, 1947, a pilot named Kenneth Arnold reported seeing 9 objects in the sky. He said they looked like saucers skipping across the water. This started the UFO craze of the 1950s (and beyond).

4134. Researchers working on the Cetacean Translation Initiative (Project CETI) study whale communication in the hopes that it will help scientists listening for radio waves from space to know when they are hearing communications from another world.

4135. On August 15, 1977, the Big Ear radio telescope at Ohio University picked up a radio signal from space that lasted 72 seconds. It's called the Wow Signal, as it's the strongest candidate as a message from another world to date.

4136. Solar flares release more energy than millions of atomic bombs exploding at once.

4137. Earth's magnetic field protects us from the radiation from solar flares.

4138. Solar storms happen when the sun emits bursts of charged particles.

4139. The strongest geomagnetic storm on record was caused by a coronal mass ejection in September 1859. When the mass of particles hit Earth, they caused electrical surges in telegraph lines that shocked operators and set some telegraph instruments on fire.

4140.

If a geomagnetic storm of that magnitude hit Earth today, researchers suggest it could cause $2 trillion in damage.

4141. At 21.4 feet across, the James Webb Space Telescope's primary mirror is the largest mirror ever launched into space.

4142. The James Webb Space Telescope has found universes more than 150 million years older than those found by the Hubble Space Telescope.

4143. Venus is the only planet in our solar system that spins in a clockwise direction.

4144. Jupiter is the fastest spinning planet in our solar system. It takes around 10 hours to complete a full rotation on its axis.

4145. Saturn's rings are made from trillions of pieces of orbiting ice.

4146. Saturn's rings can extend as far out as 111,850 miles from the center of the planet. However, they are only about 330 feet thick.

4147. Dinosaurs roamed earth before Saturn got its rings.

4148. Uranus is the only planet in the solar system that rotates on its side. This could be because of a collision at some point.

4149. Some dwarf stars are giant diamonds. BPM 37093 is a dwarf star that's a 2,500-mile-diameter diamond.

4150. Betelgeuse is one of the brightest stars in the sky and has a luminosity about 10,000 times greater than the sun.

4151. Betelgeuse is near the end of its life and may explode into a supernova. If it does, it will light up the sky on earth for two months or longer.

4152. A neutron star is what's left after a dying star explodes in a supernova.

4153. During a supernova, the star's core collapses on itself forming a super-dense neutron star.

4154. A teaspoon of neutron star would weigh 6 billion tons.

4155. A typical neutron star is only about 12 miles in diameter—but can weigh up to 3 times more than the sun.

4156. Total internal reflection is when you point a laser beam at a jet of flowing water and the beam gets trapped in the water. The light is slowed down by the heavier particles in the water.

4157. The Mpemba effect describes how hot water freezes faster than cold water. Researchers believe this is because the velocities of water particles have a specific disposition while they're hot, which allows them to freeze more readily.

4158. The deadliest virus in the world is the Marburg virus. During a 1998–2000 outbreak in the Democratic Republic of Congo, the death rate was 83%. The mortality rate of the 2017 outbreak in Uganda was 100%.

4159. The speed of sound varies due to environmental conditions such as air pressure and humidity.

4160.

Feldspars are the most abundant mineral group on earth and make up nearly 60 percent of its crust.

4161. Feldspars are used in glassmaking and ceramics as well as for fillers in paints.

4162. Calcite is found in more than 300 different shapes—more than any other mineral.

4163. Galena is a mineral that was mined as long as 5,000 years ago. The ancient Egyptians used it as eyeliner.

4164. Hematite is the principal ore of iron. It's used for paint pigment, X-ray protection, shielding, and more. The red hue of many rocks is due to hematite.

4165. Magnetite is the most magnetic mineral on earth. The iron in magnetite is used to make steel.

4166. Talc is the softest mineral on earth. It's crushed into a powder to use in cosmetics.

4167. Tungsten is the hardest metal known and is used for space travel and ballistics.

4168. Scientists believe there are 3 billion base pairs of DNA in human genes and more than 25,000 genes in the human genome.

4169.

Tomatoes (35,000) and mice (30,000) have more genes than humans (around 20,000).

4170. Marie Curie (1867–1934) is the only person to win Nobel prizes in 2 different sciences. She won the award in Physics in 1903 for her work on radiation and in Chemistry in 1911.

4171. Marie Curie was also the first woman to ever win a Nobel Prize in any field.

4172. The Curies discovered two new elements: polonium and radium. They named polonium after their homeland, Poland.

4173. The Curies coined the term "radioactivity."

4174. Marie Curie shared the Nobel Prize in Physics with her husband, Pierre Curie.

4175. Marie and Pierre Curie's notebooks are still radioactive after more than 100 years and have to be kept in lead-lined boxes.

4176. During World War I, Marie Curie and her daughter, Irene, organized mobile X-ray teams that went to the front line of the fighting to take X-rays of injured soldiers. Irene was only 17 at the time.

4177. The fleet of blue medical vans designed to hold the X-ray equipment became known as Petite Curies.

4178. The Petite Curies helped doctors treat over a million wounded soldiers.

4179. Marie Curie died of aplastic anemia, due to her close contact with radiative materials.

4180. Irene Curie went on to win her own Nobel Prize in Chemistry alongside her husband, in 1935, in recognition of their synthesis of new radioactive elements.

4181. Francis Crick, who received a Nobel Prize in Physiology or Medicine in 1962 for his work on discovering the structure of DNA, later came to believe that all life on Earth came from aliens.

4182. Francis Crick, along with James Watson and Maurice Wilkins, won the Nobel Prize for their DNA discovery, despite the fact that Rosalind Franklin's work was instrumental to their discovery and much of the credit should have gone to her.

4183. Japanese scientists measured the amount of friction between a shoe, a banana skin, and the floor. They found that the friction coefficient was almost nonexistent, and that walking on a banana peel is 6 times more slippery than normal friction between a shoe and the floor.

4184. Breathing in helium changes your voice because it is less dense than oxygen, so the sound of our voice travels faster through our vocal cords, making our voice sound higher.

4185. Helium's boiling point is -458°F. At this temperature, it turns to a liquid that flows against gravity and will run up a glass container. This is the lowest boiling point among all elements.

4186. Helium does not have a melting point at standard pressure.

4187.

The element cesium will burst into flame if it comes into contact with room temperature air.

4188. Tetranitratoxycarbon is a hypothetical molecule proposed by Clara Lazen, a fifth-grade student in Kansas City, Missouri. It is not clear whether or not Clara randomly or deliberately assembled the molecule in science class.

4189. The Matilda effect is a bias against acknowledging the achievements of women scientists whose work is attributed to their male colleagues.

4190. The Matilda effect was first described by Matilda Joslyn Gage, a suffragist who discussed this effect in her essay "Woman as Inventor" in 1870. The term "Matilda effect" was coined in 1993.

4191. Theano of Crotone's (6th century BCE) work in mathematics was attributed to her husband (or father, depending on the source), Pythagoras.

4192. Esther Lederberg (1922–2006) was a pioneer of bacterial genetics. She collaborated with her husband, Joshua, on their work with microbial genetics. Esther even discovered a virus that infects E. coli bacteria. It was her husband though, who received the 1958 Nobel Prize for Physiology or Medicine. Not only that, but she was never even offered a tenured position at a university.

4193. Jocelyn Bell Burnell discovered irregular radio pulses while working as a research assistant at Cambridge. She showed her work to her advisor, and they then worked together to discover these pulses were neuron stars. She received no credit for her work, and her advisor, Antony Hewish, won the Nobel Prize for Physics in 1974.

4194. Lise Meitner discovered that atomic nuclei split during some reactions (nuclear fission). Her lab partner and nephew, Otto Hahn, won the Nobel Prize for Chemistry in 1944 for this discovery.

4195.

Lise Meitner was nominated 19 times for the Nobel Prize in Chemistry between 1924 and 1948, and 30 times for the Nobel Prize in Physics between 1937 and 1967. She never won either.

4196. Most of an atom is empty space—99.9999999999999 percent, in fact.

4197. More than 80 percent of Earth's surface was formed by volcanoes.

CHAPTER 21
TECHNOLOGY
& INVENTIONS

4198. According to the US Patent and Trademark Office, a patent is "an intellectual property right granted by the government . . . to an inventor to exclude others from making, using, offering for sale, or selling the invention . . . for a limited time in exchange for public disclosure of the invention when the patent is granted."

4199. The first US patent was issued to Samuel Hopkins on July 31, 1790, for an improvement "in the making Pot ash and Pearl ash by a new Apparatus and Process." The patent was signed by President George Washington.

4200.

Chester Carlson invented the photocopier in 1937. During the next 7 years, his invention was turned down by more than 20 corporations.

4201. It took more than 10 years for Carlson to sell his idea and another 10 before anyone could buy a Xerox machine.

4202. According to most historians, John W. Lambert invented and made the first gasoline automobile in America in 1891, 17 years before Henry Ford's Model-T.

4203. This motorized tricycle had 2 speeds (no reverse gear) and 3 wooden rear wheels with steel rims. Although Lambert was never able to convince anyone to pay $585 for what he called the Buckeye Gasoline Buggy, Lambert and his horseless carriage were responsible for the first car accident. Lambert, out for a drive with a friend, hit a root sticking out of the ground. He lost control of the buggy and crashed into a post.

4204. In 1896, Henry Ford designed and built his first automobile, which was called the Quadricycle.

4205. The Quadricycle ran atop 4 bicycle wheels. It had 2 gears and could reach speeds of 20 miles per hour. It couldn't, however, go in reverse.

4206. Ford only built 3 Quadricycles and sold 1 of them.

4207. There are approximately 1 billion cars worldwide.

4208. The first autopen was patented in the US in 1803. Thomas Jefferson used one for the White House.

4209. In 2011, President Barack Obama was the first president to pass legislation with an autopen signature.

4210. Celebrities who have been accused of using autopens to sign books include Ozzy Osbourne, Dolly Parton, Van Morrison, and Bob Dylan.

4211. The automatic face-blurring technology used by Google Street View blurred the face of cows.

4212. The ocean appears blurred in Google Earth because of lack of data.

4213. The entire country of Israel is shown in low resolution in all US mapping services. This is due to the Kyl-Bingaman Amendment to the National Defense Authorization Act of 1997.

4214. A study in 2015 revealed that a computer model using only Facebook likes can predict your personality better than all family members except for a spouse.

4215. Teenage inventor Ann Makosinski invented a flashlight that's powered by the body heat of the hand holding it.

4216. In 1973, only 43 computers were connected to the internet.

4217. In 2005, only 15 percent of the world's population used the internet.

4218.

As of 2022, more than 5 billion people used the internet. That's 63.5 percent of the world's population.

4219. As of 2017, 977,000 people were still using dial-up technology to connect to the internet.

4220. From January 2017 to December 2021, the areas with the most interest in dial-up internet are Oregon, Virginia, Utah, and Mississippi.

4221. Internet users spend an average of 6.5 hours a day online.

4222. There are 269 billion emails sent every day.

4223. Four countries have 100 percent internet access: Bahrain, Liechtenstein, Qatar, and the United Arab Emirates.

4224. In 2000, 2 percent of people in China use the internet. By 2020 it was 70 percent.

4225. The first spam email was sent in 1978 to 393 people by an electronics marketer.

4226. In 1956, the Chrysler Corporation added record players for its cars. Known as Highway Hi-Fi, the record player measured 4 inches high and less than 1 foot wide. It was mounted under the instrument panel and played 7-inch discs that were made exclusively for the automobiles.

4227. The records spun at 16 2/3 rpm and required almost 3 times the number of grooves per inch as an LP.

4228. Chrysler discontinued the players in late 1958.

4229. In 1959, Volvo invented the 3-point seatbelt and made the patent free to all its competitors, believing "it had more value as a free lifesaving tool than something to profit from."

4230. Which came first: glue or tape? The first glue was patented in Britain around 1750. It was made from fish.

4231. Tape was invented in 1925 by Richard Drew, a 3M engineer.

4232. Which came first: the automobile or the bicycle? The first self-propelled road vehicle was a military tractor invented by a French engineer named Nicolas Joseph Cugnot in 1769.

4233. The first gas-powered cars were developed in the mid to late 1800s, and Henry Ford was the first to make cars readily available in the 1900s.

4234. The invention of the bicycle is attributed to a Scottish blacksmith named Kirkpatcick Macmillan in 1839.

4235. Which came first: snaps or the zipper? Snap fasteners were patented by a German inventor named Heribert Bauer in 1885. The snaps were used for men's pants.

4236. The zipper didn't come along until 1891. It was invented by Witcomb L. Judson, but greatly improved a few years later in Canada by a Swedish-born electrical engineer.

4237. Which came first: the telephone or the fax machine? Even though fax machines didn't become common office equipment until the 1980s, the first facsimile machine was invented in 1843 by an Englishman named Alexander Bain.

4238. The device was made up of 2 pens connected to pendulums, which in turn were joined to a wire and could reproduce writing on an electrically conductive surface.

4239. The telephone, on the other hand, was patented by Alexander Graham Bell in 1876.

4240. Another American inventor, Elisha Gray, who also developed an early fax machine, came up with a device that could also transmit sound electrically.

4241. Unfortunately for Gray, Bell reached the patent office just hours before Gray did. There was a fierce legal battle, which Bell won.

4242.

Which came first: the jigsaw puzzle or the yo-yo? Yo-yos have been around for more than 2,500 years. It's considered the second-oldest toy in history.

4243. The doll is considered the oldest toy.

4244. Ancient Greek children played with yo-yos and decorated the 2 halves with pictures of gods.

4245. The jigsaw puzzle was invented by an English mapmaker and engraver named John Spilsbury in 1767.

4246. The first puzzle was a map of the world. Spilsbury's puzzles were used to teach geography to children.

4247. Which came first: Facebook or YouTube? The social networking website Facebook was launched in February 2004, while YouTube, the video sharing website, was launched a year later in February 2005.

4248. Which came first, the Ferris wheel or the roller coaster? The first roller coasters were built in France in the early 1800s.

4249.

The first Ferris wheel was built for the 1893 World's Fair in Chicago.

4250. George W. Ferris, a bridge builder, designed the Ferris wheel to rival the Eiffel Tower.

4251. Which came first, the Frisbee or the Hula Hoop? Ancient Egyptian children played with hoops made of vines and dried-out grasses thousands of years ago.

4252. The first Frisbee went on sale in 1964, although many colleges claim they had been using Frisbie Baking Company pie tins to play catch with since the 1880s.

4253. Which came first, toilet paper or the flushing toilet? Toilet paper was first produced for the Emperor of China in 391 CE.

4254. Packaged toilet paper for the rest of the world didn't roll around until 1857.

4255. And, no, the toilet was not invented by Thomas Crapper.

4256. There is evidence of simple toilets dating back 2,800 years; however, Sir John Harrington is credited with inventing a flush toilet in 1596 for Queen Elizabeth I.

4257. The first patent for the flushing toilet was given to Alexander Cummings in 1775.

4258. On June 4, 1783, the Montgolfier brothers, inventors of the first hot-air balloon, demonstrated their invention to a crowd at the market square in the French village of Annonay. A bonfire fed the tethered 33-foot taffeta contraption, and then, one of the brothers cut the tether and set the balloon free.

4259. It traveled 6,000 feet into the air before landing in a field several miles away, where it was attacked by peasants with pitchforks, who thought it was a beast from the sky that came down to attack them. They tore the balloon to pieces and tied it to the tail of a horse and paraded the conquered beast up and down the road.

4260. Before inventing the telegraph, Samuel Morse (1791–1872) was an accomplished painter who received commissions to paint portraits of former Presidents John Adams and James Monroe.

4261. While working on a commission in Washington DC, he received a letter delivered by a horse messenger that his wife was ill. By the time he got home to Connecticut, not only had his wife died, but she had already been buried. This tragedy led him to invent Morse code and the telegraph.

4262. The first Morse code message in 1844 from Washington DC to Baltimore read, "What hath God wrought?"

4263. Almon Strowger, an undertaker from Kansas City, Missouri, invented the first mechanical telephone exchange in the 1890s, which eliminated the need for operators.

4264. Strowger's invention was necessitated by the fact that the operator at the telephone exchange was his competitor's wife, and she was redirecting Strowger's client calls to her husband's business.

4265. The first webcam was invented by students at Cambridge University in 1991 in order to monitor whether or not the coffee pot in the corridor was full or not.

4266. In 2013, Jamie Siminoff's idea for DoorBot (home security and smart home devices) was rejected by the Sharks on *Shark Tank*. In 2018, he sold his business, now named Ring, to Amazon for $1 billion.

4267. In 2022, the Klein Vision AirCar was certified as an aircraft in Slovakia. It hasn't been approved for road use yet.

4268. It can reach a height of 8,200 feet in altitude, and it needs 1,000 feet for liftoff.

4269. The fuselage of the AirCar doubles as a 2-seat road car with 4 large wheels. It has foldout wings and an included parachute.

4270. In 2021, a prototype made a 35-minute flight between Nitra and Bratislava airports.

4271. AI, or artificial intelligence, refers to the ability of a computer or machine to mimic human cognition, including learning and problem solving.

4272.

AI technology is based on the idea that human intelligence can be reduced to a set of algorithms and processes that can be replicated in a machine.

4273. One of the most interesting aspects is the ability of AI systems to learn and adapt to new information. Unlike traditional computer programs, which are designed to perform specific tasks using pre-defined rules and instructions, AI systems are capable of learning from data and improving their performance over time. This allows them to tackle complex problems and make decisions in ways that are similar to humans.

4274. AI has been a topic of study and research since the 1950s, with significant progress being made in the last decade.

4275. The term "artificial intelligence" was coined by John McCarthy in 1956 at a conference at Dartmouth College.

4276. The first AI programs were developed in the 1950s and 1960s, with the goal of enabling machines to perform tasks that required human-like intelligence.

4277. Early AI research focused on developing systems that could perform specific tasks, such as playing chess or solving mathematical problems.

4278. The field of AI experienced a period of decline in the 1970s and 1980s, known as the "AI winter," due to a lack of progress and funding.

4279. The field of AI experienced a resurgence in the 1990s and 2000s, driven by advances in computing power and algorithms.

4280. AI systems can be classified into 2 main types: narrow or weak AI, and general or strong AI.

4281. Narrow or weak AI refers to systems that are designed to perform specific tasks, such as playing chess or recognizing speech.

4282. General or strong AI refers to systems that have the ability to reason and solve problems in a way that is comparable to human intelligence.

4283. Some common applications of AI include language translation, image and speech recognition, and decision making.

4284. Machine learning is a subfield of AI that involves the use of algorithms and statistical models to enable a system to improve its performance on a specific task over time.

4285.

Deep learning is a type of machine learning that involves the use of neural networks, which are inspired by the structure and function of the human brain.

4286. The use of AI in the criminal justice system, such as in predictive policing and risk assessment, has sparked debates about bias and the potential for unfair treatment.

4287. AI is being used in the agricultural industry to monitor crops, optimize irrigation systems, and predict yield.

4288. AI is also being used in the energy industry to optimize the generation and distribution of electricity.

4289. The gaming industry has also been heavily influenced by AI, with the use of machine learning algorithms to create more realistic and dynamic game environments.

4290. The development of AI has been driven by advances in computing power, algorithms, and data availability.

4291. OpenAI is a non-profit research institute founded in 2015, that is focused on developing artificial intelligence technologies in a responsible and safe way.

4292. The team at OpenAI trained their AI using a large dataset of text, which it uses to generate human-like responses to questions and prompts.

4293. As the program states, "I am not a real person and do not have my own thoughts or feelings. I am simply a program designed to assist users in generating text."

4294. OpenAI is also dedicated to making AI accessible to everyone and providing a platform for anyone to develop their own AI applications. OpenAI's mission is to ensure that artificial general intelligence benefits all of humanity.

4295. All of the AI facts just presented came from OpenAI.

4296. Quantum computing is a type of computing that uses quantum-mechanical phenomena, such as superposition and entanglement, to perform operations on data. It has the potential to solve certain problems much faster than classical computers, which are based on traditional binary logic.

4297. Quantum computers are still in the early stages of development, and it is not yet clear how they will be used in practice. However, they have the potential to revolutionize fields such as chemistry, materials science, and machine learning.

4298. Classical computers store and process information using bits, which represent either a 0 or a 1. Quantum computers, on the other hand, use quantum bits, or qubits.

4299. Qubits can represent a 0, a 1, or a combination of both at the same time, thanks to the principles of superposition and entanglement. This allows quantum computers to perform many calculations simultaneously, potentially leading to much faster problem-solving.

4300. Using a deep-learning algorithm originally designed for particle physics experiments, the German retailer Otto can predict what will be sold within 30 days with 90 percent accuracy. This helped lower returns by over 2 million items a year.

4301. Researchers have found hackers can take over voice-controlled devices (such as smartphones) using laser pointers.

4302. Dr. Grace Murray Hopper (1906–1992) created the first computer language compiler tools to program the Harvard Mark I—IBM's computer during World War II.

4303. John von Neumann is credited with initiating the computer's first program; however, Dr. Hopper invented the code to program it. Hopper also pioneered COBOL, a programming language used to this day.

4304. Dr. Hopper coined the term "bug" to describe a computer malfunction.

4305. In 1946, 6 women programmed the first computer ever built. The ENIAC (Electronic Numerical Integrator and Computer) was invented by John Mauchly, but he didn't program it.

4306. In 2021, it was estimated that there were 1.2 billion computer viruses circulating.

4307. An iPhone utilizes 75 out of the 118 elements of the periodic table, including gold, aluminum, yttrium, terbium, europium, silicon, and more.

4308. The first tweet ever was sent by founder Jack Dorsey in 2006. It read, "just setting up my twttr."

4309. The rubber used as shock absorbers in running shoes was invented by NASA originally for space helmets.

4310.

The average smartphone user touches their phone 2,617 times a day. This number was based on 94 Android users over a period of 5 days, so more accurate numbers may be forthcoming when larger surveys are done.

4311. As of 2023, 81.6% of Americans own a smartphone. That totals 270 million people.

4312. The average American spends 5 hours and 24 minutes on their smartphones daily.

4313. Americans on average check their phones every 10 minutes.

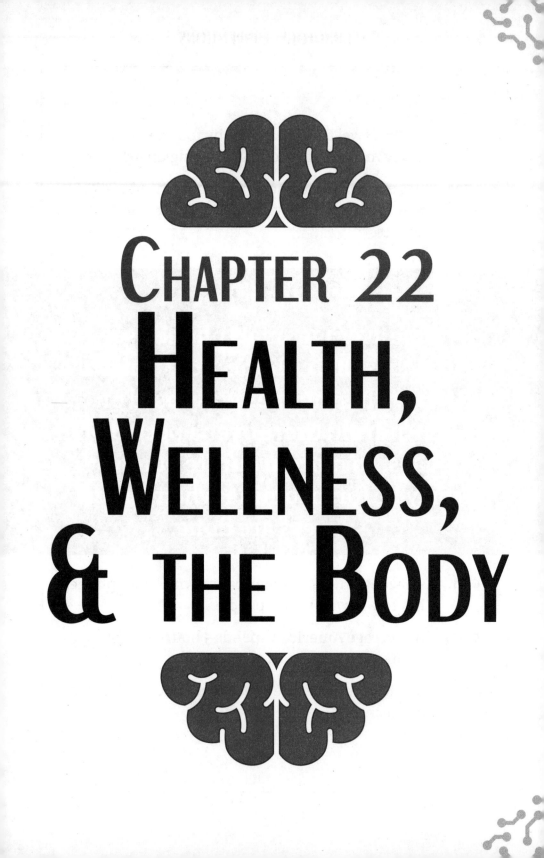

CHAPTER 22
HEALTH, WELLNESS, & THE BODY

4314. It became popular to say you needed 8 glasses of water a day in the 1980s.

4315. In 2002, the *American Journal of Epidemiology* by a Dartmouth University scientist found no scientific studies to support drinking 8 glasses of water a day.

4316. The article concluded that you don't need to drink large quantities of water to be healthy, and that you should follow 1 golden rule for when to drink water: Drink when you're thirsty.

4317. Furthermore, studies also show that you can get most of the fluid you need through your food.

4318. You sweat, even when you're swimming. You don't notice this because the water washes the sweat off.

4319. A double pregnancy is possible. It's extremely rare, but it's called a superfetation.

4320. Sugar doesn't cause hyperactivity in children. In fact, more than a dozen different experiments show that children who consume large amounts of sugar are no more hyperactive than those who don't. It doesn't affect children with attention-deficit/hyperactivity disorder or children with sensitivities to sugar. Researchers even go on to say that the behavior parents notice after sugar intake is in their own heads.

4321. One study even showed that when parents thought their kids were given a sugared drink (even though the drink was sugar-free), they rated the kids' behavior as more hyperactive.

4322. Chewing gum doesn't stay in your stomach for 7 years if you swallow it. After around 40 hours, it exits the body the way the rest of your food does.

4323. The tryptophan in turkey does not cause drowsiness. Tryptophan is converted into serotonin by the body, and serotonin is sleep-inducing; however, tryptophan can only cause drowsiness if it is eaten by itself. The other amino acids in turkey keep tryptophan from putting you to sleep. The sleepy after-Thanksgiving feeling is more a cause of eating a giant carbohydrate-rich meal.

4324.

Eating celery does not actually burn calories. Nutrition scientist Tim Garvey says, "There are no negative-calorie foods."

4325. Eating carrots does not improve eyesight.

4326. There's no nutritional difference between a brown egg and a white one.

4327. Dr. Robert Waldinger, the director of the world's longest-running scientific study of happiness, says that if people could change 1 thing in their lives to be happier, they should invest in their relationships with other people.

4328. The study followed people through 8 decades, consulting with parents and then their children. The study showed that the strongest predictors for maintaining happiness and health through life come from relationships that have satisfying levels of quality and warmth. The study also contends that relationships can act as stress regulators in our everyday lives.

4329. Waldinger describes 2 kinds of happiness: one that's like a sugar rush you get from going to a great party, for example, and another that comes from feeling like "I'm having a good life, a decent life, a meaningful life." We all want some of both, but Waldinger says some of us prioritize 1 kind over the other.

4330. In the late 19th century during the bicycle craze in Europe and the US, women found more social mobility and independence with their bicycles. However, they were discouraged from riding bicycles by medical professionals told them they might get "bicycle face."

4331. Bicycle face was described as a "face usually flushed, but sometimes pale, often with lips more or less drawn, and the beginning of dark shadows under the eyes, and always an expression of weariness."

4332. Newspaper articles said excessive cycling made women vulnerable to many diseases such as exophthalmic goiters, appendicitis, and internal inflammation.

4333. Doctors were also concerned that the bicycle saddle taught masturbation to women and girls.

4334. In Transactions of the New York Obstetrical Society in 1895, it was stated that, "The saddle can be tilted in every bicycle as desired. . . . In this way a girl . . . could, by carrying the front peak or pommel high, or by relaxing the stretched leather in order to let it form a deep, hammock-like concavity which would fit itself snugly over the entire vulva and reach up in front, bring about constant friction over the clitoris and labia. This pressure would be much increased by stooping forward and the warmth generated from vigorous exercise might further increase feeling."

4335. The outer part of the eye, called the cornea, gets oxygen straight from the air and from tears, rather than from blood.

4336. This is because the cornea has no blood vessels because the blood would obscure your vision.

4337. Despite common misconceptions, blood is actually red, not blue, because portions of the visible light spectrum easily penetrate skin and become absorbed by hemoglobin in the blood. Blue light scatters when it hits skin and gets reflected back to your eye, causing veins to appear blue.

4338. Mucus is constantly made by the body to line parts of the lungs, where it catches harmful particles before they go too deep.

4339. When you're healthy, tiny hairlike cilia move the mucus up and out, sliding down the back of the throat without you noticing it.

4340. But when you're sick, the mucus is harder to move and requires aid, such as coughing.

4341.

Goosebumps are a holdover from animal ancestors dealing with cold. Goosebumps happen when tiny muscles in the skin's hair follicles pull hair upright. For animals with thick fur, this offers greater insulation. Human body hair is too short to trap heat this way.

4342. The half-moon circles on the base of fingernails are called lunulae.

4343. Lunulae can provide clues to certain medical conditions. For example, having no lunulae can indicate a vitamin B12 deficiency.

4344. Just after 1 month, human embryos develop a 10 to 12-vertebrae-long tail. The tail gets absorbed by the rest of the body and becomes the coccyx (tailbone).

4345. It is commonly thought that logical thinkers are left-brain dominant while artistic people are right-brained. Brain imaging technology has found that there is no such thing as dominance when it comes to the brain's hemispheres.

4346. While both halves tend to handle separate tasks, they work together in complex ways and are not linked to specific personality traits.

4347. For much of its path from spine to finger, the ulnar nerve is protected by layers of bone and muscle.

4348. However, there is a 4-millimeter-wide spot at the elbow where the nerve is vulnerable. Hitting this spot, called "the funny bone," results in a tingling sensation.

4349. Mitochondria is commonly known as "the powerhouse of the cell."

4350. The heart's cells are dense with energy-generating mitochondria, which allows the heart to pump without getting fatigued.

4351. Stress can indeed cause your hair to turn gray.

4352. The human heart will beat about 3 billion times during an average lifespan.

4353. The heart pumps the entire blood volume of a human body in just 1 minute.

4354. Norepinephrine, also known as noradrenaline, is a neurotransmitter that conveys the body's fight-or-flight response, and it's been shown to cause graying when injected into otherwise unstressed lab mice.

4355.

Ears and noses get longer as people age, but they aren't growing. Instead, they are being pulled by gravity, causing them to stretch about a 10th of an inch every 10 years.

4356. The Cheerleader Effect, also known as the group attractiveness effect, is the cognitive bias that causes people to think individuals are more attractive in a group. The phrase was coined by the character of Barney Stinson in the TV show *How I Met Your Mother*. Barney points out to his friends a group of women that initially seem attractive, but who are all unattractive when examined individually.

4357. Across 5 studies by Drew Walker and Edward Vul at the University of California, San Diego, in 2013, participants rated the attractiveness of male and female faces when shown in a group photo and an individual photo, with the order of the photographs randomized. The people photographed got higher scores for their group photos.

4358. This effect occurs with male-only, female-only, and mixed gender groups, and both small and large groups.

4359. The effect occurs to the same extent with groups of 4 and 16 people.

4360. The effect does not occur because group photos give the impression that individuals have more social or emotional intelligence: this was shown to be the case by a study, which used individual photos grouped together in a single image, rather than photos taken of people in a group.

4361. In their 2015 book A *Beautiful Constraint*, authors Adam Morgan & Mark Barden posit that the limitations we face in any endeavor (be it artistic or otherwise) can be a source of inspiration. We can turn restrictions into opportunities.

4362. Laughing 100 times equals about 15 minutes of exercise on a stationary bike. Laughter is one of the ways your body can help regulate cortisol. Laughing increases your oxygen intake, which stimulates body circulation and decreases your cortisol levels. Some studies show that just the act of laughing even without having humor in it can have positive stress-relieving effects.

4363. Other benefits of laughter include boosting the immune system, defending against infectious organisms entering through the respiratory tract, lowering blood pressure, and increasing vascular blood flow.

4364.

Studies have shown that smiling can release endorphins, which help boost mood and improve sleep.

4365. Cortisol is known as the stress hormone, but it helps manage blood sugar levels, reduces inflammation, manages metabolism, and triggers the fight-or-flight response in your body at critical times.

4366. It's when your body produces too much cortisol that your body feels stress.

4367. Food takes anywhere from 24 to 72 hours to move through your digestive tract.

4368. Within 6 to 8 hours, consumed food has moved its way through your stomach, small intestine, and large intestine.

4369. Once in your large intestine, the partially digested contents of your meal can sit for more than a day while it's broken down even more.

4370. Factors such as sex, metabolism, and a range of digestive issues can also affect the speed of the digestive process.

4371. Meat and fish can take as long as 2 days to fully digest.

4372. Meat and fish proteins and fats contain complex molecules that take longer for your body to pull apart.

4373. Fruits and vegetables, which are high in fiber, can move through your system in less than a day. These high fiber foods help your digestive track run more efficiently.

4374. Processed, sugary junk foods like candy bars are the quickest to digest, which is why they leave you hungry again pretty quickly.

4375. Almost 99 percent of the mass of our human body consists of 6 chemical elements: oxygen, carbon, hydrogen, nitrogen, calcium, and phosphorus.

4376. The 2 elements that are present in the highest percentage are oxygen (65 percent) and carbon (18 percent).

4377. B, M, and P are 3 letters that are impossible to say without both of your lips touching.

4378. Blowing out the candles on a birthday cake increases the cake's bacteria count by a factor of 14.

4379. A study in 2009 contends that the average man spends about 1 year of his life staring at women.

4380. The study found that men stare at up to 10 different women for 43 minutes a day, on average. That equals nearly 11 days a year.

4381. The same study found that women spend 20 minutes each day looking at 6 men.

4382. Sixteen percent of women felt uncomfortable when stared at, while 20 percent said it embarrassed them.

4383. The study revealed that supermarkets were the number 1 venue for ogling, followed by bars and night clubs.

4384.

The World Health Organization says 1.1 billion teenagers and young adults are at risk of permanently damaging their hearing by listening to too much music too loudly. They say people should listen to music for no more than one hour a day.

4385. Richard Stephens of Keele University in England discovered that people who swear are able to hold their hands in ice water for twice as long. This indicates that swearing activates our fight-or-flight response, leading to a surge of adrenaline, as well as a pain-relieving effect on our immune system. This holds true for people who swear only a few times a day—not for those who swear constantly.

4386. Other health benefits of swearing include increased circulation, elevated endorphin and serotonin levels, and an overall sense of calm, control, and well-being.

4387. Swearing can also spark our creativity, especially for those who come up with creative words in the process of cursing.

4388. According to the American Academy of Child and Adolescent Psychiatry, American children on average watch about 3 to 4 hours of television each day.

4389. The average child is exposed to 200,000 violent acts and 16,000 murders on television by the age of 18.

4390. In 2021, the total average time spent watching TV per day among viewers aged 15 years old or over was 2.86 hours.

4391. Adults aged 65 and above spent the most time watching television at over 4 hours.

4392. Fifteen to 19-year-olds spent the least amount of time in front of the television at 1.95 hours.

4393. Elementary students who have TVs or other screens in their bedrooms tend to perform worse on tests than do those who don't have these in their bedrooms.

4394. An unborn baby can taste what its mother is eating and develop a preference for the foods that she eats.

4395. In a group setting, people tend to automatically look at the person they feel the closest to when a group laughs.

4396. Brushing your teeth will keep your heart healthier. People with gum disease have a 25 to 50 percent higher chance of getting cardiovascular disease.

4397.

Crying keeps you healthy by literally flushing away harmful bacteria and reducing stress.

4398. Emotional tears have higher protein concentration than irritant tears. This concentration makes these tears fall down cheeks more slowly, increasing the chance they'll be seen by someone.

4399. When you see a bright object even after shutting your eyes, it means the pigments in cells at the back of your eye have become bleached and the nerve cells are fatigued.

4400. A study found that anxiety disengages the prefrontal cortex, a region of the brain that plays an important role in flexible decision making.

4401. A UK survey found that couples who sleep naked together are more likely to be happy with their relationship than couples who sleep clothed.

4402. Extroverts sleep closer to their spouses than introverts.

4403. Extreme sleep deprivation can cause the brain to start hallucinating and experiencing many symptoms that mimic paranoid schizophrenia.

4404. The most common dreams for people to have are them falling or their teeth falling out.

4405. No one who was born blind has ever developed schizophrenia.

4406. Researchers believe that early visual and cognitive training that focuses on improving sensory perception as well as things like memory and attention could potentially help people at high risk for schizophrenia.

4407. Brain cells begin dying after only 5 minutes without oxygen.

4408. There is no single food that provides all the nutrients that humans need, except for breast milk.

4409. People who sleep less than 6 hours a night are 4.2 times more likely to catch a cold compared to those who get more than 7 hours of sleep.

4410. Sleeping next to someone you love not only reduces depression, but it also helps you to live longer and makes you fall asleep faster.

4411. People who practice mindfulness meditation for 30 minutes a day find noticeable changes in brain connectivity in just 2 weeks.

4412. According to a study, the number of social connections a person will have reaches a maximum at the age of 25 for both genders.

4413.

Humans spend about 25 years of their life sleeping.

4414. Eighty percent of people remain quiet even when they really want to say something in order to avoid an argument with someone they care about. A 1999 study conducted by the University of California at San Diego suggested that a person's monogram can affect his or her life expectancy.

4415. The Theory of Deadly Initials, as the study became known, found that people whose initials spelled words with positive connotations such as W.I.N. lived 4 and a half years longer than people with initials that didn't spell anything.

4416. And what about poor Penelope Ingrid Garrott and Anthony Steven Smith? According to the study, they will die nearly 3 years before the control group. The good news for them is that the study was disproved in 2005.

4417. Dr. Brett Pelham, a professor of psychology at the University at Buffalo, has come up with a theory called implicit egotism, which states that people tend to prefer people, places, or things that remind them of themselves.

4418. Examples of implicit egotism include people named Louis who are likely to live in St. Louis; Dennis and Denise who are both likely to be dentists; and people with last names with the same letter are likely to marry.

4419. Top British psychologist Geoff Beattie of the University of Manchester believes it's a woman's feet movements that reveal her intentions and feelings toward a potential romantic partner. Here are the findings:

4420. If a woman moves her feet away while giggling in order to adopt a more open-legged stance, she's interested.

4421. If she crosses her legs or tucks them under her body, she is not interested.

4422. She might be feeling nervous if her feet grow still.

4423. If she moves her feet a lot, she may be shy. If they're still, she likes to be in control or is arrogant.

4424. Beattie, who conducted the research for a shoemaking company, concludes that "the secret language of feet can reveal a great deal about our personality, what we think of the person we're talking to, and even our emotional and psychological state. They are a fascinating channel of nonverbal communication."

4425. Psychologist Colin Hendrie and 3 female researchers discreetly observed women at a big nightclub and concluded that women who covered only 40 percent of their bodies attracted the most men—twice as many as women who covered up.

4426. The study said that most of the 60 percent of exposed body parts included arms and legs, and that women who exposed more than 40 percent turned men off.

4427. The most popular women combined the 40 percent rule with tight clothing and provocative dancing.

4428. According to a 30-year study conducted in western Australia, most babies born to first cousins are just as healthy as children born from unrelated parents. Alan Bittles, an adjunct professor at the Centre for Comparative Genomics at Murdoch University, found that only 1.2 percent of births had a higher mortality rate, and that first-cousin children are less than 3 percent more likely to have genetic deformities.

4429. Joe Allen of the University of Virginia studied a group of middle school kids and followed them as they grew up. He found that the children exposed to peer pressure around the ages of 12 and 13 turned out to be more well-adjusted than the kids who weren't. The need to fit in as a teenager turns into a willingness to accommodate in adult relationships.

4430. And what about those kids who learned to just say "No"? According to the study, they didn't become the independent adults the movies say they'll turn into. Within 5 years, they had lower grades, fewer friends, and were less engaged than the other kids in the study.

4431.

A 2007 study from Columbia and Stanford Universities found that overpraising children can lead to a belief in the children that smarts and talent are inborn and that there's nothing you can do to improve. So, by praising supposed innate ability over hard work, children end up avoiding challenging situations or activities that involve effort. This phenomenon is called learned helplessness, and it can lead to losing interest in school, falling grades, dropping out of school, and, of course, issues of low self-esteem and helplessness.

4432. Researchers at Washington State University found that nearly 40 percent of people will laugh at a bad joke, while fewer than 1 in 100 will voice displeasure.

4433. Dr. Nancy Bellmade believes that it's funny when we're let down by humor, and that we laugh at how bad a joke can actually be. The bad joke that 40 percent of the people laughed at was: "What did the big chimney say to the little chimney? Nothing. Chimneys can't talk." Ha, ha.

4434. Studies show that people yawn 20 times on average per day. People with bigger brains yawn for a longer amount of time.

4435. Neil Postman (1931–2003) was an American critic and educator, whose most famous book *Amusing Ourselves to Death*, was a critique of mass communication, especially television and technology.

4436. Postman contended that patterns of thought and forms of social organization are shaped by communications media, and that these media are not neutral and have certain cognitive biases.

4437. Television, according to Postman, has to express ideas through alluring imagery, and that, in and of itself, reduces news and history and more to mere entertainment.

4438. He called TV our "vast descent into triviality." He also posited that we are imprisoned by our own need for amusement. Postman wrote, "When a population becomes distracted by trivia, when cultural life is redefined as a perpetual round of entertainments, when serious public conversation becomes a form of baby-talk, when, in short, a people become an audience, and their public business a vaudeville act, then a nation finds itself at risk; culture-death is a clear possibility.

4439. Postman believed that it wasn't Orwell's *1984* we needed to worry about, but instead Aldous Huxley's *Brave New World*, where "no Big Brother is required to deprive people of their autonomy, maturity, and history . . . People will come to love their oppression, to adore the technologies that undo their capacities to think."

4440. In a 2009 episode of her *Tyra Banks Show*, Banks introduced her audience to a dangerous and illegal century-old weight-loss tactic. It involved ingesting tapeworms.

4441. A tapeworm secretes proteins in the intestinal tract that makes digestion more difficult, so the tapeworm can feast on what you're eating.

4442. Scientists estimate that you can lose up to 2 pounds a week with the tapeworm diet without changing what you eat.

4443. In the 1870s, a doctor removed a 135-foot-long tapeworm from a patient by having the patient eat lots of tree bark.

4444. Dr. Alpheus Meyers developed a trap that consisted of a tiny metal cylinder tied to a piece of string. He baited it with food and the patient would swallow it. Once the worm poked its head into the trap, it would get caught and the good doctor could pull it out through the patient's mouth.

4445. Sending your child to school before the age of 6 in order to give him or her a leg up on the competition may do more harm than good. A study by the National Foundation for Educational Research in the United Kingdom has found that children sent to school before mastering basic skills are more likely to drop out of college—if they make it that far.

4446. They are also more likely to suffer from low self-esteem and anxiety attacks.

4447.

The human eye is capable of seeing over 7 million colors.

4448. The human nose can detect over 1 trillion different scents.

4449. The human ear can hear a range of frequencies from 20 Hz to 20,000 Hz.

4450. The human skin is the largest organ in the body.

4451. Human skin regenerates entirely every 28 days and sheds more than 30,000 cells per minute.

4452. Drivers of luxury cars tend to be less considerate of others on the road, according to a study from UC Berkeley.

4453. Researchers in 2003 found that the brain treats social rejection in the same way it responds to physical pain. The findings point toward humans' need for inclusion being rooted in our aversion to pain.

4454. A 2021 study published in the *Journal of Social and Personal Relationships* confirmed that heart rhythms synchronize when couples in long-term relationships are close to each other.

4455. Meanwhile, a 2019 study that tested 140 mothers and their 6-month-old infants found that both their parasympathetic and sympathetic nervous systems, as well as heart rhythms and behaviors, were in sync, especially when they were exposed to minor stressors.

4456. Scientific studies have shown, however, that sarcasm, when used "with care and in moderation," can lead to greater creativity . . . in both the sarcastic person and the recipient of the sarcasm.

4457. Picky eating has been linked to symptoms of depression, obsessive compulsive disorder, and anxiety.

4458. All humans can digest milk in infancy. The ability to do so as an adult developed only within the last 6,000 years. And today, most people in the world are lactose intolerant.

4459. In fact, being able to digest milk as an adult is now referred to as a condition called lactase persistence.

4460. A genetic mutation where a cytosine (C) nucleotide in a person's DNA is replaced with a thymine (T) nucleotide allows them to digest milk.

4461. People who can digest lactose often originate from northwest Europe and some parts of Africa.

4462.

Up to 35 percent of humans have a photic sneeze reflex, which means they sneeze when they look at bright light.

4463. In a 1970 *Nature* letter, an anonymous researcher who had to spend a lot of time by himself on a remote island, measured his beard growth and found that it grew much faster during the day or so before he resumed sexual activity.

4464. THC—the chemical in cannabis that is psychoactive and produces the "high"—has 20 times the anti-inflammatory potency of aspirin and twice that of hydrocortisone.

4465. Autosomal Dominant Compelling Helioopthalmic Outburst (ACHOO) Syndrome is characterized by uncontrollable sneezing in response to the sudden exposure to bright light.

4466. A condition called gustatory rhinitis can cause sneezing after eating.

4467. Snatiation is a disorder where stomach fullness causes uncontrollable sneezing.

4468. The Dunning-Kruger effect is a cognitive bias where people with low ability, expertise, or experience about a certain task or area of knowledge tend to overestimate their ability or knowledge . . . and that it's the opposite with high performers.

4469. A clinical psychologist reports that listening to Christmas music too early in the season may increase feelings of stress.

4470. The report also states that hearing the same songs over and over can drain workers who have to listen to it all day.

4471. A 2011 *Consumer Reports* survey found that 23 percent of Americans dread holiday music.

4472. As of 2023, there are 90,526 centenarians in Japan—people who have reached the age of 100.

4473. According to the Office of National Statistics in the UK, one-third of babies born in the UK today will live to 100.

4474. Women centenarians in Japan beat out male centenarians by 11.6 to 1.

4475. The US has approximately 98,000 centenarians.

4476. The United Nations estimates that currently there are 573,000 centenarians, almost quadruple the estimate of 151,000 made in 2000.

4477. Apophenia is the tendency to see meaningful connections that aren't really there. This is also known as patternicity.

4478. Apophenia can range from seeing images in clouds to believing in conspiracy theories.

4479. Pareidolia is a type of apophenia where one sees a specific (sometimes meaningless) image in a random visual pattern. For instance, seeing a man in the moon.

4480. Pareidolia used to be recognized as a symptom of psychosis, but today, it's known as part of our normal existence.

4481. We've evolved to detect faces quickly, which helps describe why we tend to see faces when we look at electric outlets or in burnt toast.

4482. In 2019, researchers from USC suggested that only about 50 percent of people feel the shivers or goosebumps when listening to music.

4483. And these people who do have brains with a higher volume of fibers connecting their auditory cortex to the areas that process emotions.

4484. The feeling of goosebumps when listening to music is called frisson.

4485. The human body consumes nearly 3 times as much energy when walking upstairs as it does walking on flat ground.

4486. Researchers estimate that a 1-hour nap can improve alertness for up to 10 hours.

4487.

Human saliva has a powerful painkiller called opiorphin that's 6 times stronger than morphine.

4488. Wounds in the mouth heal faster because of saliva's germ fighting antibodies.

4489. Every hydrogen atom in our bodies is 13.8 billion years old. Hydrogen was the first element to form in the universe.

4490. People tend to lose more hair during the fall. The scalp protects your head from the summer sun by holding onto hair better.

4491. Researchers have found that over-the-counter acetaminophen (Tylenol, etc.) can reduce the severity of emotional pain caused by rejection.

CHAPTER 23

BIZARRE BUT TRUE

4492. On April 1, 1998, Burger King took out a full-page ad in *USA Today* announcing the new left-handed Whopper, specially designed for the 32 million left-handed Americans. According to the ad, the new Whopper included the same ingredients as the original Whopper, but the left-handed one had "all condiments rotated 180 degrees, thereby redistributing the weight of the sandwich so that the bulk of the condiments will skew to the left, thereby reducing the amount of lettuce and other toppings from spilling out the right side of the burger." The following day, Burger King issued a press release revealing that although the Left-Handed Whopper was a hoax, thousands of customers had gone into restaurants to request the new sandwich.

4493. Okay, Oklahoma . . . Named after the OK Truck Manufacturing Company.

4494. Truth or Consequences, New Mexico . . . In 1950, NBC Radio host Ralph Edwards announced he would air the program *Truth or Consequences* on its 10th anniversary from the first town that renamed itself after his show. Hot Springs, New Mexico, accepted the challenge. Ralph Edwards visited the town during the first weekend in May for the next 50 years.

4495. Whynot, NC . . . Came about during a bout of indecision. Legend has it that someone said, "Why not name the town 'Whynot' and let's go home?"

4496. Last Chance, Iowa . . . The town's first grocer named it after it occurred to him that his town didn't have a name yet.

4497. Zap, North Dakota . . . From either a Minnesota banking family or a coal-mining town in Scotland.

4498.

Chugwater, Wyoming . . . This "Little Town with a Big Heart" was named after Chug Springs, which the native population called "water at the place where the buffalo chug."

4499. Frankenstein, Missouri . . . The town was founded by Gottfried Franken.

4500. In 1999, 25 skydivers, disguised as Peter Boyle-style Frankenstein monsters from the movie Young Frankenstein, descended on the town in honor of the 25th anniversary of the movie. As they jumped from the plane, they yelled "Putting on the Ritz," which was sung by the monster in the movie.

4501. Oblong, Illinois . . . Named after its shape.

4502. Coward, South Carolina . . . Named for either Captain Solomon Coward, who was granted 126 acres in the area in 1831, Colonel Asbury Coward who was a Confederate veteran, or John Wilson Coward who was partially responsible for incorporating the county. Lots of Cowards in this town.

4503. Santa Claus, Indiana . . . Named as a joke when the town found out its preferred name, Santa Fe, was already taken. Santa Claus's post office receives thousands of pieces of Christmas mail each year, and there is a theme park in town called Holiday World.

4504. Pig, Kentucky . . . Named when a resident who was helping decide on a name for the town had to help get a pig that got stuck under a building.

4505. Waterproof, Louisiana . . . Given to the town by one of its earliest residents because the land seemed high enough to withstand floodwaters from the water it was surrounded by. He was wrong, and Waterproof has flooded on several occasions, with the water reaching a depth of 2 to 3 feet over the entire town at times.

4506. Toad Suck, Arkansas . . . Disputed. It could be a corruption of a French phrase meaning "a narrow channel in a body of water." Another story is that it was named after idle sailors who would frequent the town's only tavern and "Suck on the bottle 'til they swell up like toads."

4507. Scratch Ankle, Alabama . . . Named from the fact locals were often seen scratching their ankles from mosquito bites by the train workers passing by.

4508. Ding Dong, Texas . . . Named after 2 settlers, Zulis Bell and his nephew Burt Bell. In the early 1900s, their country store had a sign with 2 bells on it with the words "ding" and "dong" underneath them.

4509. Booger Hole, West Virginia . . . Named for the boogey man after several unexplained and unsolved murders that happened there in the early 1900s.

4510. A few of these oddly named towns are featured in the board game by the US Postal Service called The Great American Mail Race. The object is to race around the US and deliver as many parcels as you can. The best mail carrier wins. The promotional copy states, "You can deliver letters to 'Big Bottom' in Dakota and drop off postcards at 'Ding Dong' in Texas."

4511. Martin Couney saved thousands of premature babies' lives in the early 1900s by exhibiting them in incubators at a Coney Island sideshow. At this time, medical professionals mostly believed that caring for premature babies was pointless.

4512. Before the 1930s, American hospitals didn't have incubators, so doctors sent premature babies to Couney. Couney accepted babies of all backgrounds, regardless of race or social class. The parents paid nothing for this, and Couney covered all costs from entrance fees to his exhibit. Known as the "incubator doctor," Couney was actually never a doctor of anything. Over his 50-year career, Couney took in 8,000 "carnival babies" and claimed to have saved 6,500 of them.

4513.

The incubator for premature children was first developed by Stépane Tarnier, a French obstetrician who had seem them being used at a zoo.

4514. In 2020, Police in Italy drove a Lamborghini Huracán to deliver a donor kidney. The 6-hour journey from Padua to Rome took them 2 hours.

4515. American actress Lee Fierro, who played Mrs. Kintner in *Jaws*, once walked into a seafood restaurant in Martha's Vineyard, Massachusetts, where the movie was filmed 25 years previously. She saw that the menu had an Alex Kintner Burger. She mentioned she played this character's mother years ago, and then she met the owner, Jeffrey Voorhees, the man who played her son.

4516. Adam Rainer (1899–1950) is the only known person to have been both a dwarf and a giant. At the age of 18, he was 4 feet tall. Several years later, he started growing up to 3 inches a year. By the age of 33, he was 7' 2". His shoe size went from a 10 to a 19 in 3 years. The growth was caused by a pituitary adenoma, which was removed. By the time of his death, he was 7'8", and was unable to stand due to his height.

4517. Traffic jams can be greatly reduced if we simply stop tailgating. MIT research showed that journey times can be cut almost in half if everyone drives at a fixed distance from the car in front of them.

4518. In 1979, 2 twins were reunited after 39 years. According to the *New York Times*, the twins, James Arthur Springer and James Edward Lewis, provided "a rare opportunity to study how environment versus heredity influences human development. First off, they shared the same first name. Each married and then divorced a woman named Linda. Their second wives were both named Betty. One James named his son James Allan. The other named his son James Alan. Each had an adopted brother named Larry and a dog named Toy. They vacationed at the same, 3-block-long beach and both drove a Chevy. Both worked part-time as deputy sheriffs, 70 miles apart from each other. They both liked mechanical drawing, block lettering, and carpentry.

4519. In 2014, a 3-year-old girl, along with her dog, survived for 11 days in a Siberian forest. She got lost while following her father while walking through the woods. Meanwhile, the father thought she was with her mother. The little girl survived on wild berries and river water. Her dog returned to her village and guided rescuers to her.

4520. Marion Stokes (1929–2012) was a television producer, activist, librarian, and compulsive hoarder. She taped thousands of hours of television shows for over 30 years on more than 71,000 VHS and Betamax tapes, which she housed in her home and in apartments she rented just for the tapes. Her son gave the collection to the internet Archives, who agreed to digitize the collection.

4521. In 2018, Payless ShoeSource, a discount shoe retailer wanted to change the perception that the company sells cheap, unfashionable shoes. So, they created a fake luxury shoe brand called Palessi, designed by Italian designer Bruno Palessi (who doesn't exist). Renting a former Giorgio Armani store at an upscale mall in Santa Monica, California, Payless's advertising team created an authentic, luxurious launch party, and put outrageous price tags on the discount shoes. They invited influencers and fashionable people to attend the launch, and had interviewers pose as salesclerks. Shoppers were completely fooled and paid up to $600 for $20 shoes. After the prank was revealed, the shoppers were allowed to keep the shoes for free.

4522.

Wattana Panich, a noodle soup restaurant in Bangkok, Thailand, has been serving a beef soup that's been simmering for nearly 50 years. Each night, the soup is removed from the pot, the pot is cleaned, and then some of the soup simmers overnight, providing the stock for the next day. The pot is 5 feet in diameter and 2¼ feet deep.

4523. Charles Osborne started hiccupping in 1922 after an accident weighing a pig. He didn't stop until a year before his death in 1990. It is estimated he hiccupped 430 million times during his lifetime. The first few decades, he hiccupped up to 40 times a minute. That slowed down to 20 hiccups a minute in later years. Osborne learned to talk with the hiccups and managed to live a relatively normal life.

4524. On December 24, 1971, 17-year-old Juliane Kopecke and her mother boarded an 86-passenger turboprop plane bound for Pucallpa, Peru. About 25 minutes after takeoff, a bolt of lightning struck the plane's right wing. The plane plummeted and fell apart, and still strapped to her seat, Juliane fell nearly 2 miles to the ground and survived. Juliane suffered a broken collarbone, a sprained knee, and gashes on her right shoulder and left calf.

4525. With only a bag of lollipops to eat, Juliane survived 10 days in the Peruvian rain forest before finding a hut, pouring gasoline onto her wounds to kill the maggots, and being rescued. She was the only survivor of the crash.

4526. Vesna Vulovic was a flight attendant on a jetliner in 1972 that suddenly exploded over what was then Czechoslovakia. Trapped inside a part of the fuselage and wedged in by a food cart, she plunged 33,000 feet and survived with serious injuries.

4527. According to the Guinness World Records, Vulovic's is the longest recorded fall without a parachute.

4528. During World War II, US Army Air Force Staff Sgt. Alan Magee fell out of a burning plane at 22,000 feet without a parachute. He fell through the glass roof of a train station and was found, alive, dangling from steel girders that were supporting the ceiling.

4529. Larisa Savitskaya of the Soviet Union, fell 17,130 feet and survived after a mid-air collision in 1981. She held onto a fragment of the aircraft as she fell for over 8 minutes. The trees she crashed into cushioned her fall. She survived for 3 days with her injuries before being found.

4530.

In 1979, 29-year-old Elvita Adams jumped from the 86th floor of the Empire State Building. Strong wind gusts pushed her back toward the building and she landed on a ledge on the 85th floor. She broke her pelvis but survived.

4531. In 1947, Evelyn McHale jumped from the 86th floor of the Empire State Building. She landed on the roof of a car and died. A photography student took a picture of her that made it look like she was resting or sleeping.

4532. The image was published in *Life* magazine with the caption, "At the bottom of Empire State Building the body of Evelyn McHale reposes calmy in grotesque bier her falling body punched into the top of a car." It was a full-page photo.

4533. The short article on the previous page said, "In her desperate determination she leaped clear of the setbacks and hit a United Nations limousine parked at the curb . . . Just four minutes after Evelyn McHale's death, (Robert) Wiles got this picture of death's violence and its composure."

4534. From there, the photo gained iconic status as "the most beautiful suicide."

4535. Andy Warhol used the photo in one of his prints called *Suicide (Fallen Body)*, and several musicians, including David Bowie recreated the photo for their albums or videos.

4536. In 1969, the water rushing over American Falls, 1 of the 3 waterfalls that makes up Niagara Falls, was diverted to clean up rock piles at its base. Two corpses were discovered.

4537. In 1918, during a World War I dogfight, British flying ace Reginald Makepeace of the No. 20 Squadron went into a steep dive to dodge German gunfire. Captain J. H. Hedley, who was in the back seat of the cockpit, was thrown from the plane. As the plane leveled off several hundred feet below, Hedley landed on the tail of the plane and hung on for dear life as the plane landed safely.

4538.

Over the past 122 years, more than a dozen people have gone over Niagara Falls in a barrel.

4539. More than 5,000 have gone over altogether, either as a stunt or a suicide attempt.

4540. The whole thing with barrels began in 1886 with a British cooper named Carlisle Graham. He, however, didn't go over the falls, but instead whitewater rafted in a barrel in the whirlpools at the base of the waterfall.

4541. On October 24, 1901, a 63-year-old (it was her birthday) unemployed schoolteacher named Annie Edson Taylor, put herself, along with some pillows and a mattress in a barrel, and went over the waterfall. She survived, but when the top of the barrel was unscrewed, and she was found alive with just a gash on her head, she said, "No one ought to ever do that again!"

4542. Two days prior to this attempt, she did a trial run . . . with her cat. The cat also survived with just a head wound.

4543. Taylor tried to capitalize on her stunt, but her manager stole her barrel.

4544. In 1911, Bobby Leach became the second to attempt the stunt. He, too, survived, but he had to spend 6 months in the hospital recovering from 2 broken kneecaps and a broken jaw.

4545. A few years later, Leach died after slipping on an orange peel.

4546. Sam Patch (1799–1829) was known as the Jersey Jumper, the Daring Yankee, and the Yankee Leaper. He gained fame by jumping from a raised platform (after climbing a 125-foot ladder) into the Niagara River near the base of the Falls in 1829. The jump was more than 80 feet.

4547. He died jumping 125 feet into the Genessee River. Doctors later said that the sudden change in temperature as he fell caused his blood vessels to rupture. He was probably dead before he hit the water.

4548. In 1920, Charles Stephens went over the Falls in a barrel with an anvil tied to his feet. The anvil destroyed the barrel, and he died.

4549. In 1995, Robert Overacker tried going over the Falls with a JetSki and a parachute. Unfortunately, the rocket-powered parachute failed to open, and he fell to his death.

4550. In 2003, Kirk Jones became the first person to survive the fall without any aid. He swam 100 yards before swimming over the Falls. He was drunk, and his friends were supposed to record the event, but they couldn't get the recorder to work. Sadly, Jones did it again in 2017, in a fatal attempt to end his life.

4551. The first ever recorded human cannonball happened at the Royal Aquarium in London in 1877. A 14-year-old named Rossa Matilda Richter (stage name was Zazel) was shot out of a cannon.

4552.

In 1937, a street cleaner in Detroit, Michigan, named Joseph Figlock was hit by a falling baby. The young girl fell from a fourth-story window and hit Figlock on the head and shoulders. Both lived.

4553. A year later, a different baby also fell out of a fourth-story window and hit Figlock on the head and shoulders. They both survived.

4554. Manuel Elizalde Jr., a Philippine government minister, announced to the world in 1971 that he had discovered a Stone Age tribe that had had no contact with the outside world. The tribe, called the Tasadays, lived in caves, wore leaves for clothing, used stone tools, and didn't have a word for "enemy." The tribe was featured on the cover of *National Geographic* and received worldwide attention.

4555. After scientists started asking questions, Philippine president, Ferdinand Marcos, declared the tribe off limits. In 1986, after Marcos was deposed, a Swiss anthropologist and 2 journalists searched for the Tasadays and found members of a local tribe who said they pretended to be a Stone Age tribe by Elizalde's instructions. However, in a different interview, 2 Tasaday members who had originally claimed they were bribed by Elizalde, admitted they had also been bribed by journalists with "cigarettes, candy, anything we wanted—if we would say what he told us to."

4556. A 2009 study conducted by Shippensburg University professor David Kalist of Pennsylvania reports that the more unpopular, uncommon, or feminine a boy's first name, the greater the chance he'll end up in jail.

4557. Kalist's study lists the top-10 bad boys names in America: Alec, Ernest, Garland, Ivan, Kareem, Luke, Malcolm, Preston, Tyrell, and Walter.

4558. In 1950, children saved their allowance to buy the Gilbert U-238 Atomic Energy Lab. It was a toy lab kit that let kids make nuclear reactions at home using actual radioactive material.

4559. The Atomic Energy Lab contained a cloud chamber allowing the viewer to watch alpha particles traveling at 12,000 miles per second, a spinthariscope showing the results of radioactive disintegration on a fluorescent screen, and an electroscope measuring the radioactivity of different substances in the set. The set contained a battery-powered Geiger-Müller counter, an electroscope, a spinthariscope, a cloud chamber, 4 glass jars containing natural uranium-bearing ore samples, a comic book introduction to radioactivity, and more. It sold for $49.50 (equivalent to $560 today). It was removed from shelves in 1951 due to poor sales.

4560. Alfred Carlton Gilbert, who produced the set, was dubbed "the man who saved Christmas" during World War I when he convinced the US Council of National Defense not to ban toy purchases during Christmas time.

4561.

A study in 2008 of security cameras in San Francisco, California, found that crime had indeed gone down . . . as in farther down the street. The study concluded that the effect on crime rates was "incredibly localized," and that although crime decreased in front of the cameras, it actually increased down the street from the cameras. The report also stated that "murders went down within 250 feet of the cameras, but the reduction was completely offset by an increase 250 to 500 feet away."

4562. Enoteca Maria, a restaurant in Staten Island, New York, hires grandmas from around the world to cook native cuisines. Half of the menu is Italian, and the other half changes daily, depending on the grandma in the kitchen.

4563. Each night, a "nonna" (Italian for grandmother) from a different country designs a fresh menu, honoring her native cuisine.

4564. In 2006, a secretary at Coca-Cola's global headquarters stole a vial of a secret new product and tried to sell it to Pepsi for $1.5 million. The conspirators wrote: "I have information that's all classified and extremely confidential, that only a handful of the top execs at my company have seen. I can even provide actual products and packaging of certain products, that no eye has seen, outside of maybe 5 top execs." Pepsi reported the employee to her bosses. Undercover FBI officers posed as Pepsi executives and pretended to make a deal.

4565. Laurence Kim Peek (1951–2009) was a megasavant who was the inspiration for the character Raymond Babbit in the 1988 movie *Rain Man*. Able to memorize things starting at 16 months. Peek could speed read a book in about one hour and remember almost everything he had read, memorizing vast amounts of information in subjects ranging from history and literature, geography and numbers to sports, music and dates. Peek read by scanning the left page with his left eye while reading the right page with his right eye.

4566. According to an article in a British newspaper, Peek could accurately recall the contents of at least 12,000 books. A 2008 study concluded that Peek probably had FG syndrome, a rare X chromosome-linked genetic syndrome that causes physical anomalies such as hypotonia (low muscle tone) and macrocephaly (abnormally large head).

4567. In 1992, several visitors to the Memphis Zoo's exhibit called Dinosaurs Live! asked for refunds after realizing the dinosaurs were in fact, not live. At least 6 people asked for their $2.50 admission charge back, not realizing that dinosaurs have been extinct for 65 million years. After receiving several telephone calls from people saying, "You mean they're not alive," the zoo's vice president, Ann Ball, said, "People have watched too much Fred Flintstone."

4568.

On average, private cars are parked 95 percent of the time.

4569. Parking takes up about one-third of land area in US cities.

4570. There are an estimated 8 parking spaces for every car in the US.

4571. The parking meter was invented in 1935.

4572. In 2023, the BBC had to apologize after pornographic moaning noises were played loudly during coverage of an FA Cup football match. A YouTube prankster hid a mobile phone in the studio and played the sounds during the broadcast.

4573. Fat men's clubs were popular in the late 19th and early 20th centuries in the US, "perhaps the last time society found corpulence to be worthy of celebration," according to a 2016 NPR article.

4574. These clubs had weigh-in competitions, 9-course meals, and a minimum weight requirement of 200 pounds.

4575. The original treadmills were torture devices used in England as prison rehabilitation devices.

4576. Pelorus Jack was a dolphin that was famous for escorting ships through a stretch of water in Cook Strait, New Zealand, which was a notoriously dangerous channel. From 1888 to 1912, Jack helped countless ships maneuver the channel, and no ships sank during this time. Jack became protected under the Sea Fisheries Act in 1904, after someone tried to shoot him from the deck of a ship.

4577. In 1882, a land surveyor named Josiah A. King was charged with surveying Minnesota's north woods. He and his crew made a mistake and placed Coddington Lake about half a mile farther northwest than it was. As a result, a part of the forest was labeled as a lake, hence mistakenly protecting it from logging. The parcel of land became known as the Lost Forty, and it is home to one of the last stands of virgin old-growth Red and White Pine trees in the state.

4578. In 2013, a father in China hired assassins to kill his 23-year-old son's online World of Warcraft character because he was spending too much time on it.

4579. Hooker's Lips is a plant that looks like big, red lips and it puckers up to attract pollinators such as butterflies and hummingbirds.

4580.

According to forbes.com, the cost of college in the US has gone up 180 percent since 1980.

4581. As of 2022, there are more Starbucks (15,450) than McDonald's (13,438). However, there are 21,147 Subways.

4582. Bottled water is required by law to have an expiration date. Water doesn't expire, but the plastic it's bottled in can leach chemicals into the water over time.

4583. Clownfish are sequential hermaphrodites, meaning that all young clownfish become male. After they pair-off, the dominant one in the pair will become female.

4584. Patrick Cooney, a fish biologist at North Carolina State University, contends that clownfish being hermaphrodites would drastically change the plot of the movie *Finding Nemo*. Basically, if Nemo's mom is killed and Nemo hangs out with his dad after they are reunited, one of them would turn female. "Although a much different storyline, it still sounds like a crazy adventure!"

4585. In 1979, Robert Shafran was confused when people at Sullivan Community College in New York, kept calling him "Eddy." Turns out he had a twin, Edward Galland, who had been adopted by a different family. When they reunited, they appeared in newspapers and TV talk shows. This led to the realization that they were actually part of triplets, when David Kellman recognized himself in a photo in a newspaper.

4586. When all 3 were reunited, they found that they all smoked the same cigarettes, liked wrestling, among other similarities—including some mental health issues. But how did they get separated?

4587. It ends up that the triplets had been separated as part of a psychological study in the 1960s that examined the similarities and differences of twins and triplets separated at birth—the old nature versus nurture question.

4588. Clinical psychiatrist Peter Neubauer and a New York adoption agency arranged to place several twins and one set of triplets in different homes in order to study them. Neither the children's biological parents nor the adopting families were informed.

4589. Neubauer visited each of the twins and the triplets once a year for 10 years.

4590. The research files have been sealed until 2065.

4591. At least 3 of the separated siblings died by suicide, including Eddy Galland, one of the triplets.

4592. In 2019, an article in the MIT *Technology Review* suggested that all hipsters looked alike. The article called it the "hipster effect," and it contends that "those in an anti-conformist population still conform to themselves." The article was accompanied by a photo of a hipster. A man emailed the magazine, angrily complaining that the photo they used was of him. He wrote, "Your lack of basic journalistic ethics and both the manner in which you reported this uncredited nonsense and the slanderous unnecessary use of my picture without permission demands a response and I am of course pursuing legal action." Unfortunately, the man in the photo only looked like the complaining man, proving the article's contention that all hipsters looked alike.

4593. A 1963 exhibit at the Great Apes House at the Bronx Zoo in the Bronx, New York, called "The Most Dangerous Animal in the World" was a cage with a mirror inside it. The original text under the exhibit read, "You are looking at the most dangerous animal in the world. It alone of all the animals that ever lived can exterminate (and has) entire species of animals. Now it has the power to wipe out all life on earth."

4594. It was later changed to read, "This animal, increasing at a rate of 190,000 every 24 hours, is the only creature that has ever killed off entire species of other animals. Now it has achieved the power to wipe out all life on earth."

4595. In 2023, a 15-year-old boy in the port city of Chittagong, Bangladesh, hid in a shipping container during a game of hide-and-seek with friends. He fell asleep and woke up in West Port, Malaysia, roughly 2,300 miles from home. It took 6 days to find him.

4596. Taylor Swift's cat, Olivia Benson, is worth $97 million.

4597. Olivia earns her money as a TV commercial actor who has appeared with Swift. She also has her own merchandise line.

4598.
Oprah Winfrey's pets each have a trust fund worth millions.

4599. Chindogu is the Japanese art of inventing silly and useless gadgets to solve problems.

4600. Kenji Kawakami, former editor for the Japanese home-shopping magazine *Mail Order Life*, coined the phrase.

4601. One example of chindogu is the Toilet Paper Hat. It makes sure you always have a tissue handy, which is helpful when you have a cold. But you will also look silly with a roll of toilet paper stuck on your head.

4602. The baby mop, an outfit worn by babies, was invented so that as they crawl around, the floor is cleaned.

4603. There's also a fork with a fan attached that cools down your food as you bring it to your mouth.

4604. In 1960 the Cinestage Theatre in Chicago used an invention called Smell-O-Vision during its showing of the movie *The Scent of Mystery*. It released perfumes and other odors for a full movie experience. Fans blew the smells through pipes that led to vents under the seats.

4605. Unfortunately, the contraption made weird hissing noises and audience members didn't get the smells until after the scene was over.

4606. John Waters released an "Odorama" version of one of his movies. Each audience member got a scratch and sniff card.

4607. Franz Reichelt (1878–1912) was known as the Flying Tailor. The Austrian-born French tailor invented a parachute coat that would provide a safe way for pilots to exit a plane and fall to the ground safely. Reichelt's final prototype was a 20-pound cloak-like garment that was deployed simply by extending your arms.

4608. In 1912, Reichelt tested his coat out for himself by jumping off the deck of the Eiffel Tower. He fell to his death.

4609. In 1958, the Ford Motor Company wanted to create a car that could go 5,000 miles without having to refuel. Called the Ford Nucleon, this car would have a small nuclear reactor in the trunk. It never got past the concept stage.

4610. Patented in the US in 1922, the Baby Cage was a cage that was suspended outside an apartment window where you could put your child. It was produced and used sparingly in England.

4611.

As of November 2022, "Revenge," a YouTube Shorts video, by the Dobre Twins, is the most disliked video ever with a whopping 54 million dislikes.

4612. It is also the first and fastest video to hit 30 and 40 million dislikes in less than 3 months, and 50 million dislikes as of November 2022.

4613. Cousins are people who share a common ancestor who is at least 2 generations away, such as a grandparent or great-grandparent.

4614. First cousins share grandparents.

4615. Second cousins share one set of 4 available great-grandparents.

4616. Third cousins share one set of great-great-grandparents. (And so on.)

4617. To find out what type of cousin you are with someone, count how many "greats" are in your common ancestor's title and add one.

4618. To be once removed from a cousin means you are separated by one generation. The number of times removed is the number of generations of separation.

4619. Your parents' first cousins are your first cousins once removed. Their second cousins are your second cousins once removed.

4620. Your grandparents' first cousins are your first cousins twice removed. And so on.

4621. A first cousin once removed can either be your first cousin's child or your second cousin's parent.

4622. Double first cousins are first cousins twice, meaning they share both sets of grandparents. For example, when 2 sisters marry 2 brothers.

4623. Double first cousins can also occur when both parents of one double first cousin are also the siblings of parents of another double first cousin.

4624. First cousins share approximately 12.5 percent of their DNA. Double first cousins share an average of 25 percent, which is the same percentage as half siblings.

4625. Double first cousins are not genetically siblings.

4626. Half cousins share one grandparent. For example, if you're not related to your grandmother but you are related to your grandfather. Your first cousins are half cousins.

4627. If second cousins share 1 out of 4 sets of grandparents, half second cousins share one of these grandparents, rather than both.

4628.

The song "I'm My Own Grandpa" was written by Dwight Latham and Moe Jaffe and recorded by Lonzo and Oscar in 1947.

4629. In the song, the narrator marries a widow, and the narrator's father marries the widow's adult daughter. That makes his father also his stepson-in-law. His father's wife is the narrator's stepdaughter . . . and stepmother.

4630. This makes the narrator's wife both the narrator's spouse and step-grandmother. The husband of the narrator's wife would then be the narrator's step-grandfather, making the narrator his own step-step-grandfather. It gets even more complicated when both couples have children.

CHAPTER 24

IN THE NEWS

4631. Real headline: Beyond Meat Boss Arrested After Trying to Cannibalize Man's Nose.

4632. Real headline: Biologist Who Discovers Blonde Moth with Tiny Genitals Names New Species after Donald Trump.

4633. Real article: The Learning Center on Hanson Street reports a man across the way stands at his window for hours watching the center, making parents nervous. Police ID the subject as a cardboard cutout of Arnold Schwarzenegger.

4634.

Real headline: Woman Accidentally Joins Search Party Looking for Herself.

4635. A group of tourists spent hours looking for a missing woman near Iceland's Eldgja canyon, not realizing that the woman they were looking for had changed clothes. The missing woman didn't recognize the description of herself.

4636. The article goes on to say, "The search was called off at about 3 a.m., when it became clear the missing woman was, in fact, accounted for and searching for herself.

4637. Real headline: Florida Couple Arrested for Selling Tickets to Heaven. The Florida couple sold tickets for $99.99, and police confiscated over $10,000, drug paraphernalia, and a baby alligator.

4638. Tito Watts, the ticket seller, said, "I do not care what the police say. The tickets are solid gold. And it was Jesus who gave them to me behind the KFC and told me to sell them so I could get me some money to go to outer space."

4639. Real headline: "We Hate Math," say 4 in 10—a Majority of Americans.

4640. Real headline: Breathing Oxygen Linked to Staying Alive.

4641. Real headline: Statistics Show that Teen Pregnancy Drops off Significantly After Age 25.

4642. Real headline: World Bank Says Poor Need More Money.

4643. Real headline: One-armed Man Applauds the Kindness of Strangers.

4644. Real headline: Missippi's Literacy Program Shows Improvement.

4645. Real headline: State Population to double by 2040; Babies to Blame.

4646. Real headline: Republicans Turned Off by Size of Obama's Package.

4647. Real headline: Psychic Arrested Again; Still Didn't See It Coming.

4648. Correction: In a recipe for salsa published recently, one of the ingredients was misstated, due to an error. The correct ingredient is "2 tsp. of cilantro" instead of 2 tsp. of cement."

4649. Police report: Police receive a report of a newborn infant found in a trash can. Upon investigation, officers discovered it was only a burrito.

4650. For sale: Honda CBR 250. Fully sick and does the Mad Skids. Can easily outrun the cops and has done so on many occasions. $1,500.

4651. Correction: A headline on an item in the Feb. 5 edition of the *Enquirer-Bulletin* incorrectly stated, "Stolen groceries." It should have read "Homicide."

4652. A Covington, Louisiana, man arrived home one day to find 3 young children burglarizing his house. Two of the suspects were 6 and the other was 3. They made off with 2 hammers, a box of fudge, a Candy Land game, some money, cigarettes, and a jar of vegetables. Police officers arrived at the scene to find the children playing across the street. The boys were too young to be arrested; however, their mother could face charges. She wasn't home at the time of the crime. She was attending a parenting class.

4653. A 19-year-old man forced his way into a home, intent on robbing it. One of the 2 occupants of the home punched the crook. He fled the scene without his gold teeth, which had fallen out after the punch. Minutes later, the crook's mother went to the home to pick up the teeth.

4654. A man who held up someone in the parking lot of a Subway sandwich shop had just filled out a job application at the restaurant. The victim recognized the 18-year-old man from inside the Subway, and police used the application to obtain the suspect's home address.

4655. A man in Gallatin, Tennessee, tried on a pair of jeans at the local Walmart and left without taking them off or paying for them. The man left his old jeans behind in the dressing room, his wallet still in the back pocket.

4656.

Three women in Springfield, Missouri, dined-and-dashed at the local Waffle House, leaving behind the unpaid $39 check . . . and their purses.

4657. A Philadelphia man handed a note to a bank teller demanding $20, $50, and $100 bills. Unfortunately for the robber, he wrote the note on his pay stub.

4658. In 2008, 2 Dutch teenagers were convicted of beating up a classmate and stealing items from him. They were both sentenced to more than 150 hours of community service. However, the classmate was never touched, nor was anything physically taken from them.

4659. The 3 teens were playing the multiplayer online game RuneScape, and the internet bullies virtually roughed up their classmate and stole virtual stuff from him. The Dutch court ruled that "virtual goods are goods (under Dutch law), so this is theft."

4660.

An Ohio woman who was arrested for lighting a bar's bathroom on fire stated that she did it because she "felt stressed because of the death of Michael Jackson."

4661. A man, after robbing a bank in Rouen, France, jumped into a police car and shouted, "Get away quick before the cops come!" He had apparently run into the wrong car.

4662. Police in Jackson, Mississippi, pulled over a car that was weaving through traffic. The passenger was too drunk to drive home, which is why he enlisted his blind friend to drive instead.

4663. A 21-year-old Milwaukee, Wisconsin, man thought it would be funny to don a ski mask and pretend to rob his mother as she came home from shopping. A very surprised mom pulled a .357 Magnum from the waistband of her pants and shot him in the groin.

4664. A woman in Houma, Louisiana, was charged with aggravated battery against her boyfriend after trying to put her drink in the freezer. Realizing the freezer was too full, she got upset, blamed her boyfriend for the lack of space, and smacked him in the face with a frozen beefsteak.

4665. A Los Angeles, California, man decided to pop the question to his longtime girlfriend at a local Burger Stop. He even wrote "Will You Marry Me?" on the back window of his car . . . the very car he then used in his attempt to run over his girlfriend after she refused him.

4666. Police helicopters spotted him a short time later, still carrying the flowers he had planned to give his bride to be.

4667. Police stopped to assist a truck that was stuck in the mud in Flint, Michigan, only to find that a 13-year-old boy was behind the wheel. The boy's 41-year-old father, who was in the passenger seat, explained politely that he was too drunk to drive, so he let his son take the wheel. Too bad the kid was drunk, too.

4668. A couple is facing felony child cruelty charges after forcing one of their children to live outside in the backyard. Police, responding to a 9-1-1 hang-up call, witnessed a man and woman yelling in front of 3 young girls. While 2 of the girls looked normal, the oldest was dirty and "ill-clothed."

4669. A 46-year-old Cobb County, Georgia man was arrested on December 20 for leading a group of middle-school football players on a neighborhood vandalizing spree. He drove the kids around in his pickup truck and had them rearrange people's holiday reindeer lawn ornaments in sexually suggestive positions.

4670. Forty drunk Santas, protesting the fact that Christmas was becoming too commercial, ran through Auckland, New Zealand, robbing stores and assaulting people.

4671. In Sparta, Washington, Santa was arrested after trespassing in a family's yard and hugging the children who were playing there. He drunkenly asked the children if they knew where his reindeer were. One of the kids, a 9-year-old girl, said, "I knew it wasn't the real Santa because Santa doesn't drink alcohol."

4672. Two women decided to see what would happen if they wrapped a mannequin in a bloody sheet and dumped it on an on-ramp to Interstate 40. Deputies found the 2 women on a nearby hill watching with binoculars as every emergency worker in the county converged on the scene.

4673.
Two children in Galatia, Illinois, walked into their home on Halloween and saw what looked like a dead body in their living room. The 6- and 8-year-olds ran to a neighbor's house and called 9-1-1. By the time the cops arrived, the parents of the kids had straightened everything out and said it was just a practical joke they were playing on their kids.

4674. A woman in Mansfield, Texas, woke up one morning to find 2 people loading her family's portable basketball goal into their truck. She ran outside to confront them, but they said there was an ad on Craigslist offering the goal as well as the woman's tetherball pole for free to the first people to pick them up. The woman had never even heard of the classified advertising website, but sure enough, Craigslist had this ad listed under her address: "Free basketball goal and tether ball pole. At dead end of roadway beside my home . . . don't knock its placed out there for you to come get. will delete when gone. thanks."

4675. It turns out that the family's neighbor, a police officer, didn't like having to look at them all the time. Police aren't quite sure what to charge the man with.

4676. A police officer in Stockholm, Sweden, reported to his superiors that he had no leads in the bank robbery he was investigating. The man was by no means upset over his failure, since he was the one who robbed the bank to begin with.

4677. A Marin County, California, sheriff's deputy was relieved of duty for using his patrol car's dashboard camera to film scantily clad women at the beach.

4678. Eleven members of a Florida antidrug task force were caught on video playing Wii Bowling at a home they had just stormed in order to execute a search warrant.

4679. A sergeant in the Miami-Dade County, Florida, police department was arrested for domestic violence and aggravated assault with a deadly weapon after assaulting his girlfriend for not holding his hand at a Miami Heat basketball game.

4680. Up to 5 teens thought they hit the jackpot when they broke into a home and discovered a large amount of drugs, which they stole and began snorting immediately. Too bad they were snorting the cremated remains of 2 Great Danes.

4681. A man from Chicago, Illinois, called a local radio station during its popular confessions show to brag about a bank heist he and his friends had committed. The man admitted to tying up employees and stealing around $80,000, which he and his cohorts spent at stores on Chicago's ritzy Michigan Avenue. An employee of the bank that was robbed was listening to the radio program and called the police. They traced the bank robber's call and made the arrest.

4682.

A Tulare County, California, man died after receiving several cuts to the leg from a rooster that had knives attached to its legs. An anonymous tip led police to a field where a cockfight was supposedly going on. In the chaos that ensued, the man was stabbed by the bird, and doctors were unable to control the bleeding.

4683. Two men wielding machetes and knives attempted to rob a sports club in Sydney, Australia, ignoring the 50 motorcycles in the parking lot. Evidently there was a meeting of the Southern Cross Cruiser Motorcycle Club that evening. The leader of the bikers told CNN, "These guys were absolutely dumb as bricks. I can't believe they saw all the bikes parked up front and they were so stupid that they walked past [them]."

4684. The robbers walked into the bar that was next to the room where the bikers were meeting and yelled at the patrons to drop to the floor as they emptied the cash registers. The bikers, hearing the commotion, grabbed anything within reach not bolted to the ground and rushed the 2 young men with chairs, tables, and more. One of the would-be crooks crashed through a plate-glass door and then jumped off a balcony to escape. He was apprehended by police shortly thereafter and hospitalized. The second man was caught by the bikers and beaten; they "hogtied him with electrical wire and left him for the cops."

4685. A Washington County, Oregon, sheriff's deputy was investigating a noise complaint. A woman answered the door and assured the deputy that she would indeed turn down the music. The deputy left, but then the woman called 9-1-1 and said, "A police officer left my house just now . . . He's the cutest cop I've seen in a long time. I just want to know his name. Heck, it doesn't come very often a good man comes to your doorstep." The same deputy returned to the woman's house and promptly arrested her for misusing the 9-1-1 system, which is punishable with up to a year in jail.

4686. A 23-year-old man in Clemson, South Carolina, was struck by an SUV while jaywalking across a 4-lane highway . . . except it wasn't really jaywalking. He was playing a real-life version of the video game Frogger.

4687. Two women in Victorville, California, were charged with interfering with the "peaceful conduct at a school" when an argument they were having turned physical, leading to a brawl . . . at their children's kindergarten graduation ceremony.

4688. A New York bookkeeper stole more than $2 million from her employer, Great South Bay Surgical Associates, and used the loot to buy lottery tickets, hoping to hit the jackpot. She spent around $6,000 a day on lottery tickets.

4689.

A French thief who had just made off with a television and some hunting rifles was arrested when he returned to the scene of the crime for the television's remote control.

4690. A drunk man outside a Wisconsin ski area stole an ambulance with the paramedics and patient still inside.

4691. When the wallet of a Columbus, Ohio, man proved to be empty of cash, the 2 men who ambushed him outside his home decided that the man and his girlfriend would take them shopping with the debit and credit cards they did find. The couple was forced to withdraw cash at an ATM and then told to hit the local Walmart. The girlfriend was sent into the store to buy 2 Sony PlayStations while the crooks stayed in the car and held the man hostage. The woman later told a local TV station, "(Walmart was) out of PlayStations. So, my next thing was, 'I really would like to speak to somebody—a security officer.'"

The crooks made the man drive off before police could arrive, leading authorities on a wild, high-speed chase that only ended when the man drove the car into a dead end. One of the crooks, thinking quickly yet not intelligently, threw his gun onto the man's lap, saying, "Tell the cops it's your gun." The man, no longer being held at gunpoint, did no such thing, and the 2 eighteen-year-olds were arrested and charged with multiple crimes.

4692. Three Long Island, New York, thieves were caught by their stolen goods. Thinking they had stolen 14 cellphones, the threesome was dismayed to learn that they had instead stolen GPS devices. Police simply tracked the devices and arrested all involved.

4693. Thieves in Austria made off with a 30-pound safe but couldn't open it. One of the crooks came up with the bright idea of placing it on a railroad track and waiting for a speeding passenger train to open it for them.

4694. A train did indeed collide with the safe, sending around $6,000 flying everywhere and nearly derailing the train, which sustained extensive damage.

4695. A Colorado man, angry over being dumped by his girlfriend, decided to seek vengeance by robbing the bank where she worked.

4696. A Colorado Springs police Sergeant reported, "He robbed a bank where people knew him. Everybody was like, 'Oh, that's Gary.'"

4697. A Columbus, Ohio, man returned to the scene of the crime (a home he had robbed 2 hours earlier) to ask one of his victims out on a date. The woman recognized the man, had a relative call the cops, and the man was arrested in front of the home.

4698. A 41-year-old man was arrested for attempting to rob a bank in Berlin, Germany. He burst into the bank and yelled, "Hand over the money!" When a teller asked if he wanted a bag, the robber responded, "Damn right it's a real gun!" The bank manager, realizing the man was deaf, set off the alarm, which was "ridiculously loud." Police arrived and arrested the deaf man.

4699. In 2007, a man accused of leaving a restaurant in El Lago, Texas, without paying was seen heading toward a vacant building. When the police arrived, they entered the building to search for him. One officer, "trying to inject some humor into the situation," called out, "Marco!" The chew-and-screw diner, whose name was not Marco, was located after he responded, "Polo."

4700. A man is behind bars for stealing 2 diamond rings and other items from a home. While in the home, he decided to check his Facebook page on the homeowner's computer. Then he forgot to log himself out.

4701. When a $1,772.50 deposit showed up in a Bloomsburg, Pennsylvania, couple's bank account as $177,250, the husband-and-wife team did what any normal Americans would do: They withdrew the money, quit their jobs, bought a new car, and moved to Florida. When the law finally caught up to them and charged them with felony theft, they claimed it was all just a big misunderstanding. They said they often got large checks because the husband is a roofer, so they didn't pay attention to exactly where that decimal point was. They simply weren't aware of any banking error. Except . . . the husband only earned about $4,000 the previous year installing roofs. The couple spent more than $120,000 before they were caught.

4702. A 51-year-old woman who was arrested for robbing a Bank of America, claimed she did it because she wanted to cross it off her bucket list.

4703. A 2005 paper in the *Review of Economics and Statistics* found that unattractive people committed more crimes than average-looking people. Beautiful folks committed the fewest crimes of all. The paper, entitled "Ugly Criminals," states that attractive people are more successful in their careers and earn more, which puts ugly people at a disadvantage. They earn less, have fewer friends, and are therefore more likely to turn to a life of crime.

4704. A California woman was pulled over in Essex County, Ontario for driving 140 kilometers per hour in an 80km/h zone. The woman explained that her Mercedes-Benz's speedometer only had miles per hour, and she didn't know how to convert miles to kilometers.

4705. Although each man's story differs as to who shot whom first, the cause of this Mississippi shootout was one man's dog pooping on the other man's lawn. The dog owner accused the lawn owner of trying to shoot his dog a week earlier and challenged the lawn owner to a duel, saying, "Just meet me at the levee and I'll shoot you down." The lawn owner accused the dog owner of shooting first and received several shotgun pellet wounds to the hands, shoulder, chest, and side for all his efforts, but was not seriously wounded. The dog owner ended up with assault charges, and police are considering charges against the lawn owner as well.

4706. A Chicago man shot and killed a neighbor who let his dog pee on his perfectly manicured lawn. The shooter was convicted of second-degree murder but only sentenced to 4 years of probation.

4707. A man hired to wear an Elmo suit for a children's event was attacked by a man who later said he felt threatened by the Sesame Street star. He began throwing punches at Elmo, but Elmo fought back and broke a couple of the attacker's fingers. A police lieutenant reported, "[Elmo] just wandered into the Guitar Center to look at instruments." Police also said in a statement that the suspect was taken to the hospital "where he would receive treatment for his injuries and undergo a mental evaluation."

4708. A woman at a party in Lincoln, Nebraska, took offense at being called fat by one of the partygoers as he walked out the door. She chased him down the block, tackled him, and bit off his ear.

4709. A Walgreens employee was arrested for stabbing a colleague with a large kitchen knife. They were fighting over who got to use the microwave in the employee break room first.

4710. A Nebraska man was arrested for throwing detergent bottles full of pee into people's backyards. The man told police it was a longtime hobby.

4711. A 25-year-old woman was attacked by 6 other women at a sports bar in Stamford, Connecticut, in October 2009. The woman was knocked to the floor, punched, kicked, and had her hair pulled. She suffered bruises and a chipped tooth, and all 6 of the women were arrested on assault charges.

Why the rough treatment? The woman was singing karaoke ("A Dios le Pido" by Colombian pop idol Juanes) and the others didn't like her performance. A police press release stated that the 6 women "made derogatory comments about the other female's singing ability."

4712. When billionaire shipping tycoon Alki David wanted publicity for his new website, he didn't take out an ad. Instead, he offered to pay $1 million to the first person who streaked in front of President Obama during a speech with the business's domain name across his (or her) chest. In order to qualify for the money, the streaker also had to yell "battlecam.com" 6 times within earshot of the president.

4713. A Staten Island, New York, man did what Alki David asked at the president's speech in Philadelphia in October 2010. He was promptly arrested on disorderly conduct and indecent exposure charges. And not only that, but David initially refused to pay the streaker because he hadn't met all the demands. He never paid the full amount even though traffic to his website doubled after the stunt.

4714. The streaker wasn't the only publicity hound at that particular speech. A man was briefly detained by the Secret Service after throwing a book at the president. The man wanted to publicize the book, but the title of the book was never released.

4715. A Fargo, North Dakota, woman called the police station asking where she could buy pot. She persisted, even after the dispatcher told her it was illegal to purchase pot, so the dispatcher finally told her they had some in a locker at the station. The woman was arrested when she showed up with $3 for the drugs.

4716. A Boston, Massachusetts, woman was arrested for trying to smuggle more than 12 pounds of cocaine in a bag full of dirty diapers. She said someone at an airport in Mexico offered her money to bring the carry-on bag back to the states and that she had no idea what was in it. The cocaine was discovered when passengers on the plane complained of the odor coming from the bag.

4717. Angela Sanclemente Valencia is a Colombian former lingerie model who found a more lucrative occupation: masterminding one of the world's largest drug gangs using female models to transport cocaine from South America to Europe and North America. Models would hide the drugs in their baggage as they traveled to photo shoots and beauty competitions.

4718. Valencia's "unsuspicious beautiful angels" (as she is reported to have called her glamour mules) made around $5,000 per trip. Valencia was apprehended (after a 2-month manhunt) when one of her models was arrested and started talking.

4719. An inmate in Orange County, California, asked for kosher meals to help him stay healthy while incarcerated. Since officials reserve kosher meals for people with religious needs, a judge asked for a reason. The inmate's lawyer said his client was a devotee of Festivus, the holiday that features an aluminum pole and the annual airing of grievances that was created by the TV sitcom *Seinfeld*. The judge granted the request, and the inmate got his meals for 2 months, until a higher court rescinded the previous judge's ruling.

4720. A Chinese man in Los Angeles, California, was arrested for creating a fake US Army unit. He convinced more than 100 Chinese nationals that joining his unit, called the US Army Military Special Forces Reserve unit, would help them gain US citizenship. The "recruits" paid hundreds of dollars to join, received military uniforms, fake documents, and military ID cards. They met regularly in an LA suburb to march and parade around. They could also pay more to their "supreme commander" (as the suspect called himself) for higher ranks within the unit. The suspect has been charged with theft by false pretenses and creating deceptive government documents. He faces up to 8 years in jail if found guilty.

4721. In 1925, an Austrian con artist named Victor Lustig read an article in a French newspaper about the high cost of maintaining the Eiffel Tower. The story led to his greatest con. He contacted 6 scrap metal dealers and, passing himself off as a government official, told the businessmen in strictest confidence that the Eiffel Tower was to be demolished and sold for scrap metal, and the government was soliciting confidential bids to do the work. Lustig picked his mark ahead of time, an insecure dealer named Andre Poisson, and told him he had won the bid to take apart the tower. All was going well with the con and Lustig was just about to close the 250,000-franc deal (nearly $1 million), when Poisson became suspicious. Lustig then demanded a bribe from Poisson, which convinced the dealer that all was well because, his thinking went, all French bureaucrats were corrupt. The deal went down and Lustig disappeared with the full amount of the bid as well as the bribe. A humiliated Poisson didn't even contact the police, which gave Lustig the confidence to return to Paris and try again. He selected 6 more dealers, but this time his mark went to the police before the deal could be completed. Lustig escaped.

4722. A Riceville, Tennessee man whose house had been robbed was talking to a detective outside his home when another officer stopped a passerby. The homeowner noticed that the man the detective had stopped was wearing his stolen pants and shoes. Detectives arrested the thief, and the homeowner got his clothes back.

4723. In the early twentieth century, Hans Schaarschmidt was serving a 6-year sentence for robbery in the decaying German jail in Gera. The windows were barred with wooden beams, so each day, Schaarschmidt chewed away at the wooden bars. He hid his handiwork by filling the holes with a paste he made from the black bread he was fed. After 3 months, he squeezed his way to freedom. He was caught again within 3 weeks and put behind iron bars.

4724. A man in Madrid, Spain, has escaped from jail twice via fax. The man was in a cell at the Arganda del Rey courthouse awaiting trial when officers received a faxed release order from a regional court. When the fax was followed up by 2 phone calls, they released the man to a waiting taxi. The fax and both phone calls were from the man's wife. The husband-and-wife team had done the same thing successfully 6 months earlier. Police found the man inside his heavily fortified home, hiding inside a hollowed-out couch.

4725. A 26-year-old Janesville, Minnesota man thought he was just doing a good deed. A 70-year-old woman asked him for a ride to the bank so she could withdraw some money to pay the rent. Instead, she told a teller she had a gun and demanded money. She left with $3,700 and got back in the car with the unsuspecting getaway driver. Police arrested both soon after (the bank's vice president followed the car for about 8 miles), but the driver was released when he explained that he had no idea what that nice little old lady was up to.

4726. A 19-year-old Philadelphia, Pennsylvania woman who was being transported to jail was able to escape from her captors and run away. It took several hours to re-apprehend the handcuffed criminal, who was finally found at the Brown Funeral Home, hiding inside a coffin.

4727.

An Ohio man who robbed a bank had his 6-year-old daughter in his getaway car. Family friends reported that the girl later said, "I was wondering why my dad was driving so fast."

4728. A man serving time in jail over driving with a suspended license was upset when an acquaintance didn't show up outside the prison to throw some cigarettes over the fence for him. So, he did what anyone would do under these circumstances: He broke out of the Camden County Jail in Woodbine, Georgia, by scaling the fence, broke into a convenience store, grabbed the much-needed cigarettes, and then . . . returned to jail.

4729. Sidney Gottlieb (1918–1999) was a military psychiatrist and chemist who worked with the CIA during the Cold War. Known as the Black Sorcerer, he was in charge of the CIA's lethal poison program.

4730. Sidney Gottlieb's plots against Castro (all unsuccessful) included poisoning his cigars, planting explosives in a conch shell to detonate while Castro was swimming, releasing LSD into a television studio where Castro was to appear, and handing Castro an explosive pen. Gottlieb thought it would be a good idea to spray Fidel Castro's shoes with thallium, a drug that would make his beard fall out.

4731. Sidney Gottlieb, as head of Project MK-ULTRA, which worked on using mind control for spying, slipped LSD into people's drinks without their knowledge to see what would happen. He was trying to see if the drug would help him develop techniques that would "crush the human psyche to the point that it would admit anything."

4732. Sidney Gottlieb tried to assassinate Patrice Lumumba of the Congo by poisoning his toothpaste. Lumumba was murdered before he could be poisoned.

4733. After he retired, Sidney Gottlieb took up dancing, goat raising, and working with lepers in India.

4734.
Giovanni Aldini (1762–1834) was a physicist who electrocuted animal carcasses for audiences throughout Europe. People flocked to see dead cows dance, jaws move, eyes blink, and more.

4735. In 1803, Aldini was given the body of a hanged criminal. He electrocuted the face, which started to twitch. The mouth and eyes opened, and when he electrocuted the body, its arms and legs started punching and kicking around.

4736. The audience clamored to have the dead body hung again . . . just to make sure he was still dead.

4737. Dr. Vladimir Gavreau was a French robotics researcher who developed remote-controlled devices for factories and the military at the height of the Cold War.

4738. His team worked in a large concrete building, and periodically they would all experience a "disconcerting nausea." The source of the sickness was found to be an improperly installed motor-driven ventilator, which was creating an infrasonic resonance (low-frequency sound no one could hear).

4739. Being in the weapons business, Gavreau went about creating a sonic weapon, a giant infrasound organ with pipes 6 feet in diameter and up to 75 feet long. The first time Gavreau turned on the device, the building they were outside of was nearly destroyed, and the researchers were gripped in what they later called "an envelope of death."

4740. Though the organ was only on for a few seconds (one of the researchers managed to turn it off), the scientists were extremely sick for the next 24 hours, and their eyesight was affected for days afterward.

4741. According to one report, their body cavities absorbed the acoustic energy and would have been torn to pieces had the power not been turned off quickly.

4742. The experiment was considered a success in that they had created an expedient way of eliminating an enemy, even as they nearly eliminated themselves.

4743. The Mars Climate Orbiter was one of a series of missions in a long-term program of Mars exploration, known as the Mars Surveyor Program. In September 1999, the craft approached Mars and then disappeared. At first, politicians and some scientists blamed NASA's new credo, "better, faster, cheaper," for the $125 million failure.

4744. A week later, NASA's scientists figured out that even though NASA had used metric units to guide its spacecrafts for years, Lockheed Martin, the company they hired to engineer the craft, used English units for its thrust data. This caused the craft's thrusters to plunge the Orbiter to its doom. Soon after the incident, Noel W. Hinners, vice president for flight systems at Lockheed Martin Aeronautics and master of the obvious, said, "We should have converted."

4745. In 1927, Professor Thomas Parnell of the University of Queensland in Brisbane, Australia, wanted to show his students that some substances that appear to be solid are actually high-viscosity fluids. He poured a heated sample of tar pitch (pitch is the name of any highly viscous liquid) into a sealed funnel and waited for it to drip. Parnell's students were rewarded with the first drip . . . in 1938. Experimenters have calculated that drops fall over a period of about 10 years, giving this pitch a viscosity that's 230 billion times that of water.

4746. In 2003, a high school student named Jillian Clarke disproved the 5-second rule by dropping Gummi Bears and fudge-striped cookies onto ceramic tiles treated with E. coli.

4747. Psychologist David Rosenhan published a paper called "On Being Sane in Insane Places" in *Science* in 1973. The study in his paper placed sane people in psychiatric hospitals to see if they could get released without any external help.

4748. Eight pseudo-patients went to different hospitals in various locations within the US and simulated auditory hallucinations (they pretended to hear voices). All were admitted, and once in the hospital, they proceeded to act normally and say they felt just fine. The staff at each hospital believed every one of these pseudo-patients suffered from a mental illness—not one doctor or nurse caught on, even though more than 20 percent of the real patients believed they were fakes. The pseudo-patients took notes on the doctors' and nurses' actions, and one nurse called this "writing behavior" and labeled it pathological.

4749. Ultimately, each imposter did get released, although a lawyer had to be hired, and in some cases, it took nearly 2 months to get out. Each imposter also had to admit to having a mental illness and promise to take antipsychotic drugs.

THE BRILLIANT BATHROOM READER

4750. In a second experiment, Rosenhan told several hospitals he was going to send imposters to try to gain entry. The hospitals falsely identified many real patients as sane. How did Rosenhan figure this out? He never sent any imposters to the hospitals. Rosenhan concluded his study thusly: "It is clear that we cannot distinguish the sane from the insane in psychiatric hospitals."

4751. In 1971, Stanford University psychology professor Philip Zimbardo had no idea that his experiment designed to study the effects of becoming either a prisoner or a prison guard would appear in nearly every psychology textbook and become the basis for novels, documentaries, songs, and even a feature-length film, to be released 40 years after it was all over.

It was a simple 2-week experiment. He chose 24 "normal" male students and randomly assigned them the role of either prisoner or guard. This prison simulation took place in the basement of the psychology building. A research assistant was the warden and Zimbardo, the superintendent.

The guards were told not to physically harm anyone and were given wooden batons and uniforms. The prisoners were arrested at their homes and taken to jail. The experiment quickly grew out of control. On day 2, the prisoners rioted. The guards quickly squashed it by squirting the prisoners with fire extinguishers.

Angry at the prisoners' behavior, the guards forced prisoners to count off repeatedly, made them exercise for extremely long periods of time, refused to let them use the bathroom (or to empty the pail they were forced to use), made them sleep on the concrete floor naked, and even had them clean toilet bowls . . . with their hands.

It wasn't until Zimbardo's girlfriend (and future wife) visited and expressed her horror at what was going on did Zimbardo end the fiasco 9 days early.

4752.

Researchers claim that up to one-third of the guards had shown genuine sadistic tendencies, and many of the prisoners showed signs of trauma. Two prisoners even had to be removed from the study early.

4753. In the 1930s, Dr. Wendell Johnson, a leading speech pathologist, wanted to better understand his own stuttering. Prevailing theories at the time were that it was caused by a physical disability of some sort.

4754. Dr. Johnson believed that children were often labeled as stutterers at very young ages, and that the label itself worsened children's speech. To test his hypothesis, he had one of his graduate students select 22 children from an orphanage, 10 of whom stuttered. The children were split evenly into 2 groups. One group was labeled normal speakers and the other as stutterers (no matter whether or not a child indeed had a stutter).

4755. The normal speakers received positive therapy, while the stutterers were belittled even if they weren't stuttering. This went on for 4 months, and many of the children in the stuttering group were traumatized for life.

4756. Often called the Monster Study, Johnson hid the experiment, fearing for his reputation, and it only became public in 2001.

4757. In 2014, a study at Ohio State University found that people who take a lot of selfies are more likely to have high measures of narcissism and psychopathy. The researchers asked 800 men between the ages of 18 and 40 to answer questions about their photo posting habits on social media. They were also asked to answer questions that measured anti-social behaviors and self-objectification. They found that posting more photos was correlated with both narcissism and psychopathy. However, editing the photos was only associated with narcissism.

4758.

Other studies have found that heavy Facebook use can be linked to low self-esteem and narcissism.

4759. In 2010, a matador in Mexico City, Mexico, was arrested for breach of contract after running away from the bull he was supposed to be fighting. As the bull charged, the man dropped his cape, ran from the bull, and leapt headfirst over a wall. The 22-year-old torero said, "There are some things you must be aware of about yourself. I didn't have the ability; I didn't have the balls. This is not my thing." The man was released after paying a fine and is considering retirement.

4760. A football coach in San Diego, California, was arrested at Abraham Lincoln High School after a fight with a parent over the recruitment of a player. The coach punched the man in the shoulder and then kicked him in the stomach, causing the parent to fall and hit his head, losing consciousness. The coach overheard the parent, who was with the other team, trying to recruit one of the coach's best players. The 2 teams playing each other were part of a youth league, and the kids were from 9 to 11 years old.

4761.

A man in Oklahoma who received a 30-year jail sentence for armed robbery wanted his number of years in jail to match his favorite basketball player's jersey number. Boston Celtics star Larry Bird wore number 33, and the district attorney was more than happy to oblige the man, increasing his sentence by 3 years. The judge in the case said, "He said if he was going to go down, he was going to go down in Larry Bird's jersey. We accommodated his request and he was just as happy as he could be."

4762. Rae Carruth played wide receiver for the Carolina Panthers from 1997 to 1999. Carruth was sentenced to nearly 20 years in jail for hiring a hit man to kill his pregnant girlfriend. Carruth helped the hit man by driving in front of his girlfriend's car and stopping while the shooter drove alongside the girlfriend and shot her. She died from her injuries, the baby lived, and Carruth nearly got the death penalty.

4763. A walk-on backup punter for the University of Northern Colorado, apparently tired of being told to "work harder" whenever he asked how he could break into the starting lineup, took matters into his own hands by stabbing the starting punter in the thigh with a 5-inch-long knife.

4764. A New Jersey dad punched his son's football coach and knocked him out. The incident was over the amount of playing time the dad's kid was receiving. The dad was vice president of football operations of the league, and he was charged with "assault while attending a community-sponsored youth sporting event while juveniles under 16 were present." The law was created to discourage violence at kids' sporting events.

4765. A Philadelphia, Pennsylvania man pulled a .357 Magnum on his 6-year-old son's youth football coach because his son wasn't getting enough playing time.

4766. An Oregon State University offensive lineman was kicked off the team after being found drunk and naked in a stranger's home. When police confronted the 19-year-old and told him repeatedly to lie on the floor, he instead dropped into a 3-point stance, used at the line of scrimmage during games, and lunged at the officers.

4767. Seattle Seahawks rookie wide receiver Golden Tate received a warning from police after a call from Top Pot, a gourmet doughnut shop, saying that they had been robbed of some of their famous maple bar doughnuts.

4768.

Tate apologized for the incident saying, "Freshly baked. I made the mistake of—A buddy made the mistake [of] going in [and] grabbing a couple. We ate them . . . But, if you ever want maple bars, that's the place to go."

4769. Coach Pete Carroll added, "No, I'm not disappointed at a guy being at a doughnut shop at 3 in the morning when they got maple bars like Top Pot has . . . I do understand the lure of the maple bars."

4770. A 46-year-old former French army helicopter pilot confessed to spiking 27 of his children's (a son and a daughter) tennis opponents' water bottles with the antianxiety drug Temesta, which causes drowsiness. The players would complain of feeling sick and dizzy, having weak knees, and nausea. Several fainted and needed medical attention.

4771. Things really came to a head when one of the drugged players, who had to pull out of a match against the son, lost control of the car he was driving after falling asleep at the wheel. He crashed into a tree and died.

Prosecutors described the father as "an adult who turned his children into objects of his own fantasies of success." They also said to the dad, "Nothing stopped you: players collapsing on the court, the sight of gurneys, of an 11-year-old girl, a young woman who collapses against a fence."

The father, speaking to the parents of the man who died in the car crash, said, "It's something that completely took me over." He's currently serving his 8-year jail sentence. There is no evidence his children ever knew what he was doing. The son gave up the sport, but the daughter kept playing for several years.

4772.

A father and son team ran onto the baseball field at Chicago's Comiskey Park and attacked Kansas City's first-base coach Tom Gamboa. He was slammed to the ground and pummeled by the 2 shirtless attackers. "He got what he deserved," said the 34-year-old dad. The entire Royals dugout jumped on the 2 attackers, and it was several minutes before order could be restored. "Security did a good job cleaning it up," said one Royals player. "If it wasn't for them, we'd still be beating on those guys."

4773. A stockbroker sitting in the stands as the Chicago Cubs took on the Houston Astros at Wrigley Field in Chicago watched Cubs reliever Randy Myers take the mound. The broker told his brother, who was sitting next to him, "If he throws another home run, I'm going to run out there and give him what for."

After Myers gave up a 2-run homer soon after his arrival in the game, the crazed fan jumped onto the field and ran at the pitcher. Not realizing Myers was trained in the martial arts, he was felled with one nasty blow from the pitcher.

4774. A light-heavyweight boxing match turned very strange when, just as Tony Wilson was getting pulverized by his opponent, Steve McCarthy, a woman from the crowd climbed into the ring and began pounding McCarthy with one of her high heels. McCarthy needed several stitches and refused to continue the fight, giving Wilson the win. The fan with the dangerous heels was Wilson's mother.

4775. A fan ran onto the field just before the final match of the 2010 soccer World Cup and tried to pick up the trophy and put a little red hat on it. The man wore a larger, matching red hat. He got within arm's reach before being punched and tackled to the ground.

THE BRILLIANT BATHROOM READER

4776. Chad Johnson was just a normal 14-year-old middle school football player whose parents had died tragically in a car accident. But something seemed a little off with him, and the more Tampa, Florida authorities dug into this 5-foot-11, 160-pound middle schooler, the less things looked normal. Finally, the truth came out: The "boy" was actually a 21-year-old man.

"He really acted like a kid," said the coach. "My son is 13, and my son was hanging out with him, and he acted more immature than my son."

4777. Immokalee High School in Collier County, Florida, had sanctions imposed on its sports program when it came to light that a forward for their soccer team, which won district titles in 2005 and 2006, was 30 years old. The local newspaper obtained documents that showed the high school used 2 other overage athletes as well.

CHAPTER 25
WEIRD WORDS & NUMBERS

4778. A figure of speech or rhetorical figure is a word or phrase that purposely deviates from ordinary language to produce an effect.

4779. A capitonym is a word that changes meaning when you capitalize it.

4780. *Hamlet* is a play by Shakespeare; hamlet is a small town.

4781. March is a month; march means to walk rhythmically.

4782. Polish is a person from Poland; polish is to shine something.

4783. An aptronym (or aptonym, namephreak) is a term for last names that fit a person's career. For example, a librarian named Mr. Page or a dentist named Dr. Smile.

4784. Real people with aptronym names include the fastest man in the world, Usain Bolt; the tennis player Margaret Court; the neurologist Dr. Russell Brain; and the poet William Wordsworth.

4785. Literary aptronyms include Mr. Talkative and Mr. Worldly Wiseman in John Bunyan's *The Pilgrim's Progress* and Ebenezer Scrooge in Charles Dickens's *A Christmas Carol*.

4786. A short list of William Shakespeare's characters whose names are aptronyms includes Robert Shallow, Mistress Quickly, Nick Bottom, Falstaff, and Toby Belch.

4787. J. K. Rowling used aptronyms for many of her Harry Potter characters, including Draco Malfoy ("draco" is Latin for "dragon" and "mal foi" is French for "bad faith").

4788. Franklin P. Adams (1881–1960), an American columnist and humorist, as well as member of the Algonquin Round Table, is credited with coining the term "aptronym," which he created by rearranging the first letters of word "patronym."

4789. An auto-antonym (also called a contronym) is a word that can take on 2 or more opposite meanings.

4790. "Strike" can mean "to act decisively" or "to refuse to work."

4791. "All over" can mean "available everywhere" or "no longer available."

4792. "Downhill" can mean "a better direction," i.e., "Thankfully, it's all downhill from here" or "a worse direction," i.e., "I'm sad to say it's all downhill from here."

4793. "Bound" can mean "tied up" or "heading to a place."

4794. "Buckle" can mean "to pull together" or "to fall apart."

4795. "Overlook" can mean "to gloss over" or "to watch over."

4796. "Cleave" can mean "to cut apart" or "to cling together."

4797. "Hew" can mean "to cut into" or "to hold to."

4798. "Off" can mean "activated" or "deactivated." "The timer went off" and "I turned off the alarm."

4799.
"Dust" can mean "to sprinkle with particles" or "to remove dust."

4800. "Peer" can mean "a person of nobility" or "an equal."

4801. "Bolt" can mean "to secure" or "to flee."

4802. "Sanction" can mean "to approve" or "to boycott."

4803. A toponym is a place name, but it can also refer to a word derived from a place name. Champagne comes from Champagne, a historic wine region in France.

4804. The game of badminton got its name from Badminton in Gloucestershire, England.

4805. The bikini swimsuit got its name from Bikini Atoll in the Marshall Islands. This is where atomic bombs were tested in 1946 . . . analogous to the "explosive" effect on the male libido.

4806. To balkanize something is to divide a place or country into several smaller units. This comes from the Balkan Peninsula, which was divided into several small nations in the early 20th century.

4807. A backronym is a prefabricated acronym purposefully created from a phrase whose initial letters spell a particular word to create a memorable name. In other words, it's a phrase constructed after the fact that is attached to an existing word.

4808. The term "backronym" was created by Meredith Williams of Potomac, Maryland, for a neologism contest in *The Washington Post* in 1983. She defined backronym as "the same as an acronym, except that the words were chosen to fit the letters.

4809. Seasonal Affective Disorder = SAD.

4810. Mothers Against Drunk Drivers = MADD.

4811. AMBER = America's Missing: Broadcast Emergency Response.

4812. A backronym can be funny. For instance, Microsoft's Bing was joked to be an acronym for "Because it's not Google."

4813. A neologism is a newly coined or invented word or expression that is not yet in wide use. According to grammarist.com, it can start off as jargon or slang that fills a need created by new technology.

4814. A portmanteau is a neologism formed by combining elements of 2 words.

4815. Lewis Carroll introduced the word "portmanteau" in his book *Through the Looking Glass*, published in 1871.

4816. In the book, Humpty Dumpty explains to Alice the words in the poem "Jabberwocky" that appears in the book. For instance, "slithy" comes from "slimy" and "lithe."

4817. He compares word combining to a portmanteau, which is a type of luggage that opens into 2 equal parts. "You see," he says, "it's like a portmanteau—there are 2 meanings packed up into one word."

4818. "Mansplain" is a portmanteau that combines the words "man" and "explain."

4819. "Chocoholic" is a portmanteau of the words "chocolate" and "alcoholic" to describe someone who is addicted to chocolate.

4820. "Frankenword" is a portmanteau describing a portmanteau that combines "Frankenstein" and "word."

4821. "Chillax" means to calm down and relax. It comes from the words "chill" and "relax."

4822. "Hangry" is someone who is so hungry that it's made them angry.

4823. "Brunch" is the meal between breakfast and lunch.

4824. A portmanteau can be a combination of more than 2 words.

4825. "Turducken" is a dish that involves cooking a chicken inside a duck inside a turkey.

4826. In 1964, the newly independent African republic of Tanganyika and Zanzibar chose the portmanteau "Tanzania" as its new name.

4827. The company Verizon combined the words "veritas" (Latin for truth) and "horizon."

4828. President George W. Bush's most famous portmanteau was mostly likely when he said "misunderestimate" in a speech in 2000.

4829. Some "words" Bush has coined include, "resignate," "analyzation," "embetter," and "Hispanically."

4830.

A homograph, also known as a heteronym, is a word that has the same spelling as another word but has a different sound and a different meaning.

4831. "Tear" (to rip) and "tear" (what you get when you cry) are homographs.

4832. "Lead" (to go in front of) and "lead" (a metal) are homographs.

4833. A homophone are two words with the same sounds that have different meanings.

4834. "To," "two," and "too" are homophones.

4835. Depending on the dictionary, a homonym can be a homograph, or it can be a homophone. Or it can also refer to words that are spelled and pronounced the same but have different meanings. (It's confusing.)

4836. "Pool" (to swim in) and "pool" the game are homonyms.

4837.

Metonymy is a figure of speech in which something is referred to by the name of something else that is closely associated with it.

4838. "The Crown" is a metonym for the British royal family.

4839. "Hollywood" is a metonym for the movie industry.

4840. Meanwhile, synecdoche is a type of metonymy in which a part of something is used to signify the whole.

4841. When you call businesspeople "suits," you are employing synecdoche since suits are part of a businessman's attire.

4842. The next time you admire someone's new set of wheels, you'll be using a synecdoche, since wheels are part of a car.

4843. Synecdoches can also work the other way where something bigger is actually referring to a smaller part.

4844. An example of this type of synecdoche is, "Chicago won the game against New York." Of course, we are referring to these cities' sports teams and not the whole cities.

4845. An oronym is a word or phrase that sounds the same as another word or phrase.

4846. Many oronyms happen when the sounds of words run into each other, and we don't know where one word starts and another one ends.

4847. "I scream for ice cream," is an oronym because "I scream" sounds the same as "ice cream."

4848. Another example is "that's tough" and "that stuff." Or "the stuffy nose" and "the stuff he knows."

4849. Humorist and wordsmith Gyles Brandreth coined the term oronym in his 1980 book *The Joy of Lex*.

4850. An anapodoton is when the main clause of a phrase is left unsaid but is implied by a well-known subordinate clause. For example: When we say, "When in Rome . . ." everyone knows we also mean, "Do as the Romans do."

4851. Other examples of anapodotons are, "If the shoe fits . . .," "If pigs had wings . . .," "When the cat's away . . .," and "Where there's a will . . ."

4852. Coined by the author Sylvia Write in 1954, a mondegreen is a mishearing of a spoken or sung phrase.

4853. Write came up with the phrase in an article in *Harper's Magazine* from a mishearing of a line in a Scottish ballad "The Bonnie Earl O'Moray." The line is "They have slain the Earl O'Moray, / And laid him on the green," which is misheard as "Lady Mondegreen."

4854. Write wrote, "The point about what I shall hereafter call mondegreens, since no one else has thought up a word for them, is that they are better than the original."

4855. When Creedence Clearwater Revival sang, "There's a bad moon on the rise," in their hit song "Bad Moon Rising," many misheard, "There's a bathroom on the right."

4856. When Jimi Hendrix sang, "'Scuse me, while I kiss the sky," in the song "Purple Haze," many thought he was singing, "'Scuse me, while I kiss this guy."

4857. In the Lord's Prayer line, "Our Father, who art in Heaven, hallowed by thy name," is often misheard as, "Our Father, who art in Heaven, Harold by thy name."

4858. The line in the Beatles' classic "Lucy in the Sky with Diamonds" is "The girl with kaleidoscope eyes." Many people heard instead, "The girl with colitis goes by."

4859. Tom Swifties are a play on words in which a quoted sentence is ascribed to Tom and followed by a pun adverb.

4860. For example, "He lost his hand in an accident," Tom said offhandedly. Or "My saw needs to be sharpened," Tom said bluntly.

4861.

The archetypal example of a Tom Swifty is "'We must hurry,' said Tom swiftly."

4862. Tom Swifties come from the Tom Swift series of books that have been published since 1910. The young scientist protagonist, Tom Swift, has many adventures, and the authors of the books tried really hard to avoid repeating "said" at the end of dialog. This provided the name of this type of pun.

4863. A paraprosdokian is a figure of speech where the last part of a sentence is unexpected, leading the reader to reinterpret the first part of the sentence. For example, Groucho Marx once said, "I've had a perfectly wonderful evening, but this wasn't it."

4864. Perhaps the most famous paraprosdokian is Henry Youngman's "Take my wife . . . please."

4865. Named after Mrs. Malaprop, from the play *The Rivals* (1775), malapropisms are when you use an inappropriate word or expression in place of a similar sounding one.

4866. One of Mrs. Malaprop's most famous malapropisms was, "She might reprehend the true meaning of what she is saying."

4867. President George W. Bush was known for his malapropisms, such as "We cannot let terrorists and rogue nations hold this nation hostile or hold our allies hostile." Or: "See, in my line of work you got to keep repeating things over and over and over again for the truth to sink in, to kind of catapult the propaganda."

4868. Toy merchant John Warnock sold 12,000 talking George W. Bush dolls in 2003. Push the button and the 12 1/2-inch doll says one of 17 "powerful and patriotic phrases," such as "I don't need to be 'sublim-in-able' about the differences between our views."

4869. Bush laughed off his critics during the 2001 White House Correspondents Dinner by saying, "You have to admit in my sentences, I have gone where no man has gone before."

4870. A daffynition is a humorous definition of a word. For example: Cannibal: Someone who is fed up with people. Or: Politics: Where truth lies.

4871. Some daffynitions can be puns. For example: Buccaneer: How much corn costs. (Buck-an-ear.)

4872.

In a paroemion, every word or nearly every word in a sentence begins with the same consonant. For example: Money makes many men marvelous mad.

4873. A spoonerism happens when you switch consonants or vowels between 2 words in a phrase, usually to humorous effect.

4874. An example of a spoonerism is, "You have hissed all of your mystery classes," instead of "You have missed all your history classes."

4875. Other examples include, "mean as custard" instead of "keen as mustard," "plaster man" instead of "master plan," and "darn boor" instead of "barn door."

4876. Spoonerisms were named after the Reverend William Spooner (1844–1930) who was prone to this mistake.

4877. Spooner, himself, claims the only actual spoonerism he said was when he called the hymn, "The Conquering Kings Their Titles Take" in 1879, "The Kinquering Congs Their Title Take."

4878. The study of spoonerisms has helped researchers work on theories of how language is produced in the brain.

4879. IKEA is an acronym for Ingvar Kamprad (the founder's name) Elmtaryd (the name of the founder's family farm) Agunnaryd (the founder's hometown).

4880. Komorebi is a Japanese word for sunlight that filters through the leaves of trees.

4881. Tsundoku is a Japanese word for letting books pile up without reading them.

4882. Freudenfreude is a German word that describes the bliss you feel when someone else succeeds, even if it doesn't involve you.

4883. The opposite of freudenfreude is schadenfreude, which is the pleasure we feel when witnessing someone's misfortune.

4884. Lypophrenia is the vague feeling of sadness seemingly without cause. This often occurs when a person misses someone.

4885. An ultracrepidarian is someone who gives opinions on subjects they know nothing about.

4886. A librocubicularist is someone who reads in bed.

4887. Sesquipedalian is an adjective used to describe someone who is prone to using long words.

4888. People who feel an urge to correct other people's grammar are actually suffering from a form of OCD: Grammar Pedantry Syndrome.

4889. Aibohphobia is the fear of palindromes.

4890. The word "aibohphobia" is a palindrome.

4891.

The longest single-word palindrome in English has 9 letters: redivider.

4892. A place name is tautological if 2 different sounding parts are synonymous.

4893. This happens usually when a name from one language is imported into another. For example, New Zealand's Mount Maunganui can be translated as Mount Great Mountain.

4894. Others include: River Avon = River River.

4895. River Avonbeg in Ireland = Small River River.

4896. Connecticut River = Long Tidal River River.

4897. Bohai Sea in China = Bo Sea Sea.

4898. Laguna Lake = Lake Lake.

4899. Lake Michigan = Lake Large Lake.

4900. Lake Ontario = Lake Beautiful Lake.

4901. Bredon Hill in England = Hill Hill Hill.

4902. Brill, England = Hill Hill.

4903. There is also a street in Brill named Brae Hill. Its residents could be said to live in Hill Hill, Hill Hill on the Hill.

4904. The district of Urbanización Nueva Cartagena in Cartagena, Spain = City New New New City.

4905. Napton on the Hill in Warwickshire = Settlement on the Hill on the Hill.

4906. The La Brea Tar Pits in California = The The Tar Tar Pits.

4907. Mekong River = River River River.

4908. The word "cyberspace" was coined by William Gibson in his novel *Neuromancer*.

4909. Charles Dickens coined the word "butterfingers" to mean a clumsy person in *The Pickwick Papers*.

4910. In *Great Expectations*, Dickens first called someone a "doormat."

4911. Dickens used the word "boredom," but contrary to popular beliefs, he did not coin it.

4912. George Eliot coined the word "chintzy" to mean "unfashionable and cheap" in a letter in 1851.

4913. Louis Carroll coined the word "chortle," which is a combination of the words "chuckle" and "snort." It appeared in the poem "Jabberwocky" that first turned up in *Through the Looking Glass*.

4914. Isaac Asimov, in his 1956 story "The Dying Night," first coined the word "microcomputer."

4915.

Sinclair Lewis, in his 1927 novel *Elmer Gantry*, came up with the phrase "shotgun wedding" to describe a wedding made under duress or in a hurry because of the bride's pregnancy.

4916. *The Pickwick Papers* is also where you'll find the first use of the word "flummoxed" and the phrase "devil-may-care."

4917. The word "gremlin" was coined by the Royal Naval Air Service during World War I to describe small creatures that caused mechanical problems in aircrafts. Author Roald Dahl then wrote a children's book called *The Gremlins: A Royal Air Force Story*, which showed the word had become popular.

4918. "Meme" was coined in 1976 by evolutionary biologist Richard Dawkins in his book *The Selfish Game*." He conceived of memes as the cultural parallel to biological genes that are in control of their own reproduction and thus, serving their own ends. So, memes carry information, are reproduced, and are transmitted from one person to another, evolving as they move.

4919. "Nerd" was coined by Dr. Seuss in his 1950 children's book *If I Ran the Zoo*. It's the only word that stuck from the following line in the book: "And then just to show them, I'll sail to Ka-Troo / And bring back an IT-KUTCH, a PREEP, and a PROO, a NERKLE, a NERD, and SEERSUCKER, too!"

4920. "Yahoo," which meant a dimwitted person, was first coined by Jonathan Swift in *Gulliver's Travels*.

4921. In *Paradise Lost*, John Milton named the capital city of Hell "Pandeamonium." "Pan" means "all" in Greek, and "demonium" is Latin for demons.

4922. The claim that William Shakespeare coined up to 1,700 words that we use today is false. According to Merriam-Webster.com, this is a misreading of the data in the *Oxford English Dictionary* (OED).

4923. The Oxford English Dictionary was first published in 1928. The volunteers that provided the information read a lot more Shakespeare than other writers, so they found the words in his plays, which were easily accessible. This does not mean Shakespeare invented the word. In fact, access to digital databases has dramatically shrunk the number of words Shakespeare supposedly coined. As an example of this, many claim Shakespeare came up with the word "elbow." There's evidence of this word existing in 1548, before Shakespeare was born.

4924. Other words, that have been claimed to be coined by Shakespeare but weren't include: assassination, bedazzle, puke, hurry, frugal, eyeball, inaudible, premeditated, bold-faced, uncomfortable, and deafening.

4925. Shakespeare did coin "green-eyed monster." It first appears in Othello, Act 3, Scene 3: "O, beware, my lord, of jealousy! / It is the green-eyed monster which doth mock / The meat it feeds on."

4926.

Other Shakespeare-coined phrases include "in a pickle," "love is blind," "salad days," "wear my heart on my sleeve," "cruel to be kind," and "wild goose chase."

4927. Dorothy Parker in 1933 wrote this line in her short story "The Waltz," introducing us to the word "scaredy-cat" for the first time: "Oh, yes, do let's dance together. It's so nice to meet a man who isn't scaredy-cat about catching my beri-beri."

4928. The dot over a lowercase "i" or "j" is called a tittle.

4929. The hashtag symbol is called an octothorp.

4930. "Umlaut," the 2 dots over an "o" or "u" came from Jacob Grimm of the Brothers Grimm. He came up with it as a way to express a sound change in his native German.

4931. A dingbat is an ornament used in typesetting. They are also known as printer's ornaments.

4932. The dingbat font was a computer font that had symbols and shapes.

4933. A dinkus is a typographic symbol—usually 3 evenly spaced asterisks in a horizontal row—that denotes a break in the flow of a text.

4934.

"Rhythm" is the longest English word without a traditional vowel.

4935. "Gardyloo" is what people in the overcrowded city of Edinburgh, Scotland, shouted in the 1700s before dumping their chamber pots out of the window.

4936. The word "widdershins" is another way to say something is moving in the wrong direction or counterclockwise.

4937. If you have a stomachache, you can say you have the "collywobbles."

4938. The numbers we use today are based on the Hindu-Arabic numeral system developed over 1,000 years ago.

4939. The ancient Greeks didn't consider zero a number.

4940. Zero was invented by the ancient Babylonians.

4941. Zero is an even number. Divide zero by 2, and you get zero, which is a whole number.

4942. One is the only number that when written in English is spelt with its letters in reverse alphabetical order.

4943. Multiplying ones will always give you palindromic numbers. (1 x 1=1, 11 x 11=121, 11111 x 11111= 123454321.)

4944. The only even prime number is 2.

4945. The only prime numbers that end in 2 or 5 are 2 and 5.

4946. In Vietnam, it is unlucky to have 3 people in a photograph. Superstition has it that the person in the middle will die.

4947. Four is the only number spelled with the same number of letters as itself.

4948. Six is the smallest perfect number, which means it can be made by summing its divisors. 1 + 2 + 3 = 6.

4949. The numbers on opposite sides of a die always = 7.

4950. 8 × 1 + 1 = 9; 8 × 12 + 2 = 98; 8 × 123 + 3 = 987; 8 × 1234 + 4 = 9876; 8 × 12345 + 5 = 98765; 8 × 123456 + 6 = 987654; 8 × 1234567 + 7 = 9876543; 8 × 12345678 + 8 = 98765432; 8 × 123456789 + 9 = 987654321.

4951. If you multiply any single digit by 9 and then add the digits of the product, the sum will always be 9.

4952. 11+2 is an anagram of 12 + 1, and the answer in both cases is 13.

4953.

Eighteen is the only number that is twice the sum of its digits.

4954. In a room of 23 people, there's a 50 percent chance that 2 people have the same birthday.

4955. The only number whose letters are in alphabetical order is 40.

4956. The sum of the first 10 odd numbers equals 100.

4957. The sum of the first 9 prime numbers equals 100.

4958. The word "hundred" comes from the old Norse word "hundrath," which, incidentally, means 120.

4959. From 0 to 1000, the only number with an "a" in it is "one thousand."

4960. To convert Fahrenheit degrees to Celsius, subtract 32 and multiply by 0.5556 (or 5/9).

4961. To convert Celsius degrees to Fahrenheit, multiply by 1.8 (or 9/5) and add 32.

4962. The equation for converting Fahrenheit degrees to Celsius at freezing is (32°F–32) x 5/9 = 0°C.

4963. -40°C is equal to -40°F.

4964. When doing percentages, x percent of y = y percent of x. For example, 50 percent of 10 (which is 5) = 10 percent of 50 (which is 5).

4965. The largest known prime number has 17,425,170 digits. The new prime number is 2 multiplied by itself 57,885,161 times, minus 1.

4966. A googol is 10 to the 100th power, or 1 followed by 100 zeroes.

4967. The word "googol" was introduced by Edward Kasper and James R. Newman in their 1940 book, *Mathematics and the Imagination*.

4968. Kasper's 9-year-old nephew, Milton Sirotta, came up with the word.

4969. Kasper and Newman also came up with the googolplex, which is 10 to the power of googol, or 1 followed by a googol 0s.

4970. This number is so large that it can't be written down because there isn't enough room in the entire universe to fit it in!

4971. Google is a misspelling of "googol." In 1998, Sergey Brin and Larry Page, founders of the company, chose the name because they wanted to build very large search engines.

4972. Brin and Page named their corporate headquarters the Googolplex.

4973. A jiffy is actually 1/100th of a second.

4974. The ratio for length to width of rectangles of 1.61803 398874989484820, is known as the golden ratio.

4975. It was named by the ancient Greeks, and throughout history this ratio is considered pleasing to the eye.

4976. The numeric value is called "phi," after the Greek sculptor Phidias.

4977. The golden ratio appears in nature in tree branches, fruits and vegetables, shells, ferns, spiral galaxies, hurricanes, and the human face, as well as in art, such as Leonardo da Vinci's Mona Lisa. It also appears in music and architecture.

4978. Mozart arranged many of his piano sonatas so that the number of bars in the second part of a sonata (the development and recapitulation) divided by the number of bars in the first part of a sonata (the exposition) would equal 1.618, the Golden Ratio.

4979. The golden ratio is frequently used by traders and analysts to forecast market-driven price movement.

4980. The golden ratio is derived from the Fibonacci series of numbers, where each number is the sum of the 2 numbers before it. (0, 1, 1, 2, 3, 5, 8, 13, 21 . . .)

4981. Mathematician Leonardo Pisano first described the Fibonacci sequence in the 1200s.

4982. The Fibonacci sequence was first described by Pisano while describing a problem about rabbits multiplying.

4983. The number of petals on a daisy is always a Fibonacci number: 21, 34, or 55.

4984. November 23 (11/23) is celebrated as Fibonacci day because when written in mm/dd format, the numbers form a Fibonacci sequence: 1, 1, 2, 3.

4985.

In 2019, Emma Haruka Iwao, a Japanese Google employee, calculated Pi to a record 31 trillion digits. She used Google's cloud computing service.

4986. Eratosthenes, a Greek mathematician, geographer, and astronomer estimated the Earth's circumference using math over 2,000 years ago. He was off by 2 percent.

4987. Every odd number has the letter "e" in it.

4988. If a month starts with a Sunday, it will have a Friday the 13th.

4989. There is more pizza in an 18-inch pizza (254 square inches) than 2 twelve-inch pizzas (226 square inches).

4990. But if you like the crust best, the 2 12-inch pizzas have 33.3 percent more crust than the 18-inch pizza.

4991. The numbers on a roulette wheel add up to 666.

4992. One million seconds is 11 days.

4993. One billion seconds is 31.5 years.

4994.

The number 4 is associated in Japanese and Chinese cultures with death.

4995. Many hospitals in China don't have a fourth floor.

4996. One bucket of water has more atoms than there are buckets of water in the Atlantic Ocean. In fact, there are more atoms in a cup of water than there are cups of water on Earth.

4997. One cup of water equals 250 grams. That equals 8.3569904e+24 molecules of water.

4998. At 3 atoms per molecule, that equals 2.5070971e+25 atoms per cup of water.

4999. All the water on Earth equals 332,500,000 cubic miles or 5.54368183 x 10^21 cups of water 2.5 x 10^25 >> 5.5 × 10^21, so there are far more atoms in a cup of water than there are cups of water on Earth.

5000. A baker's dozen, which is 13 instead of 12, dates back to the 13th century.

EXERCISE YOUR MIND AT AMERICAN MENSA®

At American Mensa®, we love trivia. In fact, we have events—large and small—centered around trivia.

Of course, with tens of thousands of members from ages 2 to 102, we are much more than that. Our one shared trait might be one you share, too: high intelligence, measured in the top 2 percent of the general public in a standardized test.

Get-togethers with other Mensans—from small pizza nights up to larger events like our annual Mind Games—are always stimulating and fun. Roughly 130 Special Interest Groups (we call them SIGs) offer the best of the real and virtual worlds. Highlighting the Mensa® newsstand is our award-winning magazine, *Mensa® Bulletin*, which stimulates the curious mind with unique features that add perspective to our fast-paced world.

And then there are the practical benefits of membership, such as exclusive offers through our partners and member discounts on magazine subscriptions, online shopping, and financial services.

Find out how to qualify or take our practice test at american mensa.org/join.

Mensa® Brilliant Brain Workouts

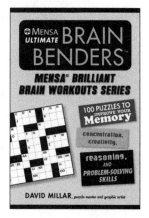

A Brand-New Series from Mensa® and World Almanac®!

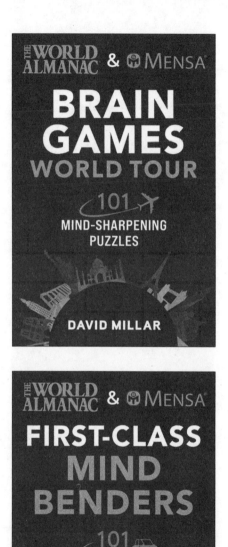

THE WORLD ALMANAC & ® MENSA

BRAIN GAMES
WORLD TOUR
101 ✈
MIND-SHARPENING
PUZZLES

DAVID MILLAR

THE WORLD ALMANAC & ® MENSA

FIRST-CLASS
MIND
BENDERS
101 🚗
PUZZLES TO TAKE
ON THE ROAD

DAVID MILLAR

Mensa® Puzzles for Kids!

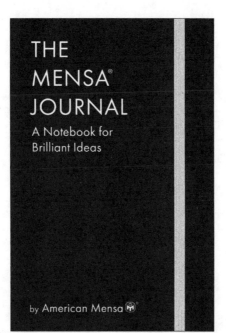